Field Notes on

Field Notes on the Visual Arts

Seventy-Five Short Essays

EDITED BY

Karen Lang

intellect Bristol, UK / Chicago, USA

First published in the UK in 2019 by
Intellect, The Mill, Parnall Road, Fishponds, Bristol, BS16 3JG, UK

First published in the USA in 2019 by
Intellect, The University of Chicago Press, 1427 E. 60th Street,
Chicago, IL 60637, USA

A catalogue record for this book is available from the
British Library.

Copy-editor: MPS Technologies
Cover designer: Aleksandra Szumlas
Cover image: Elizabeth King, Bartlett's Hands, 2005, installation:
Sculpture and stop-frame animation, LCD screen, hidden computer,
dedicated lighting, overall 72 x 24 x 60 in. Collection of Karen and
Robert Duncan, Lincoln (artwork © Elisabeth King; photograph
© Lynton Gardiner). Printed with permission of the artist.
Layout Design: Aleksandra Szumlas
Production manager: Mareike Wehner
Typesetting: Contentra Technologies

Print ISBN paperback: 978-1-78320-996-5
Print ISBN hardback: 978-1-78938-155-9
ePDF ISBN: 978-1-78938-018-7
ePUB ISBN: 978-1-78938-017-0

Printed and bound by Gomer, UK
This is a peer-reviewed publication.

Contents

TIME

TRADITION

Acknowledgments

Field Notes on the Visual Arts is the outcome of many hands. My own extend in gratitude first of all to the book's 75 authors for their richly insightful essays. The artists not only contributed essays, they granted permission to reproduce their artwork—I give them my warmest thanks. I would like to acknowledge the US College Art Association for allowing me the freedom, as Editor-in-Chief of *The Art Bulletin*, to create and develop this project in its initial form and to mention Joe Hannan and Lory Frankel especially. I am grateful to two anonymous peer reviewers for suggestions which greatly improved the book. *Field Notes on the Visual Arts* would not have appeared without the devotion of editorial assistants Kayoko Ishikawa and Carlo Avilio. Carlo Avilio also produced the index. Their meticulous work not only turned an unwieldy project into a reality, it made the process a pleasure. Mareike Wehner carefully guided the book through production while making room for my own ideas—my warmest thanks to her and to the entire team at Intellect Books. Last but not least, I would like to express my gratitude to those who contributed toward the cost of colour illustrations. Tom Huhn, Chair of Visual & Critical Studies and Art History, School of Visual Arts, New York, and Dia Holz provided generous subsidy funds for which I remain hugely grateful.

Karen Lang

Introduction

In 2011, as editor of *The Art Bulletin*, the leading journal of international art history, I introduced a feature entitled "Notes from the Field." The success of this initiative was tremendous, and produced an extraordinary collection of short polemical texts that are brought together in this volume as *Field Notes on the Visual Arts*. The essays appeared in consecutive issues of the journal under eight major headings: anthropomorphism, appropriation, contingency, detail, materiality, mimesis, time, and tradition.[1] No all-embracing theory guided the selection of these headings. My motivation was more prosaic: topics the author would have encountered during the course of their working lives. I commissioned the author to write on a specific topic but gave only basic instruction: a 1000-word essay; expository rather than scholarly (an encouragement to jettison footnoting or at least the heavy footnoting of academic writing). Otherwise, the author could approach the topic however they liked.

Rather than a "state of the field," "critical terms," or "keywords" approach, in which topics function as guideposts or bannisters, I envisioned the topics as touchstones. I was interested to discover what voices generally separated—inside and outside the humanities, the university, the museum, and so on—would make of a topic in a short essay. The format's open and generous approach to knowledge encouraged speculation and innovation, and the authors made the most of it. For all their brevity, the essays are fruitfully varied in form. They delight and instruct in equal measure.

The feature was a leap of faith, especially for *The Art Bulletin*, a field-defining scholarly journal set to celebrate its centenary when the essays appeared. But the time seemed right to open up the airways of the journal, and the consideration of aesthetic and material objects more generally. Still, I hoped for more: where tradition held that art historians, curators, and artists spoke in different languages about the visual arts, with the art historian reputedly the most scholarly of the bunch, I thought that perception derived from a certain, academic point of view that did not hold in principle. All in all, I wanted to mix it up by bringing thinkers, makers, discoverers, and menders together: to see how they worked with materials and ideas by giving them a task in common. Their essays would enable the reader to glimpse how a topic takes shape and is transformed in the telling. Precisely because each topic would take shape through what the authors made of it, the specificity and particularity of objects, contexts, and interpretations would be stressed over received ideas and universalisms. In any case, that was the hope. Received ideas and universalisms were bound to come through the back door anyway, since we are all guided by tacit knowledge of all kinds. Still, the back door seemed better than the front.

The aim to open a field of inquiry, rather than to widen the academic discipline of the history of art, was in some degree a response to endless talk of interdisciplinarity at the university. Interdisciplinarity brings knowledge and insight from one academic field into another. For at least two decades, scholars have relied on it to expand and deepen academic fields in ways that can still seem vital and important. Instead of adding to or blurring the boundaries of the discipline of the history of art, however, I wanted to uncover the spaces and intervals between disciplines and categories. By the end of the feature, which ran from 2012 through 2013, I hoped discoveries in these in-between spaces would be substantial enough to constitute a field of its own. It is a tribute to the authors that the seventy-five essays published here traverse chronology and geography to reveal the appeal, resistance, and perplexity of aesthetic and material objects. The astonishing range of illustrations is an indication that this book leads us into new territory. *Field Notes* is the thinking person's companion to this territory in the visual arts.

The experience *Field Notes* offers of the power and particularity of objects and ideas across time and space—beyond field, period, genre, or material—shows that objects and ideas are not only historically dependent and resonant. They are also open to change rather than fixed by the circumstances of their emergence. If we carry the lesson further, it reminds us why the claim to grasp reality or to fix meaning is ultimately grandiose. This is what ideologies claim and why they are dangerous. On the other hand, the stress on specificity and particularity in *Field Notes* suggests why a thoroughgoing relativism is also off the mark. Objects and ideas, like historical events, are tangible things worthy of our greatest attempts at understanding. Showing how objects, ideas, and events are made and transformed in the telling, *Field Notes* also points to the decisive role of words and narrative in the shaping of knowledge and understanding.

While the essays were originally published in *The Art Bulletin*, putting them together with a critical introduction and bibliography seemed a natural step. Whether readers venture within or across topics, whether they dip in and out, having the essays in one volume permits a synergistic effect. Reading, re-reading, and contemplation are all the more satisfying on account of the mode of the essays themselves. Each author brings a unique point of view and approach, and a variety of written forms is the result, with the reader encountering a broad gamut ranging from historical survey to personal reminiscence. As the reader travels across worlds of ideas, the topics fan out, rejoin, and then fracture again. Along the way, they become more capacious and contoured than any single definition would allow. In addition to expansion and implosion of terms, categories, and received ideas, individual topics are enriched and made complicated throughout the book by confrontation with ideas that are both complementary and challenging. There is no final conclusion but rather a dynamic synergy of ideas, arguments, and positions.

And yet it must be said that this book is a limited enterprise. There are gaps in coverage; there is over balance on the nineteenth and twentieth centuries and on the West. The final shape of a book of this kind has its own story to tell: it is made by the authors who agreed

and declined to be included; by the authors one knows or has been given a lead to and those who remain unknowingly in the shadows. My own specialism in modernism undoubtedly played its part in the final shape of *Field Notes*. The authors, meanwhile, brought assumptions and protocols, institutional frameworks, and national traditions of their own. In an attempt to lay these to one side, in *Field Notes* the authors are regarded as informed thinkers, makers, discoverers, and menders of objects and ideas rather than as representatives of a discipline or specialism.

Although *Field Notes* leads us into new territory in the visual arts, it does not provide master keys for viewing and interpretation. It offers a variety of perspectives, but it presents nothing close to total coverage. The book's strengths are also its limitations. On the positive side, history is kept open in *Field Notes*. The absent and the present in *Field Notes* tells us about time past, about today, and about ourselves. New essays and new perspectives will write a topic differently, and differently again. This is as it should be.

Anthropomorphism covers cave art, sculpture (Moche to Ife, Spanish baroque to post-minimal), painting, photography, and architecture. This broad chronological and geographic sweep shows anthropomorphism at the core of our engagements with the world. Sculpture "can take us from the outside to the inside," artist Elizabeth King explains. "A carving made long ago addresses us via our common nerve": sensitive "to the minute angle of the head to the neck, […] we practice the angle unconsciously as we look." When we respond to the beckoning of sculpture toward the human by finding the human in sculpture, this is an instance of anthropomorphism. Indeed, anthropomorphism arises from two interrelated practices: "humanizing the deity and animating inanimate material forms." These practices and their offshoots—the anthropocentric, the anthropometric, and anthropomorphosis—came under attack during the Enlightenment. Although at odds with modernity and the new science, anthropomorphism nonetheless persisted, coming to the fore when human agency was threatened or fears of mortality ran high. A recent "anthropological turn" in scholarship has acknowledged the "living presence" of the things of the world. Scholars have examined the activation of images and objects by the viewer, and the ways in which imagination, oral tradition, and technological reproducibility extend presence across time and space. In contrast to recent literature, however, the authors in this volume signal the pitfalls of universal and trans-historical understandings of anthropomorphism. In their essays, particularities of time, place, and medium shape the response to form. Accordingly, Jane Garnett and Gervase Rosser warn of the inadequacy of "the very language we habitually use of images." This includes trusty words like "figuration," "representation," and "expression." With the disclosure, through anthropomorphism, of new dimensions in human engagement with the world comes the need for language adequate to these experiences.

Appropriation resides at the origins of art making, and at the foundations of philosophy and literary studies. It is central to theories of jargon and mimicry. An essay by Georg Baselitz, an artist celebrated for appropriation, is in fact a poetic meditation on the inaccuracy of the label as a covering term for his art. It appears that his recent remix paintings

(repainted works from an earlier period) do not appropriate so much as rework his previous work. In them, Baselitz conjures his own urge to *épater le bourgeois*, presenting an economically driven art market with innovation instead of the prized fish of originality. Perhaps this is an instance of what Ursula Frohne calls "the afterlife of the previously experienced," when appropriation punctures actually existing conditions, upsetting smooth separations of past and present, old and new, original and copy. The authors show how echoes, phantoms, specters, and survivals likewise unhinge settled divisions, this time between self and other, life and death, real and unreal. The idea that originality is entangled with appropriation is not new, especially in the study of modernism, but the binary relation of originality and copy central to previous investigations is just one facet of the crystal of appropriation. The essays present a convincing case for jettisoning the binary of original and copy in favor of more richly complex ideas of cultural afterlife, epigonality, reclamation, *Shanzhai*, and translation. These ideas blast open the notion of a discrete object of experience, conceiving aesthetic and material objects, instead, as force fields of "subversive energies."

Contingency plays an inevitable part in making, thinking, and writing, even under strict rules. For the artist Linda Connor, good photographs radiate what she can feel but hardly see. Photography is "a crapshoot, a wing and a prayer, a shot in the dark." Her renowned teacher Harry Callahan put it this way: good pictures are "dumb"; they illuminate visual ideas that words often fail to approach. Just as the artist touches something unexpected in the process of making, so do pictures touch us without our being able to articulate why. Aesthetic and material objects have been held to various standards of perfection over time, yet it is interesting to note how "imperfections" can overrule the ideal, generating aesthetic responses in the spectator. Ancient Greek architecture and sculpture was "fantasized" in the eighteenth century "by Winckelmann and others as a perfect, eternal 'whole.'" But as Mark Ledbury argues, it was "experienced by this generation as ruin or fragment, or as displaced, transmuted, damaged metonymy." In photographic, electronic, and digital imaging systems, Mary Ann Doane observes, "it is the defectiveness of the image (or sound), its deficiencies, that constitute the confirmation of its contact with (touching of) the real, its collaboration with contingency." As the world becomes increasingly made over in images of visual perfection, and as we come increasingly to measure ourselves by these "perfect" image worlds, the experience of visual flaws and human vulnerability has the power to connect us with a human realm. We are learning how a daily flood-tide of images compromises our ability to respond with empathy to what we see, but what is the effect of this on the aesthetic and material object? According to Angus Fletcher, a new world of "almost uncontrollable quantities of data" is putting pressure on "a quest *internal* to the artwork itself." For those concerned with meaning and sense, contingency poses challenges to interpretation. This leads Peter Geimer to ask: "What place will the study of images concede to contingency, to the unforeseeable event, to that which is unsusceptible to being composed?" Where traditions of interpretation train our sights on the composed, the intended, and the meaningful, these essays explore the unfettered, the open, and the resistant as ends in themselves.

Detail is perceived as disconnected or part of a whole. Material, visual, and textual detail is a point of access or a pivot of the unknowable. When detail triggers a relay of meaning, it haunts the individual seeking to explain it. Any history of detail is thus punctuated by moments of metaphysical or interpretive tension and expansion. The artist Susan Hiller focuses on "the ghosts that haunt our society because collectively we refuse to enter into dialogue with them." Carlo Ginzburg explains that in addition to referring to the biblical story, Lorenzo Ghiberti's bronze panel *The Sacrifice of Isaac* alludes to the extraordinary invocations of the visual in Dante's *Divine Comedy*, and thus to "a social experience" of understanding visual details in terms of wholes (even when the whole is not presented). Where Goethe was skeptical about detail as a means of artistic expression, Sigmund Freud, Aby Warburg, and Walter Benjamin made it central to their theory. Details became the stuff of connoisseurship, a "science" emerging at the end of the nineteenth century. The same practice that linked details to notions of "artistic genius" could, on a more sinister register, link the look of human features to stereotypes of criminality and "race." By now we are more critical of the uses to which detail can be put. Nevertheless, when details command attention, power dynamics are never far off stage, as the authors show. Detail can be construed as a fetish, implicating us in the capitalist system that underpins our love of objects or, to follow Blake Stimson, it can call forth Benjamin's "beloved 'creative collective.'" Detail can also occasion the "transhistorical contact" described by Nina Rowe, when the reader or viewer joins hands metaphorically with the past. Whether perceived as disconnected or part of a whole, detail is central to our imaginings.

Materiality attracts visual attention or it fades into the background, becoming material support or mental substance. The artist Martha Rosler poses the central question: "How do we read the shape of significance in things imbued with human interest?" Does materiality refer to the objects themselves or to the contexts and discourses in which these objects intervene, or both? Rosler puts forward "a decoy," defined as "something that takes a familiar shape but that attracts people toward something else—an object or event, perhaps—that opens a door to a rather different set of concerns." This is the trick of materiality. Materiality brings imagination, ideology, and the sacred into its orbit. Medieval devotional objects are "vibrantly active stuff, a locus of divine agency," as Caroline Walker Bynum says. In Holi festival, the coming of the Hindu New Year, color is sacred. The interpretation of aesthetic and material objects requires "an understanding of the culturally specific qualities ascribed to materials," as Alisa LaGamma shows in an essay on African wooden sculpture. What is sacred to some is threatening to others, especially when they are meant to set the terms. To keep the connotations of color under control, Natasha Eaton explains that British colonial officials deemed the Indian dyer "marginal, poverty-stricken, or else entirely absent from those communities under the purview of the later nineteenth-century ethnographic state." The full range of materiality's meanings is a challenge, even a danger, to the scientifically driven societies of modernity. It is therefore not surprising to find materiality swept to the margins. Knowing this history helps us understand why the recent uptick in interest in

materiality across the academic disciplines, from film theory to the history of science, is not simply a response to the threat digital media pose to the things of the world. In the digital age, materiality pushes back against the quantified self and yet, to follow Michael Kelly, art's return to materiality is "a resistance to the subjectivization of technology and art alike." When we understand that art cannot be reduced to human artifice, materiality helps us rethink the concept of artistic agency. Materiality opens a conceptual space for the idea that art, to quote Kelly, "is practiced in the heteronomous spaces between the sacred and the material, turning one way, then the other, sometimes simultaneously."

Mimesis generally means matching and illusion, *trompe l'oeil* dazzle, fidelity between the world and its representation. Still, "being a good artist was never about getting the world to look like itself," artist Dexter Dalwood writes, if only because "mimesis—the visual trickery of naturalism—is in fact one of the easiest aspects of image making." This seems to undercut the pre-eminence of artistic illusionism since classical times, until we learn that in the visual arts mimesis has conformed to Plato's conception. Plato defined mimesis as life-likeness based on imitation. This is why he disparaged the idea: if mimesis is based on imitation, mimesis is at best empty representation. Aristotle, by contrast, recognized in mimesis our intuitive capacity to forge similarity and continuity. As Tom Huhn observes, "it is from this latter species of mimesis—the one that produces not so much likenesses and representations as unities and continuities—that we have much to learn." Aristotle's view accords with a new line of inquiry, cited by Thomas Habinek, showing that "recognition of similitude leads to action without an intermediary stage of intellection." Perhaps mimesis is "a precondition for language, music, art, empathy, cooperative action, and social learning," as recent research indicates. In our time, when "reality seems increasingly aesthetically framed–designed, as it were," Dalwood finds the question of mimesis suggests "a new congruence between images and the world they represent," one that "finds reality and naturalism through a lived and collaged version of itself." A definition of mimesis as collaged representation may bring us closer to the real way of things in times past as well. The reader discovers along with Helen Evans that in the Byzantine world "apparently simple examples of mimetic imitation" reveal "significant unexpected interconnections between cultures." Sarah Fraser finds something similar in the Dunhuang caves in the 1930s and 1940s, when Han Chinese reappropriated Tibetan and Mongolian cultural spaces "to fashion a Sino-modern agenda." Mimesis may come naturally to the human animal, but cultural regimes of mimesis are underpinned by the conventions, values, and beliefs of human societies. All this reminds us why mimesis involves more than matching and illusion. Mimesis encompasses similarity and collage, encounter and what Alex Potts calls "the world creating aspects of art." Mimesis itself is born out "of the impossibility to name and represent things 'as they are.'" This means mimetic practice is, Niklaus Largier continues, "a never-ending play with figures, their capacities to produce effects and to form networks."

Time is intrinsic to works of art, and to aesthetic and historical considerations. "All art is involved with time," artist Eric Fischl remarks. Whether the artist works to start or stop

time, whether they employ qualities of time or timelessness, the artist finds "ways of working with time to achieve its greatest effect." Through Fischl's eyes we see why Donatello chose "to leave the smallest space between the fingertips" of his wooden sculpture of Mary Magdalen: to measure "the small amount of time she has remaining." This space, "wide enough so only a soul may pass through, marks both a fleeting moment of life and the enormity of the timeless chasm to follow." In contrast to Donatello's poise of time between the secular and the sacred, Tiepolo brought time to a standstill in his fresco *Cupid Above a Landscape*. Malcolm Bull explains that Tiepolo's scene of figures strolling in a landscape, backs turned away from the viewer, depicts "a moment between two temporalities—between the eternal now of the history painter and the linear time of modernity into which those figures will eventually start to walk." What the artist makes of time points to their own time. And yet, as Darby English shows in *Just Above My Head*, a black-and-white film by British artist Steve McQueen, the artist can make work of their time, "only not compliantly so." The relation of the visual image to time is "more than an exercise in periodization," as Ludmilla Jordanova says. How is it possible "to visualize and embody" time? she asks. What is the difference between the temporality of the depicted scene and "time as we know it", Ajay Sinha asks. The subject of time always seems to shade onto the philosophical, in part because birth and death, the shaping experiences of human existence, are imbued with time. The ancient Egyptians understood the world and the afterlife in cyclical and linear time, as Jan Assmann shows. Time unfurls from inside the new media. The new media bring with them the capacity to bend time in the image. This could signal a potential mastery of time, except for an enduring paradox: we can manipulate time, but we are unable to step outside time's circle or its arrow. "The task of modern thought" is still "to *discover* time," as David Wellbery contends: "to disclose its origination, its irruption, and therewith the emergence of the world."

Tradition, a supposedly static and suffocating relic, was dethroned in modernity. And yet, what if tradition was conceived as living rather than dead? For artist Obiora Udechukwu, a "triple heritage" means "that tradition is neither static nor rigidly localized." The artist-traveller (like the artist-emigrant, immigrant, or exile) "absorbs novel elements from other locations and melds them to the familiar," changing the traditional and "giving rise to the new traditional" in turn. In stark contrast to an understanding of tradition as timeless, eternal value, Udechukwu's weaving and reweaving of past and present, like the rubbing together of universal and particular, brings tradition down to earth, tethering it to time and place. A static understanding of tradition "has very limited value as a term of critical analysis," as John Brewer says, but, he adds, "claims based on 'tradition', 'traditions', and 'the traditional' are worthy objects of scholarly criticism." The authors show how individuals harness and remake traditions, and how political, economic, and cultural circumstances conspire in what Eric Hobsbawm and Terence Ranger famously called "the invention of tradition." From modern German prints to the ritual of Durga Pujas in contemporary Calcutta, and from Canadian aboriginal art and its afterlife to the material translation of patchwork cloth across the islands of Hawaii, Tahiti, and the Cook Islands, the essays reveal that

tradition involves transmission. The path from then to now is anything but linear or fixed. If tradition is our "exquisite haunting," as Maria Loh suggests, then human life without tradition's ghosts appears as frightening as the ready-made interiority of an artificial intelligence. Tradition provides the ground for attachment and contestation. Tradition, in the words of Gregg Horowitz, "is the unwilled power of the past that, not having finished its business in its own time, offers us here and now the occasion to turn it to new purposes." Tradition is clearly more than a dead past or an eternal value; it is "the past sublimated into artifacts, images, and ideas that are on the march."

Field Notes opens a sparkling kaleidoscope of ideas and reflections on the visual arts. Aesthetic and material objects are shown to be multifarious in their meanings. However, at the same time as meaning is open and various, it emerges in particular settings. The inherent slipperiness of meaning, the way it changes according to how circumstances themselves change, makes interpretation a necessity. Still, that isn't so bad. To be active rather than passive in looking, thinking, and writing allows works of art and material culture the full measure of their capacity to satisfy, to confound, and even to shake us. In short, it gives the things of the world their due. *Field Notes* invites its readers to learn from and to argue with works of art and material culture, and to consider learning and arguing an ongoing enterprise.

Notes

1 "Anthropomorphism" appeared in the "Notes from the Field" feature in *The Art Bulletin*, vol. XCIV, no. 1 (March 2012); "Appropriation," vol. XCIV, no. 2 (June 2012); "Contingency," vol. XCIV, no. 3 (September 2012); "Detail," vol. XCIV, no. 4 (December 2012); "Materiality," vol. XCV, no. 1 (March 2013); "Mimesis," vol. XCV, no. 2 (June 2013); "Time," vol. XCV, no. 3 (September 2013); "Tradition," vol. XCV, no. 4 (December 2013). The March 2013 issue marks the journal's centenary. *The Art Bulletin* circulates to all institutional members of the US College Art Association and to individuals who chose to receive the journal as part of their membership.

ANTHROPOMORPHISM

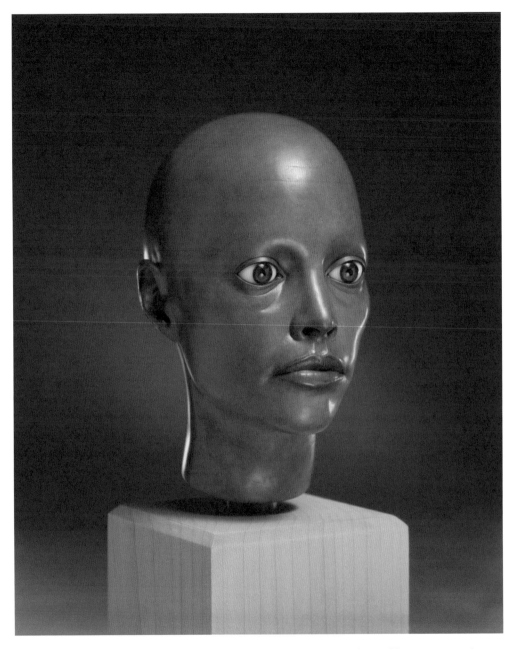

Figure 1. Elizabeth King, *Untitled*, 1991–94, bronze, glass eyes, first of a variable edition of four, 6 × 3 × 4 in. (15.24 × 7.62 × 10.16 cm). Collection of Martin Puryear, Accord, NY (artwork © Elizabeth King; photograph © Katherine Wetzel). The eyes are movable: to reposition the gaze, the back of the head may be removed to access the eye mechanism inside.

<div style="border: 1px solid; display: inline-block; padding: 10px 40px;">

Elizabeth King

</div>

Inhale, Exhale, Pause: Breath and the Open Mouth in Sculpture

I have been working on a new bronze head. Yesterday I finished smoothing out the inside walls of the casting, with my small flex-shaft grinder. People forget bronze sculptures are hollow, even small ones like this. The head is exactly half life-size, and open at the back so I can get inside. It is a self-portrait. I cast the back of the head as a separate piece to fit on later, like a surgeon replacing a section of skull; the occipital hatch. Why so smooth, these inside walls? They will not be visible once the head is closed. Nonetheless, the interior must be coherent, habitable. The bronze perimeter is thin and strong; I caliper the wall: a little over one-eighth-inch thick. Today I'm working on the openings: nostrils, eyes, ears, mouth—the elegant apertures of the head. Our points of congress with the world. In spite of our knowledge, we persist in feeling that when we close our eyes, we adjourn to a private interior, our sovereign estate, something we experience as a *space*. We move around in here, arranging this and that, checking the windows.

But gazing out, across the contested territory between our separate bodies, we shudder at the terrible darkness in another's ear, another's nostril. How far in do we dare look? Can I sculpt in a bit farther, maybe all the way in, to be sure I represent that darkness? I hold the head and bring the spinning grinder bur through the open back and into the ear canal from the inside—steady!—while eyeing the operation from the outside. Looking in the tunnel from one end at my bur entering from the other, with tiny strokes I refine the negative shape of the curved passage. Is there an exact boundary between outside and inside?

Sculpting the open mouth is a particularly difficult challenge. One would like an exhibition of works on just this theme (Bernini's *Costanza*, Houdon's *Diderot…*). Two extraordinary examples were on view recently in exhibitions in the United States. *The Sacred Made Real: Spanish Painting and Sculpture 1600–1700*, at the National Gallery of Art, Washington, DC, brought us Pedro de Mena's 1663 *Saint Francis Standing in Ecstasy* (Fig. 2).[1] A small polychrome figure carved of wood, the saint stands in arrest on an ebony plinth, pale face suspended in the dark recess of the drawn cowl, glass eyes raised under real eyelashes, mouth open to reveal two uneven rows of ivory teeth (some missing), the teeth parted over a black interior. Years ago I had searched for this figure in Toledo. The day I visited, it was all but a shadow in the cathedral, installed in the sacristy many paces behind a closed balustrade. In Washington, you could step up to within inches of the vitrine. The sculpture was lit with subdued but focused precision (what saint lit this show?). One tooth caught a tiny highlight and glinted from within the mouth. You see this and catch your breath—then realize the figure, too, is inhaling.

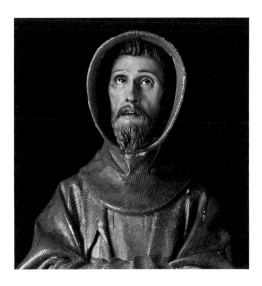

Figure 2. Pedro de Mena, *Saint Francis Standing in Ecstasy*, detail, 1663, polychromed wood, glass, cord, and human hair, with plinth, 38¼ × 13 × 12¼ in. (97 × 33 × 31 cm). Toledo Cathedral (artwork in the public domain; photograph provided by the Instituto del Patrimonio Cultural de España, Ministerio de Cultura).

No mistaking it: the contracted lift of the head, beard just sprung free of the cowl, indrawn gulp at the mouth and jaw, taut chest: an inspired pressure at the back of the throat is inferred from every part visible around it. All who looked at this sculpture held their breath.

A more hyperbolic performance was Franz Xaver Messerschmidt's *The Yawner*, in a formidable lineup of Messerschmidt's character heads at the Neue Galerie in New York (Fig. 3).[2] Has any sculptor, save the great eighteenth-century Italian anatomists of La Specola, undertaken so close a study of the floor of the mouth? The underside of the lifted tongue, the frenulum, sublingual caruncle, and salivary ducts, delicate connective epithelium—Messerschmidt has executed every clinical detail. A sculptor's paradise of ridges, bumps, grooves, hollows, and undercuts. So thin is the membrane beneath the tongue that the body absorbs a drug faster here than by swallowing, and the thermometer best reports our fever. But yawning this fevered head is not! Air is rushing out of the mouth, not in. The eyes squeeze shut so tightly that the forehead and cheeks buckle into a rack of bulges and fissures. Veins stand out on the temples. The upper lip is pulled back from the teeth. The jaw contracts back into the neck, not out from it, to marshal strength to the larynx. Could we hear the sound that goes with this face, we would never lean in for so close a look.

A third head, to calm down: this one with mouth closed, holding its tongue, but in possession of palpable interior volume. It is the *Head Called "Lájùwà"* in the exhibition *Dynasty and Divinity: Ife Art in Ancient Nigeria*, on tour in Europe and the United States from 2009 to 2012 (Fig. 4).[3] A life-size terra-cotta portrait, dated between the twelfth and fifteenth centuries, this head is as poised and self-contained as the Messerschmidt is torqued and agape. Those muscles that hold the body at full attention are in supple play across the face. The fall of light allows us to identify the slight sinus swells at forehead and flanking the nose, the lift of the muscle orbiting the mouth, the modulated rise of the cheekbone intercepted by the faint

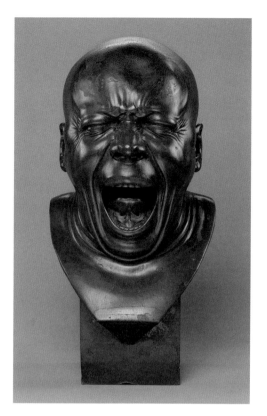

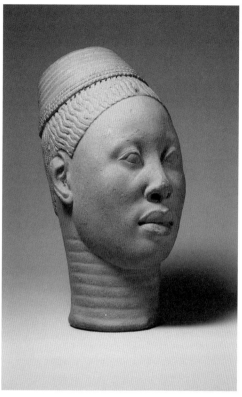

Figure 3. Franz Xaver Messerschmidt, *The Yawner*, 1771–81, tin cast, 16⅞ × 8⅝ × 9½ in. (43 × 22 × 24 cm). Museum of Fine Arts, Budapest, RSZ 53.655 (artwork in the public domain; photograph by Csanád Szesztay, © 2012 Museum of Fine Arts, Budapest).

Figure 4. *Head Called "Lájùwà,"* 12th–15th century, terra-cotta, height 12⅝ in. (32 cm). Ife Palace, Ife, Collection of the National Commission for Museums and Monuments, Nigeria, 79.R.10 (artwork in the public domain; photograph © National Commission for Museums and Monuments, Nigeria, provided by the Museum for African Art and Fundación Botín / Karin L. Willis).

crease beneath the eye. Our eye is caught almost more by these zones of transitional contour than by the nameable features, although each of these—mouth, nose, eye, and ear—delivers a smaller topology of quickening curves. The mouth in particular, the most powerful symbol in Yoruba oral culture, is articulated as a coherent set of muscles in near perfect equipoise. Nose and ear openings penetrate through to the hollow interior ("the nose, or *imú*, the source of ventilation for the soul"[4]). I am struck by a paradoxical evenness of pressure in the rise and fall of the flesh. Perhaps the air of composure arises from this buoyant evenness. Flesh and air: there is breath in this clay head. Ife sculpture is famous for its depiction of nobility of character. Who was Lájùwà? Oral tradition identifies him as steward to a ruling Ooni, who usurped the

throne after concealing his master's death. He was beheaded when the ruse was discovered.[5] The portrait head, like its subject, is a noble deception.

As are the tricks by which the sculptor gains access to the interior of a form. One might almost expect Mena to have carved not just the inside of the saint's mouth, but the throat and very trachea to the lung. Close to it: the face was carved as a separate piece, the mouth hollowed out from the back, eyes and teeth set in place, and the whole then fastened like a mask into the deep concavity of the cowl.[6] The medium, and sometimes the method, provides the way in. The lost-wax casting process makes a hollow shell that is filled with molten metal. Messerschmidt gives us two hollows, the cavern of the mouth and behind it the hollow of the head, cast in tin. Terra-cotta, "baked earth," must be hollow to be fired, and one can imagine the Ife sculptor coiling the wet clay with hands both inside and out. Indeed, the interior walls of the *Lájùwà* are so smooth the coils are barely visible. The sculptor finds the way in, then holds the door open for us.

Wood, tin, clay. *Sculpture can do this*. It can take us from outside to inside. A carving made long ago addresses us via our common nerve. We are sensitive to the minute angle of the head to the neck. Imitators all, we practice the angle unconsciously as we look. And the pose itself reaches backward into our somatic repertoire and selects the originating emotion, reverse engineers it. We look at a little statue and say, "Oh, this is Saint Francis receiving the stigmata." And our own mouth drops open. And we are wounded.

Notes

1 *The Sacred Made Real: Spanish Painting and Sculpture 1600–1700*, the National Gallery, London, 2009–10; the National Gallery of Art, Washington, DC, 2010. Exh. cat., ed. Xavier Bray (London: National Gallery, 2009).

2 *Franz Xaver Messerschmidt 1736–1783: From Neoclassicism to Expressionism*, the Neue Galerie, New York, 2010–11; the Musée du Louvre, Paris, 2011. Exh. cat., ed. Maria Pötzl-Malikova and Guilhem Scherf (Milan: Officina Libraria; New York: Neue Galerie New York; Paris: Louvre Éditions, 2010). The titles of Messerschmidt's heads do not originate with the artist; they were the caprice of an unnamed author on the occasion of the first exhibition of the heads ten years after the artist's death. That show, forty-nine heads in all, took place in Vienna at the Bürgerspital (communal hospital) in 1793 (Pötzl-Malikova, "The Life and Work of Franz Xaver Messerschmidt," 23).

3 *Dynasty and Divinity: Ife Art in Ancient Nigeria*, organized by the Museum for African Art, New York, and the Fundación Botín, Santander, Spain, in collaboration with the National Commission for Museums and Monuments, Nigeria. Exh. cat. by Henry John Drewal and Enid Schildkrout (New York: Museum for African Art, 2009). Grateful to Richard Woodward, curator of African Art at the Virginia Museum of Fine Arts, where the exhibition was on view in the spring of 2011, for spending time with me in this show and for cross-referencing the details of ear, nose, and interior of the head in Frank Willett with Barbara Blackmun and Emma Lister, *The Art of Ife: A Descriptive Catalogue and Database*, CD-ROM (Glasgow: Hunterian Museum and Art Gallery, University of Glasgow, 2003), chap. 2.26.

4 Babatunde Lawal, "Orí: The Significance of the Head in Yoruba Sculpture," *Journal of Anthropological Research* 41, no. 1 (1985): 91. As I wrote this essay, Dr. Lawal generously responded to my questions about *èmí*, divine breath, in the Yoruba cosmos.

5 Willett et al., *The Art of Ife*, chap. 2.26. See also Babatunde Lawal, "*Àwòrán*: Representing the Self and Its Metaphysical Other in Yoruba Art," *Art Bulletin* 83, no. 3 (2001): 509–10.

6 Bray, *The Sacred Made Real*, 182.

<div style="border:1px solid">

J. M. Bernstein

</div>

Art as Soul-Making from Chauvet to Cinema

For better or for worse (according to some, for much worse), art would appear to be the natural abode of anthropomorphism. Every artwork—of whatever media—could be considered as a moment in an endless effort to ascribe human form to the forever nonhuman, as if we could only make sense of our humanity by seeing it projected onto what is patently other than human. This thought is certainly the quietly insistent leitmotif of Werner Herzog's film *Cave of Forgotten Dreams* (2011). Sweeping across the walls of the Chauvet cave in southern France, Herzog's camera reveals a throbbing menagerie of horses, bison, reindeer, lions, antelopes, almost all with faces that spontaneously bear the inscription of human emotion (intense, angry, frightened); or two rhinos, horns locked, fiercely fighting it out. Animals depicted as fighting, fleeing, hunting, roaring proudly, and whinnying nervously (Fig. 5)—how else might one describe such behavior, apart from saying that we—artists and spectators alike—spontaneously and inevitably ascribe emotion and meaning to the movements of the animals, movements that are never perceived as raw or uncoded but always interpreted as actions? Herzog's assertions that we here witness "the beginnings of the modern human soul" and that the superimposed drawings of an animal's legs in different positions create a sense of movement, a kind of "protocinema," jointly take us to the precipice of an argument binding art and anthropomorphism: art in its earliest fulfillment (these 32,000-year-old drawings are too sophisticated and accomplished to be thought of as raw beginnings) and the animistic art of the moving image are joined in their commitment to anthropomorphism, which is construed, in turn, as a fundamental mechanism of soul-making.

The argument's finale comes into view with the sole inscription of a human figure in Chauvet: the drawing of the forequarters of a bison embracing the sex of a naked woman. This image offers the fierce critical reminder—everywhere in evidence in Herzog's cinema— that projection of the human onto the nonhuman is simultaneously a projection, in return, of the nonhuman onto the human. In its serious guises, anthropomorphism cannot avoid being aware of itself as an effort of projection; it inevitably tracks what resists the human, what is inhuman in the human, the trembling place where humanism and antihumanism touch. For Herzog, that place is fathomless. But Herzog's routine flirtation with mysticism can be ignored, for what is necessary here is only to acknowledge the aesthetic image—as the meeting ground of human and nonhuman, form and matter, Apollonian and Dionysian, world and earth—as excessive to the claims of a rationalized cognition that would seek to capture and displace it.

Of course, stating the matter in this heroic way utterly misstates the role of anthropomorphism in modern thought. From the launching of the term in the eighteenth century (the

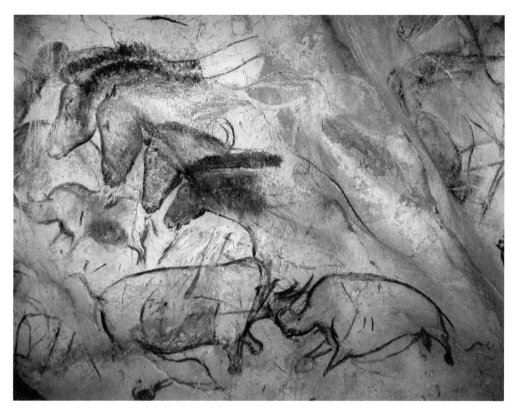

Figure 5. *Panel of the Horses*, detail of the horses and confronted rhinoceroses, ca. 30,000 BC Hillaire Chamber, Chauvet Cave, Ardèche, France (artwork in the public domain; photograph © J. Clottes-MCC).

concept is ancient, already a trope when it is used by Xenophanes in the fifth century BCE), anthropomorphism has functioned primarily as a term of abuse—as a critical concept delimiting a perennial, yet nonetheless utterly illusory habit of thought. How could anthropomorphism fail to be anything but an act of falsifying the appearance of what *is* emphatically nonhuman, and, on this account, a reduction of the objective to the forever merely subjective? "Enlightenment" is one name given to the ruthless critique of anthropomorphism. Enlightenment, in Theodor Adorno and Max Horkheimer's perspicuous account, is constituted by the reiterative practice of detaching the objective from subjective effects (including those perceptual and sensory), which is, itself, a fair description of the project and practice of modern science.[1] Construals of modern science exist that interpret it as a form of anthropomorphism, but the dominant ideology of scientific naturalism wagers that truth is just the systematic overcoming of anthropomorphism until an absolute conception of the universe is achieved.[2] From here, it becomes tempting to romantically stage the fundamental debate about the meaning of modern life as occurring between the artistic inscription of the

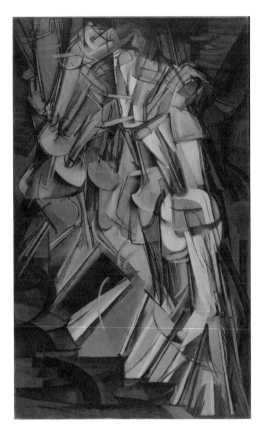

Figure 6. Marcel Duchamp, *Nude Descending a Staircase, No. 2*, 1912, oil on canvas, 57 ⅞ × 35 ⅛ in. (147 × 89.2 cm). Philadelphia Museum of Art, The Louise and Walter Arensberg Collection, 1950, Accession Number 1950-134-59 (artwork © Association Marcel Duchamp/ADAGP, Paris and DACS, London 2017; photograph provided by the Philadelphia Museum of Art Library and Archives).

unavoidability of anthropomorphism, on the one hand, against the scientific project of its extirpation on the other hand; the triumph of the latter would be complete when even the human is understood in nonhuman—causal, mathematical, mechanistic—terms (Fig. 6).[3]

It will come as news to no one that such a staging of the debate over modernity would flatly belie the history of modern art. Any robust history of modernism would have to include art's own immersion in Enlightenment rationalism, which is to say, modernism's many-sided attempt to join art making with the overcoming of anthropomorphic projection. In a brutal condensation of much of the scholarly literature, the achievement of Cubism can be interpreted as promising an art premised on de-skilling, on photographic techniques, and so forth, in favor of an increasingly mechanical and serial abstraction. Completing this thought, Rosalind Krauss urges that if "the photographic image is notoriously spun out from a single negative, the structure arrived at by abstract painters—the grids, the nested squares, the monochromes, the color fields—are themselves submitted to the mark of the multiple. [...] The logic of abstraction [...] is, then, a fight against the unique, the original, the non-replicable."[4] From this view, Krauss castigates Pablo Picasso for a retreat into classicism after

Cubism. Against the background of the celebration of the abstract and mechanical, it is but a short step to the processes of digital imaging that relocate vision "to a plane severed from a human observer," in which the human body becomes "a component of new machines, economies, apparatuses," making subjectivity "a precarious condition of interface between rationalized systems of exchange and networks of information."[5]

When anthropomorphism is regarded as the constitutive malady of the human mind, what began as the philosophical project to destroy the gods and to construct an immanent universe in their stead devolves into a generalized misanthropy in which the human placement in the natural world and the perspectival torsions of bodily experience are interpreted as if they were themselves privative, as if the vital human is nothing other than a source of error besmirching the abstract and the replicable. The idea that anthropomorphism is the primary malady of the human mind is fueled by at least two sources: a materialism that reacts against a view of the universe as composed of mysterious mind stuff and mathematically knowable matter and an opposing tendency, the desire to separate the (rational/ensouled) human from both the nonhuman animal and the causal forces of material nature. Both sources—the misanthropic and the narcissistic—depend on the blind omission of the self-moving, animate, animal world of living things to which humans belong.

My impression is that in both art and criticism, the exorbitant postmodern critique of anthropomorphism has, of a sudden, wilted—and with good reason. When human subjectivity is artistically actualized in works possessing touch, style, signature, uniqueness, and originality, the result is not a blinded subjectivism, but the normal formation of cultural objectivity, of soul making, as Herzog would express it. There is a lovely irony in Herzog's use of primitive 3D technology, not just in celebrating the power of the Chauvet cave drawings but, equally, in locating his technologically mediated art as arising from the same anthropomorphic impulses as those that inspired our great artistic progenitors.

Notes

1 Max Horkheimer and Theodor W. Adorno, *Dialectic of Enlightenment: Philosophical Fragments*, trans. Edmund Jephcott (Stanford: Stanford University Press, 2002), 1–34.

2 Bernard Williams, *Descartes: The Project of Pure Enquiry* (Harmondsworth: Penguin Books, 1978), 65–67.

3 For a failure to resist this temptation, see J. M. Bernstein, "Wax, Brick, and Bread—Apotheoses of Matter and Meaning in Seventeenth-Century Philosophy and Painting: Descartes and Pieter de Hooch," in *Against Voluptuous Bodies: Late Modernism and the Meaning of Painting* (Stanford: Stanford University Press, 2006), chap. 1.

4 Rosalind Krauss, *The Picasso Papers* (New York: Farrar, Strauss and Giroux, 1998), 128.

5 Jonathan Crary, *Techniques of the Observer: On Vision and Modernity in the Nineteenth Century* (Cambridge, MA: MIT Press, 1992), 1, 2.

$$\boxed{\text{Carolyn Dean}}$$

Rocks Like Us

> *All animals are equal, but some animals are more equal than others.*
> —George Orwell, *Animal Farm*, chap. 10[1]

Anthropomorphism depends on the notion that human beings are different, whether in appearance or behavior, from other species of animals and, indeed, distinct from all other kinds of things. This is accepted despite the fact that many of those traits that have been said to differentiate human beings from all other animals have been proven not to be exclusively human, including the use of tools, a sense of humor, and abstract reasoning. In Orwell's terms, although human beings know that they are animals, they hold themselves to be "more equal" than other animals. But do all people really think this way? Is "human" even a particularly important category of beings universally? Here, we may have a problem of terms: whether our understanding of what is meant by "human being" is identical to, somewhat similar to, or completely at odds with the perceptions of other people in distant times and places.

"Human beings" is commonly translated into Quechua, the dominant indigenous language of the Andes of western South America, as *runa*. Quechua itself is called *Runasimi*, which means "human language." Logic would imply either that only Quechua speakers are fully human or that there is something else going on. That same something else (or something very similar to it) goes on in many parts of the world where linguistic commonality supersedes species identification. Accordingly, the words translated into English as "people" or "human beings" would be more accurately translated as "beings who speak my language," while the category "human beings" would not exist at all. Many indigenous Andean peoples categorize human beings into complementary groups: "us" and "those like us." Together, these two groups form a set that can be described as "inside"; the "inside" set is then distinguished from the set comprising "other people." Historically, the set "other people" has been located outside culture since, from an insider perspective, "other people" did not share cultural beliefs and practices (including some linguistic commonality) with "us" and "those like us." In addition to "others like us," many native South American groups recognized commonality with spirit entities and animals who, while not "us" or "people like us," were certainly closer to "us" than were the set comprising "other people."[2] Under this system, would anthropomorphism imply likeness with "us" or with "other people" (and so not like

"us" at all)? Indeed, is the term *anthropomorphism* even helpful, since it suggests a unified category—that of human beings—that has not been significant to many Andean peoples across history?

Michel Foucault most famously entered into the debate over ways of categorizing things in his book *Les mots et les choses*, translated into English as *The Order of Things*. As Foucault discusses in the preface, his influential study was apparently inspired by an animal taxonomy featured in a book by Jorge Luis Borges (1899–1986), the Argentine essayist and poet, who provided a list of animal categories derived from a mysterious ancient Chinese compendium entitled the *Celestial Emporium of Benevolent Knowledge*.[3] The Chinese encyclopedia divided animals into an odd assortment of categories, including "those that are trained," "mermaids," "those that have just broken the flower vase," and "suckling pigs." Unfortunately, Borges may have been a bit of a trickster: although the Argentine author cited Franz Kuhns (1884–1961), a well-known German scholar and translator of Chinese literature, there exists no actual evidence that Kuhns ever discovered or translated such a taxonomy.[4] Despite the apparently fictional nature of the *Celestial Emporium*, Foucault's point about the historical and cultural specificity of categories of things is well taken. Human beings order their perceptions of the universe of things in ways that fit their experiences of the world, even if their taxonomies are not so astoundingly uncanny as those created by Borges.

Consider the Inka of western South America, who reached the height of their power in the fifteenth and early sixteenth centuries. The Inka identified certain rocks as sharing many characteristics with human beings (Fig. 7). Such rocks were sentient and had the ability to speak and move. They were said to eat and drink the foods and liquids humans eat and drink, dress in human clothing, and speak *Runasimi*. The *puruawqa*, for example, were a group of rocks who became animate in order to help the Inka defeat a powerful enemy. After the battle, the *puruawqa* repetrified, with the promise to spring to life again to defend Inka territory should the need arise. Visitors to the Inka capital were introduced to various named *puruawqa,* who were positioned around the city, consulted on matters of significance to the state, and given gifts. Certainly the *puruawqa* could be described as anthropomorphic. Rather than pronouncing them as such, however, we may reveal more and be more accurate by defining them as Inka "insiders," understood by the Inka as being "like us."

The Inka recognized the humanity of lowland Amazonian dwellers whom they called Anti (or Chunchu), though they were definitely not part of the set "humans like us." The Anti were said to be cannibals who did not practice agriculture, live in houses (by which the Inka meant permanent dwellings), wear clothes (by which the Inka meant clothing of woven fabric), nor did they follow Inka gender norms. Inka rhetoric tells us that the Anti were less like the Inka than were the petrous *puruawqa*. In these cases, the category "human beings" and its adjectival comparative "anthropomorphic" obscure categories and comparisons even more fundamental to Inka thinking.

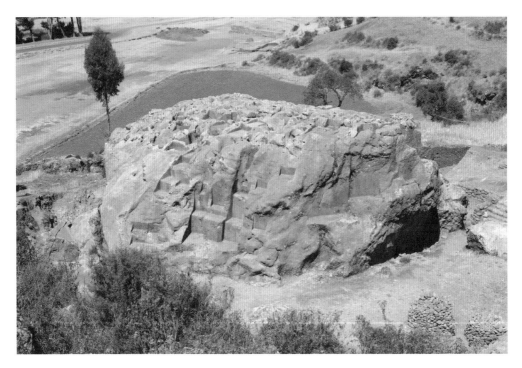

Figure 7. Inka. *Chinkana Grande, c.* 1500. This carved rock monument is a *saykuska* (tired stone), located near the architectural complex of Saqsaywaman, Peru. *Saykuska* refers to a stone that had been quarried and moved toward a construction site, but that (who) resisted Inka efforts to be incorporated into a wall. The Inka, respecting the wishes of the *saykuska*, left the tired stone alone (artwork in the public domain; photograph by C. Dean).

The Inka understood that rocks could host various essences, and valiant warriors like the *puruawqa* were just one example. Other essences embodied by rocks included the spirits of places, culture heroes, and even the Inka ruler himself, who existed simultaneously in flesh and lithic form. The Inka acknowledged a basic similarity between rocks and themselves that cannot be fully characterized as anthropomorphism. To practice anthropomorphism is to employ a category that does not resonate universally. The more relevant category for the Inka is "like us," whether human, another kind of animal, spirit entity, or rock.

Notes

1 George Orwell, *Animal Farm* (New York: Harcourt, Brace and Company, 1946), 112.
2 Norman E. Whitten Jr., "Historical and Mythic Evocations of Chthonic Power in South America," in *Rethinking History and Myth: Indigenous South American Perspectives of the Past*, ed. Jonathan D. Hill (Urbana: University of Illinois Press, 1988), 282–329, at 301–04.

3 Michel Foucault, *The Order of Things: An Archaeology of the Human Sciences*, trans. Alan Sheridan (New York: Pantheon, 1970), xv–xxiv, originally published as *Les mots et les choses* (Paris: Gallimard, 1960); Jorge Luis Borges, *Other Inquisitions*, trans. Ruth L. C. Simms (Austin: University of Texas Press, 1964), 101–05.

4 Keith Windschuttle, *The Killing of History: How Literary Critics and Social Theorists Are Murdering Our Past* (New York: Simon and Schuster, 1997).

<div style="border:1px solid">

Caroline van Eck

</div>

Anthropomorphism as Hermeneutic Mode

Anthropomorphism, endowing artifacts with human forms or characteristics, is an almost universal feature of creating and understanding art. In medieval and Renaissance architecture, it provided formal patterns for design and metaphors to understand architectural form.[1] In the nineteenth century, a new variety of anthropomorphism arose in the aesthetics of empathy, or *Einfühlung,* which explained the artworks' effects on the mind by relating those effects to human shapes and to the physical or psychological processes they expressed.[2] Perhaps the boldest attribution of human traits in the history of art, Aby Warburg's vision of art's history as a process of remembrance and revival, of Mnemosyne and *Nachleben,* humanized the succession of events related to art.[3] Warburg's vision of art history cast away chronological and stylistic development, the collection of successive events and actions that together make up history, in favor of an understanding of art history as a process of human, psychological retrieval and of images that appeared to migrate through time.

In the course of the twentieth century, anthropomorphism underwent significant change. In modernist architecture, in Le Corbusier's Modulor, for instance, the analogy between the building and the human body continued to play a role. After 1945, however, anthropomorphism came to be considered not as a reflection of metaphysical connections between art and man but as a metaphor by which to give meaning to inanimate forms of art. In art and architecture, modernist abstraction and defiguration took over, while in art history, Heinrich Wölfflin's formalism gave way to Erwin Panofsky's iconology.

Recently, anthropomorphism has returned as a hermeneutic mode. The Paris exhibition *Une image peut en cacher une autre* (*One Image May Hide Another*) of 2009 brought together a vast collection of double images that, on closer inspection, revealed human faces and figures.[4] Instead of the reassuring insight that buildings turn out to conform to human features, the conceit of anthropomorphism in Renaissance architecture, viewers at the Paris exhibition became aware that what looked like a hill or a crevice in a rock in a Hieronymus Bosch landscape turned out to be a face staring at them. In viewing, recognition gave way to an uncanny sense of human life where one did not expect to find it. The Paris exhibition thus asked to what degree the human form is inevitable in shaping what viewers see, and which psychological and perceptual processes are involved in recognition. In a seminar on the fear of images, directed by Luc Bachelot and Claude Pouzadoux at Nanterre, that brings together archaeologists, ancient historians, and philosophers, fear of the image is linked in another anthropomorphic move to fear of the body: here, the

image is considered to be an embodiment. As such, the image inspires the same fears and desires as the human body itself.[5]

Alfred Gell's 1998 book *Art and Agency* has presented a new, anthropological variety of attributing human characteristics to art, which he terms agency and personhood.[6] Gell's book, an anthropological theory of art, arises from the idea of the art nexus, meaning the network of social relations in which artworks are embedded, while art objects, for their part, are considered to be systems of actions. According to Gell, these actions are intended to change the world rather than to encode symbolic propositions about it. Artworks thus become equivalent to persons, or, more particularly, to social agents. Gell's move from anthropomorphism to anthropology has already had a considerable impact. In inquiries into idolatry and iconoclasm, for example, Gell's theory enables the study of viewer response, and it also facilitates the analysis of response in a much wider, non-Eurocentric context. The Leiden research project "Art, Agency and Living Presence," which brings together art and theater historians, philosophers, and psychologists, has conducted a series of very detailed case studies on early modern instances in which viewers attributed human and social life to works of art. Gell's art nexus has here proven to possess considerable heuristic value, allowing a fine-grained and historically grounded understanding of early modern behavior, including the ways in which viewers made sense of such apparently irrational behavior as people kissing paintings, taking them to bed, or depriving statues of their eyes.

Elsje van Kessel, for instance, has shown how Venetian viewers treated the portrait of Bianca Capello by Scipione Pulzone, a sixteenth-century Venetian patrician who eloped with a Florentine to become grand duchess of Tuscany, as the living person it represented. These viewers kissed the portrait, talked to it, and took "her" to visit the doge, who asked it to stay the night. By reconstructing the nexus in which the portrait acted, van Kessel has shown in what sense the portrait had a social life. Moreover, she has reconstructed the viewing attitudes and social and political agendas its spectators brought with them. By so integrating archival research, art historical analysis, social history, and anthropology, van Kessel has made such apparently irrational behavior understandable. Joris van Gastel, meanwhile, has studied the interaction between sculptor, viewer, and statue in seventeenth-century Roman sculpture. He has integrated well-known and often rehearsed topics of praise, such as the speaking likeness, or *vivacità,* with recent psychological research into synesthesia and the embodied character of perception.[7]

One of the main results of the Leiden program is a new awareness of the importance of sculpture and the reactions it evokes, and with it a reconsideration of viewer responses claiming that the statue they see is alive. Far from being a hackneyed cliché, a trite rehearsal of *ut pictura poesis,* the living statue became the focus of a large variety of texts on sculpture from Europe and other parts of the world, ranging from the ethnographic studies of fetishism by Charles de Brosses and Octavien de Guasco to Johann Joachim Winckelmann and Antoine-Chrysostome Quatremère de Quincy's histories of classical sculpture and polychromy.[8] In their treatment of viewer response, we can observe the birth of modern anthropological

approaches to fetishism on the one hand, and the development of academic art history and the birth of the art museum on the other hand, in which artworks, exhibited for aesthetic appreciation or art historical analysis, are at the same time deprived of their life and agency.

Gell made the attribution of personhood, emotions, agency, or animation to artworks a psychological and social phenomenon that can be studied in fieldwork. His recent, anthropological variety of anthropomorphism thereby opens up the possibility of interdisciplinary research into the relations between works of art and their viewers. As the Leiden project demonstrates, art history, anthropology, and psychology can collaborate on the study of these relations. The Berlin project, led by Horst Bredekamp, on empathy and embodiment; the Harvard project, directed by Frank Fehrenbach, on liveliness, or *Lebendigkeit*; as well as the research of psychologists, such as Alva Noë on action in perception, or Lawrence Barsalou on grounded cognition, show us that our viewing of art is ultimately founded on our own experience as embodied beings.[9]

The new developments signaled here have in common that they posit the human as the foundation for any understanding of art. One of the major challenges for art history in the twenty-first century will be the transformation of one of the discipline's core beliefs—the significant relation between art and man, expressed in anthropomorphism—into a bridge between the humanities and the social sciences.

Notes

I am much indebted to Karen Lang, the editor-in-chief of *The Art Bulletin,* for her invitation to contribute to this issue, and for the feedback given by the periodical's staff. The research on which this essay is based was very generously funded by the Dutch Foundation for Scientific Research (NWO).

1 Rudolf Wittkower, *Architectural Principles in the Age of Humanism* (London: Architectural Press, [1949] 1988).

2 Harry Francis Mallgrave and Eleftherios Ikonomou, eds., *Empathy, Form and Space: Problems in German Aesthetics 1873–1893* (Santa Monica: Getty Center for the History of Art and the Humanities; Chicago: University of Chicago Press, 1994); and Matthew Rampley, "From Symbol to Allegory: Aby Warburg's Theory of Art," *Art Bulletin* 79, no. 1 (1997): 41–54.

3 Aby Warburg, introduction to *Der Bilderatlas Mnemosyne,* pt. 2, vol. l, *Gesammelte Schriften,* vol. 2, eds. Martin Warnke and Claudia Brink (Berlin: Akademie-Verlag, 2000).

4 Jean-Hubert Martin and Dario Gamboni et al., eds., *Une image peut en cacher une autre,* exh. cat., Grand Palais, Paris (Paris: Réunion des Musées Nationaux, 2009).

5 See, for instance, their recent collection of essays, a special issue of *La Part de l'Oeil* 23 (2008), edited by Luc Bachelot.

6 Alfred Gell, *Art and Agency: An Anthropological Theory of Art* (Oxford: Clarendon Press, 1998). On the reception of Gell, see Jeremy Osborne and Robin Tanner, eds., *Art History's Agency* (Oxford: Blackwell, 2007); and Matthew Rampley, "Art History and Cultural Difference: Alfred Gell's Anthropology of Art," *Art History* 28, no. 4 (2005): 524–51.

7 Elsje van Kessel, *The Lives of Paintings: Presence, Agency and Likeness in Venetian Art of the Sixteenth Century*, Studien aus dem Warburg-Haus, vol. 18 (Berlin: De Gruyter and Leiden: Leiden University Press, 2017); Joris van Gastel, *Il Marmo Spirante: Sculpture and Experience in Seventeenth-Century Rome*, *Studien aus dem Warburg-Haus*, vol. 12 (Berlin: De Gruyter and Leiden: Leiden University Press, 2013); and Caroline van Eck, *Art, Agency and Living Presence: From the Animated Image to the Excessive Object*, *Studien aus dem Warburg-Haus*, vol. 17 (Berlin: De Gruyter and Leiden: Leiden University Press, 2016).

8 Charles de Brosses, *Du culte des dieux fétiches, ou Parallèle de l'ancienne religion de l'Égypte avec la religion actuelle de Nigritie* (Geneva, 1760); Octavien de Guasco, *De l'usage des statues chez les anciens: Essai historique* (Brussels: Chez J. L. de Bourbers, 1768); Johann Joachim Winckelmann, *Geschichte der Kunst des Altertums* (Dresden, 1764); and Antoine-Chrysostome Quatremère de Quincy, *Le Jupiter Olympien …, ouvrage qui comprend un essai sur le goût de la sculpture polychrome* (Paris: Firmin Didot, 1814).

9 Alva Noë, *Action in Perception* (Cambridge, MA: MIT Press, 2004); and Lawrence Barsalou, "Grounding Symbolic Operations in the Brain's Modal Systems," in *Embodied Grounding: Social, Cognitive, Affective, and Neuroscientific Approaches*, eds. Gün R. Semin and Eliot R. Smith (New York: Cambridge University Press, 2008), 9–42.

Finbarr B. Flood

Reflections on Anthropomorphism

In Henry James' short story *The Last of the Valerii* (1874, revised 1885), the eponymous Conte Valerio falls in thrall to the charms of a malign statue of the goddess Juno, excavated at his villa. Enchanted by the marble sculpture, the count revives a form of polytheistic worship inflected by amorous desire. Revealing the situation to the count's hapless wife, the narrator explains: "In a word, dear child, Marco is an anthropomorphist. Do you know what that means?" Fortunately, the count's wife understands perfectly and saves the day by ordering the reinterment of the enchanting statue. Despite the occultation of the object of the count's desire (not entirely, since he retains the marble hand of the goddess), the narrator concludes that he "never became, if you will, a thoroughly modern man."[1]

To be an anthropomorphist is, it seems, to be at odds with modernity. The first recorded English use of the term *anthropomorphism* is in 1753, during the height of the Enlightenment, when it was used to denote the erroneous ascription of human form to the deity. This imputation of religious error was informed by new and specifically European formulations of the rational, but its polemical thrust was common to cognate terms deployed much earlier in monotheistic polemics, to name conceptual errors often associated with idolatry. The pejorative connotations of "anthropomorphism" (and its cognates) in both theological and secular polemics highlight the generally tendentious nature of the term as applied historically to two distinct problems of iconicity. Historically, the most fundamental of these has been the conceptualization and representation of divinity, specifically the question of whether a transcendental deity or deities could be embodied, or should be depicted in embodied form. The issue is not exclusive to monotheism; polytheistic cultures have always had dissenters on this question.

Even within Judaism and Islam, seen as the most aniconic of faiths, Biblical and Qur'anic verses apparently impute not only form (and thus spatial qualities) to a transcendental deity, but also attributes common to man, including eyes, feet, fingers, and hands. Readings that took these passages as transparent descriptions were generally rejected as literalist errors. However, anthropomorphic conceptions of God may have been relatively common, even in the early Islamic world; one early tradition (considered heterodox if not heretical) even identified a mark on the rock within the Dome of the Rock in Jerusalem (692) as the footprint of God himself. Similarly, the anthropomorphic language of mystical Judaism provided ammunition for Christian polemicists such as Agobard, the bishop of Lyon (writing around 840), who accused the Jews of idolatry by virtue of their literal investment in a

corporeal God who resembled man in all respects except that the fingers of his hand did not fold, since he had no need to work with them.

One notable aspect of anthropomorphist traditions in monotheism is their presentation of the divine body in discrete parts: hands, fingers, feet. Perhaps not serendipitously, this is a quality that scriptural and mystical evocations of the deity share with the profane phenomenon of premodern prosopopoeia, in particular, the inscription on factured objects of poetic and other texts written in the first-person voice. Insofar as these texts anthropomorphize the objects to which they give voice, they usually offer a fragmented evocation of the body—referring to breasts, faces, mouths, and so forth—that frustrates the conception of a corporeal whole. This reticence brings to mind the role that the fragmentation of the (re)presented body has often played in satisfying the desires of both iconophiles and iconoclasts, Conte Valerio's retention of Juno's marble hand being a case in point.

The production of objects as actors in prosopopoeia highlights a second series of phenomena integral to "anthropomorphism" and perhaps more directly relevant to the discipline of art history. These entail the ascription of agency to apparently inanimate objects. The "presence effects" associated with crafted images that reproduce the human form and are capable of taking on a life of their own as a result are perhaps the most familiar facet of this aspect of anthropomorphism.

In *The Last of the Valerii*, both modes of anthropomorphism—humanizing the deity and animating material forms—are projected onto a remote polytheistic past that erupts into modernity through the ambiguous mediations of an embodied fragment of antiquity. Associating anthropomorphism with pagan fetishism, the tale subscribes to a view of anthropomorphism as a category error contravening distinctions between subject and object, animate and inanimate, agentive and passive that have been naturalized and universalized in post-Enlightenment thought. As an irrational confusion of animate life with inanimate matter, the anthropomorphism disdained by moderns resembles the idolatry denounced in the Old Testament as a misapprehension of humanly crafted things that lack breath.

Discussing the ascription of agency to images of divinities, the anthropologist Alfred Gell insists on a distinction between biological and social life, an approach that has inspired recent attempts to explain "living presence response," the experience of life associated with the perception of anthropomorphic sculptures.[2] However, approaches to anthropomorphism at the level of cognition and culture also highlight an important distinction between the anthropomorphism disdained by premodern theology and modern rationalism, a distinction that operates at the level of ontology. In many pre-Enlightenment traditions, the inanimate idols taken for omnipotent beings find their inverse not in the figure of the deity but in man himself, fashioned from clay (or other matter) and then infused with breath by a divine artist. In Judaism and Christianity at least, the man thus fashioned is made in God's image, a "living icon" as Christian theologians of the post-Iconoclastic period put it. In Christianity, the chiastic paradox of man made in God's image found its ultimate logic in the Incarnation, which provided a powerful imprimatur for anthropomorphic depictions of the deity.

The attempt of man, the living, breathing creation of God, to offer worship to inanimate images crafted by his own hand entails a double hubris that reveals the inadequacy of human artistry. The contrast between human and divine ability in this respect is an ancient theme; after all, Pygmalion's love for Galatea could be consummated only through the intervention of the goddess Venus, who, unlike Pygmalion, possessed the ability to transform his marble creation into a flesh-and-blood woman. The transubstantiations central to these kind of creation narratives in both monotheistic and polytheistic traditions admit the possibility of enlivening inanimate matter. Within these narratives, the *anthropos* of anthropomorphism is therefore always already constituted in a manner that blurs the oppositions between art and nature, subject and object, *physis* and *techne* integral to the modern usage of the term.

Although anthropologists and cognitive psychologists often see the ascription of agency to non-human actors, whether transcendental deities or alluring marble statues, as a recalcitrant anachronism (albeit one essential to religious belief), they disagree about whether or not anthropomorphism is intuitive.[3] The jury is also still out on the related question of whether the distinction between animate and inanimate is hard-wired or acquired (or both), although it has been noted that humans tend to ascribe agency and intentionality to moving forms in general, including even self-propelled dots on a screen. Recent suggestions that it is not merely form *tout court*, but specific elements of form—chief among them markings resembling eyes and faces—that are crucial to the development of this distinction in complex animals, including humans, hold an obvious interest for the history of reception.[4]

The importance of eyes was noted by Sigmund Freud in his classic essay on the uncanny, a condition manifest, in Ernst Jentsch's classic formulation (which Freud rejected), by "doubt as to whether an apparently living being is animate and, conversely, doubt as to whether a lifeless object may not in fact be animate."[5] Jentsch's insight that the greater the degree of verisimilitude, the more intense the feeling of the uncanny aroused by anthropomorphic forms has been validated by recent work on robotics, which has identified an "uncanny valley," a realm of negative human emotional response to sophisticated simulacra that, counterintuitively, increases rather than decreases beyond a certain point in direct proportion to the degree of verisimilitude. The locus classicus of the uncanny is, of course, the corpse, and one likely explanatory factor is that the gap between expectation and performance reminds the observer of her or his own mortality.

In *The Last of the Valerii*, a return to the earth, the ultimate fate of all animate beings, also solves the "problem" of anthropomorphism. Whether one sees this as the pragmatic dispatch of a fetish object or a live burial depends, of course, on whether one identifies with the count or the narrator. From the point of view of the narrator, the statue's disappearance into its tomb heals a rupture that began with its emergence, restoring both the ontology and temporality of modernity (although not entirely—the severed hand still remains to frustrate the undertaking).

However, the tale's ending also suggests that the polemics of "anthropomorphism" are rooted in more extensive anxieties about our own agency and mortality. These anxieties

constantly threaten to undermine the ontologies asserted to assuage them, despite the naturalization of the latter as commonsensical and universally valid. Most of us have had the experience of feeling "thwarted" by machines, usually cars and computers, devices with which we have a close haptic relationship and that function in effect as prosthetic extensions of our distributed personhood. The attribution of agency in extremis may seem cute or quirky. Yet, it provides a practical instance of the subversive ontological hybrids of nature and culture, human and non-human that Bruno Latour has argued necessarily result from the ontological stratifications that characterize modernity. Ultimately, the complex entanglements of mortality and ontology may be relevant to the creation of all images of (potentially) animate beings, and to the tensions between reference and presence that inform their function and reception. Such tensions undermine attempts to relegate anthropomorphism to a dim and distant past. As W. J. T. Mitchell (paraphrasing Latour) puts it: "When it comes to images […] we have never been and probably never will be modern."[6]

Notes

1 Henry James, "The Last of the Valerii," available at: http://www.henryjames.org.uk/lastv/LVtext_inframe.htm (accessed March 16, 2017).

2 Alfred Gell, *Art and Agency: An Anthropological Theory* (Oxford: Clarendon Press, 1998); and Caroline van Eck, "Living Statues: Alfred Gell's Art and Agency, Living Presence Response and the Sublime," *Art History* 33, no. 4 (2010): 642–59. The cognitive dimension of "living presence response" recalls the role ascribed to empathy (*Einfühlung*) in the animation of form in earlier German writings on aesthetics, most obviously those of Robert Vischer (1873). For Vischer, empathetic identification is "the natural mother of religious personification"; Vischer, "On the Optical Sense of Form: A Contribution to Aesthetics," in *Empathy, Form and Space: Problems in German Aesthetics, 1873–1893*, eds. Harry Francis Mallgrave and Eleftherios Ikonomou (Santa Monica: Getty Center for the History of Art and the Humanities, 1994), 105, 109, 119.

3 Pascal Boyer, "What Makes Anthropomorphism Natural: Intuitive Ontology and Cultural Representations," *Journal of the Royal Anthropological Institute* 2, no. 1 (1996): 83–97; and Stewart Elliott Guthrie, "Anthropology and Anthropomorphism in Religion," in *Religion, Anthropology, and Cognitive Science*, eds. Harvey Whitehouse and James Laidlow (Durham: North Carolina Academic Press, 2007), 37–62.

4 Susan A. Gelman and John E. Opfer, "Development of the Animate-Inanimate Distinction," in *Blackwell Handbook of Childhood Cognitive Development*, ed. Usha Goswami (London, 2002), 154.

5 Ernst Jentsch, "On the Psychology of the Uncanny (1906)," trans. Roy Sellars, *Angelaki* 2, no.1 (1996): 11–12.

6 W. J. T. Mitchell, "The Surplus Value of Images," *Mosaic: A Journal for the Interdisciplinary Study of Literature* 35, no. 3 (2002): 19–20.

Dario Gamboni

"Morphosis" as Cognition

"Anthropomorphism" is an explanation I encountered often while researching the artistic use of visual ambiguity for my book *Potential Images*.[1] A "potential image" is a way of seeing and interpreting visual data that becomes actual with the viewer's subjective participation. When a potential image bears resemblance to a human being or a part thereof, its existence can be attributed to the artist's anthropomorphism, to his or her tendency to attribute humanlike traits to nonhuman realities. If the existence of this image is disputed, then the claim for its existence can be attributed to the interpreter's anthropomorphism.

In the latter case, anthropomorphism is rejected as the source of a misguided perception. In the former—for example, in landscape paintings of the Renaissance—it may be accepted as expressing a historically documented worldview.[2] But it is a worldview that is obsolete, and for a long time, anthropomorphism has been at best tolerated. It is regarded as an illusion and has accordingly been condemned since at least 1620, when Francis Bacon defined the "Idols of the Tribe" in *Novum organum*: "And the human understanding is like a false mirror, which, receiving rays irregularly, distorts and discolors the nature of things by mingling its own nature with it."[3]

While there is no doubt that perception can be misguided, by construing accidental configurations as significant patterns or by attributing one's own properties to beings and things devoid of them, the validity of all that is subsumed under the term *anthropomorphism* should not be dismissed without examination. Epistemology pleads against this: there is no object of knowledge without a subject, and even resorting to mechanical prostheses and mathematical tools does not dispense with the eventual need for the interpretation of data, nor does it rid interpreters of their human characteristics. As far as art is concerned, the late nineteenth-century "aesthetics of empathy" located the basis for aesthetic communication in the interaction between object and recipient before John Dewey spoke of "art as experience" and the phenomenologists of "embodied perception."[4] The conditions of this interaction, now studied experimentally by neuroscientists, are not an impediment but a resource that must be harnessed to the study of sensory phenomena.[5]

"Anthropomorphism" also suffers from being an umbrella term, broad and vague, and often a misnomer. The characteristics imputed to its effects are often not specific to humans but are shared by other animals, by bodies in general, or by all animate entities. In such cases, one should rather speak of "anthrozoomorphism," "somatomorphism," or simply animism. During a recent study of Paul Gauguin's work, I was struck by the frequency with which his

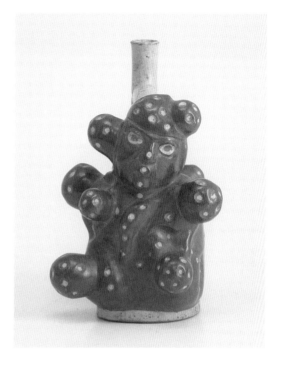

Figure 8. Paul Gauguin, *Vase in the Shape of
a Tree Stump,* ca. 1887–88, stoneware with slip
and gold, 8¾ × 5⅜ in. (22.2 × 13.8 cm). Musée
d'Orsay, Paris (artwork in the public domain;
photograph © Musée d'Orsay, Dist. RMN-
Grand Palais / Patrice Schmidt).

Figure 9. *Stirrup-spout Vessel in the Shape of a Potato with
a Human Face,* Moche, 1st-8th century, earthenware, brown
and white paints, 8⅜ × 5½ in. (21.3 × 14 cm). Museo
Arqueológico Rafael Larco Herrera, Lima, Peru (artwork in
the public domain; photograph provided by the Museo Larco,
Lima, Peru, ML007293).

depictions of animals, humans, and deities incorporated plantlike features (Fig. 8). In order
to describe this trait, I resorted to what I thought was a neologism, "phytomorphism," until
I realized it is in common usage among specialists of other cultural traditions, including
Americanists studying Moche ceramics (Fig. 9), a major source of inspiration for Gauguin.[6]

Pascal Boyer has proposed to distinguish, within anthropomorphism, between the
"projection" of anatomical structure, physiological processes, personal identity, social or-
ganization, and intentional psychology, as well as between the various "source domains"
of anthropomorphism, its different types of representations, and the effect of these repre-
sentations on its "target domains."[7] Such distinctions are welcome, but Boyer's terminology
expresses a unidirectional understanding of the epistemic process epitomized by the notion
of "projection," introduced in psychology by Sigmund Freud and generalized by Lawrence
K. Franck.[8] Hermann Rorschach, author of what is now regarded as the quintessential
projective test, never spoke of projection; instead, he aimed at providing a "diagnosis of

perception," and he regarded interpretation, or *Deutung*, as a part or moment of perception, or *Wahrnehmung*, itself.[9]

For Boyer, anthropomorphism originated in religion. This restriction, which I find problematic, permits him to explain how it could survive, over many cycles of cultural transmission, as a "salient counterfactual speculation," opposed to intuitive ontological categories and principles. The evidence I encountered so far in my own research does not support this view but agrees, instead, with Stewart Elliott Guthrie's account of anthropomorphism as an effect of the cognitive dimension of perception and "our need to find whatever pattern is most important": "The most important pattern in most contexts is that with the highest organization. The highest organization we know is that of human thought and action. Therefore we typically scan the world with humanlike models."[10]

Yet, philosophical and psychological accounts leave insufficient room for variability in the historical and cultural ways in which the relations between ontological categories have been experienced and conceptualized. In an essay on ethnometaphysics devoted to the "ontology, behavior, and worldview" of the Ojibwa (one of the largest groups of Native Americans), A. Irving Hallowell has argued that the notion of person entertained by the Ojibwa included "other-than-human persons": objects (such as stones) that were not permanently animated but possessed a potential for animation associated with specific circumstances and verified by experience.[11] Comparable claims are made by anthropologists about the Moche, who lived in northern Peru, mostly on the basis of the interpretation of artifacts such as vases.[12]

The anthropohistorical relevance of anthropomorphism does not preclude an experiential basis that may extend its validity into the present. As I tried to understand the impulse, in Gauguin ceramics, to combine human and vegetal elements, and as I compared them with Moche "Surrealist" tuber vases based on the shape of potatoes (Fig. 9) or manioc, I noticed that their focal points of animated presence, the eyes, are located on the spots—called "eyes" in many languages—where plants grow shoots or branches. For the artists concerned, as for the viewers of these objects, the animation process coincided with the morphological expression of the plant's inner dynamism. Similarly, it became clear to me that the cross-cultural use of the ontogenetic development of a plant to represent the phylogenetic development of a human lineage or group (in "genealogical trees") is in agreement with the fact that plants can breed by budding and that trees can be colonies rather than individual organisms.[13] I therefore believe it would be worth exploring to what extent certain forms of anthropomorphism can be ascribed not to a unilateral and illusionary projection of human characteristics but to an awareness (obtained by intuition and observation) of the existence of shared morphological traits and morphogenetic principles. This exploration need not be limited to the biological domain, for, as D'Arcy Thompson has shown, forms are shaped by physical laws, and they exhibit regularities across a broader range of ontological categories.[14]

Finally, one may do better justice to all that the term *anthropomorphism* encompasses if one does not assume the existence of a mechanical, indiscriminate impulse to

anthropomorphize—which that ending "ism" deterministically suggests—but examines instead concrete acts of "anthropomorphosis," to use a term that aligns with metamorphosis. We can note that one rarely speaks of "metamorphism," probably because the principle of metamorphosis is not static but consists in transformation. This, however, is also the case with anthropomorphism, at least quite often. We do not know whether we should call Gauguin's *Vase in the Shape of a Tree Stump* (Fig. 8) in the shape of a human head an outcome of anthropomorphism or phytomorphism: the point of this object is not a "source domain" or a "target domain" but the meeting between them. Whatever the prefix, *morphosis* is therefore crucial for images at large. In fact, images tend to be polyiconic so as to connect, and to articulate, several realities.

Notes

1 Dario Gamboni, *Potential Images: Ambiguity and Indeterminacy in Modern Art* (London: Reaktion Books, 2002).

2 See Anna Bentkowska, "Anthropomorphic Landscapes in 16th- and 17th-Century Western Art: A Question of Attribution and Interpretation," *Biuletyn Historii Sztuki* 59, nos. 1–2 (1997): 69–91; for an interpretation of anthropomorphism as visual exegesis and communicative strategy, see Michel Weemans, "Herri met de Bles's *Sleeping Peddler:* An Exegetical and Anthropomorphic Landscape," *Art Bulletin* 88, no. 3 (2006): 459–81.

3 Francis Bacon, *The New Organon and Related Writings*, ed. Fulton H. Anderson (New York: Liberal Arts Press, 1960), 48, quoted in Stewart Elliott Guthrie, *Faces in the Clouds: A New Theory of Religion* (Oxford: Oxford University Press, 1993), 159.

4 See Harry Francis Mallgrave and Eleftherios Ikonomou, eds., *Empathy, Farm, and Space: Problems in German Aesthetics, 1873–1893* (Santa Monica: Getty Center for the History of Art and the Humanities, 1994).

5 See, for example, Robert Pepperell, "Seeing without Objects: Visual Indeterminacy and Art," *Leonardo* 39 (2006): 394–400; Alumit Ishai, Scott L. Fairhall, and Robert Pepperell, "Perception, Memory and Aesthetics of Indeterminate Art," *Brain Research Bulletin* 73 (2007): 314–24; and Scott L. Fairhall and Alumit Ishai, "Neural Correlates of Object Indeterminacy in Art Compositions," *Consciousness and Cognition* 17 (2008): 923–32.

6 See, for example, Jürgen Golte, *Moche: Cosmología y sociedad; Una interpretación iconográfica* (Lima: Instituto de Estudios Peruanos; Cusco: Centro Bartolomé de Las Casas, 2009), 49.

7 Pascal Boyer, "What Makes Anthropomorphism Natural: Intuitive Ontology and Cultural Representations," *Journal of the Royal Anthropological Institute* 2, no. 1 (1996): 83–97, at 89–90.

8 Hartmut Häcker, "Projektive Tests, projektive Verfahren," in *Psychologisches Wörterbuch,* ed. Friedrich Dorsch, 11th ed. (Bern: Huber, 1987), 508–09.

9 Hermann Rorschach, *Psychodiagnostik: Methodik und Ergebnisse eines wahrnehmungsdiagnostischen Experiments (Deutenlassen von Zufallsformen)* (1921; Bern: Huber, 1948), 17.

10 Guthrie, *Faces in the Clouds,* 90.

11 Alfred Irving Hallowell, "Ojibwa Ontology, Behavior, and World View" (1960), in *Contributions to Anthropology: Selected Papers of A. Irving Hallowell*, ed. Raymond D. Fogelson (Chicago: Chicago University Press, 1976), 357–90.

12 Golte, *Moche,* 22–23, 71, 74.

13 See Francis Hallé, *Éloge de la plante: Pour une nouvelle biologie* (Paris: Seuil, 1999), trans. David Lee as *In Praise of Plants* (Portland: Timber, 2002), 120–23.

14 See D'Arcy Wentworth Thompson, *Growth and Form,* 2nd ed. (Cambridge: Cambridge University Press, 1959).

Jane Garnett and Gervase Rosser

The Transformative Image

In *Christ Stopped at Eboli*, Carlo Levi's account of village life in the 1930s in the southern Italian province of Basilicata, the visitor in exile marvels at the tutelary deities on display in the houses of the local peasants. In each case, two images, and two only, preside on the wall above the bed: the dark and ominous visage of the local cult statue of the Madonna di Viggiano and the broadly smiling face of American President Franklin D. Roosevelt. In a desperately poor environment, in which the hope of material salvation lay in emigration across the Atlantic and that of simple survival was entrusted to the Virgin Mary, each presence had its raison d'être. The study of miraculous images continually encounters such juxtapositions within the quotidian life of the home and the street. In the Italian city of the present, the Madonna of the street corner continues to observe and, intermittently, to engage the attention of the passerby—to contest the boundary between the sacred and the secular. In one of the narrow alleys of the old port of Genoa, a prostitute until recently kept flowers before the shrine of a Madonna, which was lit by her own red light. Business-suited men on their way to work enter the cathedral of Chiavari to speak to the miraculous Madonna of the Garden.

The attempt to understand the place of the reputedly miraculous image in the lives of its devotees presents particular problems, not least that of establishing a necessary degree of empathy for the subject without becoming its apologist. Much of our work (published in *Spectacular Miracles: Transforming Images in Italy from the Renaissance to the Present*, London: Reaktion Books, 2013) has consisted of reading and listening to stories: the dominant medium of this kind of image is not the direct sight of the venerated statue or picture but the story told about it. To find oneself in the side chapel of a church with an elderly lady who confides the graces worked in her life by the medieval crucifix on the wall is to appreciate how such a narrative, by its very telling, seeks and finds validation. It is also to perceive how far the engagement with a certain image may be invested with past experience and memory: a complex of sensory and imaginative qualities that together extend far beyond present visual perception. The ethnographer in this situation has sacrificed objectivity and become a participant, but the gain is a deeper comprehension of a larger process.

Art history has until very recently been reluctant to engage with living-presence responses to images. The issue is not merely art history's preoccupation with aesthetic quality. The very language that we habitually use of images—of figuration, representation, expression—

threatens to be reductive in this case. The language of the "visual" is inadequate to capture the ways in which the image is experienced. Sounds, smells, musical cadences, atmosphere, movement, reflections of candlelight in a puddle beneath a street shrine—all can trigger connections and signal the zones within which the miraculous can be felt. Context, therefore, is vital, yet context does not suffice to explain the experience of the supernatural. The belief in the miraculous powers of an image and the behavior that results from such belief throw into heightened relief the usual difficulties of historical interpretation. One of the principal challenges is that of grasping a concept of the mysterious that for believers readily coexists with the familiar and the everyday: that which resists explanation sits alongside, and within, that which demands no explanation. What Michel de Certeau wrote of mystical literature applies to the interpretation of miraculous images. To transpose his metaphor, miracle-working images "mark out the boundaries of an 'elsewhere' which is not remote, a place which they both produce and guard."[1]

Not confined to its wall or its street shrine, the miraculous image extends its presence, not only through its reproductions but also through the imagination of its human devotees, across an extendable space and over a lifetime. A man's childhood memory of the annual feast of the Madonna of Recco in the early 1900s captured both its dynamism and its multisensuality. In his recollection, the conventional prayer on his lips was silenced by the spectacle of gold catching the last of the evening sun and of fireworks erupting, by the sound of bells as the Virgin was carried out of the church, and by the imagined sensation, as he closed his eyes, of clutching the silk of her dress while she looked down on him—an intensely private moment yet felt and reenacted annually as part of a devotional community. The shared ownership of reproductions of, and stories about, a miraculous image creates communities with particular spatial and temporal coordinates. In the 1640s, when the bell rang at the Genoese church of the Madonna delle Vigne to announce the regular Saturday afternoon sermon in the chapel of a miraculous statue of the Virgin, in every house within earshot candles were lit at that moment before engraved copies of the venerated Madonna. Stories can reinforce an extended community of votaries of a particular image over far greater distances—a *patria* transported beyond the ocean by the gaze of the image. A painted ex-voto sent to the sanctuary of Montallegro in Liguria in 1871 depicts three members of the Costa family of Rapallo, lying side by side in sickbeds in Buenos Aires (Fig. 10). On the wall above them is depicted the copy, which they certainly possessed, of the miraculous Montallegro icon of the Death of the Virgin—the embodiment of the community to which, even at so great a distance, they felt themselves to belong. Unwell, their thoughts turned to the image, and once recovered, they commissioned this thanks offering for the shrine. These tales and habits create the context for the miraculous: when the need arises, they help to make sense of the conviction that the Madonna has saved a life or averted disaster. A familiar background presence in daily life, the image shifts occasionally into sharper focus, claiming concentrated attention through narratives that partake at once of the supernatural and the ordinary.

FIGALLO EMANUELLE E FRANCESCO COSTA, MARIA COSTA PER MEMORIA DI GRAZIA
OTTENVTA DALLA N·S· DI MONTE ALLEGRO L·II2 MARZO 1871 IN BUENOSAIRES.

Figure 10. Ex-voto commissioned by Emanuele Figallo and Francesco and Maria Costa, cured of sickness in Buenos Aires by virtue of the icon of Our Lady Montallegro, 1871, oil on canvas, 14⅛ × 18½ in. (36 × 47 cm). Sanctuary of Montallegro, Rapallo, Italy (artwork in the public domain; photograph from M. A. Bacigalupo, *Ex voto a Montallegro* [Comune di Rapallo, 1989], pl. xxvi, reproduced by permission).

Note

1 Michel de Certeau, *The Mystic Fable*, trans. M.B. Smith (Chicago: University of Chicago Press, 1992), 2.

<div style="text-align:center; border:1px solid #000; display:inline-block; padding:10px 40px;">

James Meyer

</div>

The Bodily and the Anthropomorphic

Modernist art historians have long held the idea of anthropomorphism at arm's length. What's so troubling, embarrassing even, about this notion? When did anthropomorphism get a bad name?

> Is there not, first of all, a certain fraudulence in this word *human* which is always being thrown in our faces? […] A certain anthropocentric atmosphere, vague but imbuing all things, give[s] the world its so-called *signification*; that is, investing it from within by a more or less disingenuous network of sentiments and thoughts.[1]

In "Nature, Humanism, Tragedy," an essay of 1958, Alain Robbe-Grillet established the terms of an antianthropomorphic discourse whose reverberations are still felt. Note the semantic slippage in his writing: anthropomorphism, a principle of resemblance ("the attribution of human characteristics to a god, animal, or object"),[2] is renamed anthropo*centrism*, the investment of things with a metaphysical substance. Anthropocentrism is the misguided belief that the world is inherently meaningful and that human beings can order reality in a meaningful way. Things do not so much resemble us as they exist *for* us.

In Donald Judd's critical writings of the 1960s, anthropomorphism and anthropocentricism also became homologous.[3] Judd observed, for instance, that Mark di Suvero's sculptures resembled "truncated bodies." "A beam thrusts, a piece of iron follows a gesture. Together they form a naturalistic and anthropomorphic image."[4] Di Suvero's wood beams and metal elements suggest a figurative arrangement. His sculptures imply a space inhabited by a human figure.[5] This space (imagined, virtual) has been organized in such a way that a viewer will comprehend and master it. Di Suvero's works evoke a rational system of representation, what Judd called the tradition of "European" art, stretching back to Nicolas Poussin and before. Judd claimed to have rejected this inheritance, since his artworks embodied a provisional order at best.[6] We can identify the materials comprising one of his boxes, how the artwork has been made, and how it holds its shape. We can perceive the screws and steel wires joining the sides and the floor on which it stands. Yet, a sculpture by Judd resists attributions of meaningfulness. A Judd *is*. Like those objects, devoid of meaning or affect, described with such excruciating precision by Robbe-Grillet in his novel *Jealousy*, a Judd box posits no "truths" beyond the mere fact of its existence.

During the 1960s, then, critiques of anthropomorphism and anthropocentrism typically went hand in hand. A third term was subsequently introduced into the discursive field,

Figure 11. Tom Burr, *The Poet from the Waist Up*, 2005, plywood, zinc, hinges, framed mirror, book and book pages, thumbtacks, 42⅞ × 23⅝ × 130¼ in. (109 × 60 × 331 cm). Collection Guilbaud, France (artwork © Tom Burr; photograph by Lepkowski Studios, Berlin).

which I will call the *bodily*. The seminal critical debates of this period centered on the play of the anthropomorphic and the bodily. Judd, however, never got around to describing the spectator of Minimalist work; that was left to Robert Morris. Morris conceived this viewer as a body, and though this word has become a cliché of postfeminist and Foucauldian theory, it is imperative to understand the initial import of the term for Minimalist theory.[7] Morris envisioned the viewer as a somatic being. The new sculpture was exactingly scaled, he explained, for it was meant to be experienced by an active spectator who would circulate around it, comparing its actual shape with the mental impression, or *Gestalt*, of its form, in the mind's eye. The same size as a viewer, the sculpture impressed the fact of *its* existence— its objectness—on the beholder. In 1967, in "Art and Objecthood," Michael Fried suggested that to be confronted by these bulky objects was "not entirely unlike being distanced […] by the silent presence of another *person*."[8] Fried turned the meaning of the anthropomorphic on its head. Instead of the beholder endowing the art object with meaningfulness, the viewer of the Minimalist work was the subject of a manipulative—a "theatrical"—encounter. Judd imagined the Minimalist artwork as having escaped anthropocentric projection. Fried insisted that it reminds us of *other* bodies. The new sculpture induces those emotions of isolation, that terrible solipsism we often feel in the presence of others. Rather than escape human associations, Minimal art calls up anthropomorphic suggestion only to rebuke it. In a brilliant about-face, Fried criticized Judd's art in the very terms established by the artist.[9]

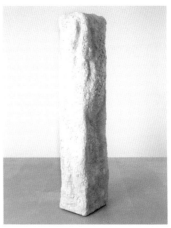

Figure 12. Charles Ray, *Family Romance*, 1993, mixed media, 53 × 96 × 24 in. (134.62 x 243.84 x 60.96 cm). Museum of Modern Art, New York, Gift of The Norton Family Foundation (artwork © Charles Ray, courtesy Matthew Marks Gallery, New York).

Figure 13. Rachel Harrison, *John Locke*, 2007, wood, chicken wire, polystyrene, cement, Parex, and acrylic, 93 × 20 × 21 in. (236.2 × 50.8 × 53.3 cm) (courtesy the artist and Greene Naftali, New York).

"Art and Objecthood" describes two kinds of bodies and emotions: the alienated subjectivity of Minimalism and the transcendental encounter, the momentary reprieve or "grace" from theatricality experienced by the beholder of modernist art. In *Passages in Modern Sculpture*, Rosalind Krauss revisited the crucial critical exchanges of the preceding period, characterizing the history of modern sculpture since Auguste Rodin as a progressive dismantling of sculpture's ontological "core."[10] In her account, the viewer's actual body, which passes around and through the sculpture (the body invoked in Minimalist and land art), overtakes the beholder of the modernist work, who perceives the artwork's form at a glance. Krauss heralded the defeat of presentness by presence and of the anthropomorphic by the bodily. Yet, the anthropomorphic cannot be so easily defeated. For as Fried noted, Minimalist sculpture alludes to and evokes the body in order to critique the anthropomorphic. A latent anthropocentrism would seem to inhabit *any* sculpture, including those works that we take to most strenuously undermine such associations. Some of the most compelling sculptural endeavors since the early 1990s have attempted to do exactly this by means of an uncanny or queer figuration, making explicit the anthropomorphism that the Minimalist artists sought to repress. The sculptures of Charles Ray, Tom Burr, and Rachel Harrison summon the body with shameless blatancy. Ray fabricates mannequins, Harrison combines them with other forms, Burr assembles sheets of wood into shapes resembling lounging figures (Fig. 11). In the work of more conventional sculptors like Kiki Smith, a disfigured body solicits the viewer's empathy. These artworks project a mournful meaningfulness, a tragic aspect of the anthropocentric. Ray, Burr, and Harrison, by contrast, explore the uncanny reaches of resemblance, the *strangeness* of the anthropomorphic. The figures of Ray—oversized and

miniaturized, cast in fiberglass and aluminum—are unsettling and inhuman. Harrison's mannequins are lifeless and empty. Burr's supine "bodies" are so obviously figurative that whatever human associations they bring up quickly fade.

Works such as these reprise Judd's critique in a seemingly opposite formal register, subverting anthropocentrism by means of resemblance. The human figure returns, utterly divested of its "humanity."[11] Nonetheless, like Minimalist practice, these works are scaled to a standing body. Ray's sculptures of businesswomen tower over a viewer, while the children in his *Family Romance*, 1993, are the same height as the parents (Fig. 12). The tilted sections of Burr's *Deep Purple*, 2000, are slightly taller than we are, though not nearly so high as the Cor-Ten panels of Richard Serra's destroyed *Tilted Arc*, whose memory Burr's work invokes. Similarly, Harrison's columnar work *John Locke* looms above a beholder in homage to the great philosopher (Fig. 13). As these works remind us, in order to be effective *as* sculpture, a sculpture must be sized for a beholder to see and to grasp. However antianthromorphic its intention, the work of art remains inescapably anthropocentric.

Notes

1 Alain Robbe-Grillet, "Nature, Humanism, Tragedy" (1958), in *For a New Novel: Essays in Fiction*, trans. Richard Howard (New York: Grove Press, 1965), 51–52.

2 *The Concise Oxford English Dictionary*, 10th ed., s.v. "anthropomorphism," 56.

3 The absence of explicit references to Robbe-Grillet and Roland Barthes in Judd's texts takes nothing from the fact that Judd espoused the sorts of antihumanist arguments circulating in the New York art and literary scenes during this period, as evinced in the writings of Barbara Rose, Susan Sontag, Mel Bochner, and Robert Smithson.

4 Donald Judd, "Specific Objects" (1965), in *Complete Writings 1959–1975* (Halifax: Press of the Nova Scotia College of Art and Design, 1975), 183.

5 Ibid.

6 "Poussin's paintings suggest there's more order in the scheme of things. […] Poussin's order is anthropomorphic." Donald Judd, in "New Nihilism or New Art? Interview with Dan Flavin, Donald Judd, Frank Stella," WBAI, New York, February 1964, published in James Meyer, *Minimalism* (London: Phaidon, 2000), 199.

7 Robert Morris, "Notes on Sculpture, Part II" (1966), reprinted in Meyer, *Minimalism*, 212–20.

8 Michael Fried, "Art and Objecthood" (1967), reprinted in *Art and Objecthood: Essays and Reviews* (Chicago: University of Chicago Press, 1998), 155, 157.

9 "I am suggesting, then, that a latent or hidden anthropomorphism lies at the core of literalist theory and practice." Ibid., 157.

10 Rosalind E. Krauss, *Passages in Modern Sculpture* (Cambridge, MA: MIT Press, 1977).

11 Judd's intriguing account of Claes Oldenburg's practice ("Specific Objects," 189) could be applied to Ray's practice in particular: "The trees, figures, food or furniture in a painting have a shape or contain shapes that are emotive. Oldenburg has taken this anthropomorphism to an extreme […] and by blatancy subverted the idea of the natural presence of human qualities in all things."

<div style="border: 1px solid; text-align: center;">

Miya Elise Mizuta Lippit

</div>

Anthropomorphic Beauty: Photography, the Empress, and Modern Japan

The ideal of feminine beauty in Japan was measured, until the twentieth century, according to clearly established standards, within the framework of a cultural discourse that drew on Japanese and Chinese aesthetic traditions. In the Meiji period (1868–1912), however, understanding feminine beauty became a much more complex endeavor. Before Meiji, the reputed beauty of the Japanese empress had marked the esteemed limit of all that was pleasurable to the Japanese eye. The empress had served as the supreme example of feminine beauty, and she symbolized the embodiment, or personification, of beauty.[1] In 1873, the widespread circulation of the Empress Meiji's official photograph destroyed this former idealization (Fig. 14). Artistic and literary representations had approximated her beauty, but the photograph, which presented her "as is," anthropomorphized her. In doing so, the photograph destroyed the traditional representational order. The empress no longer signified an immortal unrepresentable; as an extension of the emperor, who was thought to be directly descended from the gods, she, too, was "divine." She was, instead, clearly human and infinitely representable. All the attributes of beauty could not be conferred on one person alone, and the photograph, which exposed the illusion of the empress's peerless beauty, left in its wake the demand for a new aesthetic paradigm. The anthropomorphizing photograph of the empress did more than rupture the imaginary order for beauty that had existed prior to the modern period. With the demand placed on Japan to enter into the international community, the image of the empress was also expected to maintain a contradictory set of significations: she should embody national distinction (that is, she should be relative, contingent, and modern, as a symbol of national Japanese identity), yet exude universal appeal (be absolute, immutable, and eternal, to be accepted in the global configuration).

The encounter with photography and artistic realism at the turn of the twentieth century in Japan raised the question of how best to represent the empress as an icon of the nation-state and as a living model for modern Japanese women. In painting and photography, a debate was waged over whether she should be depicted in Japanese or Western dress, holding a fan or standing beside a vase of roses, and so on. The question of the empress's representation indicates how, at this juncture, the representation of feminine beauty became an urgent part of the national project. During this period, the artistic representation of women played a critical role in the Western evaluation of Japanese art, which was itself being used to appraise how Japan was measured as a civilized nation. The recognition of Japan as an artistic country—and of Japanese art as "fine art," as opposed to mere "craft"—was an

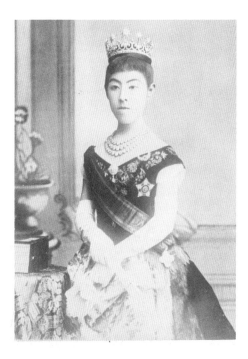

Figure 14. Empress Meiji, photograph, 1899 (photograph in the public domain).

important factor in determining how the West received Japan. As the Japanese art historian and critic Okakura Kakuzō famously remarked, "It is only art that represents Japan to the world."[2] Beginning in the 1860s, following on the era of Japonisme (the fashion for Japanese art in the West), Japanese art was largely lauded, but it was also seriously criticized for not engaging the figure of the woman as a central theme. The way in which the representation of women was perceived in the West played no small part in what was often a dismissive characterization of Japanese art as mere "decorative design," inferior to Western "fine" or "high art." Some critics went so far as to say that the Japanese did not satisfactorily express beauty in the human form, a failing that underscored, in their view, a problem with the Japanese national character. In the eyes of the Western critic, an art that did not depict beautiful women in a manner to which they were accustomed signaled a mistaken estimation of beauty. The beauty of Japanese women was thought to suffer from "self-inflicted ugliness," the effect of a deformed Japanese aesthetics.

Western critics premised their evaluation of Japanese art on Western notions of beauty, which they considered to be universal. Without regard for differing standards of beauty, those critics designated the delineation of the human figure in Japanese art, and Japanese women in particular, as ugly, "pudding-faced, greasy-haired, knock-kneed, and bandy-legged little creatures." What was at stake in the representation of women and feminine beauty was Japan's very capacity to produce art. In response, Japanese art during this period

Figure 15. Kaburaki Kiyokata, *Konjiki yasha* (Gold Demon), 1947, original for an illustration in *Kuraku*. Private collection (artwork © Nemoto Akio; photograph © Osaragi Jirō Memorial Museum).

became a woman, a beautiful woman, or *bijin* (美人). The discussion of what constituted feminine beauty and aesthetic beauty in general, and how such beauty should be represented in traditional Japanese forms as well as in newly imported artistic styles became the basis for a larger discussion on the fate of modern Japan and its arts. Writers, artists, scholars, journalists, critics, and politicians joined in the discussion, producing a national discourse on the standards of Japanese feminine beauty and its artistic representation, which laid the foundation for the dissemination of Japanese aesthetics into the world—for the entry, that is to say, of a modern Japan into world culture. The Japanese artistic establishment, in seeking to secure a place among industrialized nations, promoted the image of Japan as an artistic nation, a nation of artists, through the idealized image of the material body of the beautiful woman. In engaging the West as a nation of artists, Japan allowed for the conflation of beauty, women, and art. The nation played strategically into the desire of the West—the desire for Japan as aesthetic Japan, Japan as an artistic representation—by performing an aesthetic self-production, in part through the beautiful woman incarnate. The imperialist nation hid behind this self-produced facade as it advanced militarily into other parts of Asia.

At a time when defining artistic "beauty" became an increasingly urgent part of Japan's national project, an active feminization of Japan occurred, above and beyond the regular designation of countries as paternal or maternal entities. In the case of Japan, its aestheticization is the result of a specific feminization rather than a maternalization. The aestheticization of the nation was produced partly through the figure of the woman and through the myth of

the Japanese woman, which imagined her as an object of art. It was by means of an anthropomorphic body, personified as feminine, that Japan interrelated with the outside world; the visible, material body of the woman-as-art constituted a new limit and perspective for the nation, and it became the unified mode of access through which Japan's position among "civilized" peoples could be established. Capable of initiating and proliferating desire, Japan's presentation of itself to the world was anchored in the corporeal schema of a feminized body. The anthropomorphized nation of Japan appeared not as an inanimate artwork-object that could be colonized but as an uncolonizable human-subject, an artistic, feminized nation. In the era when the advent of photography anthropomorphized the Empress Meiji, the nation of Japan was itself anthropomorphized, inhabiting and establishing the lived time of a modern subject (Fig. 15).

Notes

1 Significantly, the name that the empress took on her ascension in 1868, Haruko, was written with the Chinese characters 美子; she was literally named "Beautiful Woman." The use of the character *bi* (beauty, 美) in the empress's name coincides with the newly coined words *bigaku* (Japanese aesthetics, 美学) and *bijutsu* (fine art, 美術), and one can speculate on the interrelation.

2 Okakura Kakuzō, quoted in *Japanese Thought in the Meiji Era*, ed. Kosaka Masaaki (Tokyo: Pan-Pacific Press, 1958), 225.

APPROPRIATION

Figure 16. Georg Baselitz, *The Forgotten Second Congress of the Third Communist International in Moscow 1920, on the Right of the Picture Ralf, next to Him Jörg,* from the 16-panel series Mrs Lenin and the Nightingale, 2008, oil on canvas, 118⅛ × 98⅜ in. (300 × 250 cm). Guggenheim Museum Bilbao (artwork © Georg Baselitz; photograph by Jochen Littkemann, Berlin).

Georg Baselitz

Back Then, In Between, and Today

To dream oneself to the other end of the world was a childhood wish. I have dug, drilled, and trenched in the sandpit in order to come out again on the other side. Then later, years later, to find the past, the eon, the things from people who have been here before us, I have excavated at that same place for urns. Dr. Weissmantel, the history teacher, said that what I had brought to him were Slavic urns, 3,000 years old.

The game was not to lift oneself out of any old bad time into a better one. More than anything, curiosity propelled the discovery of what lay hidden in there, behind, and below. A good start for a painter's life, highly recommended.

Listening to the radio waves belongs to this curiosity. Putting one's ear onto the railway tracks (there weren't any nearby) or on the telegraph poles, or peering through the ice at the frozen lake, fired the imagination. Since 1942, in front of our house there stood giant electromagnetic listening dishes for the sky. Was something happening up there, airplanes with bombs, perhaps? One can hear various things with one's ear to the trunk of a tree, in any case, rushing water, in the way that city dwellers hear the flushing system. *Eau et gaz à tous les étages.* The telephone wires sing far across the land. The red wood ants in their great piled-up castle sniff and rustle. Can you hear the sea in the conch? From where the wind comes was not so interesting, where it went was only further away. But the migrant birds passed through the sky in the formation of an arrow, or a wave, the starlings appeared as a cloud, the lapwings like whirled-up leaves. Near Fort Worth I stuck my finger into the ground and oil came bubbling up. Over here, once in a while, a mountain crystal, or a fine ammonite in the creek.

Some time later, I began with drawings and paintings, in a way like digging, drilling, eavesdropping, ruminating, mining, as I thought about what lies behind or below. And so, transmuted into lines and forms, I have transported myself from my world into another one—not so far as to no longer recognize the relatives. Such good detergents did not exist back then. Somehow everything is still here, perhaps just in other places, upside down, or maybe not.

Worshipping heroes and listening to them, slipping into them and opening up the lid of their skulls as George Grosz had done, it becomes inevitable—a leader leads by seduction.

But then, reflecting about elongated brushes, or long arms, or painting behind the canvas, painting on the floor, what do you feel below? Or letting something paint itself, pouring paint, letting it run, dropping, painting something stupid, painting everything over. Why did Picabia go that far, and then again he painted single dots onto it, like buttons on a vest?

The experience of firework music in Imperia—after all, we are living in the house of a relative of Lucio Berio, also a Berio, big iron "B" on the gate—the music began, the firecrackers blasted, and up in the grandstand, we disappeared in the smoke. We couldn't see a thing and the music sounded only faintly, and dull. Groping in the dark? Falling into a trap? Anything can happen when it gets dark during the day. Now and again I slipped on a canvas wet with turpentine, like a wild boar in a wallow. If one can't hear music, maybe one can hear the worms in the wooden table, or the birds outside the window.

If sixty years ago Dr. Lachmann's son, a person with Down syndrome, had not looked out the window and grimaced when he saw me, I would perhaps have taken painting lessons, discovered my talent and promoted it. But I knew, at most five years later, that this promotion comes to nothing and that I'd be better off letting it be. The hours diving in the South Seas are glorious, praise the Lord, because of everything one can see to the darkest depths of fish, monsters, corals, and colors. One is able to relax. Nothing more is required. At most, a game of solitaire on the beach. But then these stupid photographers and painters, these lusters after nature. When the airplane pushes up through the clouds, this expanse with stars or with blue skies, glorious, praise the Lord. Here, arias by Richard Strauss make a deep impression, but again, no pictures. The tin cans of shoe polish with the frog on the lid, two connected with a long piece of string and used as a telephone, back then, by us kids, glorious, praise the Lord. That gave pictures for the eye and ear. The breadth, the depth, the distance—first the frog was a prince, then a count, finally, a bastard.

The underground bunker in the woods, with walls covered with bed linen and my mother's green carpet on the dirt floor. When the soldiers were dead and the war ended, my friend and I moved in. A nice place for dreaming. We were well endowed with ammunition, too, from 8.8 cm caliber on down. The weapons were rusted. Before the secondary school painting advisor, Dr. Lachmann, set up his field easel in front of the old oak trees and began his little New Objectivity pictures, my high spirits to change the world in the future had no objective. I heard it rustling, but I lacked the form—no *Ahmung*, no *Lehnung*. Reading books was a great influence, and the paperback booklet with black-and-white illustrations of Italian Futurism, glorious, praise the Lord. Stuff of great pathos could also be found on stamps, Stalin for example, and in the romance novels of Jorge Amado. I was away more than I was here—more inside-outside than away-outside. That pictures meant freedom did not occur to me then. I thought to make paintings meant to draw attention to oneself. Oh well, it worked quite well in my bird's nest, or maybe better put, my rat's nest. The great prophets from the school desk next to me, the grand calculators and socialist creators of life forms, those I never saw again or heard of anymore. Presumably, they shriveled away. Also, the talented woman pianist gives only piano lessons. Even the great teachers shrink enormously after one leaves school. Why do memories tingle within us? Because one has rubbed against the wrong people? In this there is no difference in fact between the province and the metropole, at most, only in percentage.

There were many frogs in the sand pond. Before that it was slimy spawn, then the tadpole with the tiny tail, gradually it became amphibious, between land and water. With me, it was also slimy at first, and then crusted over. I, too, had my state between egg and hen. Sometimes it went like a bird, from tree to mountain and across the land. For example, the love fevers, the swank of bulging muscles, the trials of courage. Fantasy was only good for showing off (swanking). All records, everywhere, were broken. If it had existed at all, I have forgotten the envy, the comparison fails, also the incentives for faster or more efficient foraging in my milieu. The rich, whom I later met, were assholes, and the famous artists did not interest me at all at first because they existed too monumentally in another world. One just gets on easier with the starvelings, the so-called outsiders, and there were enough of them. One can hide if one does not want to be seen, but also if one does not want to see anyone.

This changed when the first paintings were made. Finally, I knew best what and how these were. The difference and the distance to what had come before could not have been greater. The painting, *P. D. Stengel*, is more a ride on the "Moscow-Petushki" line, a trip to the end of the line, than a stroll in the supermarket of any Pop artist.

For example, "Lenin and the Nightingale," Becher's idiotic Stalin poems, a roe deer… When Michael Jackson died, the obituary on the radio announced that the greatest musician of all time had died. He had received the most gold records. Damn bloody music is that, listened to by the damn bloody stupid. Becher is said to have been a snowbird on cocaine. More important, however, is that this crap poet was minister of culture. As for Lenin, please read "My Little Leniniana" by Erofeev. Lenin and Stalin with miniskirts and pumps. I, the painter, I'm getting into line, get into line, colleague. Hence the title, *The Forgotten Second Congress of the Third Communist International in Moscow 1920, on the Right of the Picture Ralf, next to Him Jörg*. One may recall Breton, Aragon, and so on—the Surrealists in the CP.

Now, Willem de Kooning is a leading figure, Tracey Emin, Cecily Brown, Richard Prince, and so on. I use method, stereotype, and particular shades of color because it feels good when these go through one's head. One should quote and see what the colleagues are doing. Sitting high in the incubator, there is a cozy, frictional heat. Still, few appear alongside Willem in my register.

When I had opened Trier's lid, it was nothing but *Ahmung* and *Lehnung* there, and also when I pushed Nay's color discs across the paper, there was a glorious feeling, praise the Lord. A fabulous, free, high-spirited mood, away over the neighbor's fence and into the distance, a condition similar to this: he who lies once is never believed again; or: when all dams are broken; or: when a reputation has been ruined, one can live without embarrassment. As long as the thread held, it all went well. But soon I was stuck again in the old muck. I didn't even want to learn French on account of the peculiar facial grimaces this required. Our teacher, Miss Härtel, said that we, as Oberlausitzers, were particularly suited for the French language. Miss Potzhuhn at the piano reeked of garlic, so playing the piano was also a lost cause.

I loved to look at pictures by Wols, back then, in 1957. But then the Americans came, this time not with chewing gum and chocolate but with Pollock, and the like. Glorious, this exhibition at our school, praise the Lord. In China, over thousands of years, over thousands of times, an alchemistic coffee cup from Meissen was already being broken. Is that a good aphorism for Europop from Saxony and Silesia? So far I have never cleaned toilet paper. We, Elke and I, are our own analysts. Our never-ending conversation about the past is reminiscent of two old apes picking the fleas from each other's fur, Elke says. Naturally, I have not only pondered. I have also dreamt in thought, putting together 1 and 1, planning and doing the next step, regardless of whoever was my helmsman in the little upper deck and whether he was choosing the right direction—this is not logical-biological but logical-visionary, and all of it before the discovery of the onboard computer. Remix paintings are not like pickled cucumbers on the basement shelf. I have never ever greeted my own reflection.

That it occurs on a white surface, I have maintained into recent years. Something is there, not far removed from drawing, inside and on it, not just all over and about. Even my *Composition* after Lichtenstein is that way, quoted on it like fly dung, the music plays after it from the score sheet, and whether the thing can fly remains unclear. The lucky numbers for the next draw are: 1, 5, 19, 23, 38, 40.

Translated from the German by Christian Katti

| 1903 | 1919 | 1962 | 1971 until today |

ERDAL Frog

Translator's Notes
For invaluable help and advice, I would like to thank Detlev Gretenkort and Karen Lang, as well as Mr. Baselitz. Footnotes would have lent an unfortunate tone and appearance to the poetic character of this essay. At the same time, much of its context was in danger of being lost. Hence, we have decided on these notes.

Eau et gaz à tous les étages. Here, we find not only "water and gas on all floors" but also, as a matter of course, a flashing reference to Marcel Duchamp.

One might think of George Grosz's *Die Stützen der Gesellschaft* (1926), where the skulls appear opened, almost like pots. "Malen aus dem Kopf, auf dem Kopf, oder aus dem Topf"

is the title of a manifesto by Baselitz, who likes to play with the homonymous metaphors "Kopf" (head) and "Topf" (pot), as well as with opening them up. (See *Painting from Memory, Upside Down, or From the Pot/Painting Out of My Head, Upside Down, Out of a Hat*, in Diane Waldman, *Georg Baselitz* [New York: Guggenheim Museum, 1995], 247.)

With Francis Picabia one might think of *Point* (1947), or of *Das schwarzeste Schwarz* (1949).

Baselitz lives and works in Imperia, Italy, and near Munich, at Lake Ammersee. He was born Hans-Georg Kern in the tiny hamlet of Deutschbaselitz. His and his wife's dates of birth might be found within the lucky numbers at the end of the essay.

With the image of the frog on the tin can, Baselitz refers to the Erdal logo, one of the most common German shoe polish firms. Its change over time frames the end of the essay.

"Ahmung" and "Lehnung": *Ahmung* might best be translated as mimicking, seeming, resembling, loose counterfeiting, or near imitation. *Lehnung* connotes leaning, following, leaning on, or even allusion. *Ahmung* is also used as a *terminus technicus* in psychological contexts, where it describes the unconscious and involuntary reaction of imitating visual stimuli (see Christian Kellerer or Marylka Bender). But the closeness to the German *Ahnung* (*ahnen* means to sense, anticipate, guess, having a hunch, suspecting) resonates as strongly. For its part, *Lehnung* feels more like the fragment of a word, though a very suggestive one. For all these reasons, we chose to keep the two expressions, with all due apologies, in the original German.

Baselitz refers in a figure of speech to a famous Russian novel of Samizdat literature. See Venedikt Erofeev, *Moscow to the End of the Line*, translated from the Russian by H. William Tjalsma (Chicago, IL: Northwestern University Press, 1992). This novel, with the original title *Moscow-Petushki*, written about 1969–70, was first "published officially" in 1973, in the Israeli journal *Ani*. It also appeared under the titles *Moscow Stations* and *Moscow Circles*. "Samizdat" denotes a main dissident activity that was not uncommon throughout the Soviet bloc. Individuals produced and copied censored works and passed them on, mostly among circles of friends, in a snowball system—therefore the scare quotes concerning "official publication." Erofeev's novel is perhaps the most popular work of Russian underground literature. In 1976 it was translated to French, and in 1978 to German under the title *Die Reise nach Petuschki* (*The Trip to Petushki*; later a critical and commented edition, *Moskau—Petuski, Ein Poem*, appeared in Zurich in 2005; sometimes the transliteration reads *Wenedikt Jerofejew* in German). The first English translation appeared in 1980. Maybe the best translation to catch the contextual vibrations would have been "a trip to 'the heart of darkness,'" as Joseph Conrad's uncanny travel to the "other side" rings a bell for all English readers, but this would have betrayed the actual reference to Erofeev's more than absurd point of departure—and return.

Erofeev's *Meine kleine Leniniade* (*My Little Leniniana*), the strongly recommended collage, or rather decollage, of quotations by Lenin, was only (partially) published in German translation in the literary journal *Lettre International*, no. 10 (1990). To our knowledge, it has not yet been translated into English.

Joseph Stalin, who is said to have enjoyed singing, was nicknamed the "nightingale from the Caucasus." In one of his panegyric poems, Johannes R. Becher, minister of culture for

the German Democratic Republic (1954–58), described Stalin metaphorically (and without the slightest irony) as a roe deer.

Trier's lid: Hann Trier, who participated in the first three *Documenta* exhibitions, was one of Baselitz's professors at the Hochschule für bildende Künste in West Berlin. Trier subsequently held the position of director.

He who lies once: here Baselitz alludes, however ironically, to a few, quite common German proverbs: "Wer einmal lügt, dem glaubt man nicht, und wenn er auch die Wahrheit spricht." A liar is not believed, even when he speaks the truth. And: "Ist der Ruf erst ruiniert, lebt es sich ganz ungeniert." Once your worldly reputation is in tatters, the opinion of others hardly matters.

Appropriation and Influence

At the turn of the twelfth century, a sculptor carved a bell player on a limestone capital for the choir of the important monastic church of Cluny in southern Burgundy (Fig. 17). The swaying posture of the musician conveys the music produced by the bells of the instrument that he carries on his shoulders, a visual complement to the liturgical chants once performed in this space. A remarkably similar musician appears on an 1120s capital from Vézelay, a priory of Cluny. About 1130, another sculptor significantly altered this stock figure on a nave capital at St-Lazare, Autun, through the addition of two men, who strike bells with mallets (Fig. 18). Patronized by that city's bishop to house relics of its titular saint, Autun further represents a change in social context, for previous carvings of bell players appeared only in Benedictine churches. Other monastic antecedents to diverse aspects of religious culture can be identified at the twelfth-century cathedral. For example, the laity participated in a rite of penance that involved prostrating oneself outside the cathedral on elbows and knees (*super cubitos*), a posture that had been used for generations at Cluny by monks as they sought forgiveness from their brothers. At Autun, we might identify a pattern of appropriation.

Already in twelfth-century Latin, the verb *appropriare* could signal annexing another's property, especially with respect to church lands. An analogous meaning underlies the extension of the term into the history of art. Appropriation can convey the neutral, albeit fundamental, idea that all artists necessarily take from others, as Okwui Ensor, Robert Nelson, and Arnd Schneider have shown. But in recent decades the term has often signaled the actions of a calculating, even transgressive, individual who uses something old in order to promote a new agenda. Indeed, among the many words that describe how artists make use of earlier works—adaptation, adoption, bricolage, cento, farrago, misprision, pastiche, and so on—none conveys artistic agency as appropriation. Perhaps the closest cognate to this sense of appropriation is the Situationists' *détournement*, or the inserting of significant images within unfamiliar pictorial contexts in order to alter their message. American artists of the 1970s, from Richard Prince to Sherry Levine, then embraced the term to signal deliberate image borrowing in their painting and photography. This understanding of appropriation, and the politics it implied, has profitably informed a host of art historical subfields. It might even be applied to an interpretation of the Autun musician.

Yet, I confess to reservations about appropriation and have long found it significant that the French historian and theorist Georges Bataille pointed to the potential shortcomings of this notion in writings from the 1920s and 1930s. Bataille, who had culled many

Figure 17. Musician, choir capital from Cluny III, ca. 1095, limestone. Abbaye de Cluny (artwork in the public domain; photograph © Kristobalite).

insights from his perusal of medieval texts, argued that appropriation posited the presence of a unified and static author working in highly rational or utilitarian fashion to advance (institutional) agendas. Bataille gravitated instead toward the notion of excretion, which for him signaled a cluster of ideas, including heterogeneity, metamorphosis, and liberation. In contrast to the static nature and hierarchy implied in models of appropriation, Bataille celebrated the exocentric, leveling effects of excretion.

Most medieval monuments, including Autun, were fashioned in conditions about which little to nothing is known: artistic practices, workshop structures, patronage systems, and other basic practical matters must be inferred or simply conjectured. In lieu of extrapolating from later artistic practices, it would perhaps be useful in such contexts to consider how the notion of appropriation impinges on or shapes art historical narratives. What does the application of appropriation in these medieval contexts potentially obscure?

Only a few points can be made here. Accounts of appropriation tend to be synchronic, privileging those moments when an artist transforms the past rather than adheres to tradition. This emphasis on a select form of individual agency perhaps offers something akin to a vicarious experience, allowing the art historian to look over the shoulder of an artist at the moment of the creation of something new. This view seems unsatisfactory, however, in the case of Herculean projects like cathedrals, which often involved scores of artists and took

Figure 18. Musicians, nave capital, ca. 1130, limestone. St-Lazare, Autun (artwork in the public domain; photograph © Colum Hourihane).

many years, even generations, to complete. The sculptural remains from Autun include dozens of capitals and two elaborately decorated portals from about 1130, an elaborate tomb for Lazarus that dates to about 1170, and various additions from subsequent centuries, including eighteenth-century plaster coverings no longer extant. Such complex, multifaceted projects belie appropriation, understood as the transformation or taking ownership of the past by a single artist or author. Instead, they reveal a heteroglossia, or heterogeneous artistic languages. What is more, appropriation sheds little light on the reception and effectiveness of art objects, especially over long periods of time. Why, for example, do the Cluny and Autun capitals, carved nearly a millennium ago, continue to move twenty-first-century viewers?

In the customary association of appropriation with artistic agency, appropriation countervails the passivity, say, of a notion like influence. The biological turn in the humanities and the rise in network studies, among other recent developments, have perhaps made us more receptive to the possibility that not all aspects of cultural products are deliberate. Indeed, I have become increasingly interested in Thomas Aquinas's elastic notion of influence for understanding the myriad causes that coalesce in the production of a work of art. In accounting for works of art, the capaciousness of the Thomistic model prompts the historian to imaginatively consider a range of possibilities.

In his earliest surviving written text, *De principiis naturae* (*The Principles of Nature*), Aquinas used the example of a bronze statue as part of his illustration of the four categories of causality: the material cause is the bronze; the efficient cause can be identified as the artist as well as specific notions of artistry guiding facture; the formal cause can loosely be described as the shape of the work or, more properly, its essence; and the final cause comprises the various functions served by the statue. Although the artist may be the most obvious and proximate cause of a given work, this interpretative system embraces a host of remote causes as likewise exerting influence. According to Aquinas, to posit "some influence [*influxus quemdam*]" is something akin to an operative conjecture that could be developed and amended in innumerable ways. Of course, appropriation might figure within such an account, but it would be only part of the story. At Autun, we might consider appropriation to be one aspect of "influence," in a Thomistic sense.

<div style="border:1px solid;display:inline-block">

Elizabeth Edwards

</div>

Photographs Can Never Be Still

The "ethnographic" photograph is perhaps the paradigmatic appropriative object, born, as many commentators have noted, of an aggressive technology in contexts of political and cultural domination.[1] Such photographs present a fixed point, literally, figurally, and metaphorically, of dispossession and appropriation. They render the bodies of the powerless through the intellectual and ideological categories of the powerful in relation to a series of dynamic axes—race, gender, subjugation, and their social classifications. These processes are undoubtedly formative in the history of visualization, geopolitics, and, indeed, biopolitics. At the same time, analytically reductionist and overdetermining concepts of appropriation and gaze are perhaps inadequate to account for the multiple and serial appropriations and revaluations in which photographs described as ethnographic are increasingly entangled, and where they are asked to do different things. The possible liberation of these photographs from the constraints of the ethnographic category, itself a reductive category, in order to see what else they can say—and sometimes they come firmly back to the problematics of the ethnographic—is part of shifts in claims to historical voice.

The trace of the body of the ancestor rendered in the camera has for decades been a powerful metaphor of the colonial and of global and local asymmetries of power. But other subject claims to these images have arisen in recent years. In this, of course, some photographs are more fluid than others, more open to multiple appropriations and revaluings. Some photographs, "hard appropriations" perhaps, carry the irreducible and unerasable marks of their violent and appropriative origins. For instance, the original act of appropriation of anthropometric photographs cannot be superseded. Although artists such as Carrie Mae Weems, Faisal Abdul Allah, and Pippa Skotnes have confronted and reworked these images, the original act of violence remains at the center of the work. Other photographs are, however, more ambiguous in their relations, raising the question: Can there be "hard" and "soft" appropriations, some "weightier" than others? Can photographs succeed in transcending the original act of appropriation on which their existence is founded?

One of the defining features of photographs is their reproducibility, meaning the possibility of their circulation, emergence, and performance within a visual economy. They are, in other words, ontologically predestined as sites of serial appropriations, reappropriations, reclamations, and recuperations within shifting and dynamic historical relations and with radical revaluations within different conceptions of rights, identity, property, and the power of knowledge. Photographs are forever exceeding their own limits. They can never

be contained. They carry an intrinsic random excess and infinite recodability. The degree to which this is so suggests that the formal qualities of images are largely irrelevant. Images emerging from appropriative historical practices can become family photographs and community history, and nineteenth-century stereotypes of "typical natives," part of the "views trade," can become scientific and historical evidence. In these contexts, photographs accrue meanings as they move through different spaces, for, after all, appropriation entails the politics of categories.

The fierceness of the debates over the control of photographs and over control of patterns of visibility and invisibility marks photographs as a potent metaphoric and actual site of appropriation. The trace and realist insistence of photographs and their ontological pastness—"it was there"—open them to sovereign claims of history. Many museums and archives are involved in "visual repatriations" (itself a politically awkward phrase) to move photographs into reappropriations deemed "positive" in a contemporary postcolonial context. In fact, here the term *reclamation* would be better, for "appropriation" implies assuming ownership of someone else's property, while "reclaiming" signals legitimate ownership all along. Despite the extensive theoretical debate around these issues, the degree to which these serial "appropriations" destabilize normative museum practices, themselves emerging from appropriative practices, remains in question.

And yet in many places, museum practice has been destabilized. In Australian museums (and elsewhere), access to "ethnographic photographs," under the auspices of "science" and its norms, has been restricted in response to demands from Aboriginal communities. For these communities, reclaiming control over their own heritage is a spiritual and political act. In Europe, on the other hand, where the control of photographs is not woven into the *realpolitik* of cultural politics in the way that it is in Australia, New Zealand, and North America, the process of reclamation is sometimes tinged with an uncomfortable sense of unarticulated curatorial romanticism, a redemptive for other categories of appropriation. The "moral algebra" of appropriation, reappropriation, and reclamation is complex.[2]

It was claimed by many peoples in the past that photographs captured the soul, drained the lifeblood, stole the shadow—concepts that have become powerful political metaphors in the present. And, of course, they were right. Photographs appropriated into Western archives for too many years did exactly that: they transferred from the subjects the power to tell about culture and history, diminishing cultural vibrancy to corrosive effect and transforming the historical particularities through which subjects are perceived.

Whereas meanings might adhere in the framing of interpretative possibilities, the shifting dynamics of dominance and subordination, historical and contemporary, insider and outsider pose a central challenge to the concept of the ethnographic photograph in which the politics of "looking past," as one activist put it, reaches into a space beyond the initial acts of appropriation, allowing images to function in multiple ways. Indeed, it is strange how in some contemporary art history and criticism, "the ethnographic" has

itself become appropriated as a shorthand for appropriation and the denial of agency, at just the moment when the category of "ethnographic" is becoming increasingly unsettled and the possibility of agency and social identity is being vigorously restored to subjects of photographs of ethnographic archiving through the demands of cultural recuperation. We are at a moment of the rise of the counternarrative of the ethnographic photograph. This does not erase the initial appropriative action, but it opens a space for other meanings beyond it.

Photographs are perhaps ultimately "vagrant" forms, condemned to wander uncontainably, carrying their marks into new spaces. Serial appropriations are in effect serial relationalities that entangle photographs and give them meaning. Photographs, including those ethnographic by intent or by categorization, are part of the debris of relationships, marking traces of the latter when they are long gone—but, like debris, they blow about, landing in unexpected places and making new meanings in a series of appropriations, expropriations, reclamations, and rejections. Photographs can never be still.

Notes

1 See, for instance M. Allouhla, *The Colonial Harem* (Minneapolis: Minnesota University Press, 1986); David Green, "Veins of Resemblance," *Oxford Art Journal* 7, no. 2 (1985): 3–16; Anne Maxwell, *Colonial Photography and Exhibitions: Representations of the Native and the Making of European Identities* (London: Continuum, 2000); and James Ryan, *Picturing Empire* (London: Reaktion, 1997), esp. chap. 5. For a differently nuanced account, see Elizabeth Edwards, *Raw Histories: Photographs, Anthropology and Museums* (Oxford: Berg, 2001); Christopher Pinney and Nicolas Peterson, eds., *Photography's Other Histories* (Durham: Duke University Press, 2003); Christopher Morton and Elizabeth Edwards, eds., *Photography, Anthropology and History* (Farnham, UK: Ashgate, 2010); and Christopher Pinney, *Photography and Anthropology* (London: Reaktion, 2011). See also Homi Bhabha, *The Location of Culture* (London: Routledge, 1994); Fred Myers and Geroge Marcus, eds., *A Traffic in Art and Culture: Refiguring Art and Anthropology* (Berkeley: University of California Press, 1995).

2 Bruce Ziff and Pratima V. Rao, introduction to *Borrowed Power: Essays on Cultural Appropriation* (New Brunswick: Rutgers University Press, 1997), 5. See also Nicolas Peterson, "The Changing Photographic Contract: Aborigines and Image Ethics," in Pinney and Peterson, *Photography's Other Histories*, 119–45; Alison Brown and Laura Peers, *Pictures Bring Us Messages* (Toronto: Toronto University Press, 2006); Fred Myers, "'Primitivism,' Anthropology and the Category of 'Primitive Art,'" in *Handbook of Material Culture*, by Chris Tilley et al. (London: Sage, 2006), 267–84; and Marilyn Strathern, "Sharing, Borrowing and Stealing Simultaneously," in *Ownership and Appropriation*, eds. Veronica Strang and Mark Busse (Oxford: Berg, 2011), 23–42.

Ursula Frohne

Revenants: Gestures of Repetition in Contemporary Art

As in popular cultural practices, so in artistic methods a paradigm shift has become apparent during the past four decades: economies of re-use, circulation, and transformation of existing artworks have shaped new ideas of creative production. Against the backdrop of a boundless availability of images, this creative production has been increasingly conducted through cooperative thinking and acting.[1] The "cult" of the original, once mandatory for the formation of modern Western art, has been consequently transformed by recodings of culturally accepted formulas, establishing modes of copying as transcultural strategies of contemporary art practice. Modified variations of creativity also occur in convenience products, and these have infused the aesthetic spheres of threshold nations, most obviously in the pronounced copy-culture in China, for example, forming a potent counterbalance to the emphatic idea of the artwork represented by its unique conceptual presence. In contrast to an ontological understanding of identity that stresses cultural roots or "originality," the appropriation of cultural techniques involves an unremitting process of identification and translation that relates and integrates heterochronous elements.[2]

The philosopher Byung-Chul Han has addressed those dynamic forms of adaptation that, instead of highlighting subjectivity as the origin of the artwork, assume its situatedness and permeability. Han subsumes this characteristic disposition under the term "Shanzhai," a creative practice that spectralizes the work, as it were, through the foregrounding of its procedural appearances.[3] The antiauthoritarian movement implied in Shanzhai releases "subversive energies" in the work of art and in the direction of political processes. The inversion of the value gradient between the "original" and replication achieved within the transcultural communication processes acquires an expanded level of meaning, as Nicolas Bourriaud has already noted in his programmatic diagnosis of the "postproduction" culture that established itself under the label of postconceptual art.[4] Its logic, increasingly defined by an abstinence of originality and based on selection or combination of "premades," crystallizes like a pledge of discharge from the creative imperative so deeply rooted in the capitalist idea of freedom. Creation and depression are, in fact, two sides of the same neo-liberal coin, as Juliane Rebentisch and Christoph Menke have argued philosophically, in an economy where outperforming everyone is the unconditional means toward self-realization. They show how, under the pressure of being autonomous and feeding one's "originality" in pursuit of a "forced self-realization," the subject acquires "pathological traits."[5]

By comparison, the act of repetition liberates the "original" from its commitment to "uniqueness," and by reanimations, reenactments, or reiterations, it manifests new realizations that breach gender and cultural boundaries, blurring the Western concept of origin, and the Occidental norms of shaping identity through subjectivity, in the process. The conceptual shades of these articulations range from congenial approach to iconoclastic repulsion. The supposedly self-contained artwork is re-created by performative conversions into a process of flux and motion, thus making perceptible its temporal (and temporally inconclusive) structure. In the early 1960s, George Kubler's "sequential" model, delineating an inevitable recurrence of pictorial forms, contributed to an understanding of the artwork as shaped by a temporality of processes and aesthetic syncretisms that also invoke Aby Warburg's Mnemosyne project as a cultural model for effective (and affective) replication phenomena, formative for an ongoing, and newly created, presence of the historically absent.[6]

Repetition thus shapes the notion of the original—aesthetically, culturally, historically—by its own means, with the innovative gesture standing in tension between recognition and repulsion. On this account, the concept of the replica is fundamentally relevant for any idea of the original: the exercise of copying is not only a precondition for the training of technical skills and the education of taste but also a category that is indissolubly linked to the criteria of the new. In her pertinent discussion concerning the authorship of the casts made for Auguste Rodin's *Gates of Hell*, Rosalind Krauss revealed the role played by the replica in a production-aesthetic principle of sculpture. Georges Didi-Huberman further developed this idea when he characterized the cast as a necessary precondition for the production of bronzes. Although the cast implies a tangency with the origin of its form, it also stands for its actual material absence. According to Didi-Huberman, a "fateful" loss of the origin is part of the production process of sculptural works, and it is engrained in the idea of an artwork's originality.[7]

Does the replica then attest to the uniqueness of the original or does it vouch for its emanating force? Can reproduction practices and appropriative artifacts be seen as indicators of "aura's" centrifugal force? Or is what Walter Benjamin called the moment of its sudden appearance diminished by the manifold dissemination of an artwork's reproductions? The complexity of the exchange relations between the work of art and the repetitious traces it yields, in time and in diverse installation contexts across the globe, is spotlighted in Candida Höfer's photography series of the twelve casts produced after Rodin's *Burghers of Calais* (2000–2001, Fig. 19).

This multi-part photographic work was featured at *documenta 11* in Kassel in a panorama-like arrangement of the globally dispersed exhibition sites of the casts. Curated by Okwui Enwezor, the exhibition questioned the hegemonic relationship of the Western-defined and globally active art canon from the perspective of aesthetic practices beyond western Europe and North America in order to thematize the multifaceted expansions and recodings of the established aesthetical order by appropriative media practices and conceptual methods. In the case of Höfer's Rodin photographs, which were on display at one of *documenta 11*'s main spaces, this curatorial decision gained a historical perspective.[8] Höfer's contribution documents the worldwide export of a Western notion of art and it testifies to the fundamental

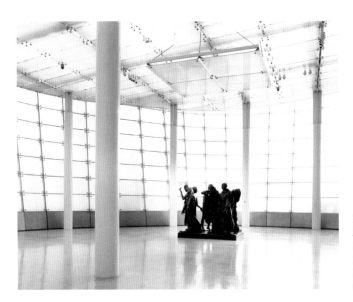

Figure 19. Candida Höfer, *Zwölf—Twelve. The Twelve Casts of the Burgers of Calais,* 2000/2001. Installation view, Kassel, *documenta 11*, Binding-Brauerei, 2002 (artwork © VG Bild-Kunst, Bonn 2017).

transformation of the concept of the artwork brought about by the technologically enabled accessibility of photography since the beginning of modernism. At the same time, her photographic series stands for the dissolution of the ontological category of the original prefigured in the sculptural technique of the cast—since the cast implies the possibility of reproduction—and brought to fruition with the introduction of photography.

What may initially appear in Höfer's series as a plain and simple strategy of photographic appropriation reveals a set of overlapping discourses. By gathering the dispersed casts of Rodin's sculpture within the context of an exhibition and arranging them into a second-order monument, Höfer's photographs lend visible form to the placelessness of the mechanically reproduced work of art in a globalized art system (Fig. 20). On the other hand, the principle of the archive resonates in the *topos* of photography's display function. Photography has this function for the artwork in general and for sculpture in particular—a principle Höfer deliberately chooses by introducing eccentric viewpoints that in turn comment on each site where the casts of the *Burghers of Calais* are to be found. In this way, she creates—via the means of a photographically intensified perception—a resonant cavity for the work's complex, (art) historical, medial, and cultural spheres of reference. Starting out from contemporary artistic practice, the focus is directed on sculptural procedures that have fundamentally widened the perceptual frame of objects and materials between site-specificity and performative processes, between the "original" and the copy.[9] A prerequisite for this discourse lies in the mutuality of the referential logic of the imprint, which is implied as much by the sculptural process as by photographic technology. The constitutive moment of sculpture, one could argue, corresponds to the "photographic act."[10]

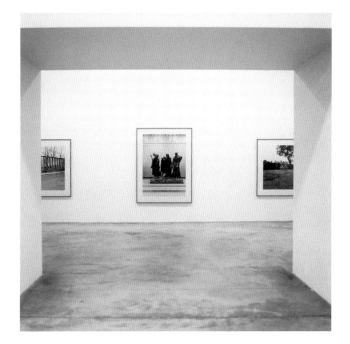

Figure 20. Candida Höfer, *Rodin Gallery Séoul II 2001*, 2001, c-print, 33½ x 33½ in. (85 × 85 cm) (artwork © VG Bild-Kunst, Bonn 2017).

The "fateful" loss Didi-Huberman identified in the production process of sculpture determines the procedure of photography as well. In the lost wax casting process of making bronze sculpture, the original wax or clay model is lost during the casting process. The technique by which the bronze sculpture takes shape is analogous to the creation of the photographic picture. In both, a motif of loss shows itself in the absence of the represented. Since the sculptural procedure only achieves the new form by first destroying the origin, here, too, the figure arises—as it does in photography—from the negative form. It is photography that serves as a sphere for imagining and projecting a sense of the possibilities of an atmospherically augmented idea of sculpture. In this manner photography resembles a sculptural "parallel medium" that "constitutes […] much more than a simple document," as it "brings out the mutual particularities of both media."[11] The special ability of the photographic *dispositive* to widen the work's creative and interpretive qualities, and thereby its field of reference, results in a tactical and intuitive approximation between sculpture and photography.[12]

Similar to the casting of a sculpture, photography raises questions concerning the status of the multiple. The autonomy of the fragment in Rodin's sculptures, their reproduction by casting and by photographic depictions, which the artist himself commissioned and even signed, evoke a multifaceted echo in Höfer's adaptations. The fruitful relations between original and repetition resonate in her series of photographs and converge

conceptually in the visual superimposition of sculpture, cast, and photographic reproduction. Höfer's recordings of the sculptures reassemble the disparate versions of the autonomous, and hence allegedly location-independent artwork, whose genuine figure can only be comprehended in visualization of its cultural diversity and dislocating dissemination. Her photography series punctuates the insight that two artifacts that look identical are never the same, even if they belong to or emerge from the same ontological category.

Höfer unfolds the manifold appearances of one and the same work and indicates its discursiveness over time and beyond temporal aesthetic taste, since the relations with art connoisseurs, collectors, and institutional framings reshape the work continuously. Its cultural afterlife within the view of following generations of artists and on display at diverse sites within the global art system can hardly be reduced to the antitheses of past and present, original, or imitation. Already, Michael Baxandall addressed the complexity of this relation between the earlier artwork and the later in his critique of the linear model of art historical influence,[13] and Mieke Bal has broached this aspect as a recursive movement of thought.[14] Accordingly, appropriations resemble the phantoms that Jacques Derrida adjures.[15] As specters, they do not adhere to a teleology of historical materialism, nor are they bound to a linear measure of time. Instead, they consistently return. Their continual survival bestows on them a *sur-vivance* that keeps them in an absence permanently present, beyond their polarity between presence and past. In this sense, appropriations run contrary to actuality by expressing the constitutive afterlife of the previously experienced. As revenants of the well-established, they transgress a purely factual, ahistorical concept of present time and the politically enhanced notion of temporal presence. In this way, contemporary concepts of appropriation subvert a logic that entails for each and every subject the ability to overcome the structures of alienation by self-realization. By means of artistic (self-)reflection, such practices direct the Western primacy of originality into the void of "de-creation [*Ent-Schöpfung*]."[16] In this regard, multiple gestures of repetition in contemporary art also generate productive syncopal ruptures in increasingly economically motivated demands of innovation. At the same time, they attest to the global exchange movements of contemporary image cultures, challenging art history to face up to the political implications of today's dominant models of creativity.

Notes

1 Exemplary studies include Marcus Boon, *In Praise of Copying* (Cambridge, MA: Harvard University Press, 2010); and Eik Kahng, ed., *The Repeating Image: Multiples in French Painting from David to Matisse* (New Haven: Yale University Press, 2008). An exhibition dedicated to contemporary appropriation phenomena: *Hirschfaktor: Die Kunst des Zitierens* [Hirschfactor: The art of citation], Museum für Neue Kunst, ZKM, Karlsruhe, October 22, 2011–April 29, 2012] introduced the term

"Hirschfactor" from the scientific field: named after the physicist Jorge Hirsch, it is an index applied to scholarly ranking. It works as a formula that calculates the number of publications in relation to the number of times in which they have been cited.

2 As Bruno Latour has said: "One is not born traditional, one chooses to become traditional by constant innovation." Latour, *We Have Never Been Modern* (Cambridge, MA: Harvard University Press, 1993), 75–76; cited in Amelia Groom, ed., *Time. Documents of Contemporary Art* (Cambridge, MA: The MIT Press, 2013), 166. See also Jala Toufic, *The Withdrawal of Tradition Past a Surpassing Disaster* (Los Angeles: Redcat, 2009).

3 See Byung-Chul Han, *Shanzhai: Dekonstruktion auf Chinesisch* (*Shanzhai: Deconstruction in Chinese*) (Berlin: Merve Verlag, 2011). As Han shows, Eastern ways of thinking about the original and the authentic consider the continuous rebuilding of temples in Japan as a sign of their authenticity. On the other hand, the contemporary Western logic of material identity finds authenticity in the fact that the same stones have been in place for hundreds of years.

4 See Nicolas Bourriaud, *Postproduction: Culture as Screenplay; How Art Reprograms the World* (New York: Lukas and Sternberg, 2002); see also in this context his book *The Radicant* (New York: Sternberg Press, 2009) and his catalog *Altermodern* (London: Tate, 2009).

5 See Christoph Menke and Juliane Rebentisch, eds., *Kreation und Depression: Freiheit im gegenwärtigen Kapitalismus* (*Creation and Depression: Freedom in Contemporary Capitalism*) (Berlin: Kadmos Kulturverlag, 2011), with contributions, among others, by Gilles Deleuze, Luc Boltanski, Eve Chiapello, Alain Ehrenberg, Axel Honneth, Diedrich Diederichsen, Tom Holert, Dieter Thomä, and Michael Makropoulos.

6 See George Kubler, *The Shape of Time: Remarks on the History of Things* (New Haven and London: Yale University Press, 1962).

7 Georges Didi-Huberman explains that the artist usually produces a model from clay or wax, the so-called *modello*, which practitioners have mentioned since the end of the Middle Ages, and which Giorgio Vasari, among others, explicated in the sixteenth century. Generally, a casting mold (a *forma*, as referred to by the Italian term), from which an arbitrary number of positive casts can be produced, is fabricated. The original model is in most cases lost in this process. See Didi-Huberman, *Ähnlichkeit und Berührung: Archäologie, Anachronismus und Modernität des Abdrucks* (Cologne: DuMont, 1999).

8 *Candida Höfer. Zwölf—Twelve, Douze.* Exh. cat. trans. from French to German by Claudia Schinkievicz; trans. from French to English by Brian Holmes (Munich: Schirmer/Mosel, 2001).

9 Martina Dobbe, *Fotografie als theoretisches Objekt. Bildwissenschaft, Medienästhetik, Kunstgeschichte* (Munich: Fink Verlag, 2007), note 8, 26.

10 Philippe Dubois, *Der photographische Akt. Versuch über ein theoretisches Dispositiv* (Hamburg: Philo Fine Arts, 1998).

11 See Jean-Pierre Criqui, "Umgekehrte Ruinen. Einführung zu Robert Smithsons Fahrt zu den Monumenten von Passaic," *trivium. Deutsch-französische Zeitschrift für Geistes- und Sozialwissenschaften* 1 (2008): 2–15, at 6, http://trivium.revues.org/364 (accessed March 11, 2017), first published as "Ruines à l'envers. Introduction à la visite des monuments de Passaic par Robert Smithson," in *Cahiers du Musée*

national d'art moderne 43 (Spring 1993), and also in Jean-Pierre Criqui, *Un trou dans la vie. Essais sur l'art depuis 1960* (Paris: Desclée de Brouwer, 2002).

12 The concept of the *dispositif* or apparatus employed here embraces the "heterogeneous set that includes virtually anything, linguistic and nonlinguistic," which applies to photography and sculpture in this discursive context. As Giorgio Agamben says, the technical preconditions, the institutional relationships, the discourses and the "network that is established between these elements" are all vital. See Giorgio Agamben, *What Is an Apparatus? And Other Essays*, translated by David Kishik and Stefan Pedatella (Stanford: Stanford University Press, 2009), 2–3. The essay was first published 2006 in Italian under the title "Che cos'è un dispositivo?"

13 "'Influence' is a curse of art criticism primarily because of its wrong-headed grammatical prejudice about who is the agent and who is the patient: it seems to reverse the active/passive relation which the historical actor experiences and the inferential beholder will wish to take into account. If one says that X influenced Y it does seem that one is saying that X did something to Y rather than that Y did something to X. But in the consideration of good pictures and painters the second is always the more lively reality. […] If we think of Y rather than X as the agent, the vocabulary is much richer and more attractively diversified: draw on, resort to, avail oneself of, appropriate from, have recourse to, adapt, misunderstand, refer to, pick up, take on, engage with, react to, quote, differentiate oneself from, assimilate oneself to, assimilate, align oneself with, copy, address, paraphrase, absorb, make a variation on, revive, continue, remodel, ape, emulate, travesty, parody, extract from, distort, attend to, resist, simplify, reconstitute, elaborate on, develop, face up to, master, subvert, perpetuate, reduce, promote, respond to, transform, tackle […]—everyone will be able to think of others. […] To think in terms of influence blunts thought by impoverishing the means of differentiation." Michael Baxandall, *Patterns of Intention: On the Historical Explanation of Pictures* (New Haven: Yale University Press, 1987), 18–19.

14 Mieke Bal theorizes the effect of historically later artworks on earlier ones. See Mieke Bal, *Quoting Carravaggio: Contemporary Art, Preposterous History* (Chicago: University of Chicago Press, 2011). For a better understanding of this phenomenon, it is important to overcome the postmodern parasitic conversion from original to copy.

15 Jacques Derrida refers to the phantoms of Communism. See Jacques Derrida, *Spectres du Marx* (Paris: Éditions Galilée, 1993), translated by Peggy Kamuf as *Specters of Marx: The State of the Debt, the Work of Mourning, and the New International* (London: Routledge, 1994).

16 See Han, *Shanzhai*, 8.

Cordula Grewe

Appropriation and Epigonality: A Romantic Narrative

> You get an idea and think, that's great, but after a certain time you realize that precisely this idea has been chewed on for a long time already. When I was in school, I was constantly frustrated because all that I did was somehow derivative. Therefore, when I began with copying works at hand, I understood this path as a kind of resistance against such frustrations. I can cease to be original.[1]

With these words, Sherrie Levine categorically postulates the impossibility of realizing one-self—and thus one's self—outside or beyond a quotation. To copy becomes an escape from the burning feeling of belatedness by seizing on that very belatedness, and this escape opens up to an unexpected free space, a space in which authenticity emerges from the conscious embrace of its lack. Self-fulfillment is experienced in the willful staging of one's own belatedness. "My intention is not to copy an artwork, but to experience it."[2] In the act of citing, Sherrie Levine comes into herself.

From the perspective of German Romanticism and, in particular, the Nazarene movement, Sherrie Levine's articulation of a "postmodern" subject position sounds uncannily familiar.[3] Levine finds herself by confiscating the form of another, and this method approximates, although with different means and greater absoluteness, the Nazarene inhabitation of chosen models and supraindividual entities. Johann Friedrich Overbeck and Peter Cornelius's collaborative double portrait exemplifies this paradoxical fusion of self-surrender and self-assertion (Fig. 21).[4] The large sheet collapses the notion of the genius's individuality by creating a perfect unity of two different hands, each artist drawing the other in a manner perfectly his own and yet indistinguishably collective. At the same time, it articulates the two Nazarenes' identity—as men, as friends, as artists—in the shape of Raphael's self-portrait with Perugino from the *School of Athens* (Fig. 22). The self is created in the image of the other.

Harold Bloom once defined the situation of the modern artist, so brutally expelled from tradition, as a Psychomachia in which the anxiety of influence leads to a psychological warfare against father figures and rival siblings.[5] Appropriation, whether "postmodern" or Romantic, does not elicit this response, or at least not in any straightforward way. In the case of the Nazarenes, the burden of the past is countered by building fellowship on the acknowledgment of modern art's belated and artificial character. The original, made available as copy and memory, remains active in an art that, as the Left Hegelian Friedrich Theodor Vischer

Figure 21. Johann Friedrich Overbeck and Peter Cornelius, *Double Portrait*, 1812, pencil on paper, 16¾ × 14⅝ in. (42.4 × 37 cm). Private collection, Munich (artwork in the public domain; photograph by Engelbert Seehuber).

Figure 22. Claude Marie François Dien, *Raphael's Self-Portrait and Portrait of Perugino from the School of Athens*, ca. 1810, etching and engraving, 13¾ × 10⅛ in. (35 × 25.8 cm). The Philadelphia Museum of Art (artwork in the public domain; photograph provided by The Philadelphia Museum of Art / Art Resource, NY).

so aptly stated, "turns back upon itself and makes itself into its own object." Emulation turns into appropriation as art becomes "an act of reflection."[6]

For Vischer, the point of appropriation is not copyright-infringing mechanical reproduction. Rather, appropriation denotes a kind of memory structure. The knowledge of the original remains active in an ongoing process of reflection and self-reflection, a spectral image that activates a *musée imaginaire*, or imaginary museum, necessary to access the interpictorial, dialogic nature of modern production. Instead of complete resemblance to or unmitigated enhancement of the emulated model, a marking occurs that exposes the seams between old and new, between model and reworking.[7] In this process, autonomy and originality are suspended and integrated into an aesthetic of reproducibility.

The visual economy of Nazarene art, with its roots in a culture of reproducibility, challenged older systems of original, replica, copy, and reproduction. With the ideal of the living artwork in mind, the Nazarenes envisioned the reintegration of art and life in a form best described as a *Gesamtkunstwerk*, or total artwork. The vastness of this ambition generated a discrepancy between project and realization and, in turn, a rupture of the temporal logic

governing traditional production patterns. Drawing, cartoon, fresco, painting, and print interacted at different and diverse stages, with reproductive prints (made after cartoons or drawings) often preceding, if not altogether replacing, the actual work. Even where the original is accessed, copying tends to rely on memory instead of immediate study. Art is *Gedankenkunst*, or an art of the concept, whose avant-garde elements spring precisely from the acknowledgment that something dead is resurrected through entirely conscious, insistently artificial appropriation.

Undoubtedly, the analogies drawn here between 1800 and 2000 are provocative. However, they are vital. They allow us to build more sophisticated frameworks for understanding historicism's modern qualities while reviving—and making available for art history—a term whose initial theoretical power all too quickly fell prey to an unfavorable reception: the concept of epigonality. It gained currency through the 1836 novel *The Epigones: Family Memoirs in Nine Volumes*, by Karl Leberecht Immermann, lawyer, poet, and theater reformer. He refined the Nazarene paradox of modern creativity (being simultaneously autonomous and heteronymous, highly original, and fiercely secondhand) by giving the new phenomenon of serial reproduction an entirely positive assessment as an utterly novel means of exercising command over art.[8] Immermann's theory of epigonality embraced the significant role of the burgeoning free-market economy as the ground for serial reproduction and the circulation of objects (whether unique or copies). Together, he claimed, these technical and economic innovations serve as the determinative mechanisms of epigonal forms of creation. "We are epigones, and carry the burden that tends to cling to every late-born generation of inheritors. The great movement in the realm of the spirit that our fathers undertook from out of their huts and hovels has supplied us with a heap of treasures, which now lie spread on every market stall."[9] Of these, we read that "every art, in its particular manifestation, is a historical manifestation."[10] The breach with tradition, which is the basis for Romanticism's historical revival, becomes here the structural principle of modern creativity. True imitation in its proper, unmediated sense is not possible, since we can no longer see with the eyes of the ancients. The tradition handed down from them must always be appropriated anew, and at a distance.

In this context, the installation of the original in a museum context emerged as a vital means of setting in motion the process of appropriation that interested Immermann, since the museum functions as a pictorial repository in anticipation of future acts of appropriation. For instance, with the German Neoclassicist Asmus Jakob Carstens in mind, Immermann had hoped for a rapid circulation of this art in the form of reproductive prints (Figs. 23 and 24). Carstens's work was particularly conducive to this approach because the artist himself—equally admired by Johann Wolfgang Goethe and the Nazarenes as the ultimate "German Roman"—had already replaced the direct study of antiquity with a procedure of memorization.[11] Accordingly, Immermann saw in Carstens the prototypical epigone, who, having "renounced the fame of all properly original production," must be honored as "the most brilliant and sensitive of after-thinkers, after-feelers [*Nach-Denker, Nach-Fühler*]."

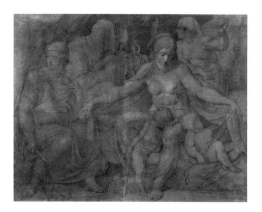

Figure 23. Asmus Jakob Carstens, *Night and Her Children Sleep and Death*, 1795, black chalk with white highlights, 28¾ x 37 in. (73 × 94 cm). Klassik Stiftung Weimar, Museums, KK 568 (artwork in the public domain).

Figure 24. Julius Thaeter after Asmus Jakob Carstens, *Night and Her Children Sleep and Death*, 1839, engraving, 9¾ x 12¾ in. (24.7 × 32.4 cm). Lübecker Museen, Museum Behnhaus Drägerhaus (artwork in the public domain; photograph © Museum Behnhaus Drägerhaus Lübeck, Grafische Sammlung).

Carstens, who had died in 1798, emerges here as a pioneer of that "brilliant appropriation"—that "*geniale Aneignung*"—that developed from a conscious rejection of eighteenth-century notions of genius and originality.[12]

Immermann's notion of epigonality, however, differs from that of the Nazarenes in one crucial point. With Immermann, self-formation always proceeds *from the appropriation of form*.[13] In other words, there is no identity-founding authority outside of the material—whether outside of the artwork or outside of the text. The Nazarenes, by contrast, always conceived of the stylistic citation *with reference to an external absolute*. In this sense, the cited motif or stylistic copy is arbitrary only up to a point.

Juxtaposed with Sherrie Levine's citational act, the Romantic historicism of the Nazarenes and Immermann's theories of writing stand out sharply for the modernity of their understanding of allegory—or, perhaps one ought to say, for their understanding of modernity *as* allegory. Allegory presumes that the signifier is always already dismembered, fragmented, anamorphized, lifeless, and torn from its context. The Nazarenes knew this, as would Walter Benjamin a century later.[14] And they reacted by seeking, in a Utopian fashion, to offset their suffering over this fundamental condition of modernity by inscribing the materiality of the artwork with a gesture toward the transcendence that lies at the back of it. Immermann's epigonality as artistic practice radicalizes Romanticism's allegorical citationality. Providing a secular alternative to Nazarene appropriation, it thus establishes an important bridge to practices of the twentieth and twenty-first centuries. In the act of citing, Immermann can cease to be original. Embracing epigonality, he comes into himself.

Notes

All translations are by Adam Eaker and me.

1 Sherrie Levine, "Sherrie Levine im Gespräch mit Noemi Smolik: 'Meine Absicht ist es nicht, ein Kunstwerk zu kopieren, sondern es zu erfahren,'" *Kunstforum International* 125 (1994): 287–91, at 288.

2 Ibid.

3 The ideas mapped out in this essay are part of a larger argument about Romanticism and early forms of conceptual art practices as made in my book, Cordula Grewe, *The Nazarenes: Romantic Avant-Garde and the Art of the Concept* (University Park: Pennsylvania State University Press, 2015), in particular in chapters 9–11: "Appropriation," 175–85; "Objectified Subjectivity," 187–207; and "Emulation and Epigonality," 209–25.

4 See Cordula Grewe, "Re-enchantment as Artistic Practice: Strategies of Emulation in German Romantic Art and Theory," *New German Critique* 94 (2005): 36–72.

5 Ibid. For Harold Bloom, see *The Anxiety of Influence: A Theory of Poetry*, 2nd ed. (Oxford: Oxford University Press, 1997); as well as *Kabbalah and Criticism* (New York: Seabury Press, 1975), esp. 63, 104; furthermore, see Louis A. Renza, "Influence," in *Critical Terms for Literary Study*, eds. Frank Lentricchia and Thomas McLaughlin (Chicago: University of Chicago Press, 1990), 186–202, esp. 192.

6 Friedrich Theodor Vischer, "Overbeck's Triumph of Religion (1841)," in *Art in Theory, 1815–1900: An Anthology of Changing Ideas*, eds. Charles Harrison, Paul Wood, and Jason Gaiger (Malden: Blackwell, 1998), 196–99, at 197.

7 See Cordula Grewe, "Historicism and the Symbolic Imagination in Nazarene Art," *Art Bulletin* 89, no. 1 (March 2007): 82–107.

8 The original title of Immermann's novel is *Die Epigonen: Familienmemoiren in neun Bänden*; see Karl Leberecht Immermann, *Die Epigonen: Familienmemoiren in neun Büchern 1823–1835; Nach der Erstausgabe von 1836 mit Dokumenten zur Entstehungs- und Rezeptionsgeschichte, Textvarianten, Kommentar, Zeittafel und Nachwort*, ed. Peter Hasubek (Munich: Winkler, 1981). My analysis was inspired by the brilliant study by Markus Fauser, *Intertextualität als Poetik des Epigonalen* (Munich: W. Fink, 1999). Having quickly gained currency, Immermann's concept of epigonality was equally quickly reduced to a mere synonym for the uncreative imitator. This is reductionist, as Immermann's "author" is always Kantian "genius" and Barthesian "scriptor" at once.

9 Immermann, *Die Epigonen*, 118.

10 Ibid., 28.

11 See here the pivotal studies by Werner Busch, such as his essay "Der sentimentalische Klassizismus bei Carstens, Koch und Genelli," in *Kunst als Bedeutungsträger: Gedenkschrift für Günter Bandmann*, eds. Werner Busch, Reiner Haussherr, and Eduard Trier (Berlin: Gebrüder Mann, 1977), 317–43; and Robert Rosenblum, for example, *The International Style of 1800: A Study in Linear Abstraction* (New York: Garland Publications, 1976).

12 Immermann, *Die Epigonen*, 81.

13 Ibid., 37–38.

14 Burkhardt Lindner, "Allegorie," in *Benjamins Begriffe*, eds. Michael Opitz and Erdmut Wizisla, 2 vols. (Frankfurt: Suhrkamp, 2000), vol. 1, 50–94, at 67.

Daniel Heller-Roazen

The Poet and the Bandits

In 1890, there appeared in the *Mémoires de la Société Linguistique de Paris* an article by the 23-year-old Marcel Schwob, who had yet to publish the works in poetry and in prose for which he would one day be known. The essay was a study of a medieval manuscript belonging to the Archives of Dijon, which contained a legal dossier, drawn from the records of the Burgundian capital, concerning a company of bandits arrested, tried, and condemned in the year 1455. The deeds of which the wrongdoers were accused seem, at first glance, unremarkable in themselves. The authorities alleged that, in Dijon and the neighboring countryside, the vagabonds had committed various acts of violent depredation: picking and breaking locks, plundering coffers, holding up hapless travelers on their way, robbing unsuspecting merchants who, for lack of funds, shared rooms in inns. It was said that some of the idlers were skilled in the arts of petty cheats and swindlers; it was claimed that others would not hesitate to murder when it might bring them profit. There was no doubt that the company of rogues possessed no wealth of its own. But, poverty being the mother of invention, the brigands had devised an ingenious technique, which enabled them to appropriate one medium that they and their countrymen otherwise possessed in common. This fact lent their many crimes some originality. For before seizing any precious things from the burgers, clerics, and aristocrats among whom they lived, the fifteenth-century Burgundian bandits had taken hold of the language. They made of the common speech of their time "an exquisite language," as the city authorities related, "which other people cannot understand [*un langaige exquis, que aultres gens ne scevent entendre*]."[1]

"Exquisite" must be taken in this setting in the etymological sense, signifying a thing literally *recherché*, the verb *exquerre* meaning "to seek out," and by extension, in its past participial form, "noteworthy," "refined," "cultivated." For this reason, the legal authorities also referred to the bandits' idiom as a "jargon [*jargon*]." That medieval word and its related forms had long designated not so much meaningful speech as the making of idle sounds resembling it: animal noises, babble, prattle, or chatter.[2] Yet, the language of the bandits was anything but idle. If one believes the municipal authorities, it served a single criminal purpose: to obscure the illicit acts they plotted, which they dared not reveal to all. Among the papers relating to the trial, the manuscript contained, therefore, a detailed description of the many expressions the vagabonds had used. These were, by and large, words that speakers of Middle French would have recognized; but the bandits had given to them new and unexpected meanings, which none but they could understand.

68

Schwob was quick to grasp the significance of the documents he published. They bore witness to the first recorded example of a criminal argot. Starting with the end of the Middle Ages, similar jargons began to proliferate. English thieves' cant, German *Rotwelsch*, Spanish *germanía*, Italian *furbesco*, Portuguese *calão*, were, in this sense, variations on a theme first recorded in fifteenth-century France: that of the distortion that a clear and common tongue could suffer when appropriated by a company of malefactors. The discourse of the bandits tried in Dijon, however, was important for another reason, and Schwob knew it well. François Villon, perhaps the greatest poet of the later Middle Ages, had himself composed at least six ballads in an impenetrable variety of Middle French that his contemporaries called "jargon." The affinities between the language of those poems and the idiom of the bandits, while troubling, were unmistakable. It seemed as if the poet, for reasons that remained unclear, had resolved to make the bandits' speech his own.

In 1489, publishing the first printed edition of Villon's works, Pierre Levet chose to separate the "ballads in jargon" from the poet's other compositions. That they were addressed to criminals, albeit of different kinds and specialties, could not be doubted. The second, in particular, opened with an explicit apostrophe to the very brigands tried in Dijon: *Coquillars enruans à Ruel…* (*Coquillars, rushing to Ruel…*).[3] Yet, the status of the discourse of the poems was the subject of considerable debate. Certain readers took the language of the ballads to be an evocation of an idiom Villon himself had heard. Others held it to be a bizarre invention, "some imagining of the poet," as one critic argued in 1888, "rather than the unique monument of a vanished language."[4] Schwob's findings resolved that question, for he produced a philological demonstration that the idiom of Villon's jargon poems was precisely that of the fifteenth-century vagabonds. Schwob showed that twenty-four of the obscure terms in the poems had been noted and glossed in the Burgundian proceedings. "These words," Schwob commented, bringing his proof by numbers to a higher sum, "being repeated many times, form a total of fifty-eight terms, with respect to which, from now on, the discussion can concern only matters of nuance and etymology, their meanings having been established."[5]

There now emerged, however, one fundamental question, which no documentary evidence, on its own, could resolve. Schwob had unearthed the oldest known criminal argot, and he had demonstrated that it quickly became the medium of a poet's work. The marriage of the arts of the poet and the bandits could not have been more rapid. Yet, what sense might one give to it? One could consider the meeting of poetry and jargon to have been as unique as Villon's oeuvre, the expression of a biography or vocation, or both. Perhaps it was no more than a fortuitous and unlikely occurrence, which brought one artificial language into proximity, if not unity, with another. One may, however, also reason otherwise, if at the risk of seeking a truth where there is only chance. Could there be some hidden link between the two varieties of hermetic speech, which makes of verse a kind of idlers' talk, or jargon a species of poetry? It is difficult to avoid posing this question, even if Schwob, for his part, seems to have done exactly that. Because of his scholarly method or his writer's craft, or because few more years would be left to him, Schwob declined to draw out the consequences of the discovery he made. Today, over a century later, they remain, therefore, still to be unfolded.

Notes

1 Marcel Schwob, "Le Jargon des Coquillards en 1455," *Mémoires de la Société Linguistique de Paris*, June, 1890, 168–83, 296–320, reprinted in Schwob, *Études sur l'argot français* (Paris: Éditions Allia, 2004), 61–150, at 83.

2 See, for example, Frédéric Godefroy, *Dictionnaire de l'ancienne langue française et tous ses dialectes du IX au XV siècle*, 10 vols. (Paris: F. Viewig, 1881–1902), vol. 4, 636; Adolf Tober and Erhard Lommatzsch, *Altfranzösisches Wörterbuch* (Wiesbaden: Franz Steiner, 1960), vol. 4, 1586.

3 François Villon, *Poésies complètes*, ed. Claude Thiry (Paris: Librairie Générale Française, 1991), 327.

4 Quoted in Marcel Schwob, "François Villon et les compagnons de la Coquille" (lecture, Académie des Inscriptions, April 2, 1890), reprinted in Schwob, *François Villon* (Paris: Éditions Allia, 2008), 25–35, at 34. Cf. Lucien Schöne, *Le Jargon et jobelin de Maistre François Villon, suivi de Jargon au théâtre* (Paris: Alphonse Lemerre, 1888), 22.

5 Schwob, *François Villon*, 29–30.

An Ethics of Appropriation

That "appropriate" is one iteration of a panoply of terms associated with art—copy, dupli-cate, emulate, homage, imitate, influence, mimesis, mimic, mirror, plagiarize, quote, reflect, repeat, replicate, represent, reproduce, simulate—attests to the subtleties, complexities, lon-gevity, and ubiquity of the idea of repetition and imitation in thinking about what art is. Ancient myths about the origins of art locate it in acts of appropriation. In Australian In-digenous art, the longest continuous tradition of art making, replication or appropriation of ancestral designs is a founding aesthetic principle. No doubt the first art resulted from an act of appropriation. The modernist notion of originality and its taboo on imitation is but a brief aberration in this story of art, whereas the postmodern cliché that the original lies beyond our grasp and the copy remains our only ontological source is business as usual.

The currency of the idea of appropriation emerged mainly from the well-named post-modernist art movement appropriation art, which continued conceptualism's critique of modernism's reification of style as an index of subjectivity and originality. This moment of appropriation art may have passed, but aesthetic appropriation has not diminished. Even the postcolonial repudiation of appropriation as identity theft has been merely rhetorical, since postcolonial artists have been its most avid practitioners. This is because, as Homi Bhabha famously argued in 1984, colonial mimicry is both a gesture of subservience and a type of camouflage or ruse that discloses the ambivalence of colonial discourse in order to disrupt its authority. Thus, despite criticism at the time of modernism's appropriations of Indigenous art, many postcolonial artists employed the aesthetic procedures of appropria-tion as the most apposite means of deconstructing colonial discourses. Gordon Bennett, Australia's most accomplished postcolonial artist, is exemplary in this respect, confirm-ing better than any artist I know Bhabha's claim that mimicry is at once resemblance and menace.

Bennett first became widely known through his appropriations of a quintessential and early practitioner of appropriation art, the Sydney-based Imants Tillers. Bennett also ap-propriated work by artists that Tillers favored, such as Georg Baselitz and Colin McCahon. If Tillers was the object of Bennett's menacing eye, he was also an apt model, as Tillers had long been alert to the decolonizing tactics of appropriation. He first adopted its doubling procedures in the mid-1970s in response to Terry Smith's analysis of American cultural imperialism in his 1974 article "The Provincialism Problem," published in *Artforum*. Con-vinced that Australian artists could never be avant-garde because they felt compelled to

Figure 25. Imants Tillers, *The Philosopher's Walk*, 2009, acrylic and gouache on 99 canvas boards, no. 84647 – 84745, 7 ft. 4¼ in. × 12 ft. ⅛ in. (223.5 × 366 cm). Collection of the artist (artwork © Imants Tillers).

mimic those of New York, Smith maintained that the more the provinces sought the secret of art in the center, the more they became enslaved in a second-degree culture, condemned to always be a step behind. This sense of being caught in an eternal delay experienced in peripheral places like Australia would soon become the postmodern condition felt by New York appropriation artists.

In arguing that the provincial copy is always betrayed by an ineradicable difference, Smith preempted Bhabha's thesis that the mimicry forced by the center on its provinces by the logic of imperialism is an effective strategy of colonial power. Tillers further preempted Bhabha in identifying the subversive potential of mimicry. His blatant appropriations of artworks by well-known contemporary artists such as Baselitz (whom he continues to appropriate, seen, for example, in *The Philosopher's Walk,* Fig. 25), which by 1984 had earned some fame for him in New York, re-presented the original as an echo from the periphery, thus troubling the inherent narcissism of the center and its claims of originality.

A kind of echo, "appropriate" is one of those words that is pregnant with its opposite. On the one hand, it means to steal or take something for one's own purpose (in this case, "appropriate" and "misappropriate" mean the same thing), and on the other, it means something that is fitting or proper. Well aware of this, Tillers transformed his provincial resistance into

Figure 26. Gordon Bennett, *Notes to Basquiat: Lone Rider*, 2001, acrylic on linen, 59⅞ × 71⅞ in. (152 × 182.5 cm). Private collection (artwork © Estate of Gordon Bennett: photograph by John O'Brien).

a metaphysical system that he persists with to this day. His appropriations are not just a ruse to trouble power but also the deliberate renunciation of power (be it the power of the original, the author's ego, or the ideology of the center) so that being will appear. Here, we are reminded that the copy, rather than the original, is the ontological source. In this latter respect, his appropriations make a claim for the metaphysical function of art. They recall the Neoclassical pedagogy of imitating the classical masters, in which the copying of classical artworks was a means to possess (or be possessed by) the spirit of these artists, thereby receiving their legacy. Aesthetic agency is gained by being an agent of another, which is an age-old idea. Tillers's art positions appropriation art as an ethical gesture, rather than merely a subversive one.

If the appropriated copy is a destabilizing and consequently subversive recontextualization of the original, it is at the same time, as Rex Butler has argued, a testament to the

original's lasting power. Appropriation is like sex: a means by which the original repro-
duces through another. It can also be described as a form of translation, a way of ex-
changing knowledge or of brokering difference. Following this line of thought, we can
say that the appropriation art of Tillers and, I would add, Bennett (each, by the way, has
appropriated the other), exemplifies Paul Ricoeur's phenomenological hermeneutics in
which meaning is neither predetermined by the original nor overdetermined by its re-
working but disclosed through an exchange or conversation between both parties (that is,
the original and the copy). In this conception, appropriation is a playful mimicry in which
subjects exchange identities—as, for example, Bennett did with Jean-Michel Basquiat in a
series of works between the late 1990s and early 2000s (Fig. 26). Bennett's series, with the
generic title Notes to Basquiat, testifies that appropriation is not just a simple colonizing
gesture but also something dialogic and complex. Despite their very real differences as
artists, the appropriations of Bennett and Tillers are a fugue or dance in which each (as
copyist) falls into step with an otherwise elusive other (the original). Being or meaning,
denied a fixed origin or address, is here condemned to temporality (or delay), an eternal
becoming (via the original's endless returning) in which the other or unknown is a key
player. Appropriation is how we feel the pulse of the other. To mirror the other, it would
seem, is to make art.

<div style="border:1px solid">Saloni Mathur</div>

The Dialectics of Appropriation: Reflections on a Changing World

A dialectical and rather vertiginous concept, appropriation opens doors onto other problems for art history, without much of a sense of arrival or resolution. In the arena of culture and representation, part of the difficulty with appropriation is its connection to the notion of property that stands at its heart. Appropriation is thus typically defined as an act of possession within or between cultures, or, more precisely, an act of unauthorized possession—a taking without asking, a repossession of sorts. The problems tend to reveal themselves immediately—or rather, they catch us in a web of entanglements. For example, acts of appropriation work to confront and undermine art history's conceptions of originality and authorship, the way in which we value the origin of a thing, the way we seek a single source for its creation, when we know that the artistic process is based in a relentless ravaging of preexisting forms. Appropriation also gives rise to the crisis of authenticity, in the sense that acts of appropriation threaten the claims to purity and originality that, for all our efforts at deconstruction, continue to determine (indeed, over-determine) the valuation of works of art. To add to this complexity, an essential ambiguity hangs over appropriation, raising the question: Is it a good thing or a bad thing, that is, should its productive aspects—subversion, creative inhabitation, reinvention, and innovation—be understood as outweighing some of its more rivalrous modes, such as violation, co-optation, distortion, and theft? Appropriation as a semiotic gesture can mean so many kinds of interactions across culture that the question of ethics is never far away. Significantly, our sociolegal bureaucracies have produced all manners of methods and systems—patents, trademarks, copyrights, permissions, fair-use laws, the commons, and so on—to control and delimit the promiscuous acts of commingling that define the basic process we understand as appropriation.

Although appropriation in art history is often connected to postmodern practice and to the theoretical discussions in contemporary art that proliferated during the 1980s and 1990s, it has reverberated somewhat differently in my area of research, which is modern and contemporary South Asian art. In fact, colonial and postcolonial societies in general can be conceived as great theaters of appropriation where the tensions, dilemmas, and revolutionary forces resulting from the appropriative acts of all participants on the stage have been played out in the most dramatic of ways. This is because the asymmetry of the colonial encounter—the primary act of unauthorized possession, if you like—produced a staggering exercise in the dialectics of appropriation in which all aspects of culture became

implicated. Every act of representation, countered by subversion, rebuttal, imitation, and repossession, became what Frantz Fanon once described as yet "another bone of contention in the grandiose battle."[1] Viewed through these lenses, appropriation as a cultural gesture appears less instrumental than it does in other contexts. Its force is felt across the entire field of human knowledge; its salience is not isolable to aesthetic practices or formal innovations; and it is never neutral, but always political. To me, the fraught history of modernity in South Asia is unthinkable without the dialectical perspective that the concept of appropriation affords.

If one thing is clear, it is that there are multiple paradigms for understanding appropriation, many of them relevant to the practice of art history: for example, the idea has been central to understanding strategies of pastiche and quotation in contemporary art, accounts of hybridity and mimesis in colonial and postcolonial society, and debates around repatriation and cultural property within museology, as well as Foucauldian conceptions of power and historiography. However, this leads me to an uncomfortable question: Does appropriation somehow *belong* to these discussions that emerged during the 1980s and 1990s, to postmodernism, poststructuralism, postcolonialism, and deconstruction? Has the concept reached a theoretical impasse or lost its edge as an analytical tool? If so, how can the idea be productively reengaged to serve the needs and concerns of our present time?

In his *Critical Terms for Art History*, Robert Nelson cautioned against too broad a concept of appropriation, suggesting that when taken too far, the idea of appropriation becomes a "theoretical Pac-Man about to gobble up all other theoretical terms and methods and thus to be rendered analytically useless."[2] An alternative approach, based in the advantage of hindsight and a wide-angle view of appropriation's theoretical repercussions in the past three decades, might point to the need to broaden the concept, to stretch it expansively across contemporary culture, to recuperate its dialectical strength, and to enliven it with the enormous challenge of the most recent dynamics of global interaction. Put differently, if appropriation is linked to changing conceptions of ownership in society, then what is the new paradigm of ownership and consumption that defines the globalizing, interdependent, and technologically interconnected world that we inhabit today? How might the concept of appropriation come to serve the unique frisson of global interaction in the twenty-first century? These questions, at once political and aesthetic, require a reassessment of appropriation's imprint on culture, increasingly comparative engagements, and a willingness to refrain from seeking the final word on the topic of appropriation any time soon.

Notes

1 Frantz Fanon, "Algeria Unveiled," in *A Dying Colonialism* (New York: Grove Press, 1959), 36.
2 Robert S. Nelson and Richard Shiff, eds., *Critical Terms for Art History* (Chicago: University of Chicago Press, 2003), 165.

On Appropriation

All art is grounded to a greater or lesser degree on appropriation. While we might attempt to forget all precedent, we cannot forget the attempt to forget: come what may, history lingers, both disenchanted and reenchanted. Georg Wilhelm Friedrich Hegel saw this as the core problem with romantic art, noting that

> for this reason, the artist relates to his content in its totality in much the same way as a playwright displays and sets out before us other persons unknown to us. He also adds, of course, his own genius and interweaves his own materials, but only at the level of the general or the entirely arbitrary; the more detailed individualization, in contrast, does not stem from him, for in this respect he needs his stock of images, styles of composition, and earlier art forms, which are a matter of complete indifference to him for their own sakes, and only become important to him when they appear to be just right for this or that subject.[1]

Hegel was writing in the 1830s, but his references to the reuse of earlier art forms, to dramatic representations of historical images, to eclectic adoption strategies, and, above all, to an essential indifference to the source material as such, makes his account oddly prescient to the modernist enterprise of appropriation, from Georges Braque and Marcel Duchamp to Andy Warhol, Jeff Koons, and Sherrie Levine.

The word "appropriation" derives from the Latin *appropriare*, which translates as "to make one's own." There is a dark side to this, however, as taking something for one's own use is typically done without the owner's permission. If appropriation itself carries this gentle tone of moral rebuke, what then of its antonym? Might it be that both appropriation and misappropriation carry negative connotations, much like Freud's much vaunted twins *heimlich* and *unheimlich*? While appropriation carries with it a whiff of impropriety, another linguistic pileup occurs when "proper" (from Latin *proprius*—"one's own, special") is understood, to cite one of its definitions in the *Oxford English Dictionary*, to mean "according to or respecting recognized social standards or conventions; respectable, especially excessively so." In the soft morality of the world of the correct and the proper, appropriation brings with it the power to shock, but usually within gentle confines. The predictable outrage with which Duchamp's urinal is greeted is about impropriety rather than shock, outrage, or any more powerful register of challenge. Blasphemous appropriation stirs stronger emotions, but only in the eyes of the believer.

Appropriation, however, entails more than passive transfer of the source image from one site of existence to another, even if the dislocation has the power to surprise or even shock. Both the source site and the new, neologistic one are modified in the process. The urinal is ennobled by its relocation into the art gallery and by its association with the cerebral, while the boundaries of art and of the gallery are expanded by the arrival of the clunky white ceramic ware, liberated from the toilet wall.

The process of appropriation, therefore, is akin to translation and can operate, like translation, in different ways. For translation can be interlingual—from one language to another; intermedial—from one medium to another; and intercultural—from one culture to another. In every case, when the object signified moves across language, medium, or culture, original meanings and restraints are loosened or shed entirely and the motif is emancipated, allowing it to take on whatever role it might fancy in the new context: profound, ironic, capricious, or downright idiotic.

Might translation theory offer a useful armature around which to theoretize appropriation? For it narrates the process of change from original to adopted state and allows us to follow the sequence of discursive constructs that enabled this process, framing the object's cultural biography. And this trajectory of change and reemployment can be traced both synchronically and diachronically against time, and also, as it travels, in the manner of a translated text, across space. Yet, as the motif is appropriated and reappropriated across cultures and over the centuries, adapting itself to new contexts and materialities, it retains an unmissable echo of its previous incarnations. And, like a translated text, the appropriated image or motif enjoys a complex relation with its source, reflecting both resemblance and difference, affirming or challenging the original model according to the transformative operations chosen by the artist. A leading voice in translation studies, Lawrence Venuti, explains:

> The interpretative force of a translation issues from the fact that the source text is not only decontextualized, but *re*contextualized. These two processes occur simultaneously, as soon as a text is chosen and the translator begins to render it. Translating rewrites a source text in terms that are intelligible and interesting to receptors, situating it in different patterns of language use, in different literary traditions, in different cultural values, in different social institutions, and often in a different historical moment.

And, as Venuti goes on to argue, the source text, in the process, "undergoes not only various degrees of formal and semantic loss, but also an exorbitant gain."[2]

To exemplify this process, one might turn to the realm of architecture and to Gottfried Semper's theory of *Stoffwechsel*, or material transformation, whereby the same motif is appropriated and reappropriated over the centuries, moving from simple materials and structures to new materials and more complex structures, while constantly maintaining a visible link to the archetypal form. Thus, the ropes and knots used to construct the primeval hut and the garlands used to decorate it survive over the aeons as architectural motifs that move

through material transformations: from cloth to wood, from wood to stone, or from stone to iron and steel. For the simple knot, this is the gain. But it is a gain predicated on the indifference of the translator or appropriator to the essential, even eidetic purity and incorruptibility of the original. This, of course, is the basis of Hegel's complaint.

Notes

1 G. W. F. Hegel, *Vorlesungen über die Ästhetik* (1835–38; Stuttgart: Reklam, 1971), 675, my translation. This quotation and the insights drawn from it have been "appropriated" from Peter Weibel, "Nachwort," in *Der aesthetische Imperativ* by Peter Sloterdijk, 2nd ed. (Hamburg: Phil & Philo Fine Arts/EVA Europäische Verlagsanstalt, 2007), 501–02.
2 Lawrence Venuti, "Ekphrasis, Translation, Critique," *Art in Translation* 2, no. 2 (July 2010): 138–39.

CONTINGENCY

Figure 27. Linda Connor, *Fireworks for the Virgin*, Peru, 2010, film-based photograph (artwork © Linda Connor).

Linda Connor

A Shot in the Dark

Contingency is not a word I use regularly. More often, it is Plan B or an expletive. When I think of contingency, I think of having to change course or having to figure out by the "seat of my pants." Contingency has given rise to some rather quaint expressions.

Being asked to write something on contingency for these pages, I have been researching the word, and more often than not, it comes along with the word "plan," as in "contingency plan." This pairing tends to be used in the context of structural thinking. However, I would like to approach contingency through its more attractive sister term, *creativity*, and the idea of possibility.

Anyone who has been practicing art for some time understands that creative thinking is less often bestowed by the "muse" than it is brought forth by frustration and the need to find alternative solutions. The notion still exists that art comes easily, and that creativity is just a kind of passive flow through certain talented people. The truth is, most creativity comes about by hitting one wall after another, and breaking through them.

When I think back to childhood and to my early attractions to art, they are always entangled with the difficulty I had in learning, especially learning to read. Much later, when I was diagnosed as dyslexic, it explained much. Dyslexia seemed to put up so many roadblocks to learning the things that interested me, whereas my ability to make and appreciate art seemed unimpeded. Music thrilled me, for instance, and I attempted to study both the piano and violin. Unfortunately, my inability to read extended beyond letters to include musical notes. The extent of my frustration was formidable. Having visual art as a means to be creative and to succeed at something gave me a path. With hindsight, I realize that the brain I was born with, and its ability to learn certain things, constituted my first major contingency, and that it led me to the gateway of the visual arts. I am so thankful for that.

As an artist, intuition and appreciation of the pictured have become my key strengths. I love photography, but camera equipment is merely the means of making my pictures. Unlike many photographers who use the equipment very technically, I use the 8 × 10 camera very simply and almost primitively. This is also why so many of my negatives are so technically variable, causing many failures. And then to make matters worse I have a tendency to shoot in the dark—dark cave, dark corner of monasteries—or in situations that are insane to consider with a view camera. It's a crapshoot, a wing and a prayer, a shot in the dark. Often I can't see to focus. I am, of course, hoping for the interjection of

83

fate, or of the good fairies, to allow the resulting image to radiate what I can feel but can hardly see.

In 2010, I was in a small town in Peru for a festival for the Virgin, the revered deity of the town. During the festival, the population swells from 5,000 to 20,000. It is a three-day 24-hour-a-day Felliniesque party, with processions and wall-to-wall people. To an outsider, utter chaos. On the final night, the town square crammed with people, a grand finale takes place with elaborate, whimsical three-story bamboo *castillos,* or castles of fireworks. Once these are lit, a chain reaction of explosions is set off, spinning and shooting sparks in every direction, until the whole structure burns to the ground. Suspecting what was coming, I staked out a position early in the evening on a balcony, where I set up my tripod and 4 × 5, hoping to get a good vantage point for the impending commotion. But by the time the fireworks began, it was extremely dark, crowded, and crazy. Mayhem. In a desperate attempt to capture something on film, I resorted to pointing the camera, using my lens cap as a shutter, and totally guessing my exposure time. As fate would have it, some of the photographs came out, and they were better than I could have wished.

As with my photography, in teaching I want lots of room to improvise. I am fortunate to be able to teach in an art school where the mix of talents and aptitudes seems to be more various than in most universities. I appreciate the unique personalities and the ways the students approach their desire to communicate visually and conceptually. Never is there only one answer. At the beginning of a course, neither the students nor I am sure where it will lead and what doors will open. Outlining too strict a plan at the beginning is bound to go awry; our path is defined by our progress, not through a plan. Many of the students who gravitate to an art school are visual learners. As a teacher, I design my courses to be visually rich. I have never taught a class where imagery wasn't the primary means through which to illuminate "ideas"; many of these are visual ideas, powerful structures that words often fail to approach.

My renowned teacher, Harry Callahan, would sometimes tap approvingly on a student's image and say, "Now that's a dumb picture." Remembering that term years later, it occurred to me that he was referring to the photograph's visual power, its dumbfoundedness. A photograph that is far better than any words or explanation, an image that is "indescribable." Real Praise!

Giovanna Borradori

Photographs Hold a Redemptive Power

The circulation of photographs of atrocities, especially atrocities perpetrated in the name of politics, has been a key strategy of modern humanitarian movements. From the campaign launched between 1880 and 1920 to stop King Leopold of Belgium from continuing to brutalize civilians in his personal colony, the Congo, to the recent campaign against torture at the American detention center of Abu Ghraib in Iraq, visual documentation of acts of cruelty seems to have literally forged our moral sensibility concerning human rights. More recently, the political force of such photographs reached a new zenith on the occasion of one of the most formidable public uprisings in modern history, the "Arab spring," which was literally set on fire by the viral dissemination of images documenting the self-immolation of 26-year-old Mohamed Bouazizi, a Tunisian street vendor. Why, I want to ask, are photographs so compelling? "Hunger looks like the man that hunger is killing," Eduardo Galeano wrote of one of the early photographs by Sebastião Salgado portraying a victim of famine in the Sahel. This fact is even more stunning given that we live in the age of Twitter, Facebook, and Photoshop, a time in which their falsification is at everyone's fingertips. In what sense, then, can photographs tell the truth?

At the height of the Weimar Republic, critic Walter Benjamin expressed both apprehension that the visual deluge would be the mark of an aestheticized and fundamentally passive society and an intense fascination for the revolutionary potential of photographs: for the beholder, he wrote, "feels an irresistible urge to search such a picture for the tiny spark of contingency, of the here and now, with which reality has (so to speak) seared the subject, to find the inconspicuous spot where in the immediacy of that long forgotten moment the future nests so eloquently that we, looking back, may rediscover it." Photographs, for Benjamin, are unique repositories of truth, but it is a truth that, while present, is not immediately visible. This is the truth of the very instant that "sears" the subject of the representation: the click of the camera. In this perspective, the photograph truthfully testifies to the reality of that unique instant, and it is this aspect of absolute contingency that attracts us so powerfully to it.

Benjamin's position on the truth that photographs tell circumvents more mainstream discussions surrounding the ethical import of photographs and other visual documentation of atrocities. From Susan Sontag to Roland Barthes, such debates have focused on the question of whether photography as a medium is able to tell the truth about what it represents and whether it is able to provide enough context to spur the viewer's critical engagement with its subject matter. In photojournalistic circles, similar questions have been raised with a slightly more concrete bent: Are there normative standards that regulate how photographers ought

to capture suffering? Should suffering be represented at all? Since photographs are ineluctably constructed, if only by the sensibility of the person who takes them, the ethical quandary of photojournalists has been formulated as whether it is possible to expose the pain of others without feeding on the public's thirst for sensationalist consumption. Or whether it is even possible not to aestheticize unimaginable pain, thus translating the private torment of a helpless victim of abuse into an aesthetic act aimed at self-expression.

Benjamin's focus on the temporal contingency of photographs makes it possible to move away from the representationalist standpoint that underlies all these debates, based on a crude conception of truth as correspondence between image and reality. In contrast, I wish to suggest that photographs of atrocity do not simply "represent" acts of cruelty but "perform" a moral imperative: they do not simply state reality as it is but constitute acts of protest, by saying that it should not be so and must be stopped. In the same way that the statement, "I now pronounce you man and wife" does not simply describe an event but enacts it, if uttered in the appropriate context (before two single people) and by the appropriate agent (a civic or religious authority), photographs of atrocity do not simply describe a state of affairs, which can be manipulated and falsified, but enact a response of moral indignation. If I am right, the truth about photographs of atrocity is, therefore, to be found not in their adherence to the facts on the ground, but rather in the moral disclosure they produce by dialectically engaging the dominant constructs of oppression and dehumanization that govern our ability to recognize atrocity at all. Said otherwise: a photograph that manages to be recognized as documentation of atrocity has already told all the moral truth it can possibly tell about what it is representing.

The problem with portraying atrocity is thus not so much that photographs are "dishonest" because they are irreducibly constructed, or that they run the risk of aestheticizing pain rather than critically engaging the viewer. The issue is that they may be engineered to induce a numbing of affect that allows the viewer to see the other as not fully real, or human, because it is either demonized or victimized to the extreme. Following Judith Butler's idea that others appear to us as truly living only if their lives are framed as vulnerable and contingent, namely, at the risk of being lost and thus grieved, I wish to claim that, on the one hand, images of suffering tap into our deepest level of moral motivations by revealing our vulnerability as contingent bodily subjects. On the other hand, these images are by definition the expression of a devastatingly oppressive social reality. Since, in a dialectical perspective, any adequate representation of social antagonism is a contradiction, these images should be read as contradictions that, by negation, disclose the system of domination and dehumanization in which they exist.

The legitimate boundaries of showing and seeing cruelty should allow the other to emerge not only as an autonomous and self-sovereign individual but also as a deeply contingent subject, who, precisely in her vulnerability to suffering, exposure to the ravages of time, and the always impending possibility of loss, finds her uniqueness and thus lays her claim to the future. In this respect, I agree with Benjamin that all photographs, but especially photographs of extreme human suffering, hold a redemptive power.

Marcia Brennan

Give Me a Kiss and Stay Connected: Reflections on Contingency in the Medical Humanities

At its root, contingency signifies a state of "touching together." According to the *Oxford English Dictionary*, the word descends etymologically from the prefix *con-*, which indicates the proximate positions of "with" or "together," and the root *tangĕre*: to touch. The topic of contingency thus provides a unique opportunity to reflect on our close contacts and resonant connections.

Since early 2009, it has been my privilege to serve as an Artist In Residence in the Department of Palliative Care and Rehabilitation Medicine at the University of Texas M. D. Anderson Cancer Center. In my "day job," I am an art historian at Rice University, where my research areas include modern and contemporary art history and museum studies, comparative religion and mysticism, and the emerging field of the medical humanities. In Houston, I have encountered extraordinary opportunities for transdisciplinary collaborations with the adjacent Museum District and the Texas Medical Center, exchanges that often transcend familiar institutional boundaries and established conceptual categories. The joke regarding these serendipitous contingencies is that "there is no zoning in Houston."

Despite their significant differences, each of these projects shares a common set of themes and challenges, namely: How do we find language to describe states of being for which there is no language? How do we represent the unrepresentable and translate the untranslatable? Notably, these questions pertain to theoretical discussions of abstract painting's simultaneously dissolving and crystallizing structures, to the contemplation of spiritual experience and mystical ecstasy, and to the very real challenges people face at the end of life. Thus, throughout all of my work, I am fascinated—and profoundly moved—by subjects and situations that repeatedly exceed our capacity to represent them, even as we repeatedly attempt to do so, often through imagery that conveys transitional states and transformational visions.

On the Palliative Care Unit, Artists In Residence furnish a context and contribute critical skills, so that people facing extraordinarily difficult life situations have an opportunity for personal and symbolic expression, which then becomes translated into visual and literary forms. As artists, we constantly confront the challenge of creating human connections across a formidable gulf of separation. Frequently, when we initially approach a patient, we are told that the work "sounds interesting, but I have no artistic ability." This invites us

to respond, "Well, let's just say for a moment that you *did* have artistic ability. What images would you want to paint or write?" Our question often inspires a flash of illumination, and the person goes on to share the image with us, frequently describing a scene that a visual artist will help realize pictorially, while I gently encourage the patient to talk and make notes to help crystallize his or her thoughts. Once the artwork is complete, I read the person's words back. The image and the narrative are then inscribed into a handmade paper journal, which the person can keep and share with his or her family, either as a medium for further creative expression or as a legacy gift that performs a memorial function. In this way, the portable microenvironment of the text represents a durable yet tender memory of this fragile moment in a person's life.

Handling Delicate Contingencies: "You Have to Be Gentle with Everything That You Touch"

One day on the ward, we encountered a young woman in the final stages of liver cancer. She told us that her mother, who had maintained a nearly constant vigil by her bedside, was having an extremely hard time accepting her daughter's imminent death, so she was continually "busy trying to be busy, trying to be a mother. Because she's scared, she's become ADHD. So I told her, 'Just give me a kiss. Just stay connected.'" This gifted young woman was herself a painter, a textile artist, and a vocal performer. During our last visit together she drew a butterfly with her own hands, both literally and symbolically. That is, she used the network of linear indentations threading through the palm of her left hand as a guide to model the patterns appearing on the butterfly's wings. She then made a miniature portrait of herself holding on to a slender thread that connected her diminutive, dangling figure to the butterfly's skyward flight. Looking first at the drawing and then back at us, she emphasized, "You have to be gentle with everything that you touch."

This woman's modest sketch is nothing if not monumental, as the drawing can be seen as an allegory of the power of art to visualize the fragile links between contingent states of being. Indeed, palliative medicine is an exceptional teacher of the nuances of contingency, imparting many vital lessons, including that there are no such things as small things, that seemingly marginal subjects can hold extraordinary meaning and value, that the relations between presence and absence are intimately intertwined in their mutually forming, informing, and unforming character, and that it is possible to see only beauty when there is nothing left to see.[1]

The Expanding Field of Our Contingencies

Recently, the crisis in the humanities has been the subject of much debate. One set of critical responses and interventions falls under the heading of the "Applied Humanities." While this term typically designates research in media studies and digital technologies, I believe that the concept could be productively expanded to encompass not only the medical humanities but also other practical areas, such as education, environmental concerns, and ethics and

human rights issues—in short, fields that could be substantially enriched by a rigorous engagement with the aesthetic and symbolic domains. While it is important to preserve the autonomy of art history's distinctive modes of inquiry, at the same time, our discipline's interpretive tools are suited for such collaborations with nontraditional subjects that engage the affective dimensions of aesthetics, while potentially expanding the reach of the humanities into difficult areas of modern life.

Finally, it may be helpful to offer some brief clarifications. Artists In Residence are not art therapists, and our clinical interactions represent an intervention rather than a therapy. Just as I am not proposing that art historians become art therapists, neither am I advocating that art history or any other humanistic discipline be placed in the service of an applied field, such as medicine. Rather, I am encouraging us to consider the unexpected ways in which creative transdisciplinary collaborations can foster exchanges that are mutually beneficial for all of the fields involved. My experiences in the medical humanities have provided invaluable insights into the ways in which existential trauma and human crises can be profoundly intertwined with vivid expressions of beauty, joy, gratitude, and love. Just as each encounter is unique, these complex subjects frequently become expressed through words and images that simultaneously evoke presence and absence, assertion and negation, and often their mutual transcendence within a single interpretive framework. It is my hope that these thoughts on contingency will inspire further reflections on what we can see, what we can know, and what we can offer when we touch and are touched by others.

Note

At M. D. Anderson, the Artist In Residence program is sponsored by COLLAGE: The Art for Cancer Network (http://www.collageartforcancer.org/home.htm), a nonprofit organization conceived and founded by Dr. Jennifer Wheler. Our work is facilitated by Dr. Eduardo Bruera, professor of medicine and F. T. McGraw Chair in the Treatment of Cancer. I am deeply grateful to them both for making our activities possible. I would also like to thank Leo Costello, Michael Leja, Lynn Randolph, and Dr. Paul Walker for their valuable insights and comments on this essay, and Karen Lang for her invitation to participate in this unique forum in *The Art Bulletin*.

1 These themes represent the subject of my book, Marcia Brennan, *Life at the End of Life: Finding Words Beyond Words* (Bristol: Intellect Books; Chicago: University of Chicago Press, 2017).

Mary Ann Doane

The Paradox of Contingency

The emergence of photographic and phonographic technologies in the nineteenth century seemed to make possible what had previously been beyond the grasp of representation— the inscription of contingency. Anything and everything in the order of materiality could be photographed, filmed, or recorded, particularly the unexpected, the sudden rupture of the fabric of existence. There is, of course, the well-known anecdote of the viewers of Louis Lumière's *Repas de bébé*, who were enthralled with the movement of leaves on trees in the background (pure contingency) rather than the ostensible subject of the film. The photographic medium provided the apparently perfect representation of contingency because it was indexical (as well as iconic), with an existential connection to its object. Its at least partial autonomy from human control was an assurance, a certification of the significance of chance in the production of images. I have argued elsewhere that modernity's fascination with chance and the ephemeral generated an obsession with the legibility of the contingent. This fixation on the representation of contingency embodied a utopian desire of resisting the rationalizing force of institutionalized and regularized time and affirming the play of chance and the stochastic.[1]

There is a strong history in which contingency has been viewed as markedly aesthetic. The artist, in a kind of empathic relation to his or her medium, through a contact or touch that is more than physical, encounters the contingencies of the medium, its resistance to intention but therefore its generous provision of the sudden, the unexpected significance. However, after photography, contingency migrated to the domain of the nonanthropological, the autonomous, that which registers without consciousness of registration. The epitome of such a technological relation to contingency is the surveillance camera, "unmanned," generating enormous amounts of footage that no one watches or may ever watch. And once it becomes subject to inspection, it is due to an imperative need to find significance, to transform the contingent into an "event," *après coup*. Here, as elsewhere in cinema, the frame becomes the privileged site of the contingent, since it marks the place where the transgression of its barrier is the precise contingency that produces visibility.

The paradox of photographic (or electronic) contingency, though, is that once registered, once fixed in representation, the contingent loses its contingency. Its relation to the supporting medium becomes a necessary one. This would be true of any form of representation, but since photography gives the impression of more effectively bearing the mark of contingency, the paradox seems more scandalous. The concept of contingency is very

90

complex and multifaceted. It is used to mean both chance—freedom from necessity, the fortuitous or unplanned—and dependence on something outside itself ("contingent on"). In this sense, contingency is not self-sufficient; it is neither true nor untrue. The *Oxford English Dictionary* traces definitions of contingency that range from "a chance occurrence; an event the occurrence of which could not have been, or was not, foreseen; an accident, a casualty," to "an event conceived or contemplated as of possible occurrence in the future," to "a thing or condition of things contingent or dependent upon an uncertain event."[2] Both unexpected and foreseen as a possibility, the various definitions all have in common the affinity of contingency with possibility and the negation of necessity. But what is most striking is the etymology of the word. Contingent is traced to the Latin "*con-* + *tangĕre*, to touch," hence "to touch together, come into contact." Contingency is linked etymologically with other words associated with touch: contact, contaminate, contiguous.[3]

Touching and happening are thus linguistically entangled here. Touch is the sense that is most strongly correlated with the real, while sight and hearing are always vulnerable to hallucination. Touch cannot be exercised at a distance. Contingency, outside of any design, plan, or intention, bears witness to a real whose very lack of predictability reinforces its reality. Perhaps it is this lust for the real in a society saturated with visual images that undergirds the desire to figure contingency, to stabilize it. Although photography is a visual medium, it is so by virtue of touch, contact. The light rays reflected from objects "touch" the film, leaving their imprint. And it is the viewer's knowledge of this technology that assures him/her of the authenticity of the photograph, of its "origin" in the real. Yet, it is not iconicity or resemblance that is at stake. Or meaning. It is, instead, the mark or trace of an existence. This is why the infatuation with re-presented contingency extends to other mechanical, electronic, and digital technologies of representation. The predilection of television for catastrophe is perhaps the epitome of the desire to capture contingency at the very moment of its happening, foregrounding the "liveness" that is television's special provenance. Most recently, this imperative has been assumed by mobile-phone video, accessible to almost anyone and present almost everywhere—providing evidence of moments when something happens, frequently political violence or excessive force on the part of police and the military. When all of these instances, from photography to cell-phone video, are more believable, the less technologically proficient they are. The shakiness of cameras, the fuzziness of images, the lack of sync of satellite communications, all these testify to the veracity of the representation, to its affinity with the contingent mark of the real. It is the noniconic, the nonfigural, the opaque aspects of the representation that, ironically, figure a grasp of contingency. Despite the reputed realism and mimesis of photographic, electronic, and digital imaging systems, it is the defectiveness of the image (or sound), its deficiencies, that constitute the confirmation of its contact with (touching of) the real, its collaboration with contingency. They mark its authenticity as a ratio of the difficulty of achieving a clearly readable image.

But if this is a "deficiency" of the image, in relation to what is it deficient? Certainly not to the real, which is not an image. Rather, its flaws emerge in comparison with the spectacular

perfection of the cinematic image, its technological and aesthetic sophistication. This is the "wrought" image that, in many respects and in collaboration with digital technology, seems to be moving further and further from indexicality and contingency (the pervasiveness of animation and of CGI). With respect to live television and mobile-phone video, however, contingency is legible in the failure or inadequacy of the media technologies. True—there must be "just enough" image for recognition. Yet, it is as though the noise of the machine played the more vital role, allowing the real to seep through and become momentarily accessible to a glimpse.

Notes

1 Mary Ann Doane, *The Emergence of Cinematic Time: Modernity, Contingency, the Archive* (Cambridge, MA: Harvard University Press, 2002).

2 *Oxford English Dictionary*, 2nd ed., 1989, s.v. "contingency"; online version, September 2011, s.v. "contingency," http://www.oed.com/view/Entry/40247 (accessed November 26, 2011). An earlier version of this definition was first published in *New English Dictionary*, 1893.

3 *Oxford English Dictionary*, 2nd ed. s.v. "contingent"; online version, s.v. "contingent," http://www.oed.com/view/Entry/40248 (accessed November 26, 2011). An earlier version of this etymology was first published in *New English Dictionary*, 1893.

Angus Fletcher

En blanc et noir

Intellectuals have nowadays before them a climate of thought and feeling that increasingly covers and even controls the field of global information, shrinking what should be the center of that field, namely, the human imagination. We have new trade winds blowing around the globe, following the spherical curves of our planet, flitting from one satellite to another, purveying almost uncontrollable quantities of data. The new digital diaspora treats migrants as countable data, while financial institutions take a leaf from the scientific book, using immensely sophisticated electronic transfers of what might or might not be called known facts, mostly in the form of numbers.

All this is familiar, but my aim here is to draw a troubled connection to the foundations of the arts. Because the issue is not easy to describe, *to occupy*, we might say, I am returning to a few central artistic concerns by making a limited inquiry into what might be called practical metaphysics.

The question is: What is it to see something "in black-and-white," or *en blanc et noir*? Our situation in the arts both fine and popular is defined by the overall contingency of the artist's creative situation, the artist's reliance on vanishing or unstable markets, on the whims of fashion, on all the dangerous detours practiced in the marketing world of buying and selling. The speed of contingent shifts is the unusual factor today. At any given moment there is so much data swirling around us that it produces a kind of vertigo, a dizzying crush of noise—exactly the opposite of its pretended (and supposedly always efficient) utility. Since, however, the arts minister to human wonder, they wage an undeclared war against pragmatic utility, where knowledge not caught and pinned as technical data is not considered a valid concern for human valuation, while more broadly—culturally and spiritually—the result is that common opinion no longer grasps what Oscar Wilde meant by announcing in his preface to *The Picture of Dorian Gray* that art is quite "useless," for him, as for the Dickens of *Hard Times*, an ironic term of highest praise. It was in Wilde's play *A Woman of No Importance* that Londoners perhaps first heard about the crass upwardly mobile inability to distinguish price from value. Underlying the matter of contingency then, as always, there is a basic question of values, those the artist is expected to ponder, not by philosophizing but by taking an action through imaginative discovery and thus shaping an aesthetic practice.

When not employing allegory, the artist always negotiates opposing attitudes and hence evades the dogmatic consistency of science and religion, both of which try to resolve or to accommodate contingent paradoxes. Do artists always break free of external conditions?

Surely not, but artistic genius refuses defeat at the hands of alien materialist forces. The burden of this note is that two aspects of contingency need to be distinguished: the *external*, material, causal contingencies of life are typically the scientist's natural forces, generations, or catastrophes, whereas the *internal* combinatorial and perceptual contingencies are mainly felt, and they concern the imaginative artist working his or her creations. In whatever mode or medium, artists encounter internal stresses and strains they themselves produce or discover acting *inside* the work of art, or rather, inside the *working* of the work of art. Whereas the force of gravity affects all masses in the universe, internal arrangements within each distinct artwork give rise to their own logic of combination, a living rhythm, and this is no less true of classical, than Romantic, styles.

Suppose an example taken from the use of color: Wassily Kandinsky argues that vital forces of color constrain the artist to meet the challenge of incoherent excess; similarly, Ludwig Wittgenstein's late epistemological notebook *On Colour* casts doubt on our human ability or desire to control for color constancy, however sophisticated our perceptual measurements. Better still, consider that documentary films appear to work far better in black-and-white than in color, as if all natural or artificial hues were a superadded distraction working against the plain truth of the matter. This documentary coldness might well be thought an artifact of circumstances like the extreme difficulty in the 1930s of getting "good color" from film stock or still-camera stock. But with the advent of digital photography, the same odd cognitive effect persists—data and documents need black-and-white. Color in nature apparently belongs to its bearers, even when those colored things are florid tropical birds and plants. Although black-and-white achromatic colors occur in nature, white and black in their pure physical form, defined by white light and its absence, continue to hold a strange place in our experience and our thoughts about whatever is *internally contingent*, in this case, exemplified by color combinations. Indeed, colors define internal contingencies.

Along with intermediate shades of gray, the two extremes of achromatic perception frame this definition, and in a scientific sense they *reduce* the rich excess of our common chromatic experience, with its plethora, by asserting a special sense of the visual world, a sense of perceptual austerity. When the great musical Impressionist Claude Debussy titled a late sonata for two pianos *En blanc et noir*, he implied such a leaner approach to harmony. This impassioned composition gets deliberately carried away ("*avec emportement*" is the composer's instruction for performing the first movement) through a paradoxical play of austerity. By deploying the halftones of the black versus white keys, Debussy rejected an overblown late Romantic sonority (as in César Franck), stripping away the schmaltz. He achieved pure design, musical fact, complex linearity of form. He achieved *en blanc et noir*.

When art turns thus to shape and line, giving up the extravagance of color, it limits the number of contingent forces stressing the forces *within* the artwork. Great line drawings have this power, attacking the outward contingencies, as it were, from within. This natural

minimalism might be thought to diminish the colorful quality of life, and yet the austere approach advances the artist's sense of shape, countering mere accumulations of data, but *that* excess our technology sadly seems unwilling to forgo.

If there is any external, even cosmic, contingency confronting the artist's creative quest, a quest *internal* to the artwork itself, it must surely be the vast increase in the complexity and numbers of "data" believed to be essential for controlling our destiny in a chaotic age. Our world is falling victim to the belief that more is not enough. Owing to that very circumstance, the artist's profession remains an essential defense against disorder and unreason.

Peter Geimer

Images and the Unforeseen

As a rule, art historians deal with meaning and sense. They reveal forgotten or hidden messages as they are embodied or articulated in pieces of art. Contingency is a challenge to this interpretative task. Contingency raises problems even when ambiguity or refusal of meaning is at stake (as in many writings on modern and contemporary art), since dealing with contingency undermines any concept of intentionality, creativity, or expression. In the case of photography, I would argue, contingency—in the sense of the *unforeseen* or the *unforeseeable*, of accidental coincidence and "useless" information—has been at work right from the beginning of the medium: not as deficiency or exceptional case but, exactly the contrary, as a positive condition of the medium. Of course, this might hold true for any kind of artistic production. Artists such as Marcel Duchamp, Jackson Pollock, or Sigmar Polke willingly accepted the break-in of chance in their work. But these concepts seem to get tangled up in a paradox: they are cases of "organized" contingency and planned irritation and as such they are, strictly speaking, not contingent. Contingency, in the sense I would like to stress here, is the quintessence of what *can not be produced*. It occurs. It has to happen as an unforeseen event, as Jacques Derrida has put it: "If something occurs that would have been possible, if it could have been predicted, then its occurrence would not be an event."[1]

In his *Pencil of Nature* (1843–44), William Henry Fox Talbot gave a precise description of one dimension of photographic contingency:

> It frequently happens [...]—and this is one of the charms of photography—that the operator himself discovers on examination, perhaps long afterwards, that he has depicted many things he had no notion of at the time. Sometimes inscriptions and dates are found upon the buildings, or printed placards most irrelevant, are discovered upon their walls: sometimes a distant dial-plate is seen, and upon it—unconsciously recorded—the hour of the day at which the view was taken.[2]

Indeed, photographers are only partly aware of what they are doing and the aesthetic or epistemic value of their pictures often depends precisely on this blind spot. Much about a photograph is calculable, foreseeable, and leaves open the potential for formal intervention. However, there is also a dimension of the unforeseen. A photograph is, in this respect, also an *occurrence*: something in the image *occurs* or something *falls into* the image.

Defining photography as a medium of registering vision is obviously not valid for all its manifestations and uses. Some photographic practices (such as the pictorialist, manual interventions, and printing process in which everything centers on the formation of a personal style) leave nothing to the contingent, whereas others derive their value from effects that cannot be planned or intentionally produced. Nothing is to be gained by playing these modes off against each other or trying to identify the "essence of photography" exclusively in one or the other extreme. Nonetheless, especially against the background of a tradition of interpretation that has developed its methods above all through the analysis of intentional, composed, artistic, and "meaningful" pictures, the question still remains: What place will the study of images concede to contingency, to the unforeseeable event, to that which is unsusceptible to being composed.

There is a second scenario of contingency in photography. It also touches the visual appearance of photographs but it is rooted in their material basis. Appearance and disappearance of photographs have always been closely related. The demons of representation emerged in the shape of blurs, dots, and fogs, disappearing images, all kind of alterations of color or perspective. In photographic journals and handbooks, they were addressed under many names: "accidents," "waste," "secondary image," "annoying disturbances," "mysterious phenomena," "accidental witchcraft," "disastrous effects," "parasites," or "enemies." In the early days of the medium, the original accident of photography was photography itself: the incident was light, and the accident was too much light that could not be stopped and spoiled the image. A whole set of precautionary measures concerned the photographic laboratory. In the following decades, every new photographic procedure produced its own specific accidents (and it would be interesting to ask whether the digital image really overcame this logic). As a rule, these unintended and "senseless" traces escape any historical narration. According to a common historiographical scheme, the history of photography has been an enterprise of permanent success. It went from long exposure times in early days to shutter speeds of times below one-thousandth of a second, from black-and-white to color, from the clumsy camera obscura to a whole bunch of specialized hand cameras. Of course, the photohistorical details given by these accounts are essential to any historical study of photography. But there is another story behind or beyond the teleological narrative of continuous progress. It takes place in black boxes and darkrooms, and the actors of this story are the material components of photography itself. The rising line of inventors and inventions has always been counterattacked by the invented itself.

In all these cases, photographers could make the experience of what Martin Heidegger called "the modes of conspicuousness, obtrusiveness, and obstinacy." These modes, Heidegger argues, appear when equipment loses its *readiness-to-hand*, or *Zuhandenheit*. "When we discover its unusability, the thing becomes conspicuous […]."[3] However, Heidegger adds, this conspicuousness of the unusable is no mode of mere deficiency. On the contrary, it is just in disturbing the assignment that equipment comes to the fore. With this in mind, we can say that it is in producing photographic noise that photography becomes explicit. The emergence of noise is no deficiency, no exceptional case of photography but, exactly the contrary,

its explicit manifestation. Given artistic and cultural-historical traditions of interpretation, which have above all trained their methods on intended, composed, and meaningful images, a notion of images that can also incorporate contingency, the unforeseen, and the uncomposed seems to be at stake. The investment of the photographer (or society) in the image is not a static category. It varies according to function, use, and context of photographs.

Notes

1 Jacques Derrida, "Une certaine possibilité impossible de dire l'événement," in Derrida, Gad Soussana, and Alexis Nouss, *Dire l'événement, est-ce possible?* (Paris: L'Harmattan, 2001), 96: "Ce qui arrive, comme événement, si c'était possible, si c'était prévisible, c'est que cela n'arrive pas." I thank Karen Lang for the translation.

2 William Henry Fox Talbot, *The Pencil of Nature* (London, 1843–44), n.p.

3 Martin Heidegger, *Being and Time: A Translation of "Sein und Zeit,"* trans. Joan Stambaugh (Albany: State University of New York Press, 1996), 69, 68 (sec. 16).

<div style="border:1px solid black; display:inline-block; padding:10px 40px;">

Mark Ledbury

</div>

Eternal Contingencies

Art historians live comfortably in the long penumbra of certain gloriously opaque intellectual structures, themselves contingently and hastily thrown up but mysteriously metamorphosed into eternal verities. One obvious example is this endlessly cited moment in Charles Baudelaire's whimsical, brilliant, but infuriating essay "The Painter of Modern Life":

> Modernity is the transient, the fleeting, the contingent; it is one half of art, the other being the eternal and the immovable.[1]

Baudelaire's actually rather rare and novel use of "le contingent" in French here as an adjectival noun, meaning those things having the quality of contingency, and his larger poetic but unsustainable oppositional structure have been absorbed by endless repetition into the canon of our received ideas despite the evident triteness of his opposition. No doubt, a powerful argument can be made for the contingent as specially privileged in the modern and contemporary—as Martha Buskirk, for example, has done in her recent book *The Contingent Object of Contemporary Art*.[2]

The curiosity of Baudelaire's passage lies, however, in the characterization of the "eternal and the immovable [*immuable*]" other half of art. Where, precisely, is this other half located? What art or quality or part of art (Beaudelaire does not say "beauty" here, or even seem to mean this) could be considered eternal, immutable? For generations of students introduced to this phrase, it has come to mean "all art produced before about 1863 […]," but of course, Baudelaire would have been fully aware that for centuries before him, artists and indeed critics were preoccupied with the very "interrupted," mutable nature of all artworks, their fragility and vulnerability to erasure, ruin, displacement, their utter transience. Scholars of iconoclasms of various stripes never stop reminding us of art's enduring vulnerability and lack of durability.[3] The transience and mutability of artworks are equally recognized as a viable topic of scholarly inquiry.[4] Modernity, then, has no monopoly over the contingent: wherever specialists look, the eternal and the immutable is thin on the ground.

My own preoccupation has been with the extraordinarily varied narrative of the history of Neoclassicism in France. To be sure, immutable ideals of beauty, the fantasy of eternal verities, the pull of posterity dominated its rhetoric. However, the more fine-grained our knowledge and understanding of its key protagonists and their artworks, the stranger and more compelling that narrative becomes. From Jean-Baptiste Greuze's self-destructive

Figure 28. Anne-Louis Girodet de Roussy-Trioson, *Endymion: Moon Effect, or The Sleep of Endymion*, 1793, oil on canvas, 77.9 × 102.7 in. (198 × 261 cm), Musée du Louvre, Paris (artwork in the public domain; photograph © Mark Ledbury).

Septimius Severus and Caracalla through Pierre Peyron's absent-present *Socrates*, François-Guillaume Menageot's gouty *Meléagre*, Anne-Louis Girodet's oily *Endymion* (Fig. 28), the French strain of Neoclassicism is shot through with accident, contingency, impermanence, transience, not to mention eccentricity.[5] This was even before the Revolution made contingency the order of the day, and Jacques-Louis David gave us example after example of what philosophers will forgive me for calling "necessary contingency," from *Marat at His Last Breath* to the mutilated *Distribution of the Eagle Standards*.

Indeed, it is my contention that compelling history painting is always aware of the gravitational forces of contingency tugging it from its lofty heights. Certainly, among this generation, the precariousness not just of history painting but of all painting was acknowledged openly. Witness the report submitted on the condition of Raphael's so-called *Vierge de Foligno* by François-André Vincent, Nicolas-Antoine Taunay, and the scientists Louis-Bernard

Guyton and Claude-Louis Berthollet in 1801. They begin their detailed history of the "restoration" (in fact, the multiple and complex changes to the painting and its support) with the frank admission of painting's vulnerability:

> Painting is at a great disadvantage with respect to posterity: Other products of genius can survive across the centuries; but she [painting] confides her creations to perishable canvas. Sun, humidity, the fetid vapors to which they are exposed by neglect, even unwitting negligence when they were first prepared, all this puts masterpieces under imminent threat of irrecoverable loss.[6]

Never mind war and revolution—what hope is there for painting, scuppered from the start by its creators, and further destroyed by the very error-prone humanity of its patrons and audiences? Sculpture, too, and ancient architecture, for that matter, though fantasized by Winckelmann and others as a perfect, eternal "whole," was experienced by this generation as ruin or fragment, or as displaced, transmuted, damaged metonymy.

The late Richard Rorty began his controversial and passionate account of contingency precisely at that point when "The French Revolution had shown that the whole spectrum of social institutions could be replaced almost overnight."[7] Rorty's philosophical account of contingent selfhood identifies a key tension, which has always been useful to me as a place from which to investigate history painting: "the quarrel between poetry and philosophy, the tension between an effort to achieve self-creation by the recognition of contingency and an effort to achieve universality by the transcendence of contingency."[8] This, for me, describes neatly some key knots and tensions of every complex work of art, the struggle with contingency, and it makes possible a way out of the seductive binary that has led us to consider contingency the product and even the genetic marker of modernity.

As is well known, Rorty's *Contingency, Irony and Solidarity* is in thrall to the idea of the "Strong Poet" who can acknowledge and appropriate all contingencies, including his own; indeed, this strong poet is the role model for Rorty's ideal liberal polity.[9] As art historians, we, too, have been too ready to be seduced by the idea of the "strong poet," in the guise of the rich, dense artist who is miraculously self-aware, mastering the contingent and fashioning it for universal political or cultural purpose. Can we not make room to explore strong contingency, a force beyond appropriation, a force of plans "gang aft agley," of truly unknown and unknowable unknowns? Certainly, in my own scholarship, to even begin to chart the fortunes of the Neoclassical generation is to appreciate both the force and unpredictability of contingency in the making of lives, works, and careers.

To end where I started, with Baudelaire. Three lines up from the passage quoted above, he throws away this line:

> David, having chosen subjects Greek or Roman, could not do otherwise than present them in the style of Antiquity.[10]

Surely, the very opposite is true. Between David and "the style of antiquity" lay the gulf of history and of contingency; whether he ever really thought it could be bridged remains a matter of speculation, but we can say that David's artwork, and his vision of antiquity, was constantly compelled and jostled by the uncertainties of his present. Rather than conclude from this that David is *modern*, can we not instead concede that contingency is one of art's constants?

Notes

1 Charles Baudelaire, "The Painter of Modern Life," in *Baudelaire: Selected Writings on Art and Artists*, trans. P. E. Charvet (Cambridge: Cambridge University Press, 1981), 403.

2 Martha Buskirk, *The Contingent Object of Contemporary Art* (Cambridge, MA: MIT Press, 2003), esp. 311–60.

3 Bruno Latour and Peter Weibel, *Iconoclash: Beyond the Image Wars in Science, Religion and Art* (Cambridge, MA: MIT Press, 2002); and Dario Gamboni, *The Destruction of Art: Iconoclasm and Vandalism since the French Revolution* (London: Reaktion Books, 2007).

4 See, for example, the work of Jennifer Roberts, especially "Copley's Cargo: *Boy with a Squirrel* and the Dilemma of Transit," *American Art* 21, no. 2 (Summer 2007): 20–41.

5 On the *Septimius*, see Musée Greuze, *Greuze et l'affaire du Septime Sévère* (Paris: Somogy, 2005); on Peyron's Socrates, see Claudia Einecke, *Final Moments: Peyron, David, and "The Death of Socrates"* (Omaha: Joslyn Art Museum, 2001); on Menageot, see Nicole Willk-Brocard, *François-Guillaume Ménageot (1744–1816): Peintre d'histoire, directeur de l'Académie de France à Rome* (Paris: Arthéna, 1978) and for Girodet's misadventures with olive oil, see Sylvain Bellanger, ed., *Girodet: 1767–1824*, exh. cat. (Paris: Gallimard/Musée du Louvre Éditions, 2005), 206–15.

6 Rapport à l'Institut National sur la Restauration du Tableau de Raphael connu sous le nom de La Vierge de Foligno par les citoyens Guyton, Vincent Taunay et Barthollet, reprinted in J.-D. Passavant, *Raphael d'Urbin et son père, Giovanni Santi*, ed. Paul Lacroix (Paris: Renouard, 1860), vol. 2, 622–23 (my translation).

7 Richard Rorty, *Contingency, Irony, and Solidarity* (Cambridge: Cambridge University Press, 1989), 3.

8 Ibid., 25.

9 Ibid., 53.

10 Baudelaire, "The Painter of Modern Life," 403.

<div style="border: 1px solid;">

Chris Spring

</div>

Out of the Blue: Two African Textile Contingencies

When I research any subject, the unexpected becomes more and more the norm, simply because my mind becomes more attuned to seeing things and making connections that otherwise might have passed me by. So it was that last year, while drinking in a bar on Fuerteventura in the Canary Islands, I went to answer the call of nature, and there on the door of the "Gents Room" was the unmistakable image of King Glèlè (1858–98) of Dahomey (today the Republic of Benin) in the guise of a number of gods, or *vodun*, of the Fon people, including the warrior Daghesu and the androgynous, one-legged creator god Mawu-Lisa (Fig. 29). It is an image that is familiar to me from the magnificent nineteenth-century appliqué banner in the British Museum's collections showing King Glèlè in divine aspect, holding the sun in one hand and the moon in the other (Fig. 30). I could only assume that this modern image, pared down to a simple outline, was created by one of the many migrants from Benin and other West African countries who are now desperately seeking a way into Europe through the Spanish territory of the Canaries, many of them perishing in the attempt, in a sad inversion of the infamous Middle Passage of the slave trade, which carried African gods and religious practices to the Caribbean and the Americas, including the Fon pantheon, which today may be found among the syncretic Voodoo cults of Haiti. For me, deeply involved in working on a book about African textiles, it represented a textile story that poignantly illustrated the global phenomenon of African textiles.

Ten years earlier, my work at the British Museum took me to Tanzania, ostensibly to research divination and spirit healing, though quite unexpectedly it also took me down a path of research into the printed textile traditions of eastern and southern Africa, which have been a growing interest of mine ever since. I had been told (by a senior colleague of mine at the British Museum who should have known better) that there are no significant textile traditions to speak of in this region of Africa, so it came as quite a surprise, on my first morning in Dar es Salaam, to find myself in the midst of arguably the largest and most dynamic textile tradition in Africa. Of course, what my learned colleague meant when he referred to "textile traditions" are the handwoven, locally produced cloths, often intended for use only on certain special occasions and requiring a high level of manual skill in their production. So I deliberately set out to find a pair of *kangas* (printed cotton cloths with images and slogans that are sold in pairs and later cut and hemmed by Swahili women) in the local market that least conformed to my colleague's notion of an "African textile." My eye was immediately drawn to a design of blue and red circles, a bit like a Damien Hirst spot painting,

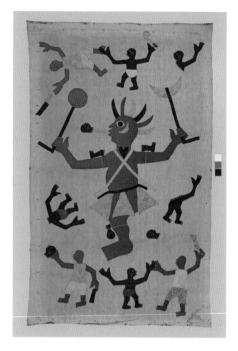

Figure 29. Image of King Glèlè, Fuerteventura, Canary Islands, 2011 (artwork in the public domain; photograph © Chris Spring).

Figure 30. Appliqué banner showing King Glèlè in divine aspect, Kingdom of Dahomey (Republic of Benin), 19th century. The British Museum, London, 1982 Af23.1 (artwork in the public domain; photograph © The Trustees of the British Museum).

contained within a simple border of black lines (Fig. 31). Factory-printed in India and wrapped in cellophane, the cloth was considerably cheaper than some of the other *kangas* on sale, which I later discovered were locally printed in Tanzania. I showed my purchase to my friend David Nyahongo,* who was working with me; in common with all *kangas* it had an inscription in Kiswahili printed immediately below the central design: "HUJUI KITU." "What does that mean, David?" "You know nothing," he answered smiling. "I know I know nothing, but what does it mean?" "You know nothing—that's what it means!" David went on to tell me that it was a design and inscription often worn by older women as a rebuff to their younger and cocksure rivals, and from that point I began to realize why this textile tradition was so popular, so significant, so extraordinary, and so "African."

Next day, on the road to Bagamoyo, I saw a woman wearing "HUJUI KITU," and it struck me that the textile's message could apply equally as well to me and to my learned colleague from the British Museum as it could to the women for whom it was intended; if "you know nothing," you may begin to learn something, whereas if you think you know everything, you will never learn anything. Bagamoyo has been fought over by many

Figure 31. *Kanga* with the printed legend "Hujui Kitu" (You know nothing), Tanzania, 2002, printed cotton. The British Museum, London, Af2002,09.4 (artwork in the public domain; photograph © The Trustees of the British Museum).

people, not least British, German, and Arab invaders; it is also a place where witchcraft and supernatural activity is unusually powerful, precisely because so many people have passed through the town over the centuries—or so the *mganga*, or spirit healer, Bibi Akili Ubwani* told me when I met her in the bush a short drive outside the town. It just so happened that I was in Bagamoyo at the same time as the Bibi and her associates, who had been summoned from the southern province of Mtwara to deal with cases of witchcraft and possession that the local *mganga* was powerless to prevent. It also happened to be the month of Ramadan, which meant that, as the Bibi and her assistants were Muslim, the exorcism they were to perform, which involved the consumption of various substances, had to be undertaken after dark. Once again, I had come ostensibly to study divination and spirit healing but, fascinating as the unexpected opportunity to record the exorcism undoubtedly was, the costumes worn by the Bibi and her team fascinated me even more (Fig. 32). She herself wore a style, pattern, and color of *kanga* that I have never seen since, specially imported from the Masood Textile Mills in Faisalabad, Pakistan, and undoubtedly signifying her status as an *mganga* with extraordinary powers.

Figure 32. Bibi Akili Ubwani and her assistants, Bagamoyo, Tanzania, 2002; David is on the left, holding my witchcraft-sensitive camera (photograph © Chris Spring).

Her associates, men and women, wore military-style "uniforms" of red, black, and white cloth, which she described thus: "Red and white are the colors of the *mganga*; black was used by our ancestors when they were performing this profession—they had no access to other colors—and so some of us wear black out of respect for and in memory of them."

Out of all the hours of film that I shot on that field trip, the only time the camera jammed was during the minute or so that the Bibi was working her magic that night. Perhaps it was her way of saying I should pay more attention to the *mganga* and less to the *kanga*, though it was one contingency for which there can be no provision.

*These are pseudonyms.

DETAIL

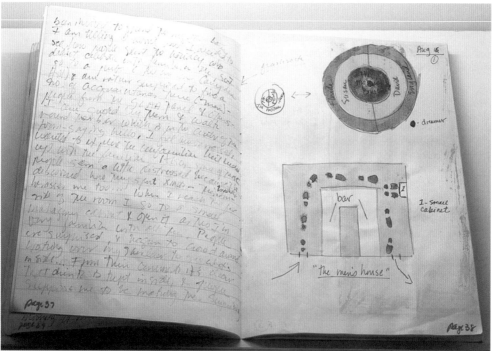

Figure 33. Susan Hiller, Two Dream notebooks by participants in *Dream Mapping*, 1974, a three-night event for seven dreamers, Hartley-Wintney, England (photograph courtesy of the artist and Lisson Gallery, London).

Susan Hiller

Dream Art

We spend about one-third of our life sleeping, mostly dreaming. We share the experience of dreaming with all mammals and perhaps other creatures and life forms, too. Our dreaming self is organized on a different principle from our waking self and is just as much a part of us. In dreams, we are completely honest with ourselves, but the series of fluctuating images we use to express our thoughts and feelings is unstable and ungraspable. The dream self uses what the philosopher Erich Fromm called "the forgotten language." We think in pictures and we think differently, combining and recombining details in a creative way, putting ideas and emotions together as complex symbols. When we wake up, the dream experience is transformed into what William Shakespeare called "words, words, words." Waking consciousness has no way of retrieving all the details of the dream because words can never be the exact equivalent of images. Words fail us. So the richness of our dream experience is lost when we try to capture it. But retrieving something, even a fragment, is better than not retrieving anything. Thinking about dreaming may immerse you in a vortex of philosophical paradoxes, enigmas, and conundrums that challenge fixed, conventional notions of "self" and "reality."

At the beginning of the twentieth century, Sigmund Freud published a book that brought the subterranean, aquatic underworld of dreams up to the surface of consciousness for everyone to see. In English, this astonishing book is usually called *The Interpretation of Dreams*, but in fact the original German title would be more accurately translated as *An Attempt at Grasping for a Deeper Understanding of Dreams*. The original title draws attention to an important process of "making-sense-of," which is provisional and always in flux, rather than proposing a single authoritative interpretation.

Enthusiastic interest in dreams (and in the closely related states of ecstasy, trance, hallucination, and waking reverie) comes and goes in Western literary and visual culture. Fascination with dreaming, mysticism, and spirituality has always been followed by periods of reaction. In recent years, reductive models of the human mind, in combination with some versions of Conceptualism and some theories of postmodernism, seem to have driven most of contemporary art out of the depths. Personal investigations of inner psychic states by artists has been relegated to the margins of critical thought, while the principles of psychoanalysis have been misused in advertising and politics to construct all of us as passive consumers. Recent neurophysiological research is radically deconstructing not only common sense notions of dreaming but also philosophical theories of mind, psychological

and psychoanalytic concepts of consciousness, and anthropological ideas of cultural relativity. Yet, the scientific account of dreaming is at odds with the details of what we feel "really" happens when we dream.

At the same time, what amounts to an uncritical obsession with the paradoxical nature of dreaming and related states of awareness permeates the mass media in comic books, television, film, and computer games. This popular resurgence of interest in states of altered consciousness is accompanied by thoughtful, more questioning work by an emergent generation of artists who are creating bridges, elastic locations where we can communicate with one another about the reality of certain specific sorts of insights. Such works revitalize connections to the unconscious details that are present in every aspect of our lives by giving them visible form in the collective social world.

In 2000, I curated and organized a touring exhibition called *Dream Machines*, presenting artists whose work derives from their experience of dreaming and related states of mind, those unstable zones where the visual merges with the visionary. Some of the works I selected for the exhibition proposed the possibility of shifting the viewer's consciousness through visual means to induce revelation, sudden multilevel insights, visions. Other pieces offered routes to unusual states of awareness by playing with words and breaking up language so that signifiers float free of their signified. Others documented the subjective experiences of artists who had used themselves as guinea pigs or initiators of psychological experiments. And some of the works were ironic, even cynical, regarding the entire realm of the irrational. I see the exhibition as part of a conversation that has been going on for centuries.

Remembering and reintegrating dreamed material into my sense of myself, operating from the perspective of dreams, is an abiding interest of mine. I often say that as an artist, I'm committed to dealing with ghosts—overlooked, discarded, fragmentary details—focusing on situations, ideas, and experiences that haunt us collectively.

In this spirit, I've produced several works that approach dreams and dreaming in a variety of ways. In 1974, I made *Dream Mapping* with a group of collaborators. I was and remain interested in figuring out how to capture something of dreams not as narratives or pictures but as diagrammatic or symbolic triggers that provoke detailed recollection and suggest the special way that time and space flow and warp and overlap in our dreams. I was and remain interested in how the dreams of individuals coincide.

More than twenty years after *Dream Mapping*, an invitation from the Dia Foundation in New York to experiment with the then still rather new medium of the Internet gave me the opportunity to make a multimedia interactive piece called *Dream Screens*. By that time, I was committed to an approach that allowed the possibility—or even *provoked* the possibility—of recognizing those unconscious details that are part of every aspect of our lives and that haunt our society because collectively we refuse to enter into dialogue with them. Underlying *Dream Screens* was my awareness of the extent that film and television have affected our dreams and the kinds of images we report seeing in dreams. The formal structure of *Dream Screens* is like a spider's web, in reference to the World Wide Web, which in turn

refers to the world of rhizome connections, the hidden pathways, and routes that connect us unconsciously to each other.

Keeping a dream notebook, thinking about dreams, and making art that incorporates as far as possible insights not incompatible with what I've learned in the process convince me that we benefit from reconnecting with the details of our forgotten language. Focusing on what could be called "the problems of translation" brings into visibility something politically urgent—the importance of developing a real sense of connection to ourselves and, through that, to other people, to the past, and to the realities of the social order and the consequences of history. We humans have achieved remarkable things through using our waking consciousness; these achievements have been at great cost and have failed to unify us as a species. We are separated from one another in every conceivable way. At the risk of idealizing an intrinsic human nature, it seems to me that retrieving, translating, and sharing the details of our "forgotten language" provides access to the understanding that, like other animals, we have a common awareness of what is real and an instinctive knowledge of what is good for us and what isn't.

Spike Bucklow

Material Details—Artists' Pigments

Details about the materials in works of art are often dealt with in a summary fashion (such as "oil on canvas") or are overlooked. Yet, without the artist's materials, a patron's wishes would come to nothing. Materials—whether relatively homogeneous, like clay, or extremely heterogeneous, like television screens—are the physical foundation for all visual and plastic arts, the substrate for all color and imagery. For millennia, knowledge of materials was the ground on which all artists built, and it was acquired by hands-on experience through extended periods of apprenticeship.

Loss of the master–apprentice relationships in painters' studios reduced Sir Joshua Reynolds to dissecting old master paintings in a vain attempt to discover how his predecessors achieved their effects. But as artists' attention shifted away from their materials, some outside the studio became increasingly interested in them; by the mid-twentieth century, conservation scientists were having slightly more success than Reynolds in their investigation of old masters. However, the scientists' methods and motivations were different from Reynolds's, and the results of their endeavors can seem clinical and forensic—dry in themselves, perhaps of interest for the purposes of attribution. Modern science has created a new web of material associations—including isotope ratios in lead pigments and growth rings in oak panels—that would have been unnoticed or considered irrelevant by the artist but that now allow trading links to be established and paintings to be dated, among other results.

Yet, focusing on material details can provide a starting point for reconstructing the original artist's lost web of material connections. *The Art Bulletin* has published essays that treat artists' materials in a manner that is far from clinical or forensic. For example, Fabio Barry has excavated layers of meaning from marble floors, and Michael Cole has shown how casting bronze can contribute significance to sculpture.[1] These pioneering works demonstrate that raw materials and material processes can yield profound insights into both the artist's studio and the finished product.

Today, marble floors and bronze statues are perceived as such, even when the original understanding of their materials is overlooked. But when looking at a medieval or Renaissance painting, the modern viewer probably sees a blue passage as the Virgin's robe, the sea, or the sky. They do not see a ground-up, purified rock imported from Afghanistan (Fig. 34).

I would suggest that the Virgin's robe and the processed rock were perceived simultaneously by contemporary viewers because, for them, visual representations were not

Figure 34. Lapis lazuli, rough stone, length approx. 2 in. (5 cm) (photograph © Spike Bucklow).

habitually divorced from their material vehicles, as they have become for us. Premodern artists' materials were connected to their host cultures by complex associations every bit as intricate and nuanced as iconographic associations. And some now-forgotten material details would have been considered extremely important by the artist and his or her contemporaries, since the values associated with works of art emerged from both visual images and physical materials.

Once materials are identified in works of art—such as lapis lazuli in the Virgin's robe—connections can be made and significance recovered. Historical patterns of use are not restricted to issues of provenance, trade, and the economics of luxury. They also involve issues of function, identity, and cosmology. Lapis lazuli may have come from Afghanistan, and the processed pigment may have cost as much as gold, but the stone and powder had medicinal uses and their reflected light touched the beholder's soul. Lapis lazuli was believed to facilitate the answering of prayers. Indeed, it was the physiological, psychological, and spiritual interaction between the material and privileged individuals—explicated in cosmological terms—that accounted for the rock's economic value and its journey from a central Asian mountain to a European painting. Yet, cultural significance was not restricted to luxury materials or the specialist processes associated with them. Biblical imagery, for example, draws on gold, silver, and the refining process, but it also evokes wheat, chaff and agrarian skills that harness the wind.

The master–apprentice relationship was a remarkably stable means of transmitting practical and cosmological knowledge about materials. The material aspects of artworks therefore furnish continuity through developing traditions to the extent that some pigments endured on painters' palettes for millennia, and Classical authorities are acknowledged in seventeenth-century painters' manuals. Up to the seventeenth century, artists' manuals had an empirical side, but they also had a cosmological side, like the bestiaries, herbals, and lapidaries that served as sources. Although the vast majority of artists left no record of their

Figure 35. "Pictures Painted with Mummies" and "Artists Colours Made from Egyptians Buried 5,000 Years Ago." *London Illustrated Mail*, October 17, 1903, detail (photograph © Chris Titmus, by kind permission of the Syndics of the Fitzwilliam Museum, University of Cambridge).

thoughts about materials, market forces and the stability of inherently conservative craft practices make it possible to interpret the material aspects of artworks by reference to popular texts. After all, rich patrons specified lapis lazuli rather than an identical-looking but much cheaper blue pigment because those who beheld the image knew the properties of many artists' materials; much premodern cosmology was a commonplace, not specialist knowledge.[2]

Post-seventeenth-century artists worked under the influence of the Enlightenment, industrialization, and increasingly determinist (scientific) and imperialist (political) world-views. These shifts had direct impact on materials in the studio, increasing the number of available pigments and changing artists' relations with them. Of course, individual artists' responses to the world outside the workshop varied, but, whether embraced or rejected, a work of art's material nature inevitably reflects the culture in which it was created.

Today's attitudes toward artists' materials differ radically from even those of the nineteenth century, when international government-sponsored competitions were held to encourage development of a synthetic alternative to lapis lazuli (French ultramarine) and when human remains were plundered and ground up to make brown paint (Fig. 35). Archaeologists and anthropologists have long engaged with the material details of cultural artifacts. My own "work in the field" aims to facilitate engagement with material details in the history of art.

Notes

1 Fabio Barry, "Walking on Water," *Art Bulletin* 89, no. 4 (2007): 627–56; and Michael Cole, "Cellini's Blood," *Art Bulletin* 81, no. 2 (1999): 215–35. See also Byron Ellsworth Hamann, "The Mirrors of Las Meninas: Cochineal, Silver, and Clay," *Art Bulletin* 92, nos. 1–2 (2010): 6–35.

2 Spike Bucklow, *The Alchemy of Paint* (London: Marion Boyars, 2009).

Johannes Endres

Goethe on Myron's Cow: A Detail

Detail is a relational term, and the whole is its closest relative. An offspring of an antecedent unit, the detail's justification was long rooted in a principle other than itself. The detail was conceived and conceptualized as the particular, the minor, the marginal, the remaining, or the typical, and thus neatly separated from but also tied back to its respective opposite: the general, the major, the central, the former, the type.[1] In such light, the detail always concerned both makers and beholders of works of art, even though its merely subordinate role for the bigger picture was hardly ever in doubt.[2] Characteristically, when the French term first appeared in the German language toward the end of the eighteenth century, it was in its plural form (as *Details*)—indicating that, first and foremost, one single detail by itself lacks significance.[3]

The emancipation of the detail from such subordination did not occur until the late nineteenth century.[4] With authors like Walter Benjamin, Aby Warburg, and Sigmund Freud, the detail entered the scene as an unprecedentedly prominent topic, gradually gaining autonomy from its various constraints. However radical and groundbreaking this paradigm shift might appear, its obvious connection to a concurring media shift is anything but coincidental. On the contrary, the new and exposed position the detail assumed in the works of Benjamin, Warburg, Freud (and others) emerges from a close—but also mediated—look at objects that were either *photographed* or *filmed*. The advent of the detail as a focal point of aesthetic and cultural attention therefore seems to be largely conditioned by new forms of technical reproduction.[5]

In the eighteenth century, the question of detail and its aptness and role in visual as well as textual media was already determined in principle. Gotthold Ephraim Lessing's essay *Laocoon*, for instance, states that the representation of detail can be an objective of the *visual* arts only, while in texts "spatial details" dissolve into a linear succession of signs in time—and consequentially evaporate.[6] Any text that focuses on the depiction of minutiae is therefore predestined to fail. Even nineteenth-century literary realism, in its programmatic sense, distanced itself from a mere portrayal of details, which was associated with painting; instead, authors strove to efficiently integrate the detail and merge it with a meaningful whole.

At a first glance, we find Johann Wolfgang von Goethe's use of "detail"—as both a word and a concept—no exception from such rule and custom.[7] His short essay entitled "Myron's Cow," published in 1818, presents an insightful example of a classicist reconciliation of problems evoked by detail and detailedness, and their intrusion into the "body of art." At the

same time, Goethe's essay reflects how the visual and textual arts respond differently to the artistic challenges the detail conjures. Myron's cow, a Greek bronze sculpture of the late fifth century BCE, praised by many authors (mostly from later ages, who had never seen the cow) for its unsurpassed naturalness and attention to detail, had long been lost before Goethe took an interest in it.[8] No reliable copies of the work have survived. Goethe's knowledge was based exclusively on literary rumors and ramifications. Nonetheless, in his essay he strove to reconstruct Myron's legendary achievement from its "remnants," in an effort similar to Johann Joachim Winckelmann's famous *Description of the Torso in the Belvedere in Rome* in his eponymous article of 1759. Thus, details matter to both Winckelmann and Goethe for reasons of the object's adequate depiction and its restricted material and visual presence. Yet, Goethe did more than aim to relate the work's remaining "traces" back to its original physical form. He also argued away its venerable reputation as a masterpiece of mimesis and emulation: "It was certainly not Myron's goal to achieve a realism that vies with nature." In light of the work's precarious subject, its fame must have a different reason: "How then did Myron manage to turn a cow into an important and significant work of art which attracted and fascinated so many through the centuries?"[9]

Goethe's answer is as original as it appears far-fetched to modern readers: "It was a nursing cow because only a nursing cow has significance. […]"[10]—a witty twist, which boldly extends Myron's design into the realm of fantasy. Interestingly enough, Goethe substituted the lost subject of epigrammatic praise with an equally hypothetical one, which takes shape in a detailed "ekphrasis" revolving around a literary conceit: "The cow, sturdy on her legs as if on pillars, provides with her splendid body protection for her nursing calf. The hungry young creature is sheltered as if in a niche, a cell, a sanctuary, and occupies with utmost grace the space that is organically defined by the cow's body."[11] Goethe's evocative description refers to the cow as an "adornment," which makes room for the newly introduced calf and the motif of nursing—since only these can add naïveté and grace to an otherwise embarrassing and inappropriate topic: the detailed depiction of a cow in a classical work of art.

Goethe's allusions to a variety of other art historical references (such as the Capitoline Wolf and representations of the Virgin lactating the Christ child, favored by romantic artists and utterly disliked by Goethe himself) cannot be pursued here. More pertinent to our question is the obvious skepticism with which Goethe treated the detail as a means of artistic expression. The minuteness of his own "description" corrects what he considered a false attention to detail advocated by epigrammatic texts; it redeems Myron's cow from a long-held misconception. As a result, Goethe literally helped bring Myron's cow back to life: his contemporary, Carl August Schwerdgeburth, in illustrating Goethe's description (and relying on the cast of a coin Goethe mistakenly identified as Myron's cow), restores a version of the antique image that disregards Myron's invention to the extent that it resembles Goethe's (Fig. 36).

Goethe's text establishes a *paragone* with Myron's iconic piece and its literary descriptions— a *paragone* that transforms the "representation of detail" famously ascribed to Myron's cow

Figure 36. Carl August Schwerdgeburth, *Myrons Kuh*, from Johann Wolfgang von Goethe, *Über Kunst und Althertum*, 1818, frontispiece, engraving, 5⅝ × 3¼ in. (14.2 × 8.4 cm) (artwork in the public domain; photograph © Klassik Stiftung Weimar).

by a formerly unknown "detail of its representation": the suckling calf whose attachment to the overarching principle of life, in Goethe's eyes, can free artistic mimicry from the lowering notion of dilettantism.

Notes

1 The so to speak "holistic" bias of the detail is instructively outlined by George Didi-Huberman, "L'art de ne pas décrire: Une aporie du détail chez Vermeer," *La part du l'œil* 2 (1986): 102–19.

2 The detail has a long and prosperous history, though, in rhetorical tradition—as *diaeresis* (a detail often overlooked). However, its reputation began to fade in the eighteenth century, so that the detail's career in aesthetics and culture reciprocally mirrors its demise in rhetoric. See Heiner Peters, "Dihaerese," in *Historisches Wörterbuch der Rhetorik*, ed. Gert Ueding, vol. 2 (Tübingen: Max Niemeyer, 1994), 748–53.

3 See *Deutsches Fremdwörterbuch*, ed. Hans Schulz (Strassburg: Trübner, 1913), vol. 1, 138–39.

4 See Carlo Ginzburg, "Morelli, Freud, and Sherlock Holmes: Clues and Scientific Method," in *The Sign of Three: Dupin, Holmes, Peirce*, eds. Umberto Eco and Thomas Sebeok (Bloomington: Indiana University Press, 1984), 81–118.

5 See Sigrid Weigel, "'Nichts weiter als …': Das Detail in den Kulturtheorien der Moderne; Warburg, Freud, Benjamin," in *"Der liebe Gott steckt im Detail" Mikrostrukturen des Wissens*, ed. Wolfgang Schäffner, Sigrid Weigel, and Thomas Macho (Munich: Fink, 2003), 91–111. One might also think of the prominence of the detail as a cinematic technique in early twentieth-century film and film theory, such as in André Bazin, "The Evolution of Film Language" (1958), in *The New Wave: Critical Landmarks*, ed. Peter John Graham (Garden City: Doubleday, 1968), 25–51.

6 See Gotthold Ephraim Lessing, *Laocoon: An Essay on the Limits of Painting and Poetry*, trans. and ed. Edward Allen McCormick (Baltimore: Johns Hopkins University Press, 1984), 94–95 (on the famous "shield of Achilles"—a notorious subject in the discourse on detail in text).

7 See *Goethe Wörterbuch*, ed. Berlin-Brandenburgische Academy of Sciences, Academy of Sciences in Göttingen, Academy of Sciences in Heidelberg, vol. 2 (Stuttgart: Kohlhammer, 1989), 1157–58.

8 See Wolfgang Speyer, "Myrons Kuh in der antiken Literatur und bei Goethe," *Arcadia* 10, no. 2 (1975): 171–79. Besides questions of detail, of course, those of liveliness and animation (and their confines), seem central to Myron's invention and its reception since antiquity. See Michael Squire, "Making Myron's Cow Moo? Ecphrastic Epigram and the Poetics of Simulation," *American Journal of Philology* 131 (2010): 589–634. However, in redefining liveliness as a matter of content rather than representation (see my closing remarks), Goethe altered the traditional discourse.

9 Johann Wolfgang von Goethe, *Essays on Art and Literature*, trans. Ellen von Nardroff and Ernest H. von Nardroff, ed. John Gearey (Princeton: Princeton University Press, 1994), 24.

10 Ibid., 26.

11 Ibid.

On Detail

Détail, like "detail," its English counterpart, is a noun based on the French verb *tailler* (from the popular Latin *taliare*): to cut. A detail is something that has been cut off (either literally or metaphorically) from a larger ensemble. One might approach the relation between part and whole by starting from a well-known case: two small panels, representing, respectively, a city surrounded by walls and a castle on a bank (Pinacoteca Nazionale, Siena). Long regarded as early (and possibly the earliest) examples of landscapes in European painting, they had been traditionally attributed either to Ambrogio Lorenzetti (ca. 1290–1348) or to his brother Pietro (ca. 1280–1348). In a brilliant article, Federico Zeri advanced the date of the two panels nearly one century, arguing that they had been cut off from a large polyptych painted in 1425–26 by Stefano di Giovanni di Consolo, nicknamed il Sassetta (1392–1450/51). Zeri dismissed the assumption that the two panels were independent landscapes as an absurd anachronism, comparable to positing a work painted by Piet Mondrian in the age of Tiepolo and Sebastiano Ricci.[1]

As always, connoisseurship is art history in a nutshell. In order to identify a painting either as a detail or as a whole, one must take into account the historical process that, in the fifteenth and sixteenth centuries, turned details into wholes, establishing new pictorial genres such as landscape and still life. As Ernst Gombrich pointed out, lost works from antiquity, of which Vitruvius and Pliny the Elder gave accounts, presumably contributed to the emergence of landscape; in the case of still life, the connection is more hypothetical.[2] But Gombrich himself paved the way to a broader perspective on this issue in commenting on a different topic: the development of Greek art, which he tentatively connected, among other elements, to the impact of Homer's poems (we can only speculate about their competitors, since they did not come to us). Their vivid details—as, for instance, the description of a gold brooch with its ornament, a dog hunting a deer (*Odyssey* 19.227-31)—added circumstances ("how") to the basic plot ("what").[3]

To assume that Homer, "the best of painters," as Lucian of Samosata retrospectively labeled him (*Images* 9), had a belated impact on painting (and sculpture) does not seem far-fetched.[4] One might develop this line of inquiry by staging an imaginary dialogue between Gombrich and Erich Auerbach. In the first chapter of *Mimesis* (a book that, strangely enough, Gombrich failed to mention), Auerbach famously opposed two passages from, respectively, the *Odyssey* and the Bible: a long recounting of a hunt, elicited by the discovery of the scar on Odysseus's knee (*Odyssey* 19.391-466), and Isaac's sacrifice and its unexpected conclusion (*Gen.* 22).

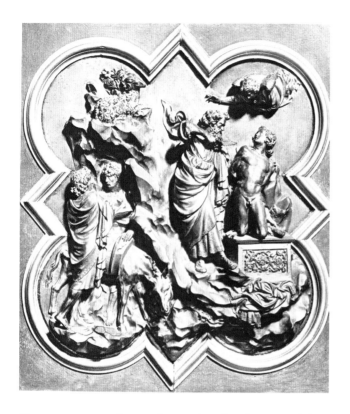

Figure 37. Lorenzo Ghiberti, *The Sacrifice of Isaac,* competition panel, 1401, gilded bronze, 17¾ × 15 in. (45 × 38 cm). Museo Nazionale del Bargello, Florence, inv. n. 203 B (artwork in the public domain; photograph provided by the Polo Museale della città di Firenze Gabinetto Fotografico, courtesy of the Ministero dei Beni e delle Attività Culturali e del Turismo–Museo Nazionale del Bargello).

Two narrative modes: on the one hand, a slow-paced digression, packed with details; on the other, abrupt transitions, suppressed details, ellipses.[5] Can Auerbach's suggestive dichotomy throw some light on the development of visual arts in fifteenth- and sixteenth-century Italy?

The impact, both direct and indirect, of the biblical model, is obvious. Isaac's sacrifice was the subject chosen for the competition that took place in Florence in 1401 to award the decoration of the Baptistery's doors. The two finalists, Lorenzo Ghiberti and Filippo Brunelleschi, provided two reliefs that closely followed the biblical narrative, translating its few, scattered elements into a language derived from Classical antiquity (Fig. 37). In his later work, *The Gates of Paradise,* Ghiberti, the competition's winner, evolved toward a decoration full of wonderfully carved, "Homer-like" details: a label that may be not entirely arbitrary, since in those years the Florentine chancellor, the humanist Carlo Marsuppini, was working at a Latin translation of the *Iliad* (Fig. 38). Although Ghiberti presumably never had access to that translation (which remained unfinished), a wish for Homer-like descriptions was a definite element of the intellectual atmosphere in mid-fifteenth-century Florence.[6] But the role played by the Homeric model remained marginal and mostly indirect.

The aforementioned dichotomy, however, must be supplemented, in the perspective we are discussing, by Dante's *Comedy,* a literary work that was (as Auerbach himself

Figure 38. Ghiberti, *Cain and Abel*, from *The Gates of Paradise*, the Florence Baptistery, 1425–52, gilded bronze, 31⅛ × 31⅛ in. (79 × 79 cm). Museo dell'Opera del Duomo, Florence (artwork in the public domain; photograph provided by Opera di S. Maria del Fiore Archivio storico e fototeca).

masterly demonstrated) deeply indebted to biblical ellipses, as well as receptive to all sort of details connecting everyday life to the ultramundane sphere. The long-term impact of the *Comedy* both on art and art history is well known. It will suffice to recall the large number of illustrated manuscripts as well as the poem's indirect echoes, either visual, most famously in Michelangelo's *Last Judgment,* or verbal, as in Filippo Villani's definition of Stefano Fiorentino as a "good ape of nature [*di natura buona scimia*]" (echoing *Inferno,* canto 29, line 139). Significantly, Dante's parallel between painting and poetry (*Purgatorio,* canto 11, lines 94–99: "Credette Cimabue nella pittura [...]" [Cimabue thought to hold the field in painting [...]) is quoted on the very threshold of Giorgio Vasari's *Lives* to convey its organizing principle: the notion of artistic progress.

But Dante's *Comedy* also had a more widespread, and more elusive, impact. The poem is presented as a vision, and the verb *vidi* (I saw) and its synonyms are ubiquitous. Let us take a random example: the beginning of the *Inferno,* canto 21, showing sinners who, since they made money trafficking public offices, are buried in thick pitch. Line 4: "vedere" (to see); line 6: "e vidila" (and I saw it); line 19, "I' vedea lei, ma non vedea in essa" (It I saw, but in it I saw nothing); line 22: "fisamente mirava" (while I was gazing fixedly); line 23: "Guarda, guarda!" (Watch out, watch out!); line 26: "di veder" (to see); line 28: "per veder" (he looks back); line 29: "e vidi" (I saw).[7] Dante shared with his readers a series of extraordinary visual experiences, from the most earthly to the supernatural. Among them, fragments of

landscapes, incrusted in the poem's imposing structure and evoked in unforgettable lines: "Come 'l ramarro sotto la gran fersa / de' dì canicular, cangiando sepe, / folgore par se la via attraversa" (As the lizard under the great scourge of the dog days, darting from hedge to hedge, seems a lightning-flash, if it crosses the way) (*Inferno*, canto 25, lines 79–81); "L'alba vinceva l'ora mattutina / che fuggia innanzi, sì che di lontano / conobbi il tremolar de la marina" (The dawn was vanquishing the matin hour which fled before it, so that I recognized from afar the trembling of the sea) (*Purgatorio*, canto l, lines 115–17).[8] And so on.

In his splendid book *Painting and Experience in Fifteenth Century Italy*, Michael Baxandall argued that the perception and appreciation of quattrocento paintings relied on social experiences, such as dancing or listening to sermons, that the audiences shared with the painter.[9] Reading Dante's *Comedy* was also a shared social experience, which trained generations of beholders to look at paintings based on details turned into wholes—paintings that had not yet been painted.

Notes

Many thanks to Maria Luisa Catoni for her pointed comments (which I only partially accepted).

1 Federico Zeri, "Ricerche sul Sassetta: La pala dell'Arte della Lana (1425–1426)" (1973), in *Giorno per giorno nella pittura* (Turin: Umberto Allemandi, 1991), 189–98. Zeri noted that his argument had been somewhat anticipated by Emilio Cecchi: see the latter's brilliant *ekphrasis* in *Pietro Lorenzetti* (Milan: Fratelli Treves Editori, 1930), 40–41. The old attribution to Ambrogio Lorenzetti is retained, contra Zeri, in the entry for Lorenzetti in the *Dizionario biografico degli italiani*, vol. 65 (Rome: Istituto della Enciclopedia Italiana, 2005), 796–97.

2 E. H. Gombrich, "The Renaissance Theory of Art and the Rise of Landscape" (1950), in *Norm and Form: Studies in the Art of the Renaissance* (London: Phaidon Press, 1966), 107–21; and idem, "Tradition and Expression in Western Still Life" (1959), in *Meditations on a Hobby Horse and Other Essays on the Theory of Art* (London: Phaidon Press, 1963), 95–105.

3 E. H. Gombrich, *Art and Illusion: A Study in the Psychology of Pictorial Representation* (London: Phaidon Press, 1962), 107–13.

4 Lucian of Samosata, *Descrizioni di opere d'arte*, ed. Sonia Maffei (Turin: Einaudi, 1994), 90–91.

5 Erich Auerbach, *Mimesis: The Representation of Reality in Western Literature*, trans. Willard R. Trask (Princeton: Princeton University Press, 1953), 3–23. Gombrich (*Art and Illusion*, 110), who also referred to book 19 of the *Odyssey*, made a passing allusion to Gen. 1: 1.

6 See Paolo Viti, "Marsuppini, Carlo," in *Dizionario biografico degli italiani*, vol. 71 (Rome: Istituto della Enciclopedia Italiana, 2008), 14–20.

7 Dante Alighieri, *The Divine Comedy*, trans. Charles S. Singleton, 3 vols. (Princeton: Princeton University Press, 1970–75) , vol. l, *Inferno*. The title of Dante's poem took its standard title, *The Divine Comedy*, only in the mid-sixteenth century, with Ludovico Dolce's edition of 1555. On the scriptural roots of the deictic elements in Dante's *Comedy*, see Auerbach, *Mimesis*, 180–81, who quotes, among other passages, Abraham's sacrifice and its sudden turning point: "et ecce Angelus Domini de caelo clamavit, dicens:

Abraham, Abraham" (And the angel of the Lord called unto him out of heaven, and said, Abraham, Abraham) (Gen. 22: 11). See also Carlo Ginzburg, "Ecce: On the Scriptural Roots of Christian Devotional Imagery," in *Wooden Eyes: Nine Reflections on Distance* (London: Verso, 2001), 79–93.

8 Dante, *The Divine Comedy,* vol. 3 *Purgatorio* (1973). See also "par tremolando mattutina stella" (as seems the tremulous morning star) (*Purgatorio,* canto 12, line 90); both lines, reworking Virgil, *Aeneid* 7.9: "splendet tremulo sub lumine pontus" (the sea glitters beneath her [the Moon's] dancing beams; trans. Henry Rushton Fairclough, revised by G. P. Goold, Loeb Classical Library, vols. 63–64) and Ovid, *Heroides* 11.75: "mare fit tremulum tenui cum stringit in aura" (as the sea is set a-trembling when a light breeze passes o'er; trans. Grant Showerman, revised by G. P. Goold, Loeb Classical Library, vol. 41) exemplify Dante's amazingly productive memory, as Gianfranco Contini put it ("Un'interpretazione di Dante" [1965], in *Un'idea di Dante: Saggi danteschi* [Turin: Einaudi, 2001], 69–111). See Levi Oscar Kuhns, "Dante's Treatment of Nature in the Divina Commedia," *Modern Language Notes* 11, no. 1 (January 1896): 1–9.

9 Michael Baxandall, *Painting and Experience in Fifteenth Century Italy: A Primer in the Social History of Pictorial Style* (Oxford: Oxford University Press, 1972), esp. 29–108.

Joan Kee

Why Chinese Paintings Are So Large

Scale, or the relative proportions of an object, place, or person, is among the most obvious and therefore overlooked of details. Often mistaken as size, scale is usually invoked as a means by which to discuss the symbolic, and, occasionally, the affective, implications of being excessively large or small. Yet, even more than other foundational constructs such as color, line, or shape, scale directs attention toward the capacity of an artwork to respond to a specific location and place, while simultaneously calling into question the role of the viewer. Scale foregrounds the relation between materiality and meaning by its very refusal of arbitrariness; things are not a particular size for their own sake, but are scaled according to some predetermined rule or standard of judgment.

The commentaries that emerged in the wake of Minimalism, during the mid-to-late 1960s in the United States, present a telling exception to the general suppression of the distinction between size and scale. In these writings, scale was taken up as a fundamentally humanist proposition, and it was keyed, inevitably, to the proportions of the human body. Phenomenology became an appealing lens through which to explore this sense of scale. As it turned out, a humanist proposition was not exclusive to Minimalism's fiercest advocates and detractors; it was also vigorously explored by artists affiliated with the Japanese group Mono-ha, for example. Nonetheless, scale has most often been taken up by critics associated with Greenbergian formalism, with the result that scale has been tacitly regarded as a concern specific only to a certain subsection of postwar Western art. This is unfortunate, not only since scale might help us better envision art history, without first having to consider geographic and national distinctions, but also because scale is here defined as necessarily correlated to the human body.

Works scaled according to criteria other than the human body have often been excluded or criticized. Very large installations made for a specific exhibition venue have been condemned as alienating spectacles, while official art made at the behest of an authoritarian state has routinely been omitted from mainstream histories of modern and contemporary art. This official art often turns on an awareness of scale, sometimes to the point that the significance of the artwork depends less on its capacity to communicate a specific political agenda than on how it considers size: Is the work in question merely large? Or is its largeness intrinsic to the artwork's efficacy as a visual image?

Consider, for instance, large paintings in China made after the People's Republic was established in 1949. There, scale was deployed to emphasize art's social and political

Figure 39. "Using Brushes as Weapons," *Renmin Huabao* (China Pictorial) 18 (November 1967) (photograph © China Fotobank).

implications. Predictably enough, the state mobilized scale in ways that made material accede to the authority of its constituents, and it did so by suppressing the existence of an individual viewer, in at least three ways. The act of creation was reframed as a distribution of labor across a large expanse of space. This recalibration was widely circulated through photographs published in magazines, such as *Renmin Huabao* (Fig. 39). Paintings were also made through a concurrent awareness of architecture. The extreme largeness of many paintings, such as Fu Baoshi and Guan Shanyue's *This Land So Rich in Beauty*, is scaled according to the massive dimensions of structures like the Great Hall of the People. Here, if the dimensions of the human viewer matter at all, it is only to make the prospective viewer aware of his or her miniaturization, as we see exemplified by the Chinese and United States delegations standing under *This Land So Rich in Beauty* on the occasion of Richard Nixon's visit to China in 1972 (Fig. 40).

The state's mobilization of scale was such that particular approaches to scale could have dire consequences, as it did for Shi Lu. *Fighting in Northern Shaanxi*, nearly contemporaneous with Fu Baoshi and Shanyue's 1959 painting, *This Land So Rich in Beauty*, measures 93¾ by 85 inches (238 by 216 cm), large enough to correspond reasonably well to the galleries of the newly erected Museum of the Chinese Revolution, for which it was intended. Yet, the work was criticized for making Mao Zedong look detached

Figure 40. Richard Nixon standing with the Chinese and United States delegations in front of *This Land So Rich in Beauty*, by Fu Baoshi and Guan Shanyue, 1959, *Renmin Huabao* 23 (April 1972), suppl. (photograph © China Fotobank).

from the land, an accusation based not only on Mao's apparent miniaturization vis-à-vis the depicted landscape, which appeared to exceed the artwork's physical boundaries, and on the fact that it reintroduced somatic scale. Despite the painting's ostensible subject, the portrayal of Mao resonates with the proportions of an individual viewer standing directly in front of the work.

Scale was thus meant to propose another view of the world, the state's attempts at imposing its own worldview notwithstanding. This is particularly evident in the way in which some artists play size and scale against one another. In Pan Tianshou's 1963 depiction of Mount Yandang, one of the areas newly consecrated as a key site in what the state termed its "geography of progress," part of the mountain appears close-up and in detail. In the context of a very large support, this has the effect of making the mountain seem both inaccessible and accessible; that Pan chose only to emphasize what distinctly looks like a fragment suggests that the mountain is too large to be contained within the support. At the same time, the mountain fragment appears extremely flat, without any sustained effort at shading or contour. The fragment becomes more convincing as a rather literal restatement of the surface than it does as a metaphoric depiction of the nation as channeled through the image of Mount Yandang. The fragment, or boulder, now comes across as scaled to the physical edges of the support rather than to the guesthouse where the work was initially shown. Pan

tried to generate from state-endorsed iconography a sense of an internal realm not governed according to institutional proportions. That he adds two small frogs perched comfortably on the boulder's top edge only further divests the image from its presumed function as a monument.

Today, scale tends to refer to the rate at which the demand for Chinese art continues to grow. One need look no further than the rising value of Pan's works; another example, from the early 1960s and also based on Mount Yandang, was offered at auction in 2010 for almost $9 million. If the decision to scale things in a particular way represents an effort to assess one's place in the world, then the question of the fit of scale still needs to be asked, lest the measure of the world be permanently connected to the market. How does scale fit into the world? Or rather, how can scale offer a different measure for a world art history?

Spyros Papapetros

Hairy Details

Whether bored or amused during a day of his studies at the Art Historical Institute in Florence in November 1888, the young Aby Warburg drew in his notebook a series of ornamental flourishes and figurative doodles (Fig. 41). This ostensibly calligraphic nonsense acquires some meaning with the same caption written under two friezes with rhythmically repeated motifs: "Ein Haar meines Schnurrbartes" (a hair of my mustache).[1] The caption creates an abrupt juxtaposition in scale. What initially appear as decorative meanders, perhaps of a painted ceiling or a mosaic floor (which Warburg in fact describes in similarly embellished notes on an adjacent page), turn out to be no wider than a fraction of a millimeter, objects barely visible to the naked eye. Warburg's scrolls invoke memories of *haptic* vision: the young student might have been caressing his mustache with one hand while replicating its texture with the other. As the future art historian *embodied* the act of magnification, his own body acted as a virtual microscope. Even if we can never be sure whether the young Warburg had in fact seen "a hair of his mustache" under a magnifying apparatus, contemporary advances in forensic technologies would make such self-observation possible. Images of human and animal hair magnified and drawn in cross section were reproduced in numerous contemporary criminological publications. Such scientific images reveal that Warburg's visual analogy between spiral motifs and hair dissections was both acute and accurate. The proliferation of these curlicues rehearses the intensification of psychological excitation, but it could also cover the residue of mental fatigue. Perhaps the young student ruminated, initially, on ornamental patterns, yet gradually began to see hairs in them. Once the previously abstract shapes began to flourish with manifold associations, it is as if these inorganic appendages grew organically out of the spiraling scrolls. However, the abstract tangle of lines underneath Warburg's ornamental friezes may signal how details themselves can endlessly bifurcate, turning, thus, into a forest of knots that may never cohere into a regular pattern.

"Uns geometrisch auf ein Haar, beweist wie gross der Biertopf war": this is how Warburg's German edition of *Sartor Resartus* renders Samuel Butler's maxim "By geometric scale, doth take the size of pots of ale." Thomas Carlyle quotes the humorous proverb to satirize the excessive exactitude of German scholars, including his main character, the odd German Professor Teufelsdröckh, a fictional character with whom Warburg nurtured an empathetic identification since his high-school years.[2] The German translator added "one hair [*ein Haar*]" to the English original to make his version rhyme. This additional strand presents further proof that hair serves as evidence of rigorous precision. The ruler that appears in

Figure 41. Aby Warburg, *A hair of my mustache* (*Ein Haar meines Schnurrbartes*), 1888, manuscript notes and sketches from his student notebook, "Masolino und Masaccio. *Übungen*, KHIF," Warburg Institute Archive (WIA) III, 33.2.7, fol. 91v. The Warburg Institute, London (artwork in the public domain; photograph provided by the Warburg Institute, London).

Warburg's scribbles ostensibly serves as a sign of a similar pseudoscientific accuracy. Were one to pursue such allegorical interpretation, the stick figure climbing the ruler could essentially be a self-portrait depicting the emerging art historian about to hatch from his scholarly cocoon. Weaving the hair of his own face with the bristling hair of animals and excitable females in the physiological studies of Charles Darwin and Tito Vignoli, and finally lacing those undulating tresses with the art historical forensics of Giovanni Morelli and the wind-blown hair of Renaissance nymphs, the young scholar created a new historiographic fabric. What seemed an idle meditation on curlicues would eventually develop into a methodical inquiry on the resilient strands that constitute the genetic fibers of art history.

Fast-forward thirty-five years:

> [...] the lecture itself [...] expanded on a large quantity of knowledge, but in a manner that was somewhat disordered: the principal facts [*Hauptsachen*] are too heavily covered by *accessory elements* [*Beiwerk*], and the important viewpoints are indicated only in passing by intimate archaeological allusions that only very few people in the audience can understand.[3]

However critical (and implicitly envious) Ludwig Binswanger's assessment of Warburg's well-known 1923 Kreuzlingen lecture might be, it is perhaps the most accurate diagnosis that the psychiatrist ever made on his patient. While grumbling about details and thus himself missing the "principal fact" in the scholar's thinking process, Binswanger implicitly acknowledged that for Warburg, accessory details are not marginal elements, but central methodological apparatuses. Following Carlyle, the "main facts" (*Hauptsachen* or *Hauptwerk*) are clothed by multiple layers of "accessory elements" (*Beiwerk*): this is how

Figure 42. Jan Toorop, "Delft salad oil (*Delftsche Slaolie*)," 1894, paper, 37.4 × 24.6 in. (95 × 62.5 cm), Rijksmuseum (artwork in the public domain).

Warburg circumscribes the conceptual periphery of his subject, which the art historian describes by the term *Umfangsbestimmung*. Perhaps Binswanger was alarmed because, in too many of his patients' dream narratives, he had already witnessed this bewildering process of inflating seemingly disparate details and transposing them from the periphery to the center.

But could the logic of accessory elements form the basis of a scholarly lecture? Perhaps the psychiatrist overlooked the fact that, in this case, the scholar was an art historian and that a similar inverted logic was already ingrained in his patient's academic trade. The use of "accessories" as methodological apparatuses was ubiquitous in Warburg's work since the writing of his dissertation, launched after his studies in Florence under August Schmarsow. Similar to Sigmund Freud's series of "overdetermined elements," ostensibly peripheral objects that occupy the core of the dream narrative (such as the small dried flower in the dream of "the botanical monograph" or the droplet earring in Dora's first dream), accessories and other visual or philological details suffuse Warburg's art historical interpretations.[4] Details do not simply embellish the surface but structure the very center of his circuitous investigations.

Referring to its overabundance of "references and quotations," Ernst Gombrich characterized Warburg's dissertation on Sandro Botticelli as a "mosaic"—a lavishly decorated surface artfully pieced together within an architectural frame.[5] The same metaphor also implies the

Figure 43. Henry van de Velde, "Gentlemen's working space (Herren-Arbeitszimmer)," Secession Exhibition Munich 1899. *Deutsche Kunst und Dekoration* 3:1 (October 1899), p. 15.

required *distance* for the mosaic's patterns to take shape. Without that distance, the viewer (or the reader) may get lost inside the myriad of fragments and ornamental details embedded within the intricate texture and fail to grasp the overall design. Such a loss would also signal the empathetic identification between viewer and surface and would consequently eliminate any space between the art historian and the artwork. Once within rather than observing the mosaic tiles, one loses any normative sense of scale, space, and perspective.

Empathetic immersion into a universe of endlessly circulating minutiae might appear incompatible with a tectonic understanding of visual or textual space. Yet, the mosaic's reversed logic is part of an entirely modern mobile architectural framework. Envision an architecture of infinite extensibility produced not by erection and division of large structural blocks but by piling up and accumulation, rather loosely, of masses of peripheral details. One example contemporary to Warburg would be Jan Toorop's famous 1890s poster advertising "Delft salad oil," in which a thread of hair redraws all human figures and turns the

hybrid milieu into a forest of lines (Fig. 42). There is no figure or frame in such representations: all objects are reconstituted by a single line whose origins remain unlocatable.

As Daniel Arrase has observed, aberrant details extracted from a painting have a tendency to disengage themselves from the larger picture and the more general context in which an artwork was produced.[6] But one may also argue that the same "mutilated" extracts also have the capacity to build their own autonomous and self-replicating environments. Think here of the fin de siècle interiors by Henri van de Velde, in which a linear motif crawls up from the carpet to the wallpaper and then wraps the furniture and finally the arches and other structural members of the building (Fig. 43). The same, minute pattern can be applied to a jewel, book cover, fabric, piece of furniture, and, finally, the facade or even the floor plan of a building. The buoyant ornamental detail defies both gravity and scale; it can contract into shallow surface or expand into three-dimensional space.

Details turn into autonomous plastic elements that can infinitely replicate in any material or size, as well as cultural or historical background. While turn-of-the-century art historians and connoisseurs would draw on marginal details to decipher the personal identity of an author (not to mention the collective identity of a race or nation), ornamented fragments can also be used to blur or even eliminate such distinctions. Such is the detail's epistemological revolution led by Warburg and his contemporaries, which has remained with us ever since. We live and thrive inside a magnified world. That "one hair" of the art historian's mustache springing from his student notebook is only a microscopic detail tangled within a macrocosm of coded information.

Notes

1 Notes on the next page describe Raphael's Camera della Segnatura in the Vatican Palace. A different cluster of notes on the same page dated November 29, 1888, mentions Giotto and the Florence Baptistery. Aby Warburg, "Masolino und Masaccio. *Übungen*, KHIF," notebook, Warburg Institute Archive (WIA), III, 33.2.7, fols. 91v, 92.

2 Thomas Carlyle, *Sartor Resartus*, ed. Peter Sabor (Oxford: Oxford University Press, 1987), 5. Warburg's copy, the German edition *Sartor Resartus, oder, Leben und Meinungen des Herrn Teufelsdröckh: in drei Büchern*, trans. Thomas A. Fischer (Leipzig: O.Wiegand, 1882), is in the library of the Warburg Institute, interleaved with blank pages for Warburg's manuscript annotations, p. 3.

3 Ludwig Binswanger, entry in his clinical diary for Aby Warburg, April 22, 1923, in Binswanger and Aby Warburg, *Die unendliche Heilung: Aby Warburgs Krankengeschichte*, eds. Chatal Marazia and Davide Stimilli (Zurich: Diaphanes, 2007), 79, my emphasis.

4 Sigmund Freud, *The Interpretation of Dreams*, vol. 4 of *The Standard Edition of the Complete Psychological Works of Sigmund Freud*, ed. James Strachey (London: Hogarth Press, 1953–74), 282–84, 306–08; and "Fragment of an Analysis of a Case of Hysteria," in ibid., vol. 7, 64–93.

5 E. H. Gombrich, *Aby Warburg: An Intellectual Biography* (Chicago: University of Chicago Press, 1986), 59.

6 Daniel Arasse, *Le détail: Pour une histoire rapprochée de la peinture* (Paris: Flammarion, 1992), 8.

<div style="border: 1px solid black; text-align: center; width: 40%; margin: 0 auto;">

Joanna Roche

</div>

Moving In and Stepping Back

> *I could no longer recognize my world in the wreckage of those hours. Details caught my attention. Fragments that I was unable to set into a whole picture. I was too close or too far removed.*
> —Chantal Thomas, *Farewell, My Queen*[1]

My interest in detail stems from a writer's—and an educator's—sense of urgency for specificity. Detail draws us in and anchors us, allowing us to expand into another state of perception, one where time takes on dimensions. At present, our access and exposure to visual information is both exhilarating and staggering. Daily visual experience is often lived in a useful, if detached, "channel surfing" mode of perception. It's necessary to our survival—this ability to scan without getting distracted by details—but it is also crucial, especially in this culture "of instantaneity, to foster the conditions of perception that details demand. [Some] things happen which one can only perceive with slow thinking," writes Matthew Goulish.[2]

This deeper engagement with the visual world is often associated with "the art experience," yet this mode of seeing—the act of coming in close—is also a method of perception that gives us the scope to process the enormity of our circumstances. Moving in and stepping back is akin to breathing: we inhale detail, then step back/exhale to grapple with the whole. Two artists I visited in their studios, Joe Biel and Patrick Merrill, gave me the opportunity to examine large-scale works that summon viewers to take in massive, even obsessive, amounts of detail. These epic artworks are also worldviews.

Joe Biel's twelve-foot-wide *Veil* currently occupies a long wall of a large studio-living space that was once a retail business on Chung King Road in downtown Los Angeles (Fig. 44). This work on paper, begun in 2010, comprises 1,124 television screens, each bearing a unique image roughly 1 by 1½ inches. In the process of selecting the screens for *Veil*, Biel collected more than five thousand images from still photography, film, art history, the Internet, and television. He offers the viewer an overwhelming array of specific detail without advocating any narrative direction or focal priority. Clearly, there is a defined structure via the frame of the individuated television sets in their repeated, irregular stacks, but each of the screens is a distinct painting. Biel modifies old master techniques, using layers of gouache and watercolor over an underdrawing in graphite to achieve the luminosity of egg-tempera glazing. These hand-painted still images are unexpected, even jarring. We are accustomed to the constant motion and "easy" imagery of the televisual; *Veil* is fixed.

Figure 44. Joe Biel, *Veil*, detail, 2010, graphite, watercolor, and gouache on paper, 55 in × 145 in (139.7 × 368.3 cm) (artwork © Joe Biel; photograph provided by the artist).

Equally meticulous is Biel's method of collecting and composing the disconnected fragments that make up the threads of *Veil*. The laborious process of gathering sources and organizing the composition is an orchestration the artist refers to as a "score." And it is a dark song: Iraq, Vietnam, World War II, Princess Diana's funeral, … *Veil* imparts a strong sense of structure, in which chaos is contained. Yet, like the woven object, Veil conceals some details while it reveals others.

Patrick Merrill's 2006 print *Masters of War*, 10 by 6 feet, consists of four woodcuts printed separately and adhered together (Fig. 45). Here, we are confronted with another epic work on paper, except one that is narrative, even allegorical. Overtly political, *Masters of War* challenges us to take a stand on militarism and war. While *Veil* employs an open, antinarrative

Figure 45. Patrick Merrill, *Masters of War*, 2006, woodcut, 120 in × 72 in (304.8 cm × 183 cm) (artwork © Estate of Patrick Merrill; photograph provided by the Estate of Patrick Merrill).

structure, both of these works are deeply populist in making use of recognizable form. However, the worldviews presented by these artists insist that we look closer, dig deeper.

The three warriors of *Masters*, modeled after medieval depictions of archangels, wear United States Army camouflage, their faces concealed by comic-book demon masks. Merrill's prints, like those of his artistic mentors, Francisco de Goya, Käthe Kollwitz, and Frans Masereel, are steeped in the anguish of his time. "The innocents [the mass of limbs on the bottom] are naked, vulnerable, and modeled after the classic images of the fallen angels," Merrill wrote.[3] In the traditional dualism of Revelation, the archangels drive the demons down. Here, the relationship between those in power and those destroyed is inverted. The artist flips the good-versus-evil drama of Michael and Lucifer and leaves us questioning not

Figure 46. Detail of Fig. 45 (artwork © Estate of Patrick Merrill; photograph provided by the Estate of Patrick Merrill).

just who is in power, but if there is a righteous use of power. Merrill borrowed Christian iconography to speak in a language familiar to Right and Left; he wanted his work to be a site of dialogue between the camps. The hovering protagonist in this and other prints is the nuclear explosion. For Merrill, this was the ultimate apocalyptic image and his greatest fear—the end of days brought about by the acts of man.

Stepping in, we can absorb some of the print's detail from the work's central, oblong mass (Fig. 46). Up close, we see that the print is a cosmology of tens of thousands of incisions that have become an abstract symphony of marks and meanings, rather than a site of revolution. The mass of feathery cuts resolves into the cloudlike ground on which the warriors stand, their spears forming an inverted vanishing point into the confusion of twisted bodies below. This is an area of the print that reads like an accumulation of all the feathers (read tears, grief, sorrow) of the fallen.

The play between details and the whole in these works encourages our two-step dance. Stepping in, we absorb the minutiae of each screen of *Veil* and the abstract chaos of cuts that

composes *Masters*. Both artists wielded the virtuoso techniques of centuries past, yet these epic works comment on our times: the active apocalypse of war and the passive viewing of the apocalypse as entertainment. The devil is in the details.

Notes

My thanks to Karen Lang for the opportunity to contribute to this exciting forum and to Debra Winters, Stacy Kamehiro, and Brie Roche-Lilliott for their insightful comments on this essay.

1 Chantal Thomas, *Farewell, My Queen*, trans. Moishe Black (New York: Simon and Schuster, 2004), 195.

2 Matthew Goulish, *39 Microlectures: In Proximity of Performance* (London: Routledge, 2000), 82.

3 Patrick Merrill, quoted in *Patrick Merrill: Revelation* (Santa Ana: Grand Central Press, 2012), 88.

Nina Rowe

The Detail as Fragment of a Social Past

For centuries, the work of the artist has been idealized and the detail has been held in contempt. Remarks ascribed to Michelangelo denigrate the minutely rendered paintings of the Flemish, filled with "stuffs and masonry, the green grass of the fields, the shadow of trees."[1] In the androcentric language prevailing in foundational texts in the humanities, such paintings characterized by "external exactness" are said to "appeal to women […] and to certain noblemen who have no sense of true harmony."[2] Joshua Reynolds contrasted the fussy detail of the "ornamental" style to the "manly, noble, and dignified manner" of the sublime.[3] Charles Baudelaire celebrated the artist who could "see things broadly" and reject the "riot of details all clamoring for justice with the fury of a mob in love with absolute equality."[4] From the Renaissance into the era of modernity, in the salons of Europe the detail has been associated with the finicky, the effete, the emotional, or the anarchic, while the whole was celebrated for a virile and rational coherence.

If the detail was denounced by generations of men seeking to theorize the work of artistic production, those engaged with the reception of art have perforce grappled with it. Deriving from the French *détailler,* a designation with the word for "to cut" at its core, the term *detail* is intimately bound to the fragment. And it is fragments of the past—architectural, sculpted, painted—that fill museum galleries, illustrate art history textbooks, and circulate on the Internet. Whether the art under consideration is physically broken or virtually dissected by the camera lens or the zoom function on a computer screen, art history is structured by the technologies of cutting.

Artistic fragments from the European past entered the public arena in the present by way of the military, political, and economic ruptures of the modern age. In the wake of Napoléon's conquests and throughout the nineteenth century in Europe, as ecclesiastical foundations were dissolved, church treasuries looted, and noble collections dispersed, a new breed of dealer could break apart fifteenth-century altarpieces, frame or refinish the individual elements, and sell these pieces as integral objects. Well known are the quattrocento predella panels or German limewood figural sculptures extracted from their original devotional ensembles and offered up as narrative vignettes or portraits. Less considered are collages made up of cuttings from medieval or Renaissance illuminated manuscripts—the text discarded and the miniatures re-presented as independent panel paintings.[5] Twenty-first-century scholars uncomfortable with such dismemberments and reconfigurations would do well to remember that artworks, canonical and noncanonical, have often only come before the eyes of the public on account of the violence of war or the quest for financial gain.

139

The breaking up of larger works by nineteenth-century dealers and collectors precipitated a new intellectual enterprise, connoisseurship, that focused on the artistic detail. Between 1874 and 1876, Giovanni Morelli published a series of articles outlining a method of attribution for paintings of the Italian Renaissance, many of which existed as fragments that had entered the market to satisfy nineteenth-century appetites for Renaissance panels. Morelli's *Italian Painters*, expanded, translated into English, and republished in 1892, is perhaps best known for its illustrations reproducing tracings of the hands and ears in paintings by artists such as Filippo Lippi and Sandro Botticelli. In Morelli's amputated "characteristic forms," the viewer was to recognize the touch of a given painter.[6] The goal of Morelli's method was, in part, to make democratic and systematic a practice that had previously relied on the numinous authority of the expert. But connoisseurship and the work of the authenticator typically continue to be derided in popular and scholarly venues alike, as modes that celebrate the authority of the expert and in which only dupes or the greedy could have faith.[7]

Calls to rethink a blanket censure on connoisseurship cast the search for attributions not as a quest for the individual genius of an artist, but rather as a means by which to understand the conditions, tastes, and power dynamics that drove the creation of a work of art at a particular time and place.[8] Regarded in this way, the connoisseurial enterprise can offer insight into communal ideals and the individual human's relation to the collective. In an intellectual era in which broad consensus exists on the merits of analyzing the materialities of art in relation to politics, culture, and their attendant ideologies, Morelli's method has the capacity to sharpen scholarly sensitivity to the fact that every detail in a work of art, placed consciously or not, is a mark of human presence by an artist grappling with the expectations and exigencies of his or her own day.

Iconography, the analytic method perhaps most deeply entrenched within art history, likewise orbits around the fragmented detail. The approach exemplified in Erwin Panofsky's 1934 article on Jan van Eyck's *Arnolfini Portrait* effectively slices individual elements from the work, interrogates them for their "disguised" symbolism, and proposes a synthetic argument in which all the pieces fit together neatly to explain an interpretative puzzle.[9] Among the many scholars who have enriched Panofsky's approach over the years by recognizing the ways in which images and the motifs within them hold multiple allusions, Daniel Arasse shows that the iconographic detail and its material nature can exist outside a language of symbols. The detail might act as the point of contact between a dead artist and the living individual, as the element that arrests the beholder's attention, sending a shiver down the spine in a moment of transhistorical contact.[10]

Like the formal detail considered by Morelli, then, the representational one examined by Panofsky might bind a present-day individual or crowd to a person, a practice, or an arena long gone. The pressing sensation of the detail, the fragment that commands attention and can focus the viewer in an atemporal, sometimes melancholic, holding environment, offers up an exhortation.[11] The art historian's challenge is to make an incision into the visual realm of the past and to find the words to capture that experience of recognition.

Notes

1 Francisco de Hollanda, *Diálogos em Roma (1538): Conversations on Art with Michelangelo Buonarroti*, ed. Grazia Dolores Folliero-Metz (Heidelberg: Universitätsverlag C. Winter, 1998), 77.

2 See the insights of Svetlana Alpers, *The Art of Describing* (Chicago: University of Chicago Press, 1983), xxiii, 223; and the remarks in Laura Camille Agoston, "Male/Female, Italy/Flanders, Michelangelo/ Vittoria Colonna," *Renaissance Quarterly* 58, no. 4 (2005): 1175–1219, at 1176.

3 Sir Joshua Reynolds, *Discourses on Art*, ed. Robert R. Wark (New Haven: Yale University Press, 1997), 153. For commentary, see Naomi Schor, *Reading in Detail: Aesthetics and the Feminine* (New York: Methuen, 1987), 11–22.

4 Charles Baudelaire, "The Painter of Modern Life," in *The Painter of Modern Life and Other Essays*, trans. and ed. Jonathan Mayne (London: Phaidon, 1964), 1–40, at 15–16. For commentary, see Daniel Arasse, *Le détail: Pour une histoire rapprochée de la peinture* (Paris: Flammarion, 1992), 18–19.

5 Sandra Hindman et al., *Manuscript Illumination in the Modern Age: Recovery and Reconstruction* (Evanston: Block Museum of Art, 2001), 52–62, 93–101.

6 Giovanni Morelli (Ivan Lermolieff), *Italian Painters: Critical Studies of Their Works*, vol. 1, *The Borghese and Doria-Pamfili Galleries in Rome*, trans. Constance Jocelyn Ffoulkes (London: John Murray, 1892).

7 On recent popular conceptions of connoisseurship, see David Grann, "The Mark of a Masterpiece: The Man Who Keeps Finding Famous Fingerprints on Uncelebrated Works of Art," *New Yorker*, July 12, 2010, 50–71.

8 Richard Neer, "Connoisseurship and the Stakes of Style," *Critical Inquiry* 32, no. 1 (2005): 1–26; and the less developed remarks of Henri Zerner, "The Crisis in the Discipline," *Art Journal* 42, no. 4 (1982): 279.

9 Erwin Panofsky, "Jan van Eyck's Arnolfini Portrait," *Burlington Magazine for Connoisseurs* 64, no. 372 (March 1934): 117–27.

10 Such contact is explored in various ways throughout Arasse, *Le détail*.

11 See Michael Ann Holly, "The Melancholy Art," *Art Bulletin* 89, no. 1 (2007): 7–17.

<div style="border: 1px solid black; display: inline-block; padding: 20px 60px;">

Alain Schnapp

</div>

Antiquarians in the Field

Most societies desire to persuade themselves that they are the products of a very lengthy past. The expression of this feeling varies from one society to another; Herodotus recounts with much humor how the priests of Thebes demonstrated the great depth of their past.[1] In response to the line of sixteen generations boasted by Hecataeus of Miletus, the Egyptians invited him to admire their 341 "colossi" in wood, representing the continuous line of high priests that had presided over the sanctuary since times immemorial. Even Herodotus experienced this same lesson in humility presented by the Theban priests, despite the fact that he himself saw no need to claim any genealogy at all. Indeed, the historian's discourse was based not on a theory but on a matter of detail: the Theban priests' possession of a gallery of statues.

This is to say that there are many ways to go back in time and to account for the origins of populations and institutions. One way of considering the past is to cast a retrospective gaze on it, as Hecataeus or the Theban priests did, but another is to establish a clear break from it, to deliberately deny it. It was Pascal Vernus who first remarked on an Egyptian document probably dating to the eighteenth century BCE. In this short text, a scholar going by the name of Khakheperreseneb takes issue with the whole Egyptian tradition of devotion to the past:

> If only I could have at my command unheard expressions, original formulations, made from new words that have not fallen out of use, that include nothing repeated, without orally transmitted expressions already spoken by my ancestors. I wish to cleanse my sentiments of everything that can be found (in that tradition), to break away from all that humans have already expressed to detach myself from everything that has already been expressed, for indeed, by its nature, that which has already been expressed can be repeated; and that which has been expressed will of course be expressed again. We should not take on the words of our predecessors as our own in order to pass them on as pertinent for our successors only so that our successors might appreciate their pertinence.[2]

The insight of this scribe, as Vernus interpreted it, goes against the very essence of the Egyptian conception of time: the scribe conceives instead a present that is not related to the past and a tradition that is of use neither to explain the present nor to predict the future. This cry of rage, this will to do away with the past, is completely contrary to a tradition common to the great empires of Egypt, Mesopotamia, and China. It refutes a tradition that enjoins society to imitate its ancestors and that considers, as did the Mesopotamians, that the past

is "in front of us" and the future "behind us." If anything, the attitude of our scribe seems to foreshadow a memorial strategy employed in the third century BCE by Qin Shi Huangdi, the first emperor of unified China. In order to achieve the tabula rasa on which to establish his irresistible greatness, the emperor did not hesitate to burn the ancient books and to slaughter the scholars who wished to preserve them. By placing these attitudes in parallel, I do not seek to cast a shadow on the memory of this Egyptian scribe, who is in no way responsible for the emperor's delirium of destruction. I aim rather to underline, as Jorge Luis Borges suggested,[3] that memorializing can be as oppressive as forgetting can be destructive. I am inclined to think that if we were to classify civilizations on a range from maximum recall to maximum forgetfulness, with the ancient Egyptians on one end of the scale and possibly some hunter-gatherer societies on the other, then even among those societies considered the most memory-prone we would find some dissident voices, as determined as that of Khakheperreseneb. That an isolated scribe dares to express an unprecedented opinion, is this merely a matter of detail?

The contradictions of memory are numerous. On the front lines, one finds an opposition between the partisans of remembering and those of forgetting. The latter camp is probably more numerous than one might expect, since it includes all those who remain indifferent, for whom the past represents neither a moral duty nor an intellectual necessity. The destructive nature of this indifference was observed by Victor Hugo, who claimed that the "bande noire" (property speculators in post-Revolutionary France)[4] had caused more damage to France's monuments than all the vandalism of the Revolution.[5] Mesopotamian sovereigns so feared the destruction of their *temenu*, those votive inscriptions placed in the foundations of their temples, that the incantations they hurled against those who would vandalize them were as severe as those pronounced against the desecrators of graves. Sargon, king of Lagas, thus castigated those who would dare attempt to destroy his inscriptions:

> Whoever removes this inscription,
> May Shamash tear out his roots
> Consume his seed,
> Whoever removes this statue,
> May Enlil remove his name,
> Break his weapon.
> Before Enlil he will not stand up.[6]

As violent as they may have been, such menacing terms did not manage to abolish vandalism and the destruction of the monuments of the past, be they through intentional acts or, as happened more frequently, through negligence due to absolute indifference. It is an inescapable fact, to which all despots and tyrants of all kinds must resign themselves, that nothing made by the hand of man is indestructible. To quote Simonides of Ceos: "[E]ven human hands can destroy a marble monument."[7] Hence the recourse to an alternative approach; rather than

Figure 47. Illustration from David Sigmund Büttner, *M. David Sigmund Büttners Beschreibung des LeichenBrands und Toden-Krüge/ Jnsonderheit derer/ so Anno 1694. zu Lütherstädt unfern Qvernfurth gefunden worden*, Halla: Zeitler (1695) (artwork in the public domain; photograph © Herzog August Bibliothek Wolfenbuttel: Xb 8442).

relying on monuments and inscriptions to ensure the propagation of one's actions, might it not be more reliable to turn to those whose craft is to assemble words and polish sentences? Pindar already said that his poems were more resistant than the marble of statues or inscriptions, because their very immateriality protected them from all forms of decay. Likewise, the Egyptian poets of the New Kingdom claimed that their verses were more solid than the best quarried funerary chapels or the best mounted stelae. Horace's notion of *monumentum aere perennius* (a monument more lasting than bronze) is not limited to the Latin way of thinking. One can observe it in Egypt, in Scandinavia, and, to go by the extraordinary excavation carried out by José Garanger in the atoll of Retoka, also among the Melanesian communities of the Vanuatu archipelago, which have retained the precise memory of a funerary rite, by means of an oral tradition handed down over more than five centuries.[8]

Remains, relics, treasures: memory is made up of accumulations and rejections, of losses and rediscoveries, of material and immaterial elements. Victor Hugo celebrated the idea that, thanks to printing, no literary work would ever again be lost.[9] Johann Wolfgang von Goethe, on the contrary, celebrated the Americas, unencumbered by memories and ruins.[10] Could we believe that? Humans have never ceased to rack their memories and to excavate the soil.

Yet, as a minuscule detail reminds us, by the end of the seventeenth century, the soil had become a veritable history book. No longer satisfied with merely excavating it, the antiquarians of central Europe undertook to unearth the layers of which this "book" was made, and to their spades and shovel they added a new instrument, the probe (Fig. 47).[11] This modest probe, the first ever to figure in the illustration of an excavation (between the two figures at right), seems to announce a new era: "Archaeology: a new notion in Europe, a new craze. The past is saved, it is uprooted."[12]

Notes

1 Herodotus 2.143.

2 Khakheperreseneb, quoted in Pascal Vernus, *Essai sur la conscience de l'histoire dans l'Égypte pharaonique* (Paris: Champion, 1995), 4ff.

3 Jorge Luis Borges, "La muraille et les livres," in *Oeuvres complètes* (Paris: Gallimard, 1993), 673–75.

4 In his essay against the "bande noire," Victor Hugo deplored the destruction of ancient monuments; quoted in Louis Réau, *Histoire du vandalisme, les monuments détruits de l'art français* (Paris: R. Laffont, 1994), 682.

5 Ibid., 692–93.

6 Sargon, quoted in Gerdien Jonker, *The Topography of Remembrance: The Dead, Tradition and Collective Memory in Mesopotamia* (Leiden: Brill, 1995), 83.

7 Simonides frag. 76/581, in D. L. Page, *Poetae melici greci* (Oxford: Clarendon, 1962).

8 José Garanger, "Tradition orale et préhistoire en Océanie," *Cahiers de l'ORSTOM—Série Sciences Humaines* 13, no. 2 (1976): 147–61.

9 Victor Hugo, *William Shakespeare* (Paris: A. Lacroix, 1864), bk. 4, 220–21, quoted in Judith Schlanger, *Présence des oeuvres perdues* (Paris: Hermann, 2010), 193.

10 J. W. Goethe, "Den Vereinigten Staaten" (1827), in *Zahme Xenien*, in Johann Wolfgang Goethe, *Sämtliche Werke, Briefe, Tagebücher und Gespräche*, vol. 2, ed. Karl Eibl (Frankfurt: Deutscher Klassiker-Verlag, 1987), 739–41.

11 Many thanks to my colleague Dietrich Hackelberg, Freiburg University, who drew my attention to this document.

12 Hans Magnus Enzensberger, "GBP" (Gian Battista Piranese), in *Mausoleum* (Frankfurt: Suhrkamp, 1976), 41.

<div style="border:1px solid;display:inline-block;padding:10px 40px;">

Blake Stimson

</div>

The Feminine and Vegetable Principle of Life

It is nothing to say that art historians *love* details—of course we do—but it is something to say that we love them *fetishistically*. Just think of the last time you triumphantly crowned a classroom disquisition on *Las meninas* with the image of King Philip and Queen Mariana reflected in the mirror on the wall behind Diego Velázquez (Fig. 48). Or recall a moment of being particularly enthralled with the minutiae of an exceptional formal analysis (stretches of T. J. Clark's 2009 National Gallery of Art lectures on Pablo Picasso come to mind as I write). Yes, our attention to detail is a form of analytic rigor, a kind of science even, and, as such, just one element of our larger scholarly machinations, but we also experience details as a surplus benefit greater than such a technical characterization allows, greater, that is, than the pleasures given by other kinds of detail-work—that of accountants, say, or engineers, or maids. Spreadsheets, bridges, and tidy rooms can be things of beauty, of course, but generally they are so as the sum of their interrelated parts and, as such, do not reach that distinctive realm of experience that, for several centuries now, has fallen under the special heading of the aesthetic. When our details perform their magic on page or screen, they are more than mere components of larger sums, more than mere triumphs of artistic craft or art historical exegesis: they are glittering jewels, objects of libidinal cathexis unto themselves. This is what Erwin Panofsky meant when he said that the "very objects" we attend to as art historians are not made of paint and stone but instead "come into being by an irrational and subjective process."[1]

There are two types of fetishism, and we art historians have our ways with both. The traditional fetish gives us the pleasure of sublimity: a detail like an idol, crown, or relic expands outward from part to whole with the reciprocal relation between object and subject serving as anchor and engine for the welling up of shared being in God or King or Leviathan. As Michel Foucault put it famously about *Las meninas*, for example, the painting's beholder and the blurry, shimmering image of king and queen in the background "reverse their roles to infinity."[2]

The modern fetish, by contrast, inverts this pleasure. Instead of sublimity, it offers us ratio and control; instead of the object opening out to subject, it presents us with the opposite experience of subject contracting into object. This is the existential pleasure, long familiar to us now, of sexual fetishism and commodity fetishism that is inherently iterative rather than accumulative—think, for example, of Andy Warhol's 1962 diptych *Marilyn Monroe's Lips*. Experienced in the ways that capitalist modernity invites, details like those in Warhol's *Lips* provide a giddy release from the sublimity of tradition through the easy exercise of

146

Figure 48. Diego Velázquez, *Las Meninas*, detail, 1656–57, oil on canvas, 125.2 × 108.7 in. (318 cm × 276 cm). Museo del Prado, Madrid (photograph courtesy of the Museo del Prado via Google Earth).

Figure 49. Karl Blossfeldt, *Phyllitis scolopendrium, Hart's tongue, Young curled fronds magnified six times*, 1920–28, gelatin silver photographic print. (© Karl Blossfeldt Archiv / Ann and Jürgen Wilde / Cologne, Germany / Artists Rights Society [ARS], NY).

consumption. As pleasurable as that release is, according to Theodor Adorno, the most sensitive among us experience it together with an involuntary shudder, "a memento of the liquidation of the I, which, shaken, perceives its own limitedness and finitude."[3]

In one sense, it is easy to explain these two pleasures and thus to understand the prevailing double temptation of the detail: the older is the pleasure of submitting to and merging with a larger authority; the newer is the pleasure of power over things and people-as-things that comes at the price of lost communal subjectivity. As art historians, we conjure one or both of these pleasures daily when we inventory details that, on the one hand, mark power as a vertical, transcendent exception—crowns and scepters, angels and putti, gilding, jewels, and fur—and, on the other, mark the subsumption of power to our individual desire by distributing it through mundane, horizontal equivalence—stone breakers and courtesans, honest brushstrokes and automatist accidents, urinals and soup cans. Our enjoyment of either of these pleasures is always a form of collusion with the exercise of power, of course, but it is only so in a manner consistent with our age.

There is also a third pleasure proffered by the detail that is not properly fetishistic and, in a sense, not properly of our age. This is the detail that does not substitute part for whole in either traditional or modern ways but instead integrates part and whole in the pleasure of shared form. This sort of detail has long existed, even if it could also always be reclaimed and repurposed by fetishism of either sort. It was there in religious figures (think of how the mandorla or the Eucharist were used to conjure common cause, for example), in objects of secular absorption (the bubble in Jean-Baptiste-Siméon Chardin's *Soap Bubbles*, say, or the aesthetic itself as an Enlightenment ideal), in figures of involuntary memory (such as Marcel Proust's madeleine) and involuntary identification (Roland Barthes's *punctum*), and in details that speak through their abstraction to the inbuilt commons of form.

This last about the "commons of form" is a large topic as fundamental as it is familiar. Paul Cézanne's valiant struggle with "nature in terms of the cylinder, the sphere, and the cone" is an obvious example, as are the cubes of Picasso's Cubism and the geometric shapes of Kazimir Malevich's Suprematism. One testimony to the detail doing its work in this third sense can be found in Walter Benjamin's 1928 paean to Karl Blossfeldt's *Urformen*: Blossfeldt's photographs speak to "the deepest, most unfathomable forms of the creative," Benjamin gushed, the forms of "genius," of the "creative collective," of the "feminine and vegetable principle of life" (Fig. 49).[4] Instead of generating the immense authority of an externalized god or king or nature, and instead of diminishing our authority by reducing it to rank power over things and people-as-things given to us by market relations, the authority that Blossfeldt's close-ups presented to Benjamin was self-as-nature, self-as-god, self-as-king.

As distant as it is from the world we find ourselves in today, it is important to recall that the self Benjamin had in mind was not capitalism's isolated, individuated, lonely self but instead the self of his beloved "creative collective." The abstraction of cylinders, spheres, cones, and cubes, like that of madeleines, bubbles, and mandorlas, like that, in the end, of art historical details isolated from their original context, has always provided the language—the signs and syntax, the "feminine and vegetable principle"—of collective human self-creation. It is a matter of how that abstraction is seen, how it is felt, how it is owned, how it is venerated. Human autonomy is endlessly purloined as its wholeness is redirected to its parts, as we are redirected from the dream of enlightenment backwards to the premodern past's "estates of the realm" or forwards to the postmodern future's "nation of haves and soon-to-haves" (as American politicians have termed it of late). The great promise of art history's love of the detail, like its love of the whole of art, has always been to reach through the fetishization of power to the fullness of human self-determination on the other side.

Notes

1 Panofsky's label for that process, the reader will recall, was "aesthetic re-creation." Erwin Panofsky, "Introduction: The History of Art as a Humanistic Discipline," *Meaning in the Visual Arts: Papers in and on Art History* (Garden City: Doubleday Anchor Books, 1955), 14–15.

2 Michel Foucault, *The Order of Things: An Archaeology of the Human Sciences* (New York: Vintage, 1994), 5.

3 Theodor Adorno, *Aesthetic Theory*, trans. Robert Hullot-Kentor (Minneapolis: University of Minnesota Press, 1998), 244–45.

4 Walter Benjamin, "News about Flowers," trans. Michael W. Jennings, in *The Work of Art in the Age of Its Technological Reproducibility, and Other Writings on Media*, ed. Michael W. Jennings, Brigid Doherty, and Thomas Y. Levin (Cambridge, MA: Belknap Press, 2008), 273.

MATERIALITY

Figure 50. Martha Rosler, *Gray Drape*, from the series House Beautiful: Bringing the War Home, New Series, 2008 (artwork Martha Rosler © 2008).

Martha Rosler

Materiality and Objecthood: Questions of Sedimented Labor

Where does meaning reside? How do we read the shape of significance in things imbued with human interest? We can regard the embodiment of something, its objectness, separately from its physical existence and irrespective of its presence. Fixity is never far from human imaginings, from within the immaterial world we inhabit as the real, but modernity brings into question the solidity and permanence of objects in its own characteristic ways. In modernity's historical trajectory, science investigates atomic structure, and the space between atomic particles debunks the solidity of objects; artists embrace optical theories to produce representational paintings; and gentlemen chemists and others figure out how to fix a shadow, eventually even moving ones, allowing the visualization of units of space/time divorced from human sensory capacity, and further confronting viewers with the dilemmas of fidelity and the problematic boundary between metaphor and metonymy. Canals, then railroads and planes, free travelers from topography, while messages are sent through wires and then without wires, and other wires carry energy that allows human life to resist diurnal cycles. Attacks from the air, by balloon and then by plane, make death into a visualized abstraction. An artist of the revolution paints a black square over a whited-over landscape, announcing a new reality under construction, a preoccupation shared with members of the Western avant-garde—and all share a fascination with the aerial view. Texts, seeming more and more to be fixed, become unfixed, and the materiality of the text itself could be held to reside in the context of human reception, conferring on it a fluidity of signification despite its concrete realizations.

Surrealists doubled the presentation of everyday objects as simultaneously concrete and as significations, sweeping them into the realm of the uncanny; the schizophrenia of critical detachment in the reception of art experiences has been laid at the door of Marcel Duchamp, while perpetually living in the future has been the ordinary condition of everyday life for a century or more in the industrializing economies. The conditions of daily life have been cradled or buffeted by the pace of technological change, pulling the rug of the present out from under us. Heraclitus's aphorism "everything flows, nothing stands still" challenges the fixity of Platonic forms. (Plato's solution was to posit a distinction between the worlds of the sensible and of the real.)

The great economic and cultural transformations of the 1960s took place in the context of globalization and anticolonialism. A new worldwide mass image culture and a huge jump in the capitalization of artworks helped spur the radical redefinition of the work of art. From

Fluxus and performance to multiples and Conceptualism, artists took aim at received ideas about visuality, objecthood, ownership, and the very telos of art. Forget authorship! How necessary is it even to realize a work—might a set of instructions suffice? What if the work became the environment in which you (might) stand—as "installation," say?

Michael Fried, setting "presence" against "presentness," provided a handy way to frame the artistic chasm between artists' revolt and the expectations of high modernism. Reacting to Minimalism (or, as he dubbed it, literalism), Fried rejected the "theatricality" and temporal performativity—"duration"—of the work sharing the same physical space as the viewer, championing instead the critical distance he saw epitomized by "instantaneity." Fried's antiliteralism hangs onto the immateriality of the work of art (or to a conception of materiality as that which is in motion toward […]), a "thing" harboring an essence. In this rigid view, the problem with Conceptualism, another great concurrent movement, lies in its ever-present suggestion that it could as well reside in the collective memory of people as in concrete materiality or in that transcendent space, which—now that God was dead—could remain only immanent.

As tempted as I might be by the thought of a wholly immaterial/nonphysical artwork, in my own work I find the world of objects and their apparent impenetrability, their immobility, interesting enough. As a young painter, I had tried to answer the question how one locates a visual idiom that goes beyond a formal exercise and becomes a mode of representation. Despite the repressive and isolating doctrines of high modernism, the concerns of "citizenship" (for want of a better word) reasserted themselves; suddenly the "art world" became visible in relation to other social institutions and "systems," which helped enlarge the arena of action. Materiality and objecthood, questions of sedimented labor and the commodities circulating in the art world, became matters of intense interest to artists like me. Countercultural values and social activism pierced Cold War quiescence and acquiescence, giving rise to new social movements. I saw artists seeking greater autonomy from art world gatekeepers, those controlling monetary value and cultural value alike. Women artists were engaging in hermeneutical readings of modernist objects, contesting their reception as wholly genderless, while insisting on the deformalization of artistic production; this was the place for me.

I found it useful to reverse Fried's valuations, embracing what he condemned as theatricality; but rather than literalism, I moved toward Conceptualism's deemphasis of objecthood. I considered the familiar passages in Karl Marx on commodity fetishism and its origins in the mode of production; commodity fetishism, Marx posits, shapes our responses to much of the object world. Here was a more powerful route of inquiry, by my lights, than transcendence or sheer, dumb materiality.

It is this fetishism and the vexed status of the work of art to which I keep returning. My work puts forward a decoy, something that takes a familiar shape but that attracts people toward something else—an object or event, perhaps—that opens a door to a rather different set of concerns. The decoy challenges a naive concreteness, a commonsense positivist-empiricist view of things. Its thingness may be apparent, depthless while still impenetrable, yet it becomes, in effect, transparent in its wooden insistence on being there in front of you,

Figure 51. Martha Rosler, *Martha Rosler Library*, Paris, 2007 (artwork Martha Rosler © 2007).

with you. Looking for meaning, you are forced to look through it. Change the conversation! A "Garage Sale," a messy salesroom of discarded ordinary items, why is this array of unworthy objects in the art gallery? Propositions may lurk among the objects of desire and disgust—but where exactly is the work of art? That video of a woman reading the manual for an electric wok; is there something worth considering in an appliance manual?

Here is a room full of books, with tables and comfortable seating: a traveling library (Fig. 51). The books can be read and pages photocopied; where is the artwork here? If it is the library, is it looking at the artist or at the viewer, or does it make visible a universe of discourse out of which art is made, thought, performed? Photographs of skid-row storefronts are paired with lists of words, while the ostensible subject, the drunks, are nowhere to be seen; portraiture by other means, perhaps, but of whom—"us" or "them"? A partly erased TV newscast is overlaid with snippets of the newsman's words, making that flow suddenly visible, if not material. Images from a theater of war coincide, in the same frames, as anodyne ads for happy homes; we know about them both, but not in the same thought. Or take these flat-footed photographs of airports, ordinary roads, streets: we have been there, but what are they doing here?

The decoy, the "as-if"-ness, depends on a materiality that like any text is realized only in the contexts of its reception, which means that while materiality powerfully sets up a work, the thing itself, whatever it is, is not fixed, static, as a generation of audience studies has set out to prove. As Allan Kaprow observed, "Today," thanks to Duchamp, "critical discourse is inseparable from whatever other stuff art is made of." My work, standing amid the world of cultural objects, also wishes to make propositions and hypotheses for the receiver to make her own.

Medieval Materiality

We have long been told that theology in the European Middle Ages attributed to religious images a threefold function of teaching doctrine, preserving memory, and triggering a turn toward the divine. Or, as the titles of two important recent volumes put it, they induced "looking beyond" or "spiritual seeing." Yet, we are coming to realize that medieval devotional objects—panel paintings, three-dimensional sculptures, winged altarpieces, relics in their reliquaries, books of hours, altar furnishings, and so forth—should be understood as the immediate presence of the holy more than as indexes, icons, or symbols pointing to something else. They are not merely Lorraine Daston's "things that talk" but vibrantly active stuff, a locus of divine agency.[1] Although sacraments, relics, and images make the holy present in different ways, they were far less distinct to the medieval devout than modern studies suggest. And in the later Middle Ages, they all demanded of the viewer/recipient responses that were tactile, sometimes even gustatory, as well as visual. Pietàs and manuscript pages as well as relics and reliquaries were grasped, stroked, even kissed and tasted. We hear of devout persons who bit into relics or who, while praying, felt the stone of a statue become living flesh under their hands.

I focus here on the subset of religious objects modern scholars usually characterize as "images" or "art," although it is important to realize that the word *imago* in medieval discussions more often refers to a textual image, such as an analogy or concept. I want to argue that medieval images call attention to, indeed, thematize, materiality in ways art historians have not fully understood.

First, medieval images refer to their specific stiffness as what it is. The point of the leather that is pasted onto the robe of a wooden Madonna or the oval crystals inserted into the stomachs of Mary and Elizabeth in a Visitation group is not illusion or naturalism. The added materials call attention to themselves as such. The crystal is a crystal as well as a womb; its material announces it to be a valuable container parallel to a reliquary. In a Renaissance painting where the damask backdrop of a Madonna is painted to convincingly mimic cloth, the illusion calls attention to the painterly skill that produced it; exactly by tricking our eyes, it announces that it is not what it appears to be. When a medieval Madonna is literally clothed in brocade, the viewer admires not the skill of the execution but the actual stuff, which remains, to our eyes, stuff.

Second, medieval images thematize their materiality not merely by making crystals, brocade, and so forth apparent as such but also by referring explicitly to themselves as material. In an example I discussed in my recent book, *Christian Materiality*, the artist depicts on a manuscript page (that is, on parchment) Christ's body as a charter offering salvation.[2] The image presents Christ as skin (body) becoming skin (document) that is on skin (parchment).

Or to take another example, images of the side wound of Christ announce in rubrics written inside the wound that it is a length that can be multiplied to obtain the real measure of Christ's wound or of his height; such images were also reproduced on girdles tied around women to ease the pain of childbirth. Thus, the image of an opening speaks explicitly (by means of a text written on it) of itself as a physical measure; it also speaks metonymically of another opening (vagina or womb) parallel to Christ's because, as a mother gives birth to a baby, so Christ gives birth to the world. The image refers to itself both as what it represents (an opening) and as what it is (a mark of a certain length on the page).

Third, the stuff these images thematize is paradoxical. By its nature, it sublimates what it depicts. For example, winged altarpieces (which emerged in the European North about 1400) tend to be flat and sometimes even painted in grisaille on the outside; when opened (in the feast-day position), the side panels, although more highly colored, are also usually flat; the inner shrine tends, however, to be sculpted in high relief or in the round. Therefore, the closer the viewer comes to the central encounter with the holy, the more tactile and three-dimensional the scene. Space is left for viewers in their imaginations to move into the central shrine among the figures. Yet, the inner scene is usually not so much painted as gilded. More tactile, it is also more heavenly, sparkling in gold. In this way, the inner shrine both emphasizes and sublimates its stuffness. Paradoxically, then, it displays earthly, mutable, malleable stuff as lifted into heavenly changelessness.

Art historians have spent much time puzzling over the reaction of medieval Christians to the Second Commandment: "Thou shalt not make to thyself a graven thing, nor the likeness of any thing […] in heaven above, or in the earth beneath, or […] in the waters under the earth. Thou shalt not adore them nor serve them" (Exodus 20: 4–5).[3] How could such vibrant, three-dimensional religious art emerge in a tradition so suspicious of graven images? The very materiality of medieval objects is, oddly enough, a partial answer. For medieval believers understood another book of the Hebrew Scriptures, Genesis, to assert that the entire universe is God's creation and manifestation, or as Bonaventure said, God's footprints. Hence, the thirteenth-century nun Mechtild of Hackeborn could see, in a vision, that all earth's flora and fauna down to the smallest fleck of dust is caught up in the humanity of Christ, and the mystic Nicholas of Cusa could argue that Christ not only leads all creation back to God but also gives God to the world in creation. What medieval painters, sculptors, visionaries, and pilgrims encountered in churches was not so much images or "likenesses" as God in his handiwork. When statues and altarpieces, like relics and sacraments, called attention to themselves as material stuff, they asserted themselves to be creation, the expression of the divine.

Notes

1 Lorraine Daston, ed., *Things That Talk: Object Lessons from Art and Science* (New York: Zone Books, 2004).

2 Caroline Walker Bynum, *Christian Materiality: An Essay on Religion in Late Medieval Europe* (New York: Zone Books, 2011).

3 Douay-Rheims translation, 1609.

Natasha Eaton

Materiality of Color: South Asia

Holi—the coming of the Hindu New Year (Fig. 52)—is associated not only with the love between Radha and Krishna but also with the bravery of Holika, who, to save her devout nephew Prahlad from his evil father, sacrificed herself by immolation. Holi, as either Krishna's water play—the spraying of colored liquid at revelers—or as an instance of the royal carnivalesque, may have been a subject much celebrated by Indian artists, but it was avidly avoided, perhaps even feared, by European painters. The chucking, rubbing, or mixing pigments that takes place at the beginning of the Hindu spring month of Phalguna during Holi, with their tactility, enact its own kind of painting, while to throw dry and wet colors at the paper is to perform painting as a kind of Holi—that is, to partake joyously in sanctified games of playing with color. Although once ground from flowers (also used for medicinal purposes), today many of Holi's pigments are toxic. Color as sacred waste is noxious, even contagious.[1] Vertiginous and disorienting, color wreaks havoc with the conventions of its gendered coding and its engendering of what Edward Said has famously termed the colonial power politics of Western attempts to dominate the "East"—"Orientalism."

Maybe we can view the chromatic materiality of the artist's palette as one force field for approaching anew the visual cultures of colonialism. European artists and collectors *imitated to appropriate* the enchanted, color-filled technologies of Indian miniatures, which they deemed desirable rarities but which also carried the threat of becoming waste. The Hapsburg empress Maria Theresa ordered her court artists to cut, paste, and, in places, supplement the colors and compositions of precious Indo-Islamic images for their display in the *Millionenzimmer* of her palace in Schönbrunn, Vienna. With exposure to direct sunlight, their colors soon atrophied, giving them the appearance of sepia drawings—an art form viewed by her court as even more singular than painstakingly colored miniatures. This is just one of many instances where the mechanism of chromatic waste became an object of imperial desire: waste operates as the defining principle in affluent societies driven by the anxiety of scarcity.[2] Waste is not only nonproductive expenditure, it also inhabits a theory of imperial rubbish dependent on ambivalence and the politics of affect.[3]

To espy neglected, affective materials like pigments in South Asia is to account for the context-making effects of color. These effects smash divisions between objects and subjects, humans and things. After one of his opium-fueled hallucinations, nineteenth-century English writer Thomas De Quincey describes how he morphed (or anthropomorphized anew) into gold and an ancient Egyptian mummy, both of which constituted the mysterious substances of the colonial paint box.[4] For architect and arts administrator Owen "Alhambra"

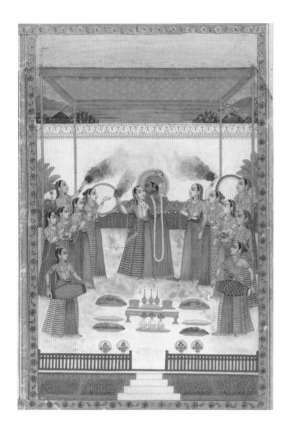

Figure 52. *A Holi Festival,* Lucknow, Avadh (Oudh), India, 19th century, opaque watercolor and gold on paper, 11⅜ × 7½ in. (28.9 × 19.2 cm). Freer Gallery of Art, Smithsonian Institution, Washington, D.C., Gift of Charles Lang Freer, F1907.255 (artwork in the public domain).

Jones, Oriental color promised respite from and inspiration for industrial design, as well as promising a remedy against the proliferation of dreary or garish synthetic dyes. But Jones's rigorous, isolated swatches of Eastern fabrics, reproduced as sumptuous, aniline plates in his tour de force publication, *The Grammar of Ornament* (1856), also expose the Victorian phobia of the ground-breaking potentialities of unregulated color. Maybe even today, we in the West "are nonsensuous creatures who are frightened of passions and the body. [...] The combustible mix of attraction and repulsion toward color brings out its magical qualities."[5] Here, Michael Taussig conjures up modernity's shamanism as a threatening, enchanting mimesis, which he associates with color's etymology as crime or deceit, as in Plato's *pharmakeus* as the grinder and mixer of multicolored drugs.

To be chromophobic is nonetheless to be chromophiliac, precisely because of our (un)certain obsession with color. Taking his inspiration from Roland Barthes's subtle musings on color as a kind of bliss, as a tiny fainting spell, David Batchelor claims that color causes us to fall into a state of grace.[6] But there would also seem to be a more forceful and affective politics at stake, since color, as *figure* (that is, what Jean-François Lyotard refers to as that space beyond speech where intensities are felt), induces a sentient blindness: *aporia as becoming* is then the space of color.[7]

British colonial officials deemed the "obdurate" figure of the Indian dyer to be marginal, poverty-stricken, or else entirely absent from those communities under the purview of the later nineteenth-century ethnographic state.[8] Their numerous surveys of dyeing across the Indian subcontinent conclude that colored cloth was infrequently worn and only then by liminal groups—Muslims, prostitutes, or tribals. Color is in, of the margins at that point where it might either lose its vitalism or gain an indeterminable currency. Perhaps it was this that made its nuanced recognition by colonial officials almost impossible. In the eugenically inflected thought of the ethnographic state, Indian use, abuse, or shunning of color registered a "primitivist" or degenerate inability to detect chromatic thresholds—a position that can be seen at its most polemical edge in the ambiguous case of elusive blue.

The redemptive/violent dimensions of color are best attested to during states of exception and moments of crisis. Blue—actual, virtual, and spectral—perhaps had the potency to destroy the critical, material realities of empire. Bengali indigo laborers physically fought and symbolically performed a massive rebellion against the British in 1860 in order to cast blue in terms of the specific identificatory criteria of both the evil eye (*nazar*) and the mirror (*nīl darpan*).[9] Revolutionary and sometimes revolting, the ingredients of the colonial palette—human/cow urine, wine, opium, beetles, arsenic, indigo, bulls' blood, and stinking human remains (mummy brown)—challenged those Indian artists who fought to register, recuperate, or remake the quasi-alchemical and ambivalent "sauvage/savage" of paint's materiality.[10] In the first three decades of the twentieth century, nationalist artist-writers Abanindranath and Rabindranath Tagore and Nandalal Bose injected color into the heart of their reactionary pedagogy, practice, and aesthetics by variously favoring Japanese wash, Buddhist mural techniques, or German inks. Then the Bengali painter Jamini Roy, possibly inspired by Mahatma Gandhi's advocacy of the curative powers of ingesting village soil, which was intended to anticipate the corporal, *sub*–grass roots level of an independent Indian political constitution, ground pigments from the rich red earth of Bankura, his home.

Jump-cutting to the state of becoming postcolonial, somewhere between the local and the global, offers us a glimpse into the rich colors of the South. Integral to the postcolonial South, color quivers as the figure, the flash, the bloodied, redemptive flesh of longing. This is perhaps best attested by Mexico's most poetic ambassador to India, Octavio Paz:

The uprising spring
Blue flame of cobalt
Burnt amber
Greens fresh from the sea
Mind's indigo …
The blue body of Kali
The sex of Guadalupe …
Wave upon wave of imminent oppositions
The canvas to body
[Color] dressed in its own naked enigma.[11]

Notes

1 G. Sudip et al., "The Holi Dermatoses," *Indian Journal of Dermatology* 54, no. 3 (2009): 240–42.

2 Nicholas Xenos, *Scarcity and Modernity* (London: Routledge, 1989).

3 For nonproductive expenditure, see Georges Bataille, *The Accursed Share*, vol. 1, *Consumption,* trans. Robert Hurley (New York: Zone Books, 1988).

4 Thomas De Quincey, *Confessions of an English Opium Eater* (London: Taylor and Hessey, 1823), 89.

5 Michael Taussig, *What Color Is the Sacred?* (Chicago: University of Chicago Press, 2009), 12.

6 Roland Barthes, "Cy Twombly, Works on Paper," in *The Responsibility of Forms: Critical Essays* (Oxford: Blackwell, 1996), 166, quoted in David Batchelor, *Chromophobia* (London: Reaktion, 2000), 12.

7 Jean-François Lyotard, *Discourse/Figure,* trans. Anthony Hudek and Mary Lydon (Minneapolis: University of Minnesota Press, 2011).

8 Ibid.

9 *Nīl darpan* means "indigo mirror." It is associated with the infamous play produced in response to the eastern Indian indigo revolt in 1860; Dinabandhu Mitra, *Nīl Darpan or the Indigo Planting Mirror, a Play,* trans. Michael Madhusudan Dutt (Calcutta: Seagull, 1997). See also Ranajit Guha, "Neel Darpan: The Image of a Peasant Revolt in a Liberal Mirror," *Journal of Peasant Studies* 21, no. 1 (1974): 1–46.

10 For Indian yellow made from cow urine, see Jordanna Bailkin, "Indian Yellow: Making and Breaking the Imperial Palette," *Journal of Material Culture* 10, no. 1 (2005): 197–214; for mummy brown, human urine, and human remains in art, see Natasha Eaton, "Nomadism of Colour: Painting, Technology and Waste in the Chromo-Zones of Colonial India, c. 1765–c. 1860," *Journal of Material Culture* 17, no. 1 (2012): 61–81.

11 Octavio Paz, "The Painter Swaminathan," in *The Collected Poems of Octavio Paz, 1957–1987* (Manchester: Carcanet, 1988), 45.

Michael Ann Holly

Materiality Matters

The *National Geographic* magazine of June 2012 contains a fascinating cover story on so-lar storms and the dangers they pose for this planet's technology. Replete with ultraviolet photographs of the "seething turmoil" in the sun's atmosphere, the report speaks of "planet-size prominences [that] rise into black space like glowing jellyfish, only to loop and slither back hours or days later, as if enthralled by some unseen force" (Fig. 53).[1] The history of art may possess neither the power nor the threat of a "titanic thermonuclear furnace," but clearly something is seething in this not-so-quiet corner of the humanities. *Materiality*, a concept long relegated to the dark fringes of the art historical universe, is bouncing back from a number of different directions. Might this renewed attention be, in part, an antidote, a reaction to digitalization? Before I wrote a word, I had been envisioning my assigned topic of materiality as a rising sun with various rays both bombarding and shooting out from it (Fig. 54). Armed with the cosmic enticements of the photo-essay, I was emboldened to carry on, if only metaphorically. To be sure, this illustrated attempt to stock my intuition with names, concepts, and categories that "loop and slither back" with each passing work of "hot" new scholarship could never be coolly accommodated in a mere note.

A working definition is in order. I regard materiality as *the meeting of matter and imagina-tion*, the place where opposites take refuge from their perpetual strife. This characterization, of course, lies in the background of many other slippery distinctions: surface/depth, vision/touch, subject/object, absence/presence, visibility/invisibility, meaningfulness/meaningless-ness, image/medium. Several "weighty" synonyms are perhaps unavoidable: corporeality, physicalness, substance, voluminosity, texture, tangibility, thingness, touchability. A prima-ry issue, it seems to me, is that the history of art has frequently sacrificed an attention to the material *presence* of works, and, by that, I certainly do not mean an attention to the materials of which they are composed. The obdurate physicality of things has often been repressed in the discipline because of its eagerness to energize some kind of meaning production, wheth-er configured as social contexts, stylistic developments, iconographic precedents, artistic genealogies, traces of gendered identities, psychoanalytic symptoms, and so on. At the other extreme, aesthetics long ago seduced the attention of philosophers of art away from objects so that they might dwell not so much with the stuff of world as in an abstract, rarefied realm (Hans Belting).[2] Consequently, it is quite refreshing to consider this rejuvenated fascination with the objectness of the object, maybe even the thing in its thingliness (to paraphrase Martin Heidegger).[3]

Figure 53. NASA/SDO/Goddard Space Flight Center Scientific Visualization Studio, wispy "plasma dancer" on the limb of the Sun, 2012 (photograph in the public domain).

Yes, it comes down to a matter of phenomenology and embodied perception, emblematized by Maurice Merleau-Ponty's ode to the "flesh" of the world: "things and my body are made of the same stuff [...]. The eye lives in this texture as a man in his house."[4] Why not take "physicality as seriously as possible" (James Elkins)?[5] Works of art are wrapped round by their own materiality, to which embodied spectators respond. The exchange need not be about locating meaning. Materiality (even virtual?) is something that gets in the way of certain kinds of thinking, sometimes even looking—if looking involves seeing through to something that lies before or behind or beyond. Materiality is that which halts transparency.

At one time or another, anthropologists seemed to come to art historians' aid, at first through studies of material culture (culture comes from stuff; things make people) and eventually through concepts of agency (Alfred Gell).[6] If not precisely animate, objects are viewed as enlivened by their material passage through the lives and loves of people. And then there is an allied claim. At the beginning of the twenty-first century, distinctions among humans, animals, and other forms of life, from microbes to marigolds, no longer seem as clear-cut as they once did in the aftermath of the Enlightenment. "Quasi-subjects" and "quasi-objects" (Bruno Latour)[7] are made of the same stuff, the stuff of this planet (maybe even its stars), so as inquisitive humans we do not so much work *on* this world as *within* it (shades of Heidegger). "After all, the world is around me, not in front of me" (Merleau-Ponty).[8] As embodied spectators we can—and often do—animate material works of art as though they are living things, capable of communicating novel ideas and principled commitments back to us. Thing theory has lent a suggestive "as-if"-quality not only to significant physical objects but also, and especially, to powerful works of art.

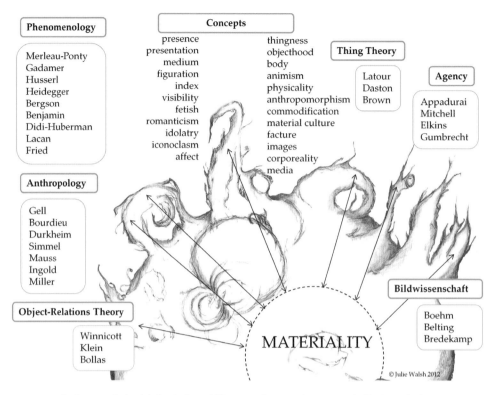

Phenomenology

Merleau-Ponty
Gadamer
Husserl
Heidegger
Bergson
Benjamin
Didi-Huberman
Lacan
Fried

Anthropology

Gell
Bourdieu
Durkheim
Simmel
Mauss
Ingold
Miller

Object-Relations Theory

Winnicott
Klein
Bollas

Concepts

presence
presentation
medium
figuration
index
visibility
fetish
romanticism
idolatry
iconoclasm
affect

thingness
objecthood
body
animism
physicality
anthropomorphism
commodification
material culture
facture
images
corporeality
media

Thing Theory

Latour
Daston
Brown

Agency

Appadurai
Mitchell
Elkins
Gumbrecht

Bildwissenschaft

Boehm
Belting
Bredekamp

MATERIALITY

© Julie Walsh 2012

Figure 54. Michael Ann Holly (with help of Julie Walsh), *Materiality*, 2012 (image provided by the author).

Materiality is more than a medium. A medium is that which carries a visual message, and together—structure and image—they result in the thickness, the sensuous materiality of a work of art, a thing among other things. Yet, in its physical vibrancy, its affect and effect, this special thing possesses a certain kind of agency. "Art historians may 'know' that the pictures they study are only material objects … but they frequently talk and act as if pictures had feeling, will, consciousness, agency, and desire" (W. J. T. Mitchell).[9]

And, finally, a note on this note. What if works of art are not material objects at all but instead are seen through their representations? Not only digital and video arts but also many performance arts, some conceptual arts, and so on, would seem to possess a medium without corporeality. As Bill Brown has recently maintained, "no matter how variously the term may be deployed, *materiality* has come to matter with new urgency" because of the "threat" that digital media pose in a wide range of disciplines from film to the history of science.[10] I would argue, nevertheless, that because these digital images manifest themselves as presences, that is, even though many of them are regarded as disembodied, they exist in the form of "as-if"-presences with different ontologies made real in the material world. They

enrich our perceptions, fill our consciousness, and add to our experiences "as if" something substantive has transpired. New media extend and expand our optical capacities, exceed our visionary capacities. They have a "texture" and character of their own. The *National Geographic* writer unwittingly offers us a synonymous phrase for this immaterial, material universe when he characterizes the solar magnetic fields as composed of plasma, what he calls the "fourth state of matter,"[11] neither liquid, solid, nor gas. As Belting would assert, the fact that the image is neither here nor there does not mean it is immaterial. It is an event in the world, a substance that occasionally is substanceless, evinces tangibility sometimes without physical touch, and even might cunningly illustrate materiality without being material.

Notes

1 Timothy Ferris, "Sun Struck," *National Geographic* (June 2012): 36–53.

2 Hans Belting, *An Anthropology of Images: Picture, Medium, Body*, trans. Thomas Dunlap (Princeton: Princeton University Press, 2011), 12.

3 Martin Heidegger, "The Origin of a Work of Art" (1960) and "The Thing" (1954), in *Poetry, Language, Thought*, trans. Albert Hofstadter (New York: HarperCollins, 2001).

4 Maurice Merleau-Ponty, "Eye and Mind" (1961), in *The Merleau-Ponty Aesthetics Reader: Philosophy and Painting*, trans. and ed. Galen A. Johnson (Evanston: Northwestern University Press, 1993), 125, 127.

5 James Elkins, "Limits of Materiality in Art History," Academia.edu, http://saic.academia.edu/JElkins/Papers/78187.

6 Alfred Gell, *Art and Agency: An Anthropological Theory* (Oxford: Clarendon Press, 1998).

7 Bruno Latour, *We Have Never Been Modern*, trans. Catherine Porter (Cambridge, MA: Harvard University Press, 2000).

8 Merleau-Ponty, "Eye and Mind," 138.

9 W. J. T. Mitchell, *What Do Pictures Want? The Lives and Loves of Images* (Chicago: University of Chicago Press, 2005), 31.

10 Bill Brown, "Materiality," in *Critcal Terms for Media Studies*, ed. W. J. T. Mitchell and Mark Hansen (Chicago: University of Chicago Press, 2010), 50.

11 Ferris, "Sun Struck," 44.

<div style="text-align: center; border: 1px solid black; display: inline-block; padding: 10px;">

Michael Kelly

</div>

Material and Sacred Artistic Agency

The turn to materiality in contemporary art and theory invokes the profane (for example, sensation, affect, empathy, desire, neuron, evidence, thing—or power), regardless of whether the materiality at issue concerns the artist, participant, or work of art. Yet, this turn is accompanied by a countervailing turn to the sacred in art (for example, presence, alterity, vitalism, the sublime, the transcendent, the immaterial, the spiritual—or power), which is imagined to be beyond materiality and even art. The connection as well as contrast between these turns should not be surprising if we remember that materiality implies not only the tangible physical world but also its structure, which is immaterial and sometimes associated with the sacred or sublime (such as chaos or complexity). We can see echoes of these divergent but connected turns in several developments in contemporary art. For example, conceptualism in art since the 1960s (not just conceptual art) entails both the *de*materialization of the art object and the materialization of art experience (as in installation, performance, and participatory art). And as technology from photography through digital media increasingly shapes the production, reception, and archiving of art, art assumes an immaterial appearance (that is, virtual, cyber), yet theorists recognize that digital media depend as much as traditional art media on material support (Fig. 55).

Are the turns to the sacred and to materiality as rivalrous as the classic form/matter distinction from which they likely originate? Does the tension between them represent the contemporary defiance or confirmation of Marx's critical insight about modernity in the *Communist Manifesto* that "All that is solid melts into air, all that is holy is profaned?" Or are these turns reflective of various attempts to counter or extend the limits or successes of contemporary art theory?

Alternatively, are these turns (also) complementary, if conflicting strategies for critiquing the (overly) subjective conception of modern art, namely, that the artist's agency (understood as autonomous creativity, representational powers, expressive needs, and the like), whether affirmed or resisted, has generated the logic(s) and meaning(s) of modern art? If so, there is a shared motivation between these turns to reconceive artistic agency without a primary focus on the agency of the artist.

One way to recognize what is driving this Janus-faced critique in art is to look at how technology and art are related to materiality. Technology is, in part, a set of practices and artifacts emerging from subjectivity's attempts to endure, understand, and control materiality. Over time, these practices and artifacts appear to acquire independence from the very

Figure 55. Francis Alÿs, in collaboration with Cuauhtémoc Medina and Rafael Ortega, video still from *When Faith Moves Mountains*, 2002 (Lima, Peru), video (36 minutes) and photographic documentation of an action (artwork © Francis Alÿs).

materiality that engenders them, to the point that technology seemingly renders subjectivity autonomous and itself immaterial. Similarly, art is, in part, a set of practices and artifacts enabling subjectivity to differentiate itself from materiality, culminating in art's as well as the subject's apparent autonomy (from society and nature). When technology progressively shapes the production, reception, and archiving of contemporary art, these two forms of subjectivity are compounded, making the break from materiality seem realizable, if not realized. In this light, art's turn to materiality in the digital age is a resistance to the subjectivization of technology and art alike. At the same time, because such subjectivization entails a disregard of the sacred, the turn to the sacred complements the material turn. In short, the turns share an object of critique—the (over)subjectivization of art (and technology)—even though they pursue different strategies of critique (Fig. 56).

However, the underlying issue here is not merely technology, the various iterations of materiality and the sacred, or even subjectivity. What is at stake is artistic agency, for the more art has become subjective and autonomous over the course of modern history, the more it seems to have lost agency (that is, power, aura, purpose, or function). One way to counter this loss—in an effort to ensure that art matters (again)—is to reconceptualize artistic agency, starting with a relative decentering of subjectivity and a measured disavowal of autonomy.

Figure 56. Lynn Hershman Leeson, image of Roberta Breitmore, screenshot from *Life²*, an ongoing artwork in Second Life (artwork © Lynn Hershman Leeson; image provided by the Kunsthalle Bremen, the Paule Anglim Gallery, Waldburger Gallery, and Bitforms Gallery).

Sometimes this reconceptualization involves a conflict between the material and the sacred, as we have seen, but sometimes the conflict is within the concepts of materiality or the sacred. For example, "materiality" can mean the "pure" or "base" materiality that alludes to art's Other as the source of artistic agency, which cannot be attributed merely to the artist but which is also not attributable just to the materiality of the artwork or the historical materiality of society. While this allusion leaves space for the sacred in the material, there is a similar conflict regarding the sacred because part of its essence is to be materialized in art, it is argued, yet no artistic materialization is adequate to the sacred. In both instances of conceptual conflict, what is invoked is an agency that cannot be reduced to human artifice, whether art or technology, though neither artifice is possible without it (Fig. 57).

The reconceptualization of artistic agency is complicated. Although modern artists reasonably imagined they would acquire more agency once art became autonomous (as autonomy is equated with freedom), they eventually realized that subject-based artistic agency has lost efficacy because autonomy implies distance (whether as withdrawal or exclusion) from the world stage on which agency can be enacted. So modern artists gradually, if unwittingly, ceded autonomy by relinquishing subjective agency (considered as authorial control) to the unconscious, desire, affect, sensation, neurons, and other modes of

Figure 57. Marina Abramović. *The Artist Is Present*, 2010, The Museum of Modern Art, New York (artwork © 2012 Marina Abramović; photograph by Jonathan Muzikar, © 2012 The Museum of Modern Art, New York, courtesy the artist and Sean Kelly Gallery).

materiality that sometimes, however, are couched in terms of the sacred (for example, play or chance) because it, too, is beyond the autonomous subject. In effect, because the various iterations of materiality and the sacred embody art's heteronomy, modern artists exchanged autonomy for heteronomy (Fig. 58).

Put in more positive terms, we are now in a position to avow the heteronomy of contemporary art, albeit with a critical eye (granted, once the link between autonomy and critique is reconceptualized), and to understand artistic agency as a function of the conflicting and converging modes of agency in the artist, participant, work of art, and their shared, if disjunctive, worlds. As such, artistic agency may dethrone the artist as an autonomous agent, but it also secures the avowal of heteronomy as a condition for art's relative autonomy; it may deconstruct the subjectivity of the participants as well, but it occasions and anchors their collective participation in art; and it provides objective credentials beyond subjectivity for the work's historical roles as evidence, witness, or the like. The turn to materiality, especially if interpreted in connection with the turn to the sacred, allows us to recognize the avowal of heteronomy as a way to understand artistic agency in contemporary art.

Figure 58. Doris Salcedo, *For Hans Haacke and Edward Fry*, 2009, framed archival pigment inkjet print on Hahnemühle Photo Rag, 29⅛ × 39⅜ in. (74 × 100 cm) (artwork © Doris Salcedo; image courtesy of Alexander and Bonin, New York).

Art is practiced in the heteronomous spaces between the sacred and the material, turning one way, then the other, sometimes simultaneously. For art is the enactment of a composite agency inspired in the material processes of producing, experiencing, and conceptualizing works of art. A major task of aesthetic theory today is to make better conceptual sense of this composite artistic agency in relation to particular forms of contemporary art and their various aspirations, operations, and effects.

Materiality Is Somewhere Else

A photograph that Timothy H. O'Sullivan took for a geological survey in the American West led by Clarence King depicts a miner wielding a pickax against a rocky tunnel wall (Fig. 59). The photograph speaks to the durability of this geologic matter, which gives way to the hammering iron only chip by chip. It thus speaks as well to the hard labor of the miner, whose material existence a ruthless industry has cramped. O'Sullivan has composed the photograph around these unyielding matters. The arm and the pickax occupy the center, directing our attention to the act of striking the rock, which concentrates the miner's bodily force on a single point in the shallow depression he has hewn. The rocky slab rises between two posts, while two boards extend toward us from below, giving the composition an internal frame and a rough symmetry. The miner sits on one board, and the wheel of a cart rests on the other. The pairing reminds us of the mechanical motions of the miner, who must trace arcs with his pickax time and again, as his labor grinds on.

This description of the photograph suggests that it is all about materiality, and in a sense it is. But then again, this description has treated the photograph as an image, which is to say, as something immaterial. My description would apply to a glass negative in the National Archives, Washington, D.C., an albumen print in the collection of the George Eastman House, Rochester, New York, a duotone reproduction in a magazine, or a digital reproduction on a computer screen. It focuses on issues of iconicity and composition that the image retains from one material instance to the next and ignores the reproductive economy itself. Although art history is thought to celebrate originality and uniqueness, it has always trafficked heavily in reproductions and shaped itself intellectually around the aesthetic qualities that thrive in its reproductive chains. When I treat O'Sullivan's photograph as if it were an *image* all about materiality, I am implicitly insisting that the particular materiality of the photograph—in all its instances—does not in fact matter.

On this score, O'Sullivan is ahead of me, because his photograph recognizes its materiality as a photograph through analogy and trace. The position of the miner echoes that of the photographer: each is an agent of western enterprise who brings a light into darkness to work a silver-bearing surface by framing it up, taking aim, and hoping for a lucky strike (O'Sullivan made the picture in a silver mine and used plates coated with a silver emulsion). Even as this analogy wheels us back to the labor of photography, traces in the photograph recall the light and time that this labor requires. The glare on several surfaces and the two threads of light that drop in from the left are remnants of the ignition of magnesium powder that O'Sullivan used to illuminate the tunnel. Although we associate flash photography with

Figure 59. Timothy H. O'Sullivan, *At Work—Gould & Curry Mine*, January–February 1868, albumen print, 7 × 7⅝ in. (17.8 × 19.4 cm). George Eastman Museum, Rochester, N.Y. (artwork in the public domain; photograph courtesy of George Eastman Museum).

crisp depictions of moving bodies, his flash lasted too long to catch the miner in the act of swinging his pickax. The labor we see is staged: we can detect the miner's static pose in the placid muscles and tendons of his arm. In the moment of production, an expenditure of one precious mineral, magnesium, illuminated a search for another, silver, which was being expended along with time to make the photograph. In this way, O'Sullivan deposited many signs of the material economy of his labor. These signs survive the translation from photograph to image but always remind us of what does not.

The photograph of the miner offers us an occasion to rethink the relation of materiality to modernism. There is much caricaturing of modernism these days that cabins its reflexive ambitions within the confines of a rarified concern for medium specificity or vague drivel about purity or presence. But so much great modernist work vitally addressed the material conditions of its production far beyond arty issues of medium, and in so doing plunged headlong into impurity and absence. To me, O'Sullivan is a modernist of the first water not because he anticipated or influenced later photography (most practitioners who have claimed him as an inspiration have not followed his example in any meaningful way) but because his work so trenchantly recognizes its material demands and implications. This kind of modernist reflexivity was always directed against the making of objects into images, a principal function of commodification.

Remembering the material dimensions of modernist reflexivity is particularly important now, when our desire to make the world into images has attained such spectacular

and dismal fulfillment. The museum without walls and the commercial arcade have given way to the humming streams of cyberspace, which disseminate digital imagery to seemingly every purse and pocket. Where the flaneur once roamed in search of modern delights, ear-budded pedestrians text and tweet. When it comes to visual culture, our fluid screens are hegemonic, and everything else is on the margins: odd, inert, and quaint. Analogue photography, which once, in comparison with older pictorial media, seemed de-skilled and dematerializing, now appears difficult, tactile, and dense. Anything fashioned by an individual without keyboard or mouse has an aura of lost artistry and reminds us, however briefly, of the real. Photographs might as well be paintings.

Although this may not be cause for nostalgia, it is certainly grounds for reconsidering what kind of materiality matters most now. The dialectical materialism of Karl Marx insisted that social life is essentially practical. As Slavoj Žižek has perspicaciously suggested, this axiom implies that the place of ideological illusion is not in the knowing but in the doing.[1] If, for example, my belief in a crisis of human-induced climate change and other impending ecological devastations does nothing to change my practical habits, my belief is immaterial. Being aware and informed offers no protection in itself against ideology. This reconsideration of materiality brings up the question: Which of the matters that are lost in the making of images are most vital to remember now in the course of taking practical action? In light of the climate problem, our energy woes, and the plight of the working class, mining may be as good a place to start as any.

As we proceed, we might remember the inexorableness with which materiality leads us back to tautology. To write that O'Sullivan's photograph speaks grimly of its materiality in ways that we can reconstruct from a reproduction is not to enter into the materiality of his photograph per se but rather to write about it. Today, writing means tapping on plastic keys, staring at a screen, and establishing a pattern of distraction. This, in turn, requires a material substrate that we rarely think about. A personal computer commonly contains aluminum, antimony, arsenic, barium, beryllium, cadmium, chromium, cobalt, copper, gallium, gold, iron, lead, manganese, mercury, palladium, platinum, selenium, zinc, and even silver, in a trace amount. The fluorescent bulbs in most offices contain rare earth phosphors, tungsten, and mercury vapor. The massive servers that handle Internet searches run on electricity, the leading global source of which is coal. Materiality never arrives in an argument any more than it arrives in an image. But if we are ever to act on what we know, then we ought to know what we do, which means seeing our materiality in the work of another. As I labor through my paragraphs, this is what I am aiming at: somewhere else, someone is mining.

Note

1 Slavoj Žižek, *The Sublime Object of Ideology* (London: Verso, 1989), 28–35.

Alisa LaGamma

A Lexicon of Meaningful Artistic Media

Over the last century, "African art" in Western consciousness has become synonymous with wood sculpture. This reflects the fact that wood sculpture is the dominant form of material culture from the region represented in museum collections. Yet, sub-Saharan Africa's legacy of material culture is actually distinguished by the sheer variety of media harnessed by its artists. This diversity of materials sometimes reflects pragmatic choices based on what has been most readily available. More often, a work's medium has been selected for conceptual associations calculated to enrich its content. In African art, form and material are inextricably linked in the definition of a work's aesthetic and intended meaning.

Local resources such as gold, copper, and ivory, identified with life force and physical might, were drawn on to create artifacts of great prestige, which were exported globally through trans-Saharan and coastal trade (Fig. 60). While the gold regalia of Akan notables in Ghana were recast every generation, north of the Limpopo River at the thirteenth-century site of Mapungubwe, elites were buried with distinctive gold artifacts conceived to define them for eternity. Of equal importance has been the inspired translation of ordinary matter, such as mud or clay and stone, into sculptural and architectural landmarks. At Djenne, in present-day Mali, generations have resurfaced and reshaped the ever evolving form of its Great Mosque, the world's most monumental adobe structure. In contrast, the incalculable labor required to produce the pilgrimage site of Lalibela in northern Ethiopia is so beyond contemporary imagination that angels are credited with its miraculous apparition. There, in the twelfth century, an epic excavation of living rock transformed the lithic landscape into a complex of thirteen churches. About the same time, Zimbabwe's granite hills and boulders were refashioned into the massive structures of Great Zimbabwe that are striking for their organic blend of natural blocks and coursed and dressed masonry laid with meticulous care and precision.

Expanding the repertory of matter that defines major forms of expression has been a priority for ritual specialists in West and Central Africa, who have mined the natural world for potent ingredients, such as porcupine quills, bird skulls, antelope horns, termite mounds, and earth. Exactingly customized blends of such esoteric matter are added to the surface of Komo headdresses or to the interior cavities of power figures carved out of wood by Senufo, Bamana, or Kongo sculptors (Figs. 61 and 62). Each of these collaborative creations is essentially defined by its unique composition. Artists have also exploited imported matter for its rarity, exoticism, or novelty. Access to European brass fueled the casting of a diverse

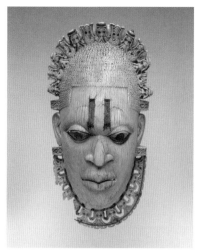

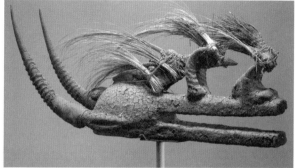

Figure 60. *Queen Mother Pendant Mask*: Iyoba, Edo peoples, court of Benin, Nigeria, 16th century, ivory, iron, copper, 9⅜ × 5 × 3¼ in. (23.8 × 12.7 × 8.3 cm). The Metropolitan Museum of Art, New York, The Michael C. Rockefeller Memorial Collection, Gift of Nelson A. Rockefeller, 1972 (1978.412.323) (artwork in the public domain; photograph © The Metropolitan Museum of Art).

Figure 61. *Kòmò Helmet Mask (Kòmòkun)*, Komo or Koma Power Association, 19th–mid-20th century, wood, bird skull, porcupine quills, horns, cotton, sacrificial materials, 13⅞ × 33¹¹⁄₁₆ × 8¹¹⁄₁₆ in. (35.2 × 85.6 × 22.1 cm). The Metropolitan Museum of Art, New York, The Michael C. Rockefeller Memorial Collection, Bequest of Nelson A. Rockefeller, 1979 (1979.206.150) (artwork in the public domain; photograph © The Metropolitan Museum of Art).

repertory of sculptural genres at the court of Benin; glass beads from Asia and eastern Europe inspired the proliferation of forms of personal adornment across the continent; and the aluminum detritus of beverage bottling companies in eastern Nigeria has been resuscitated in the contemporary handwoven sculptural panels and installation pieces by El Anatsui.

An incisive appreciation of the material creations of African artists provides a critical point of entry into their world-views, ideals, aspirations, and concerns. This is especially the case for cultures that have undergone profound transformations and for which few other documentary sources survive. The relatively small fraction of Africa's precolonial material culture that is preserved in institutional collections in the West was itself for the most part minimally documented before it was dispersed internationally. The sudden and wholesale uprooting of this heritage by Europeans from the end of the nineteenth to the mid-twentieth century has made it challenging to form a coherent vision of the artistic legacy of particular communities. Science is increasingly allowing us the means to analyze the physical composition of such precious primary sources in great detail. Tools such as polarized light microscopy, X-ray fluorescence, and X-ray diffraction are affording exhaustive descriptions of individual artifacts. In order to interpret those data, however, it is necessary to relate them to an understanding of the culturally specific qualities ascribed to particular materials.

Figure 62. *Power Figure (Nkisi N ' Kondi: Mangaaka),* Kongo peoples, D.R.C or Republic of Congo, mid to late 19th century, wood, paint, metal, resin, ceramic, height 46 ⁷⁄₁₆ in. (118 cm). The Metropolitan Museum of Art, New York, Purchase, Lila Acheson Wallace, Drs. Daniel and Marian Malcolm, Laura G. and James J. Ross, Jeffrey B. Soref, The Robert T. Wall Family, Dr. and Mrs. Sidney G. Clyman, and Steven Kossak Gifts, 2008 (2008.30) (artwork in the public domain; photograph © The Metropolitan Museum of Art).

For all its fragmentary nature, Africa's scattered material culture is especially precious in light of the fact that its precolonial creations constitute the only direct points of historical engagement between us and their authors. In societies that relied on oral traditions for the transmission of information, the artistic record remains the only fixed primary source concerning the past. In *A History of the World in 100 Objects*, Neil MacGregor foregrounds our reliance on the interpretation of material culture as the primary means of obtaining insight into the chapters of human experience without texts.[1]

This past year, I gathered together a diverse corpus of works produced in eight distinct artistic centers across West and Central Africa as the focus of the exhibition *Heroic Africans: Legendary Leaders, Iconic Sculptures*, which considered the overarching significance of an array of sculptural traditions conceived as material markers for influential men and women.[2]

As enduring material surrogates for their subjects, those creations embodied the aspirations of individuals to define and extend their legacy beyond their lifetime. The artists charged with their creation afforded their influential subjects a lasting physical presence within their communities. These landmarks filled the void that was the inevitable result of their mortality and provided important points of reference through which they might be invoked. In many instances, it was possible to relate specific works to their origin subject through oral traditions that had been recorded (Fig. 60). For the vast majority, however, it was clear that although the impetus for their creation had been an important individual, the

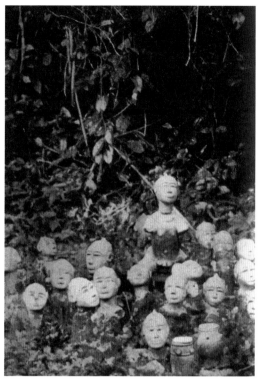

Figure 63. *Commemorative Figure of a Chief (Lefem)*, Bamileke peoples, Bangwa chiefdom, Grassfields region, Cameroon, 19th century, wood and organic matter, 38 × 13 × 11½ in. (96.5 × 33 × 29.2 cm). The Metropolitan Museum of Art, Gift of Sidney and Bernice Clyman, 2015 (2015.763) (artwork in the public domain; photograph © The Metropolitan Museum of Art).

Figure 64. Ancestral shrines to Oba Ovonramwen (reign 1888–97) and Oba Ekewa II (reign 1914–33), Royal Palace, Benin City, Nigeria, 1970. Eliot Elisofon Photographic Archives, National Museum of African Art, Smithsonian Institution, Washington, D.C., EEPA EECL7595 (artwork in the public domain; photograph by Eliot Elisofon, © Eliot Elisofon Photographic Archives, National Museum of African Art, Smithsonian Institution, Washington, D.C.).

works themselves constituted the only surviving trace of the very existence of those figures who can no longer be specifically identified.

Often, such works were themselves the concrete site of veneration through which their subjects were petitioned on an ongoing basis. Both the forms of representation and the rites and customs developed to activate these material points of engagement took many different forms. Often, the surfaces of sculptures that acted as living shrines were altered through the accretion of layer upon layer of applied libations (Fig. 63). Also striking is the often emphatic density of accumulated material culture assembled as the point of connection with revered ancestors. For example, at the court of Benin in Nigeria, altars dedicated to the memory of particular kings featured an array of carved ivory and brass artifacts in addition to brass

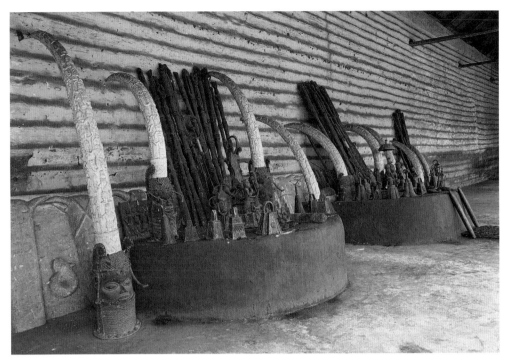

Figure 65. Deposit site of memorial terra-cottas, near Agona Swedru, Ghana, ca. 1898–1911. Basel Mission Archives, D-30.23.023 (artwork in the public domain: photograph by Otto Lädrach, provided by Basel Mission Archives / Basel Mission Holdings).

commemorative heads associated with that particular leader (Fig. 64). Outside Akan communities of Ghana and Cote d'Ivoire, rites celebrating the passage of distinguished individuals culminated with the deposition of ceremonial terra-cottas at dedicated groves defined by enormous piles of sculptures accrued over generations (Fig. 65). Among the most sublime sculptural creations are the figures carved by Hemba masters in the Democratic Republic of the Congo to commemorate exceptional members of a chiefly lineage (Figs. 66 and 67). These monumental wood sculptures gave material expression to a leader's claim to a particular territory and allowed him to petition his ancestors on behalf of the community in times of crisis. A great family might possess as many as twenty. Although such bodies of work were inaccessible to all but the chief, their emphatically expansive presence within a dedicated structure adjacent to his residence was nonetheless apparent to all (Fig. 68).

The choice of the media for such monuments was culturally determined—costly locally harvested ivory and imported metals were favored by the kings of Benin, common clay closely associated with Creation was harnessed by Akan and Yoruba notables, while various locally available hardwoods were the choice of ambitious patrons in other centers across West and Central Africa. Ultimately, their shared imperative was to furnish these elites with

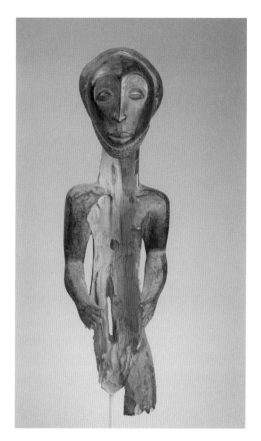

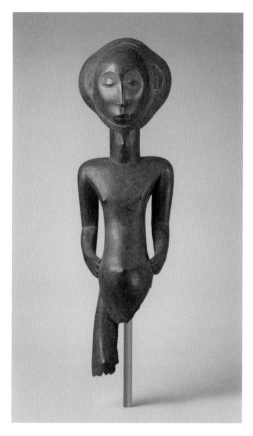

Figure 66. *Commemorative figure*, Hemba peoples, Niembo group, Mbulula region, Democratic Republic of the Congo, 19th–early 20th century, wood, height 27⅞ in. (71 cm). Private Collection (artwork in the public domain; photograph © The Metropolitan Museum of Art).

Figure 67. *Commemorative Figure*, Hemba peoples, Niembo group, Mbulula region, Democratic Republic of the Congo, 19th–early 20th century, wood, 26¾ × 7⅞ in. (67.9 × 20 cm). Private Collection (artwork in the public domain; photograph © The Metropolitan Museum of Art).

a material landmark. In each instance, the representations were conceived as tributes that afforded influential individuals a concrete locus as an extension of their ephemeral bodily being. The form of material expression that most blurs the boundaries between physical bodily presence and evocative representation is that of the many distinctive reliquary traditions sponsored by extended families across equatorial Africa. Those of the Kota from Gabon and the Republic of the Congo and of the Fang from southern Cameroon, Equatorial Guinea, and Gabon are the best known for the sculptural elements that have survived (Fig. 69). These were the profane accessible dimension of portable shrines within which relics drawn from distinguished ancestors were preserved in attached hide bundles or bark containers. The sacra assembled within, crania and bones relating to as many as nine different

Figure 68. *Installation View of the Hemba Circle, Heroic Africans, Legendary Leaders, Iconic Sculptures,* The Metropolitan Museum of Art, New York, September 2011–January 2012. The Metropolitan Museum of Art (artwork in the public domain; photograph © The Metropolitan Museum of Art).

generations of familial ancestors, were identified with exceptional individuals conceived as especially effective advocates with the divine. Their highly abstract figurative sculptural corollaries were, in contrast, associated with the entire extended family. The physical immediacy of carefully composed reliquary ensembles allowed the experiences of past generations of an extended family to remain vivid. A young person's education consisted of mastering his family's genealogy, which was made manifest through its constituent relics and ritual performances in which both sacra and sculptural elements were manipulated by elders.

Across Africa, material works of art were crucial to keeping their subjects alive and their example relevant in the memory and imagination of members of their community. They survive from earlier periods as far more than footnotes that provide insights into broader historical narratives. Instead, in the absence of contemporaneous written diaries, journals, or any fixed literary texts and musical scores, they constitute the only direct expressions relating to major societies. At the same time, this material culture represented but one dimension of forms of expression that were originally integrated into dynamic contexts in which song, dance, and ritual performances expanded on their significance. Conceived

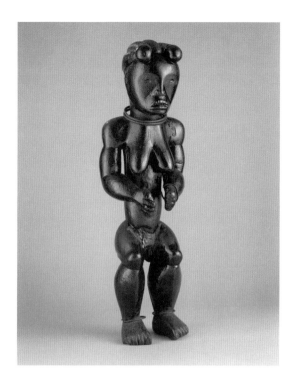

Figure 69. *Figure from a Reliquary Ensemble: Seated Female*, Fang peoples, Okak group, Equatorial Guinea or Gabon, 19th–early 20th century, wood, brass, oil, height 25³⁄₁₆ in. (64 cm). The Metropolitan Museum of Art, New York, The Michael C. Rockefeller Memorial Collection, Gift of Nelson A. Rockefeller, 1965 (1978.412.441) (artwork in the public domain; photograph © The Metropolitan Museum of Art).

as tangible bridges with the past for members of their own communities, these enduring physical creations now serve that role for all of humanity. The material record, MacGregor notes, gives back to their creators a voice through which history may be told.[3]

Notes

1 Neil MacGregor, *A History of the World in 100 Objects* (London: Viking, 2010), xix.

2 Alisa LaGamma, *Heroic Africans: Legendary Leaders, Iconic Sculptures* (New York: Metropolitan Museum of Art, 2011).

3 MacGregor, *A History of the World*, xvii.

Monika Wagner

Dust: Recomposing the Decomposed

Dust: Literally as well as metaphorically, dust appears as the sediment of time. Dust is found everywhere, at first invisible, but constantly accumulating and sooner or later becoming visible. Dust is *the* entropic material; it permanently confronts us with the end of all things and forms. As the *decompositum* of former objects, materials, or living beings, dust is the paragon of deformation. Though it is persistently and uncompromisingly fought in the daily routine, in art dust has acquired the status of *vanitas*.

In the hierarchy of materials, dust ranks as useless residue—literally, as having dropped to the lowest level—and is considered to be an extremely poor substance. This is already verified in the patristic literature, with its scaling from dust to gold. From the middle of the nineteenth century, the sciences began to study dust systematically, as one can see in the micrographs of Christian Gottfried Ehrenberg (Fig. 70).[1] Such illustrations were popular enough to prompt caricatures, because the microscopic forms of dust, invisible to the human eye, seemed intriguingly unreal.

Dusting—a project of modernism: Walter Benjamin characterized plush, the material epitome of the late nineteenth-century historicist interior, as "dust traps."[2] These traps were dusted and purified by the avant-garde's uncluttered surfaces. To dust the masterworks of traditional museums, which is like dusting a neo-Baroque interior, was Robert Filliou's concern in the 1970s: the fluffy dusting cloth in a cardboard box, together with a photograph of a famous museum's exhibit being dusted by the artist with a cloth exactly like the one in the box, claim that the fabric physically preserves the dust of the masterwork, like a contact relic (Fig. 71).[3] Moreover, the cluster provides the owner of the work with an instrument for literally participating in the dusting project. While Filliou in a witty gesture demonstratively blew off dust, Marcel Duchamp—like many later artists—virtually celebrated it in an objection to the overall purifications of the early avant-garde.

Getting dusty: Duchamp contaminated the modernist clearing by allowing the dust to settle as a visible trace of passing time on his uncompleted *Large Glass* (Fig. 72).[4] Already in 1875, John Ruskin had praised "the ethics of the dust" as "golden stains of time." In doing so, Ruskin defended the patina of stone surfaces of centuries-old buildings.[5] By contrast, Duchamp's "dust breeding" took only half a year, with the dust accumulating on the glass panels of the unfinished picture that the artist had left lying on the floor of his New York studio while he traveled in Europe. The avant-garde ideal of gloss, transparency, and immateriality embodied in glass thus turned opaque, dull, and dirty. Man Ray fixed the

Figure 70. Christian Gottfried Ehrenberg, *Dust from Scirocco,* engraving, from *Passat-Staub und Blut-Regen,* Berlin, 1849 (artwork in the public domain; photograph provided by the Universitätsbibliothek Augsburg).

Figure 71. Robert Filliou, *Poussière de Poussière de l'effet Frans Hals, La Bohèmienne,* 1977, box with duster and photograph, 2½ × 6½ × 4¾ in. (6.2 × 16.5 × 12 cm). Andersch Collection, Neuss (artwork © Marianne Filliou; photograph provided by Andersch Collection, Neuss).

ephemeral "dust breeding" in a photograph, the irregular texture of the dust appearing on the glossy surface.[6] When the photograph was published in 1921, uncropped and with captions, in the Surrealist magazine *Littérature,* it provided an extraterrestrial view of a planet made of dust.

In Duchamp's *Dust Breeding,* the dust, to which Georges Bataille devoted an entry in his *Dictionnaire critique* in 1929, already appeared to be on the path to victory:

> When plump young girls, "maids of all work," arm themselves each morning with a large feather-duster or even a vacuum-cleaner, they are perhaps not completely unaware that they are contributing every bit as much as the most positivist of scientists to dispelling the injurious phantoms that cleanliness and logic abhor. One day or another, it is true, dust […] will probably begin to gain the upper hand over domestics.[7]

Figure 72. Man Ray, *Dust Breeding*, 1920, gelatin photograph of Duchamp's *Large Glass*, 4½ × 6¾ in. (11.4 × 17.2 cm). Manfred Heiting Collection, Amsterdam (artwork © Man Ray Trust, Paris / VG BildKunst, Bonn 2017).

Refiguring dust: During further work on his "definitely unfinished" picture, Duchamp fixed parts of the dust with varnish. The shapeless stuff was thus refigured as brownish cones, only to be crushed again within the narrative of the picture by the chocolate grinder. Forty years later, Joseph Beuys refigured dust and benefited from the rhetoric of the poor material for *Halved Felt Cross with Dusted Pictures "Magda"* (Fig. 73).[8] A vaguely shaped figure of fluff glued to paper and kept under glass was five years later, in 1965, mounted on a "halved felt cross [Halbiertes Filzkreuz]," correlating dust with felt—a material made of waste, such as hair.[9] The title *Staubbild Magda* refers to Mary Magdalene, the penitent who threw herself into the dust before Jesus and who is depicted in traditional iconography robed only in her own hair. Beuys saved the dust as Christ had saved the sinner. Dust here evolves from an entropic material to become part of an everlasting cycle, in which materials are continually transformed.

Raising dust and reading dust: Since the 1980s, when memory and the archive became major concepts in the humanities, many artists have used dust as the debris of destruction and annihilation.[10] While some treat dust as a witness to historic incidents or disasters, such as Xu Bing in his *Dust Project* referring to 9/11, Claudio Parmiggiani shows in his shadow library traces of vanished books that can be tracked in the dust. In the late 1980s, the Austrian experimenter Erwin Wurm also raised lots of dust. Though his "dust sculptures" indicate

Figure 73. Joseph Beuys, *Halved Felt Cross with Dust Picture "Magda,"* 1960/1965, felt, picture frame with image in handwriting and dust on paper, wire, 42½ × 26¾ in. (108 × 68 cm). Museum Ludwig, Cologne (artwork © VG Bild-Kunst, Bonn 2017).

passing time and change, showing the traces of objects withdrawn from showcases, the artist positioned himself beyond the pathos of authenticity, which is easily invoked by the paradigm of the absent. Instead, he plays with the stimulation of the imagination. Wurm avoids elevating the absent as historically prominent and he keeps the origin of the dust traceable. For, like a conceptual artist, Wurm sells certificates for realizing dust sculptures (Fig. 74). With the certificate for "Dustpiece o.T." from 1990, Wurm gives a demystifying instruction on "how to make the dust":

> take the dust of a vacuum cleaner and put it into a t-shirt. Hold the bag ca. 30 cm over the pedestal and start beating the bottom of the bag with the other hand—while doing it go all ways around the pedestal [...]. The dust should look like the amount of dust which is falling naturally in aprox. 2 weeks![11]

Wurm's instructions for producing dust in time-lapse motion at home recycles not only symbolically but materially the ever accumulating dust and matter-of-factly reconciles us with the inevitable.

Figure 74. Erwin Wurm, *Certificate, Instructions to Install the Dustpiece*, 1990, felt-tip pen on paper, 11¾ × 8½ in. (29.7 × 21 cm) (artwork © VG Bild-Kunst, Bonn 2017).

Notes

1 Jens Soentgen, "Die Kulturgeschichte des Staubes," in *Staub—Spiegel der Umwelt*, ed. Armin Reller and Jens Soentgen (Munich: Oekom, 2006), 15–31.

2 Walter Benjamin, "Aufzeichnungen und Materialien," in *Das Passagen-Werk*, in *Gesammelte Schriften*, ed. Rolf Tiedemann (Frankfurt: Suhrkamp, 1982), vol. 5, pt. 1, 158.

3 *Robert Filliou 1926–1987: Zum Gedächtnis*, exh. cat. (Düsseldorf: Städtische Kunsthalle, 1988), 98–99.

4 Jonathan R. Fardy, "Double Vision: Reviewing Man Ray and Marcel Duchamp's 1920 Photo-Text" (MA thesis, Bowling Green State University, 2007); David Campany, "Man Ray and Marcel Duchamp: Dust Breeding 1920," in *Singular Images: Essays on Remarkable Photographs*, ed. Sophie Howarth (London: Tate Publishers, 2005), 47–53; and Elio Grazioli, *La polvere nell'arte* (Milan: Mondadori, 2004), 55–60. See also David Campany, *A Handful of Dust* (Paris, 2015).

5 John Ruskin, *The Ethics of the Dust*, in *The Works of John Ruskin*, ed. E. T. Cook and Alexander Wedderburn (London: Allen, 1905), vol. 18. For Jorge Otero-Pailos's project from 2009 referring to Ruskin, see Caroline A. Jones, "Dusting," in *Jorge Otero-Pailos: The Ethics of Dust; Thyssen-Bornemisza Art Contemporary*, eds. Eva Ebersberger and Daniela Zyman, exh. cat. (Cologne: Walther König, 2009), 34–41.

6 Rosalind Krauss, "Notes on the Index 1," in *The Originality of the Avant-Garde and Other Modernist Myths* (Cambridge, MA: MIT Press, 1988), 202ff., compares the glass plates with a camera on which dust rather than light is inscribed.

7 Georges Bataille, "Poussière," *Documents* 1, no. 5 (1929): 278, trans. Iain White, in *Encyclopaedia Acephalica* (London: Atlas Press, 1995), 43.

8 Museum Ludwig Köln, *Kunst des 20. Jahrhunderts* (Cologne: Taschen, 1996), 90.

9 Monika Wagner, *Das Material der Kunst: Eine andere Geschichte der Moderne* (Munich: Beck, 2001), 212–21.

10 See Grazioli, *La polvere nell'arte*, for rich material.

11 *Erwin Wurm: The Artist Who Swallowed the World; Ludwig Forum für Internationale Kunst, Aachen,* exh. cat. (Ostfildern: Hatje-Cantz, 2006), 15.

Oliver Watson

Awkward Objects

I moved a year ago from a life in museums to the university and am beginning to settle in, though the process has taken longer than I had imagined. I have much more time with the subject as I prepare new lectures, attend those of my colleagues, and finally write up pieces of research. Gone are the tasks of museum management and administration that eventually drove away almost all contact with the collections. I note two marked differences from the museum world: entry to the subject is now almost entirely through text and illustration, not by seeing or handling the things themselves. As a result, the entry point to discussion and new ideas is not necessarily through the individual object, as it almost invariably is for the curator. I am surprised by my slight disquiet at having no collection of my "own"—things that I can play with as I like. Can this really be a hangover from the (rightly) much condemned habit of curators who believed their task was to protect their collections as owners rather than to give access in the manner of librarians? I was long ago described as a "young turk" and had thought myself progressive in these matters. Although progress is surely made in offering access for the noncurator (as in the new ceramic galleries at the Victoria and Albert Museum, London, or the Jameel Study Room at the Ashmolean Museum, Oxford), it remains true that certain types of museum collections are easy of access while others are much more difficult. It is understandable, perhaps, but nevertheless ironic that direct access is expected and provided through specialist facilities to the most vulnerable and valuable objects but not to those of the more common and cheap materials: it is often much less trouble to gain direct contact with old master drawings or ancient gold coins than with pottery or glass. This does not help the study of a great part of what is covered by the term "Islamic art," nor of decorative arts generally, and as museums come under increasing financial pressure, we are bound to see ever shrinking numbers of specialist curators who until now have made up the core phalanx of their study. Will universities be willing or able to fill this gap?

In unpacking boxes of files built up over the years and waiting to be considered more closely, I came across one of my favorites: awkward objects. This category comprises things whose authenticity is unquestioned but that throw spanners of various sizes at the carefully constructed chronological or geographic frameworks from which our subject is built. The identical type of simple glass vessel found in excavations thousands of miles apart: surely not traded so far? But why so similar? A bronze vessel of a form I discover (from Wikipedia!) to be an Archimedean solid with fourteen faces, a *cuboctahedron*, and not as impossibly cataloged having "a dodecagonal body."[1] It has a foot and a tall flaring neck, and twelve of the fourteen faces are

engraved (Fig. 75).[2] The authoritative view of the eminent specialist in the catalog is that the decoration is "typical of Samanid Khorasan," that is, from eastern Iran of the tenth century. But I have a record of exactly the same shape of bottle in pottery: a fritware with turquoise glaze over molded palmettes.[3] The ceramic cannot be earlier than the mid- to late twelfth century. Am I to believe that a form as complex as this was made continually for two centuries (especially as no intervening examples survive)? That the potter copied an "antique"? Or is it more plausible that we have our dating schemes very wrong? This possibility is supported by other similarly awkward metal-ceramic correspondences. The metal is dated by stylistic argument alone, the ceramic also by technical. Neither has an absolutely secure basis, though the ceramic framework is more extensive and better buttressed by epigraphic and other evidence.

A pottery bowl painted with swirls of colored glaze almost forming a peacock and found in excavations in the ruins of old Cairo is claimed by some archaeologists to be an example of the first Islamic glazed ware found in Egypt (Fig. 76). However, we have accepted for the last hundred years that the glazing of Islamic pottery was a technical revolution inspired by the import of fine Chinese wares into the Persian Gulf in the ninth century. The resulting white-glazed Islamic copies made in Iraq were traded across the Middle East and stimulated local production in provincial styles. But this Egyptian dish has no Chinese flavor, is of a late antique shape, demonstrates a different and innovative technique, and is found first in early Islamic layers in Egypt and Syria, and then also in Iraq. I recently published an article arguing that our century-old model is back-to-front, that Egypt and Syria have precedence, and that the Chinese wares were, if anything, "influenced" by the Islamic: specific shapes and decorations appear to have been commissioned in China to suit an Islamic taste—a taste established not in ninth-century Iraq but earlier and further west.[4] If accepted, this particular spanner will have brought down a long-established structure that will need no little rebuilding.

A final spanner, this one revealed to us during a seminar given by our distinguished colleague and emeritus professor of the history of Islamic science, Emilie Savage-Smith. It is a privilege of Oxford life to have had such an authority show us one of the most famous of all Islamic manuscripts and a star of the Bodleian Library collections. Marsh 144 is a copy of the famous treatise on the fixed stars by the Persian scholar Abd al-Rahman al-Sufi, composed in Shiraz in the 960s. Marsh 144 is of great significance, not only for its splendid set of drawings of the constellations but also for the colophon stating it was copied, possibly by al-Sufi's son, in the year 400 AH/AD 1009–10. This documentary evidence has ensured the prominence of the manuscript, establishing it as the earliest surviving copy of a key scientific text and made within half a century of its composition. It is also (apart from some fragments) the oldest illustrated Islamic manuscript to survive, and therefore a keystone in the subject. In a suitably reverent and impressed silence we were shown through the manuscript, until we came to the colophon… What? *This* is what its eminence is based on? Dumbfounded, I noted that the final page is a composite with a fragment of medieval paper pasted with later sheets, probably seventeenth-century European, to make up a full page (Fig. 77). The four-line colophon is in two parts, one giving thanks to God and calling for

Figure 75. Bottle, Iran, 10th or 12th century, cast bronze with engraved decoration, height 7½ in. (18.9 cm). Victoria and Albert Museum, London, 777–1889 (artwork in the public domain; photograph © Victoria and Albert Museum, London).

Figure 76. Dish with polychrome glazing, Egypt, 8th century, earthenware painted with colored glazes, diameter 7¼ in. (18.5 cm). Ashmolean Museum, University of Oxford, presented by the American Research Center in Egypt, 1974, EA1974.48 (artwork in the public domain; photograph © Ashmolean Museum, University of Oxford).

blessings on the Prophet in a black ink, the second in a red ink giving the name of the copyist and the date. The hand of each seems to differ from that of the main text and from each other, as do the inks. Professor Savage-Smith pointed out that the text on the back of this fragment differs in style and spacing from the text in the rest of the book. She also expressed her unease that the paper of the whole book did not to her feel quite "right" for such an early date, though, as she said, there are few comparanda. Unease expressed by a specialist so experienced in handling such manuscripts should not be lightly discounted. Are we actually dealing with a later medieval facsimile of an earlier text supplied, possibly even later, with a bogus colophon, as was suggested already more than a decade ago by Abolala Soudavar?[5] The experts will no doubt continue to argue, and Savage-Smith has since published her views in an article on this and the next earliest dated copy of the text, now in Doha.[6]

As a nonspecialist, I was struck that so little attention seemed to have been hitherto paid to the colophon as a problematic physical object. Once this documentary anchor had been cut away, our group was able to speculate freely on date and provenance. We followed Savage-Smith on the dating (to the later twelfth century, perhaps?), but on provenance, judging by stylistic considerations of the drawings, we were naturally able to span the Islamic world, from central Asia to North Africa. I myself rather fancied an Egyptian attribution but, more seriously, I hope that further specialist study of this important manuscript will start with a closer examination of the thing itself.

Figure 77. Colophon of a copy of Abd al-Rahman al-Sufi's *Book of Constellations*, dated 400 AH (AD 1009–10) and signed alHusayn ibn Abd al-Rahman ibn Umar ibn Muhammad, 10⅜ × 6¾ in. (26.3 × 17 cm). The Bodleian Libraries, University of Oxford, MS Marsh 144, p. 419 (artwork in the public domain; photograph provided by The Bodleian Libraries, University of Oxford).

Notes

1 A revised description from the equally erroneous identification as a "tetradecahedron" given by the author in the original publication.

2 A. S. Melikian-Chirvani, *Islamic Metalwork from the Iranian World, 8th–18th Centuries; Victoria and Albert Museum Catalogue* (London: HMSO, 1982), 44, no. 5. Interestingly, the piece had been earlier published as twelfth century, in A. U. Pope's notoriously unreliable *Survey of Persian Art* (Oxford: Oxford University Press, 1939), pl. 1277d.

3 Museum of Islamic Art, Berlin, no. I.31/63, unpublished. Yasser Tabbaa also noted the similarity of form in "Bronze Shapes in Iranian Ceramics of the Twelfth and Thirteenth Centuries," *Muqarnas* 4 (1987): 105.

4 Oliver Watson, "Samarra Revisited: The Rise of Islamic Glazed Pottery," *Hundert Jahre Grabungen in Samarra,* Beiträge zur Islamischen Kunst und Archäologie, vol. 4 (Wiesbaden: Ernst Herzfeld Gesellschaft, 2014): 123–42.

5 A. Soudavar, "The Concepts of 'al-aqdamo aṣaḥḥ' and 'Yaqin-e sābeq', and the Problem of Semi-fakes," *Studia Iranica* 28 (1999): 262–64.

6 Emilie Savage-Smith, "The Stars in the Bright Sky: The Most Authoritative Copy of 'Abd al-Rahman al-Sufi's Tenth-Century Guide to the Constellations,'" in *God Is Beautiful; He Loves Beauty: The Object in Islamic Art and Culture,* eds. Sheila Blair and Jonathan Bloom (New Haven: Yale University Press, in association with Qatar Foundation and Virginia Commonwealth University, 2013), 123–55.

<div style="border: 1px solid; display: inline-block; padding: 10px;">

Tristan Weddigen

</div>

On the Textility of Spatial Construction

Confronted with postwar movements such as Post-Minimalism, feminism, and Arte Povera, which questioned and expanded traditional uses of materials, and faced with an alleged digital dematerialization of contemporary reality, materials have become a field of art historical research, to which Monika Wagner has signally contributed. *Textiles* are not only part of this new field, but, more interestingly, they also challenge established notions of artistic material. A fabric is commonly called a material. Being a technological product and not a raw material, however, the label "textile" is correct only in the metaphoric sense of designating anything, processed or not, that can be used in the manufacture of something else, such as clothes. But, raw material itself being irrelevant to a definition of "textility," and used to designate equally wickerwork, written text, and metal curtains in architecture, textiles should rather be defined by specific techniques of production. Then again, the techniques of assembly implied in embroidery, in weaving, or in connecting the World Wide Web are so diverse that we need to operate with a vague "family resemblance." Textiles are also often understood as a specific medium of art. Yet, this definition tends to reduce textiles to material neuters and flattened carriers of visual information—rather the opposite of the meaning connoted by the materiality of mediums that is the focus of today's scholarship. So, "the textile" is a hybrid under which properties are often strung together—material, technology, medium, and metaphor—and only rarely does it refer to one of these in isolation. The study of textiles consequently requires a wide range of methodologies, and it must concern itself with a vast array of objects.[1]

The history of artists' materials contributes to the study of material culture. Over time, the appreciation and meaning of materials and mediums can drastically change. The textile decoration of sacred and profane interiors in early modern Europe is a prominent case in point. Back then, textiles were arguably the most important and expensive means of representation, apart from architecture itself. With the end of the *ancien régime* and the emergence of modernist aesthetics, textiles have slowly withdrawn from interior design. Moreover, the textile medium was already marginalized in the aesthetic discourse with Leon Battista Alberti's rejection of material in favor of pure artistic form, with the rise of Italian idealist "disegno" theory, with Georg Wilhelm Friedrich Hegel's spiritualization of art, and with the succeeding modernist primacy of painting among the visual arts, which contributed to its fading, in both art and research, until today. Nonetheless, an emerging history of artistic materials is not content with technological analysis, iconography, or the history of design, but will probably move toward a more comprehensive iconology of materials and history of objects.[2]

A more phenomenological approach to late-medieval and early-modern textile interiors shall be sketched here in order to illustrate the potential of an iconology of materials and, more specifically, the possible relation of materials to something as abstract as space. In order to look back to a vanished textile culture, we might start with its modern reception. In his *Arcades Project*, left unfinished at his death in 1940, Walter Benjamin critically analyzes the late nineteenth-century French *intérieur*. Referring to Theodor W. Adorno's habilitation thesis on Søren Kierkegaard, published in 1933, which portrays the bourgeois flâneur and his inauthentic interiority, Benjamin characterizes the Parisian apartment as the surrogate of a domesticized public space, such as an arcade, theatrically costumed in fabrics. In Benjamin's account, the upholsterer's art fights against modern glass and iron architecture, disintegrates architectural space itself, and transforms it into an arachnean cocoon or uterine cave. According to him, the prototype of the historicist dwelling is not the house but the case or container (*Gehäuse*), the silk-lined etui, sheath, or capsule (*Futteral*), which holds the imprint of their occupants and receives the traces of their lives. Benjamin's *Arcades Project*, an archaeology of the bourgeois culture that amassed and commodified all styles dating before the Restoration, layers a modernist stance onto medieval and early modern notions of interior space. Benjamin might have also been aware of Adolf Loos's article "Interior," first published in 1898 and again in 1921 and 1931, which adopts Gottfried Semper's anthropological clothing principle, or *Bekleidungsprinzip*, as laid out in his *Style* of 1860/63, and his notion of "truth to materials." What matters most here is that Loos demands the architect start by imagining the emotional impact of the planned interior spaces that are developed from basic decorative elements, such as carpets. Only thereafter shall the architect conceive of a tectonic structure to sustain or "wear" those interior spaces.[3]

Norbert Elias's understanding of dwelling structures as socially inflected and of spatial dispositions as materializations of communication structures and social formations, which he expounded in his *Court Society* of 1969, has been foundational to the sociology of space and to the study of architecture. Still, while he stresses *decorum* as the expression of negotiated and regulated social distinction, he says little about *decoration*. More to the point, the attempt to link interior arrangement with social practice often fails to accept the de facto multifunctionality of architectural spaces and their ad hoc definition by furniture. Indeed, in premodern residences, habitable spaces or cubicles are constituted by lining a building's architectural cavities with fabrics. The alcove appears as a *mise en abyme* of such textile spaces, a phenomenon that contradicts the Renaissance notion of architecture as transparent geometric space. Thus, Benjamin's analysis of the historicist interior and Loos's conception of architectural space as perceived from within are useful for overcoming two common approaches in scholarship: one that views tapestries as autonomous, decontextualized works of art, akin to paintings, and another that considers wall hangings as superfluous froufrou disguising architecture. Instead, textile decor should be understood as a most vital element of a cultural "habitus."[4]

A close reading of late medieval and early modern visual evidence for textile interiors reveals some characteristics of textile spaces, such as the temporal thickness and aesthetic

longevity conferred by narrative tapestries; the ability of textile ephemeral microarchitecture, such as baldachins and balconies, to literally turn inside out, in a manner reminiscent of the topological model of the reversible "sock" described by Benjamin; and tapestries' function as portable iconographic contexts or symbolic spaces fostering a typological perception of a doubled reality and creating immersive panopticons. The late medieval tradition of courtly "chambers," room-filling and often furniture-covering sets of *verdures*, millefleurs, and genre scenes in landscapes, transformed bare architectural interiors into *loci amoeni*, or artificial paradises, as Aby Warburg made clear in his essay "Peasants at Work in Burgundian Tapestries" of 1907. Such *verdures* powerfully suggest the nonarchitectural, spatially ambiguous depth and texture of nature itself. As places of atemporal pleasures and unlikely encounters, they established a "heterotopy." In Michel Foucault's "Of Other Spaces," a lecture delivered in 1967 and published in 1984, the heterotopia is exemplified by the garden as a microcosm and the carpet as a mobile garden. On the one hand, the material and colored flatness of wall hangings was to reemerge later, as the modernist "carpet paradigm" of abstract art. On the other hand, tapestries undulating in the draft, folded, pulled back, or, especially, hung around the corners of a room created a unique, immersive experience of visual depth by warping an otherwise flat or relieflike picture, which offers an alternative notion of illusion based on the materiality of the textile image in which figure and support merge. This medium-specific effect, which outdoes perspectival panel painting, can sometimes be experienced in museums today, but it was observed and documented already by the Limbourg brothers with the greatest perspicacity in the early fifteenth century (Fig. 78). In their *January* miniature of the Très riches heures for the Duke of Berry, a *War of Troy* tapestry is hung around the left corner of the room and wrapped up above the chimneypiece so as to suggest that the turret of the city wall protrudes into the room, that the cavalry enters and storms the real space, and that it crushes the enemy into the tapestry's folds. Tapestries' incongruous and material spatiality adapts to a plurality of moving eyes looking at nonplanar and multifocal images.[5]

At the turn of the twentieth century, with August Schmarsow, Alois Riegl, and Heinrich Wölfflin, an art historical concept of space emerges that is not based on architectural and perspectival definitions and techniques. In combining the "history of seeing" with the history of representational techniques, Erwin Panofsky's *Perspective as Symbolic Form* in 1927 still offers a master narrative for the history of visual space. Panofsky describes early and high medieval pictorial flatness as a Neoplatonic repudiation of the Aristotelian topological notion of place, in favor of a qualitative, bodily two-dimensionality, conceived as an immaterial fabric made of light, lines, and colored surfaces. Late medieval art then discovers the transparency of the picture plane and creates boxes, niches, and textile baldachins in order to form a pictorial and sculptural space for human figures. The transition from medieval discontinuous space to infinite *res extensa*, from relational space (*Aggregatraum*) to absolute space (*Systemraum*), began with the invention of linear perspective and was later theorized by Isaac Newton. As Wolfgang Kemp remarks,

Figure 78. Limbourg brothers, *January*, from Très riches heures for the Duke of Berry, 1412–16, ink, tempera, and gold leaf on vellum, 11⅜ × 8¼ in. (29 × 21 cm). Musée Condé, Chantilly, fol. lv (artwork in the public domain; photograph © RMN-Grand Palais [Domaine de Chantilly]/Rene-Gabriel Ojéda).

pictorial space from Giotto to Jan van Eyck can be described as a carved-out relieflike cavity, furnished with figures and objects, constituted by their reciprocal relation, both spatial and narrational. Here, textiles follow or replace the walls, fabricate alcovelike spaces, and are lifted to open the view through the missing "fourth wall." Early modern perspectival space, instead, gives a view through a continuum in which textiles, hung or folded, are reduced to two-dimensional planes symbolizing the opaque materiality and deficiency of pictorial representation.[6]

The fact that textiles defined the experience and idea of interior space from the Middle Ages well into the nineteenth century, as Benjamin and Loos acknowledge, contradicts a one-dimensional, modernist, evolutionary narrative. The reconstruction of a premodern "textile discourse," which has been obscured by the paradigm of perspectival transparency, can profit from phenomenological and topological approaches, as sketched out in Foucault's lecture and explored by Gilles Deleuze, that emerge with the recent "spatial turn" in the humanities and social sciences. Medieval and early modern textile interiors testify to a notion of space as something material, opaque, sensorial, discontinuous, non-Euclidean, folded, polyfocal, social, and topological. For instance, Jan Vermeer's boxlike, furnished, textile *intérieurs* have

been recently associated with a relational understanding of space endorsed by Gottfried Wilhelm Leibniz and Christiaan Huygens against Newton's theory. Instead of a *longue durée*, bodily understanding of space, art history assumes the breakthrough and pervasiveness of the perspectival idea of space since the quattrocento, defined as something transparent, immaterial, neutral, rational, uniform, and infinite. In the history of visuality, the instauration of the perspectival *tableau* and the idea of absolute space have eclipsed an earlier, but long-lasting textile spatiality, which contemporary art and architecture, today, help to rediscover.[7]

Notes

I would like to thank Gail Feigenbaum (The Getty Research Institute), Julia Gelshorn (University of Hamburg), and David Young Kim (University of Pennsylvania) for their valuable comments.

1 Monika Wagner, "Material," in *Ästhetische Grundbegriffe*, eds. Karlheinz Barck et al. (Stuttgart: Metzler, 2000–01), vol. 3, 866–82; idem, *Das Material der Kunst* (Munich: Beck, 2001); Monika Wagner and Dietmar Rübel, eds., *Material in Kunst und Alltag* (Berlin: Akademie, 2002); Monika Wagner, ed., *Lexikon des künstlerischen Materials* (Munich: Beck, 2002); and Dietmar Rübel et al., eds., *Materialästhetik* (Berlin: Reimer, 2005). See also Michael Baxandall, *Painting and Experience in 15th Century Italy* (Oxford: Oxford University Press, 1972); Jean-François Lyotard and Thierry Chaput, eds., *Les immatériaux*, 3 vols. (Paris: Centre Georges Pompidou, 1985); Hans Ulrich Gumbrecht and Karl Ludwig Pfeiffer, eds., *Materialität der Kommunikation* (Frankfurt: Suhrkamp, 1988); Thomas Raff, *Die Sprache der Materialien* (Munich: Deutscher Kunstverlag, 1994); Andreas Haus et al., eds., *Material im Prozess* (Berlin: Reimer, 2000); and Michael Cole, "The Cult of Materials: Sculpture through Its Material Histories," in *Revival and Invention*, eds. Martina Droth and Sébastien Clerbois (Oxford: Lang, 2011), 1–15.

2 Leon Battista Alberti, *De statua—De pictura—Elementa picturae*, eds. Oskar Bätschmann et al. (Darmstadt: WBG, 2011), 235–37; and Georg Wilhelm Friedrich Hegel, *Vorlesungen über die Ästhetik III* (Frankfurt: Suhrkamp, 1990), 11–16.

3 Walter Benjamin, *Das Passagen-Werk*, ed. Rolf Tiedemann (Frankfurt: Suhrkamp, 1982), 281–300; Theodor W. Adorno, *Kierkegaard: Konstruktion des Ästhetischen*, eds. Rolf Tiedemann et al. (Darmstadt: WBG, 1998), 61–69; Adolf Loos, "Intérieurs," in *Gesammelte Schriften*, ed. Adolf Opel (Vienna: Lesethek, 2010), 68–74; and Gottfried Semper, *Style* (Los Angeles: Getty Research Institute, 2004). Cf. Christoph Asendorf, *Batterien der Lebenskraft* (Giessen: Anabas, 1984), 89–99; Philippe Ariès and Georges Duby, *A History of Private Life*, 5 vols. (London: Belknap, 1987), vol. 3; Claudia Becker, *Zimmer-Kopf-Welten* (Munich: Fink, 1990); Sabine Schulze, ed., *Innenleben* (Ostfildern: Hatje Cantz, 1998); Susie McKellar and Penny Sparke, eds., *Interior Design and Identity* (Manchester: Manchester University Press, 2004); Charles Rice, *The Emergence of the Interior* (London: Routledge, 2007); Felix Krämer, *Das unheimliche Heim* (Cologne: Böhlau, 2007); Markus Brüderlin and Annelie Lütgens, eds., *Interieur Exterieur* (Ostfildern: Hatje Cantz, 2008); Karl Schütz, *Das Interieur in der Malerei* (Munich: Hirmer, 2009); Karl Schütz, ed., *Raum im Bild* (Munich: Hirmer, 2009); and Alla Myzelev and John Potvin, eds., *Fashion, Interior Design and the Contours of Modern Identity*

196

(Farnham: Ashgate, 2010). Cf. Alina Payne, "Notes from the Field: Anthropomorphism," *Art Bulletin* 94 (March 2012): 29–31.

4 Norbert Elias, *The Court Society* (New York: Pantheon, 1983). Cf. Émile Durkheim, *The Elementary Forms of Religious Life* (New York: Free Press, 1968); Pierre Bourdieu, "Post-face," in *Architecture gothique et pensée scolastique*, by Erwin Panofsky (Paris: Minuit, 1967), 134–67; Henri Lefèbvre, *The Production of Space* (Oxford: Blackwell, 1991); and Martina Löw, *Raumsoziologie* (Frankfurt: Suhrkamp, 2001).

5 Walter Benjamin, *Kleine Prosa*, ed. Rolf Tiedemann (Frankfurt: Suhrkamp, 1982), 283–87; Aby Warburg, "Peasants at Work in Burgundian Tapestries," in *The Renewal of Pagan Antiquity*, ed. Kurt W. Forster (Los Angeles: Getty Research Institute, 1999), 315–24; Michel Foucault, "Des espaces autres," *Architecture, Mouvement, Continuité*, no. 5 (1984): 46–49. Cf. Philipp Ekardt, "Benjamins Bekleidungsmodelle," in *Visuelle Modelle*, ed. Ingeborg Reichle et al. (Munich: Fink, 2008), 85–98; Oliver Grau, *Virtual Art* (Cambridge, MA: MIT Press, 2004); Joseph Masheck, "The Carpet Paradigm," *Arts Magazine* 51 (1976): 82–109; and Birgit Franke, "Die Januarminiatur der *Très riches heures*," in *Die Bildlichkeit symbolischer Akte*, eds. Barbara Stollberg-Rilinger and Thomas Weissbrich (Münster: Rhema, 2010), 55–90.

6 Hans Jantzen, *Über den kunstgeschichtlichen Raumbegriff* (Munich: Beck, 1938); Erwin Panofsky, *Perspective as Symbolic Form* (New York: Zone Books, 1991); Wolfgang Kemp, *Die Räume der Maler* (Munich: Beck, 1996); idem, "Beziehungsspiele," in *Innenleben*, ed. Sabine Schulze (Ostfildern: Hatje Cantz, 1998), 17–29; and idem, "Raum," in *Metzler Lexikon der Kunstwissenschaft*, ed. Ulrich Pfisterer (Stuttgart: Metzler, 2011), 367–69.

7 Gilles Deleuze, *The Fold*, ed. Tom Conley (Minneapolis: University of Minnesota Press, 1992). Cf. Karin Leonhard, *Das gemalte Zimmer* (Munich: Fink, 2003). My note from the field here is part of a larger research project conducted at the University of Zurich. See also the Textile Studies series published with Edition Imorde, Emsdetten: Philipp Zitzlsperger, ed., *Kleidung im Bild: Zur Ikonologie dargestellter Gewandung* (2010); Tristan Weddigen, ed., *Metatextile: Identity and History of a Contemporary Art Medium* (2011); idem, ed., *Unfolding the Textile Medium in Early Modern Art and Literature* (2011); and David Ganz and Marius Rimmele, eds., *Kleider machen Leute: Vormoderne Strategien vestimentärer Bildsprache* (2012).

MIMESIS

Figure 79. Dexter Dalwood, *Night Mirror*, 2012, oil on canvas, 36¼ × 39⅜ in. (92 × 100 cm) (artwork © Dexter Dalwood, courtesy of the artist and Simon Lee Gallery, London and Hong Kong; photograph by Dave Morgan).

Dexter Dalwood

The Vertiginous Image

In his studio in Nice in the 1930s, Henri Matisse kept a reproduction of Antonio Pollaiuolo's *Hercules and Antaeus* (Fig. 80), an image he "drew and redrew over the next few years when he felt himself under attack from all directions."[1] What was it about this image that held so much power for him? Did he empathize with Hercules, the hero who purposefully lifted Antaeus from the ground, severing his connection with ground and reality, the source of his strength, so as to crush him with a spiritual and heroic idealism? Or did he identify with Antaeus, whose destiny was to remain permanently grounded in reality, lest he perish?

Getting the world to "look" as it looks, finding a form of naturalism in the making of a painted image, is not an important prerequisite for painting in the twenty-first century. The history of art shows us that mimesis—the visual trickery of naturalism—is in fact one of the easiest aspects of image making. One only has to consider the nineteenth century, when any wealthy enough middle-class person, with the help of a drawing tutor who could coax out the basic skills of rendering and the use of perspective, could "match" the world. Queen Victoria could even draw well enough. The basements and storerooms of regional museums are groaning with the work of artists who took the "grand tour," exercising the simple set of skills they had learned from their drawing masters, perhaps embellished with a legend or two pulled from what Philip Larkin, a century later, would dismiss as the "myth kitty."

The resulting acres of stumbling Neoclassicism and hackneyed versions of the old masters led to a connoisseurship of mediocrity. However, while the academies of Europe churned out vast numbers of purveyors of such derivative images, the really interesting artists of that period were breaking new ground. J. M. W. Turner, whose academic drawing was feeble, tried to find a new way of using paint to represent both what he could see and what was about to be lost. John Constable constructed a particular and new "reality" by cleverly contraposing a protoimpressionist technique to depict a pastoral world that he wished to see preserved. Both demonstrated brilliantly that being a good artist was never about getting the world to look like itself.

Mimesis raises the question not only of deception but also of connection. What constitutes a vital link between a painting and reality? The 2012 exhibition at the Centre Pompidou in Paris of work by Matisse, *Pairs and Series*, made clear his desire for the alarming, shuddering "truth" of immediacy, his audacious forcing of pictorial change, and his part in the final severance of paintings' perspectival link to the Renaissance window (Fig. 81). His understanding of how Paul Cézanne, Pablo Picasso, and Cubism, along with photography,

Figure 80. Antonio Pollaiuolo, *Hercules and Antaeus*, after restoration, 1460, tempera on wood, 6¼ × 3½ in. (16 × 9 cm). Galleria degli Uffizi, Florence, Inv.: 1478 (artwork in the public domain; photograph © Photo SCALA, Florence 2017, courtesy of the Ministero dei Beni e delle Attività Culturali e del Turismo).

Figure 81. Henri Matisse, *Le Violoniste à la fenêtre (Violinist at the Window),* 1918, oil on canvas, 59 × 38⅝ in. (150 × 98 cm). Centre Pompidou, Musée National d'Art Moderne, Centre de creation industrielle, Paris, AM1975-26 (artwork © Succession H. Matisse; photograph © Centre Pompidou, MNAM-CCI, Dist. RMN-Grand Palais / Philippe Migeat).

had changed perception forever evidently strengthened his rejection of naturalism. Matisse rejected naturalism in the pursuit of a more profound connection with reality.

Yet, mimesis raises a further question about the pictorial nature of reality itself. When Ernst Gombrich, in *Art and Illusion*, proposed that "the world does not look like a picture but the picture can look like the world," he was speaking from the point of view of a pre-digital age.[2] In an age in which reality seems increasingly aesthetically framed—designed, as it were—the question of mimesis returns, suggesting a new congruence between images and the world they represent. Reproduction has become so accurate that the process of reproducibility has itself become a new reality of sorts, which in turn can become a new subject matter.

Figure 82. Christopher Wool, *Untitled*, 2009, silkscreen ink and enamel on linen, 126 × 96 in. (320.04 × 243.84 cm) (artwork © Christopher Wool, courtesy of the artist and Luhring Augustine, New York; photograph by Christopher Burke).

Of course, this is not new. Looking back on Sherrie Levine's 1980 artwork *After Walker Evans* (her rephotographing of Walker Evans's photographs of sharecroppers from the 1930s), it seems that what then appeared to be an uncompromising conceptual premise has in fact an aura of generosity about it. *After Walker Evans* represents the beginning of a long inquiry into the nature of what is original or indeed "real" in the reproduced image. Thirty-odd years later, this process of appropriation of found images, artistic styles, or even ironic takes on artistic practice has evolved (when it works) into a deeply embedded subjective form of appropriation. It is a newer way of representing the world, within which both artist and viewer are visually aware entities with a now-habitual ability to rapidly digest high and low cultural references: less a postmodern "death of the author" than a processed version of the world that finds reality and naturalism through a lived and collaged version of itself. Observe the contemporary artist Christopher Wool, who has mined the almost airless seam left for the "space" in painting in a post-screen-print world. For Wool, making an image entails giving himself up to a way of painting that offers the viewer no clue about what is actually painted and what is a painted reproduction of something being painted (Fig. 82).

So what's left for the painted image? I have been asking myself this question for some time. For artists working away in their studios, or wherever they might establish an art-making practice, "reality" always seems to be happening elsewhere. By day, the painter is alone (working) in the studio. News images on a screen bring in a slice of the outside world: But how can the image be pinned down, not as a reproduction of the look of the photograph but as a suggestion of the vertiginous experience of the present? And where does this image stand in relation to images from the past?

When I am looking at contemporary painting I always ask myself the simple question, "Why am I looking at this now?" I ask the same of painting itself: "Why is it engaging, both subjectively as subject and objectively as painting?" And further, "How are the two integrated?" It seems clear (clearly evident in the Matisse exhibition at the Pompidou) that techniques of mimesis have been overridden by techniques of collage and montage over the past one hundred years, and collage now underlies many modes of recent painting. I like the idea of collage as "the guerrilla occupation of a prescribed and readymade field," in which collage "sets itself up as a machine for reprocessing the idea of painting in terms of so much other processed information."[3]

Notes

1 Hilary Spurling, *Matisse: The Life* (London: Penguin, 2009), 430.
2 E. H. Gombrich, *Art and Illusion* (London: Phaidon, 1972), 138.
3 John Kelsey, "Collage and Program: Rise of the Readymade Maidens," *Parkett*, no. 79 (2007): 51.

<div style="border: 1px solid black; padding: 10px; width: 300px; text-align: center;">

Daniela Bohde

</div>

Visual Hermeneutics: Art History and Physiognomics

We are familiar with mimetic art but we are not yet aware of the great extent to which art historical methodology is informed by mimesis. Mimetic thought dwells at the core of art history. Throughout the history of the discipline, visual artifacts have been conceived of as expressions of invisible entities, such as the character of the artist or period. The visible outside seems to mimic an invisible inside, and the artwork is governed by a kind of indwelling or involuntary mimetic process. The concept of a natural or involuntary mimesis is also at the foundation of physiognomics, which means that art history is imbued with physiognomic thinking. One need only name Johann Caspar Lavater and his famous readings of qualities of soul in facial characteristics to make the point.

Especially in the period about 1800, but also in the early twentieth century, a physiognomic reading was applied not only to faces and bodies but also to landscapes, plants, and even the stars, which were all believed to mimic some interior quality. Architecture was also regarded as a mimetic art, a fact well demonstrated by illustrations in architectural treatises that present facades in the guise of faces (Fig. 83). The anthropomorphic notion of architecture prevailed until the nineteenth century, if not later, and it made possible a physiognomic reading of architecture, as shown by Charles Blanc (Fig. 84). The anonymous book *Untersuchungen über den Charakter der Gebäude* (*Investigations into the Character of Buildings*) of 1788 applied the principles of Lavater's *Physiognomische Fragmente zur Beförderung der Menschenkenntnis und Menschenliebe* (*Essays on Physiognomy: For the Promotion of the Knowledge and the Love of Mankind*) (1775–78) to buildings in order to determine their moral character (Fig. 85).

The search for a hermeneutics of the visual also fueled the natural sciences, as exemplified by such texts as Karl Friedrich Struve's *Versuch einer Physiognomik der Erde oder die Kunst aus der Oberfläche der Erde auf ihren obern Inhalt zu schließen* (*Attempt at a Physiognomy of the Earth, or the Art of Deducing from the Earth's Surface the Qualities of Its Interior*) (1802) and Alexander von Humboldt's *Ideen zu einer Physiognomik der Gewächse* (*Essay on the Physiognomy of Plants*) (1806). The outward appearance of plants was used not to establish a taxonomy but to obtain information about them and their habitat. Within this visual turn in many sciences, the new discipline of art history emerged, taking physiognomics—the leading visual hermeneutics—as an orientation. This is evident, for example, in Johann Joachim Winckelmann's concept of style, which is based explicitly on physiognomics. Winckelmann's point of departure is as physiognomic as it is mimetic: the body mirrors the soul.

RAPPORT DE L'ARCHITECTURE A LA FACE HUMAINE.

Figure 83. Tuscan entablature after Scamozzi, from Jacques-François Blondel, *Cours d'architecture* (Paris: Desaint, 1771–77), 1st vol. of plates, pl. XI (photo provided by Universitätsbibliothek Johann Christian Senckenberg, Frankfurt am Main).

Figure 84. Correlation of architecture and the human face, from Charles Blanc, *Grammaire des arts du dessin – Architecture, sculpture, peinture* (Paris: Librairie Renouard, 1876, third edition), 108 (artwork in the public domain; photograph provided by Bildstelle des Kunsthistorischen Instituts der Goethe Universität, Frankfurt am Main).

Accordingly, Greek statues express the Greek soul. Winckelmann's physiognomic concept is not restricted to the representation of the body in art, however, but forms the very matrix of his notion of style, according to which the visual surface describes the invisible interior and style discloses the spirit. Winckelmann believed that bodily constitution and factors such as climate or political situation influence a people's way of thinking, and that these are expressed in artistic style.[1]

Winckelmann's physiognomic understanding of style was retained by later generations of art historians, and it was reintegrated into physiognomics. Many physiognomists did not develop a system of defined signs for deciphering faces. Instead, they interpreted faces stylistically, taking art historical methodology as their orientation. Already Lavater relied on the aesthetic theories of his time, especially Winckelmann's notion of style as an expression of the period. Lavater used the physiognomy of a painter, for example, as a basis for interpreting

Figure 85. Physiognomies of buildings, from Anonymous, *Untersuchungen über den Charakter der Gebäude; über die Verbindung der Baukunst mit den schönen Künsten und über die Wirkungen, welche durch dieselben hervorgebracht werden sollen*, Leipzig, 1788, pl. 1, a. Basel, Universitätsbibliothek, Sign. AC VIII 7 (artwork in the public domain; photograph provided by Universitätsbibliothek Basel).

that painter's style, and vice versa. In Lavater's view, physiognomy and style revealed the character of artist and artwork, which, according to him, had to be identical.

In fact, Lavater was a leading figure in the establishment of the concept of character. Originally—which is to say, in antiquity—character was considered a kind of external sign, like a brand on the hide of a cow. It was not until the eighteenth century that character became the equivalent of an internal quality man had to possess and show outwardly. At about this same time, character became an important notion in the art historical discourse. Here, as well, the meaning of "character" changed. Initially used to refer to the specific characters of a handwriting style, character was then applied to the brushwork and manner of the artist, until finally it was loaded with psychological meaning. In 1699, Roger de Piles connected the character with the way the artist thinks and how he expresses his genius.[2] In the art historical writings of the nineteenth and early twentieth centuries, character became a leading concept. Art historians maintained that they could discern the hidden character of a period or nation by analyzing its style. It was in good part this assertion on which art history based its claim to being a leading discipline in the first decades of the twentieth century, and other sciences and disciplines modeled themselves after the art historian's ability to read the visual. Many were impressed, for instance, by Heinrich Wölfflin's alleged recognition of the Gothic spirit in the Gothic shoe.

In the 1920s, as a general distrust in language and its ability to analyze and represent the world spread, many writers expressed the sentiment that they could no longer decipher the rapidly changing post-World War I world. Especially in new metropolises like Berlin, the city seemed to show the contemporary an anonymous, impenetrable face. Not surprisingly,

physiognomics experienced a remarkable revival, while all forms of visual interpretation were highly appreciated in general. Art history figured largely in this state of affairs, and style was a key term.

Writing in the 1920s, Béla Balázs argued that the cinema would restore the lost physiognomy of people and things. Meanwhile, the photographer August Sander wanted to document the "face of the period" by portraying different classes and professions. For the psychiatrist Ernst Kretschmer, the appearance of the patient's body was the main source for his diagnosis, which he said should be carried out with an aesthetically trained gaze. Racist anthropologists such as Ludwig Ferdinand Clauss classified people according to their racial style. These men were not the only ones to rely on art historical categories; scholars of economics and history likewise turned their disciplines into forms of stylistic research. In this period, art historians such as Wilhelm Pinder, Hans Sedlmayr, and Wilhelm Fraenger proclaimed a physiognomic turn in art history. Pinder saw the art historian as physiognomist of style; Fraenger developed a psychographological physiognomics of artistic form; and Sedlmayr declared the physiognomic gaze the foundation of art historical research. Sedlmayr developed different ways of discerning the invisible character in the visible, most famously in his 1948 *Verlust der Mitte (Art in Crisis: The Lost Center)*, a book in which artworks figure as symptoms of the crisis of the modern world.

Today, the hypertrophy of style is obsolete. However, echoes of older physiognomic aspirations can still be heard in debates over a visual or iconic turn in art history. The visual is once again credited with superior qualities, and art historians claim to be generally capable of reading the visual world. Especially in the field of neuroaesthetics, mimetic relations between brain processes and artistic forms, or even between the artwork and the artists' character, are again in *vogue*. Mimesis seems to be an undying companion of art history.[3]

Notes

1 Johann Joachim Winckelmann, *Geschichte der Kunst des Altertums, erster und zweiter Teil* (Dresden, 1764; reprint, Baden-Baden: Heitz, 1966), 19–25.

2 See Roger de Piles, *Abrégé de la Vie des Peintres: Avec des réflexions sur leurs Ouvrages, Et un Traité du Peintre parfait, de la connoissance des Desseins, & de l'utilité des Estampes*, Paris 1699, 71–72. Cf. Daniela Bohde, "Die künstlerische Handschrift als Ausdruck des Charakters? Die scheinbare Kontinuität eines Topos': Giorgio Vasaris maniera – Roger de Piles' caractères – Wilhelm Fraengers Formpsychogramme," in *The Paradigm of Vasari: Reception, Criticism, Perspectives*, eds Fabian Jonietz and Alessandro Nova (Venice: Marsilio 2016), 69–71.

3 Precise references to all of the texts mentioned can be found in Daniela Bohde, *Kunstgeschichte als physiognomische Wissenschaft: Kritik einer Denkfigur der 1920er bis 1940er Jahre* (Berlin: Akademie Verlag, 2012).

Helen C. Evans

Byzantine Innovative Mimesis

The study of mimesis has been an essential tool of art historical research since the founding of the field more than a century ago. Use of the term has expanded from the meaning popularized by Plato and Aristotle in the fifth and fourth centuries BCE on the limits of man's ability to copy/not copy nature in literature and art to include its application in other contemporary academic fields. In sociology, the term relates to the deliberate imitation of the behavior of one group of people by another as a factor in social change; it carries the implication that the deliberate imitation is usually by those less advantaged. In biology and zoology the term is identified as referring to mimicry. Art historians make use of all these meanings with critical theory, postcolonial theory, and so on, questioning the traditional top-down center-periphery model by increasingly focusing on issues of multiple cultural centers and the reaction of the so-called periphery to the dominant center(s). Through these issues mimesis offers an essential tool for defining the "visual voices" of the varied political, religious, and other cultures whose interaction we increasingly seek to understand.

For Byzantine culture, mimesis has generally been understood as imitation as it was defined in the 1991 *Oxford Dictionary of Byzantium*.[1] There, Byzantine culture, which understood itself to be a continuum of the Roman Empire and the intellectual life of the classical past, was described as prioritizing *mimesis* over innovation in its preference for imitating or continuing classical models. Within this construct, the Byzantine use of mimesis was identified as including the creative reidentification of classical concepts to mask new ideas and forms. This understanding of the role of mimesis in Byzantine culture encouraged a vision of the state as a static society, an ever-weaker echo of the greatness of the classical age in which the concept of mimesis was developed. Byzantine scholars have also tended to accept the traditional identification of mimesis as representing culture emanating from a center, the capital Constantinople, and being copied, often poorly, in the provinces and by neighboring peoples.

More recently, Byzantine scholars have increasingly concentrated on the mimetic innovations hidden within the Byzantine appearance of mimetic traditionalism. Thomas Mathews demonstrated that Byzantine manuscript illuminations were commentaries on texts, rather than increasingly confused copies of original illuminations, as once argued. John Lowden, in his study of the Jaharis Lectionary, pointed out how the dramatically new lectionary format for the *Four Gospels* was made acceptable by keeping the traditional name for the text.[2]

The exhibitions at the Metropolitan Museum of Art, New York, *The Glory of Byzantium: Art and Culture of the Middle Byzantine Era (843–1261)* in 1997 and *Byzantium: Faith and*

Figure 86. Roundel fragment with confronted hunting Amazons, said to have been excavated at Panopolis (Akhmim), Egypt, 7th–9th century? weft-faced, compound twill (samite) in blue-violet and beige silk, 8⅛ × 8⅛ in. (20.5 × 20.5 cm). Musée National du Moyen Âge, Thermes et Hôtel de Cluny, Paris, Cl.21840 (artwork in the public domain; photograph provided by Art Resource, NY).

Figure 87. Roundel fragment with a cross and confronted hunting Amazons, Egypt or Syria? 7th–9th century? weft-faced compound twill (samite) in green, beige, and brownish silk, 8¼ × 7¾ in. (21 × 19.9 cm). The Metropolitan Museum of Art, New York, Gift of Mrs. Hayford Pierce, 1987, 1987.442.5 (artwork in the public domain; photograph © The Metropolitan Museum of Art).

Power (1261–1453) in 2004 presented other examples of Byzantine innovative mimesis in their exploration of the interaction between the empire, the center, and the periphery—border states, the West, and the Islamic world. The cultural strength of the center during eras of prosperity and decline was shown to have been both accepted and reworked or rejected by the periphery seeking its own "visual voices." In these instances, mimesis functioned as an interactive connection to other peoples throughout the history of the state.

The diverse approaches to understanding the center and the periphery in these exhibitions were extended further in the Metropolitan Museum's 2012 exhibition *Byzantium and Islam: Age of Transition (7th–9th Century)*, which explored the interconnections within a limited region, the wealthy southern provinces of the empire, from Syria to Egypt and across North Africa, during a specific moment in their evolution as power shifted from the existing Byzantine state to the newly emerging Muslim world. The transformation was viewed through the varying Christian, Jewish, and Muslim communities of the region. In recognizing the plurality of the communities involved and their often underappreciated well-established relations with each other—Christian and Muslim Arabs, Jewish, Christian, and Muslim merchants on Red Sea trade routes—apparently simple examples of mimetic imitation were revealed to contain significant unexpected interconnections between cultures.

Figure 88. Roundel fragment with confronted hunting Amazons and *bismallah*, 7th–9th century, weft-faced compound twill (samite) in polychrome silk, 9½ × 6¾ in. (24.1 × 17.1 cm). The Metropolitan Museum of Art, New York, Rogers Fund, 1951, 51.57 (artwork in the public domain; photograph © The Metropolitan Museum of Art).

Three silk roundels in the show depicting mounted hunting Amazons demonstrated the need to consider mimesis from multiple perspectives. One displays only the figures of the classical theme (Fig. 86). Another repeats the scene, adding a small Christian cross to the interstices of at least one roundel (Fig. 87). The third contains the first phrase of the *bismallah* (In the name of God, the merciful, the compassionate) in Arabic (Fig. 88). All are associated with the ancient Egyptian city of Panopolis (now Akhmim, Egypt), named after the Dionysian figure Pan and well known as a weaving center. Thus, the images are as much a product of the region's deep-rooted interest in classical themes extending back before the founding of Alexandria, by Aristotle's pupil Alexander the Great, in 331 BCE, as they are about the influence of the dominant centers, Christian Constantinople or Muslim Damascus. Moreover, limiting reading of the patterns as simply dominant/inferior mimetic copying through the chronology of religions and conquest—pagan Roman, Christian Byzantine, Muslim caliphate—ignores the questions as to why they all date to the same time frame, probably when Panopolis was under Muslim rule.

Thelma Thomas, in her study of the silks, identified the Amazons as related to contemporary popular literature.[3] As she recognized, this fact makes the mimetic source of the motif less important than their relatively concurrent use, which suggests a common taste among the elite of all local communities at that time—Christian, Jewish, and Muslim. The Amazon silks thus give evidence that the *paideia*, the common classically based culture of the elite of the late antique Byzantine world as identified by Ruth Leader-Newby, could

expand to include members of the Muslim upper classes, some of whom would have already known the Byzantine/classical world through military service and trade.[4] Through these textiles, we glimpse an unexpected multicultural koine, an innovative mimesis, whose existence challenges the traditional explanation of an abrupt cultural shift with the change in political power between Byzantium and Islam. At the same time, the Christian symbol and Arabic Muslim inscription on two of the silks are elements of the distinctly different mimetic "visual voices" pertaining to the religious affiliations of those who had and would dominate the region.

In the multiple readings of their mimetic connections, the silks demonstrate that mimesis in such cultural interaction needs to be understood from the differing perspectives of all the participants in their own time. Mimesis is imitation, but, as art historians increasingly recognize the complexity of cultural development, we should ask not only the source but also the varying reasons for its employment by cultures as they develop their "visual voices." By doing so, mimesis continues to be a critical tool for art historians today.

Notes

1 The entry for "mimesis" refers the reader to "See Imitation. Vol. 2, p. 1375": Alexander P. Kazhdan and Anthony Cutler, "Imitation," *Oxford Dictionary of Byzantium*, ed. Kazhdan (Oxford: Oxford University Press, 1991), vol. 2, 988–89.

2 Thomas F. Mathews, "The Epigrams of Leo Sacellarios and an Exegetical Approach to the Miniatures of Vat. Reg. Gr. 1," *Orientalia Christiana Periodica* 43 (1977): 94–133, reprinted in *Art and Architecture in Byzantium and Armenia: Liturgical and Exegetical Approaches* (Brookfield: Variorum, 1995), chap. 8, 94–133; and John Lowden, *The Jaharis Gospel Lectionary: The Story of a Byzantine Book* (New York: Metropolitan Museum of Art, 2009).

3 Thelma Thomas, "Silks of the Panopolis (Akhmim) Group," cat. no. 103, in *Byzantium and Islam: Age of Transition (7th–9th Century)*, eds. Helen C. Evans with Brandie Ratliff (New York: Metropolitan Museum of Art, 2012), 154–59.

4 Ruth E. Leader-Newby, *Silver and Society in Late Antiquity: Functions and Meanings of Silver Plate in the Fourth–Seventh Centuries* (Aldershot: Ashgate, 2004).

<div style="border:1px solid">

Sarah E. Fraser

</div>

Ethnographic Mimesis: A Collaboration between Zhang Daqian and Tibetan Painters, 1941–43

Theoretical texts addressing questions of mimesis in Chinese painting and calligraphic traditions begin in southern cultural centers during the fourth century. Cong Bing's (375–443) *Introduction to Painting Landscape* discusses the mimetic possibilities of landscape representation and painting's role as a substitute for experience in nature—a theme that is well developed by the Northern Song period (960–1127).[1] Gu Kaizhi's (ca. 345–ca. 406) *Essay on Painting* (*Lunhua*), with its emphasis on the human figure, reflects the early domination of figure painting and concerns with conveying the human body and spirit. Zhang Yanyuan's mid-ninth-century survey *Record of Famous Painters throughout the Ages* signals new aesthetic issues articulating a performative mimesis in which the artist plays a critical role in mediating nature's imprint on painting. While the artist's body serves as a conduit for natural forces, it is only as a vehicle through which nature conveys its imitative representation on silk and wall.[2] In eleventh-century texts, cognition and artistic agency take center stage in debates about mimesis. Su Shi (1037–1101), the renowned poet, scholar, and statesman, emphasized the cultivation of the artist's character, shifting discussion to questions about representation of the self through objects in nature.[3] Mi Fu (1052–1107) highlighted one of the primary reasons for the massive transformation in subject matter (from figure to landscape painting) in the history of Chinese art at this juncture: the abstraction possible with landscape motifs better suits the exploration of interiority—or an inner mimesis.[4] Subsequently, in the period from the fourteenth to the eighteenth centuries, when innovation in landscape dominated both academy and independent ateliers, theories of representation were often reduced to an oversimplified, frequently repeated bifurcation describing two different kinds of reality: "depict or express ideas [*xieyi*]" or "depict from life [*xiesheng*]." Highly aestheticized nomenclature became a critical part of discursive conventions associated with brushwork; "willow-leaf line," "nail-head and rat-tail" contour, and "rain-drop" and "hemp-fiber" texture strokes are a sampling of the terms used in later painting manuals. Poetic artifice is more critical to understanding art than any direct references or praxis invoking nature in Qing Dynasty (1644–1912) painting.[5]

In the modern period, mimesis made a comeback. Its resurgence, however, was not brokered through new technologies, as in Europe, or with colonial exploits abroad, as outlined so adroitly by Michael Taussig in *Mimesis and Alterity*, but rather took the form of cultural encounters with the "other" on home turf. In a 1943 photograph, the painter Zhang Daqian

Figure 89. Zhang Daqian and Qinghai
painters reproducing wall paintings, Yulin
Caves, Anxi, Gansu Province, China, 1943,
photograph, 6⅞ × 9⅜ in. (17.3 × 23.9 cm)
(photograph provided by The Lo Archive).

(1899–1983) is depicted collaborating with Tibetan artists in the multicultural world of western China in a Buddhist Silk Road cave temple (Fig. 89). It represents a classic case of what Taussig defines as mimesis in the ethnographic sense—the "art of becoming something else."[6] This mimetic process, in effect, consists of becoming more like oneself, or "pure self-identity in otherness." The process of self-discovery was contextualized in a neocolonial framework, with Han Chinese reappropriating Tibetan and Mongolian cultural spaces to fashion a Sino-modern agenda. Zhang was a minor celebrity in the Shanghai art world in the early 1930s, where he, along with his older brother, produced nationalistic-themed paintings, generic landscapes, and forgeries of Ming dynasty works.[7]

Zhang participated in a larger Western exodus of millions fleeing coastal chaos during the Sino-Japanese War, which lasted from 1937 to 1945. Along with other artists and intellectuals, Zhang found his way to Gobi Desert monuments in search of an idealized Han past void of Euro-American modernity. The medieval wall painting he encountered in the Buddhist Silk Road temple, widely viewed as quintessentially Han Chinese, was thought

inaccessible in the modern artistic lexicon. Zhang and his Tibetan assistants made copies of the Buddhist murals at Dunhuang; others excavated tombs of medieval Turkic rulers and the westernmost ruins of the Great Wall. For most Chinese in the wartime capital of Chongqing, these sites were available only through accounts in newspapers or available in exhibition copies. The multiethnic Western frontier became a discursive space of Han fantasy among Chinese during the war—a zone that expanded notions of what it meant to be modern and Chinese, providing a refuge to fashion a Sino-modernity through an ethnic other.

Zhang leveraged this shifting world by employing native informants who possessed a technical expertise in Buddhist art that enabled him to capture this medieval pictorial domain with precision. Zhang reframed and repacked it with much enigmatic, lavish fanfare for a Nationalist audience in a series of exhibitions. And, as is suggested in this photograph in the Lo Archive, part of that mimetic journey of self-discovery literally involved entering the world of those paintings. With the canvas lashed to the wooden frame, Zhang leans in to make color notations on the copy after the tracing was complete. Touching and digesting the wall surface, his bodily engagement often extended to peeling or ripping away the upper mural layers in search of the earliest Han Chinese paintings. He traced each layer before discarding it and then tore down to the layers underneath. This is consumptive, possessive mimesis, "To get ahold of something by means of its likeness."[8] In the process, he destroyed centuries of painting, going well beyond the typical boundaries of inspiration and appropriation.[9]

Aside from their superior technical skill, Zhang's collaborators may seem like a random choice for a partnership, until one considers the long Tibetan presence in the region, going back to the period of Tibetan control of Dunhuang during the eighth and ninth centuries. Later, during the early modern period, Qing imperial armies reestablished imperial hegemony over the western regions in the eighteenth century, and, in the modern period, the neocolonial Republican project fixed its sights on an inner frontier reclamation from the 1920s through the 1940s.[10] Thus, Zhang's undertaking was part of a millennium-long struggle between the Tibetans and Chinese. Understood in an ethnographic framework, mimesis does not exist without historical encounters between nations or kingdoms that, in the course of interaction and hegemonic struggle, construct representations of each other.[11] It had been more than a millennium since Dunhuang had been under Tibetan rule (786–848 CE) when Zhang and the Tibetan painters from nearby Qinghai Province gathered in this cave to trace murals in the 1940s.[12] Poignantly, this grotto, known as the Treaty Temple of the Turquoise Grove, may have been built, as Matthew Kapstein proposes, to commemorate a peace agreement between the Tibetan and Chinese empires in about 825 CE, after a long period of Tibetan control.[13] The multicultural modern team selected this cave for several mural copies retracing the Tibetan-Chinese pictures of the past. Zhang's path to self-awareness was only possible through the expertise of artists adept at delineating scenes of the Western Paradise and the Paradise of the Future Buddha painted within.

Notes

1 Cong Bing's text has Buddhist meditative components; Northern Sung texts on landscape articulate concerns of officials confined to court life. Excerpts from Cong Bing, *Introduction to Painting Landscape* (*Hua shanshui xu*), and Guo Xi, *Lofty Message of Forests and Streams,* ca. 1180, are analyzed and translated by Susan Bush and Hsio-yen Shih, *Early Chinese Texts on Painting* (Cambridge, MA: Harvard-Yenching Institute, 1985), 36–38, 150–53, 165–69, 176–77, 364, 367. Other early key essays, such as Xie He's sixth-century *Classification of Painters* (*Gu huapin lu*), are found in *Complete Texts of Chinese Painting and Calligraphy* (*Zhongguo shuhua quanshu*), eds. Lu Fusheng et al. (Shanghai: Shanghai Fine Arts Publishers, 1992–94), vols. 1–2.

2 Sarah E. Fraser, *Performing the Visual: The Practice of Buddhist Wall Painting in China and Central Asia, 618–960* (Stanford: Stanford University Press, 2004), chap. 6. For Zhang's text (Lidai minghua ji), see Lu Fusheng et al., *Complete Texts,* vol. 1, 119–58.

3 See Bush and Shih, *Early Chinese Texts,* 193, 218, 224; and Fraser, *Performing the Visual,* 211, 293 n. 44.

4 Mi Fu, *History of Painting* (*Huashi*), ca. 1103, in Lu Fusheng et al., *Complete Texts,* vol. 1, 963–75, trans. Susan Bush, *The Chinese Literati Texts on Painting: Su Shih (1037–1101) to Tung Ch'i-ch'ang (1555–1636)* (Cambridge, MA: Harvard-Yenching Institute, 1971), 68. Peter Sturman analyzes the issue of liberating self-expression in "Wine and Cursive: The Limits of Individualism in Northern Sung China," in *Character and Context in Chinese Calligraphy,* eds. Cary Liu, Dora Ching, and Judith Smith (Princeton: Princeton Art Museum, 1999), 200–31.

5 Benjamin March, *Some Technical Terms of Chinese Painting* (Baltimore: Waverly Press, 1935), 43–44, 33, 35–36. The seventeenth-century woodblock print links terms with didactic images as a manual for instruction; see *The Mustard Seed Garden Manual of Painting, Chieh-tzu yuan hua-chuan, 1679–1701,* trans. and ed. Mai-Mai Sze, Bollingen Series (Princeton: Princeton University Press, 1977).

6 Michael Taussig, *Mimesis and Alterity: A Particular History of the Senses* (New York: Routledge, 1993), 36–37.

7 Shen C. Y. Fu, *Challenging the Past: The Paintings of Chang Dai-chien* (Washington, DC: Sackler Gallery, Smithsonian Institution; Seattle: University of Washington Press, 1991); and Clarissa von Spee, *Wu Hufan: A Twentieth Century Art Connoisseur in Shanghai* (Berlin: Reimer, 2008).

8 As best phrased by Taussig, *Mimesis and Alterity,* 21.

9 Sarah E. Fraser, "Buddhist Archaeology in Republican China: A New Relationship to the Past," *Proceedings of the British Academy,* no. 167 (London: Oxford University Press, 2011), 176–78. See the excellent range of articles on the subject of appropriation in "Notes from the Field," *Art Bulletin* 94, no. 2 (June 2012): 166–86, and in this book. Especially relevant here are Ursula Frohne's consideration of reworking and decreation; Cordula Grewe on emulation.

10 A large portion of Kham—one of the two regions of eastern Tibet—was annexed by the Republican government as "Xikang Province" after a protracted struggle from 1931 to 1939; it is now part of western Sichuan Province. Neighboring Qinghai Province, with its large Tibetan population, did not become a province until 1928.

11 Gilles Bibeau, review of *Mimesis and Alterity: A Particular History of the Senses*, by Michael Taussig, *American Ethnologist* 22, no. 3 (August 1995): 627.

12 The start of the "Tibetan period" is debated; the traditional earlier date is 781 CE. Jacob Dalton and Sam van Schaik's recent path-breaking work on the Dunhuang Tibetan manuscripts demonstrates that the political occupation of the site is less important than the region's cultural history; it is clear that Tibetans continued to have a significant cultural presence for some time after the collapse of Purgyal rule at the caves. Dalton and van Schaik, *Tibetan Tantric Manuscripts from Dunhuang* (Leiden: Brill, 2006); and Sam van Schaik, *Manuscripts and Travellers: The Sino-Tibetan Documents of a Tenth-Century Buddhist Pilgrim* (Berlin: De Gruyter, 2011).

13 Matthew Kapstein, "The Treaty Temple of the Turquoise Grove," in *Buddhism between Tibet and China* (Boston: Wisdom Publications, 2009), 21–72.

Thomas Habinek

Classical Mimesis as Embodied Imitation

Classical accounts of mimesis were never intended to provide norms for art. Plato, Aristotle, and others articulated a theory of mimesis in order to exempt philosophy from it. Implicitly or explicitly, their discussions and those of their philosophical successors assume that thought, especially as practiced by philosophers, is a privileged, nonmimetic practice. Even the later classical expansion of mimesis to encompass representation of the spiritual in nature or the fancy of the artist, while it broadened the definition of art, insulated the practice of philosophy. As a result, we should view with suspicion any attempt to recover a defense of artistic practice or dispassionate analysis of art's nature and function from such writers. They wrote not to answer our questions but to advance their own objectives in relation to their contemporary readers and professional rivals.

Which is not to say that there is nothing to be gained from exploring the vast array of references to mimesis in Greek and Roman texts or from reflecting on the reception of those references by later readers. The persistent interest in mimesis, if only to belittle or contain it, speaks to the ubiquity of the practice and the failure, even of its opponents, to imagine human existence in its absence. The ancient accounts anticipate contemporary scientific discussion of the species-specific faculty of imitation and, precisely because of their polemical, invested nature, raise questions that might otherwise be neglected by dominant modern approaches.

For example, we might turn the tables on the classical philosophers and ask not whether and how mere mimesis is to be justified, but whether and how any human activity, including cognition, can escape the chain of resemblance. Recent research has indicated that the capacity to identify and construct similarities is a precondition for language, music, art, empathy, cooperative action, and social learning.[1] The propensity to imitate is so pervasive that many researchers now regard the development of inhibitions on imitation as a key step in human evolution.[2]

Crucial to this new line of inquiry is the rejection of mental representations as a necessary component of cognition: recognition of similitude leads to action without an intermediary stage of intellection. From this standpoint, it is the Platonic project of belittling mimesis at the expense of dialectic that requires explanation, not the craftsmanlike reworking of matter (including one's own body) that is lauded in other traditions, past and present. Indeed, it is striking, if rarely observed, that in order to denounce painterly mimesis as inferior to thought, Plato found it necessary to change the term applied to images from *eikon*, which

implies a substantive connection between imitation and imitated, to *eidolon*, which does not.[3] The folk wisdom about images that Plato was repudiating seems to have come closer to modern scientific understanding than his own influential construction of a separate realm of cognition.

Much of Plato's anxiety about imitative practices (not limited to painting but including drama, music, and dance) derives from their association with pleasure. The connection is reinforced by Aristotle, who in attempting to justify at least some mimetic arts, calls attention to the pleasure inherent in noting that "this is like that." Rather than situating such claims in a long history of ethical debate over the uses of pleasure, as is usually done, we might stop to ask whether recognition or construction of similarity actually yields pleasure and, if so, how and why. Given the proliferation of imitative impulses documented by neuroscientists, the answer may well lie in the subtractive aspect of imitation rather than in imitation itself. An imitation is never an exact replica, and artifactual imitation in particular depends on a process of selection. The philosopher John Kulvicki makes this point in arguing that pictures, as a subtype of imitation, depend on explicit and implicit noncommitments: we readily recognize that a black-and-white photograph is not telling us about the color of the object whose resemblance it presents.[4] Aristotle may have had something similar in mind when speaking of multiple dramas on the same topic: resemblance is established through omission as well as inclusion. Is it possible that the pleasure of mimesis derives from the settling of the impulse to imitate rather than from its exercise? Does the biological need for the inhibition of mimesis help account for artistic style and its regularity? The mimetic impulse that energizes artistic genres and traditions shapes and disciplines similitude (of perception, action, belief) even as it multiplies and transmits it.

Precisely because of its power to limit, artistic mimesis is an important means of social as well as individual regulation, as ancient thinkers of every persuasion apparently recognized. Without the inhibition of imitation with the individual organism, there is potential for compulsive as opposed to coordinated or purposive mimetic practice. But coordination and inhibition are necessary at the social level as well, to allow for communication, cooperation, and transmittal of knowledge across time and space.[5] Who decides on the forms coordination and inhibition are to take? This is, in effect, the question at the heart of Plato's *Republic*, which despite its critique of mimesis, proposes to empower the philosophical rulers and their entourage of guardians to determine the patterns for imitation, not to dispense with it. And it is the question still largely neglected in contemporary discussions of imitation, whether scientific or humanistic in nature. Mimesis may be a natural phenomenon, but regimes of mimesis are contingent human constructions. Because works of art play a critical role in establishing, transmitting, and, at times, altering or resisting mimetic regimes, art historians would seem to have both an opportunity and a responsibility to critique those inhibitors of mimesis that enable and constrain human personal development and social interaction in any given context.

Notes

1 Susan Hurley and Nick Chater, eds., *Perspectives on Imitation: From Neuroscience to Social Science*, 2 vols. (Cambridge, MA: MIT Press, 2005).

2 See the special issue entitled "Evolution, Development and Intentional Control of Imitation," *Philosophical Transactions of the Royal Society, B: Biological Sciences* 364 (2009).

3 Suzanne Saïd, "Deux noms de l'image en grec ancien: Idole et icône," *Comptes rendus de l'Académie des Inscriptions et Belles Lettres* 31 (1987): 309–30.

4 John Kulvicki, "Pictorial Representation," *Philosophy Compass* 1, no. 6 (2006): 535–46.

5 Roy Rappaport, *Ritual and Religion in the Making of Humanity* (Cambridge: Cambridge University Press, 1999).

<div style="border: 1px solid black; text-align: center; padding: 10px;">

Tom Huhn

</div>

The Mimetic Pulse of Primal Unity

Mimesis is an ideal term to describe the dynamics of affirming continuity between things and ourselves, or—more generally—the word *mimesis* might best refer to the plausibility of likeness in the world. We may not fully fathom just how deeply mimesis grounds such connectivity.[1] Aristotle's renowned definition of drama as a mimesis of human action—as well as his characterization of both knowledge and human events as centrally mimetic—has overshadowed his more profound insight regarding narrative unity as itself a mimetic achievement.[2] That is, the seeming obviousness of Aristotle's delineation of plot as the inexorable procession from beginning to middle and thus to end has obscured the real triumph of narrative chronology in the unity conjured up out of singular events. The thoroughly mimetic character of plot can be seen, then, not solely in its representational content—the imitations of human actions—but rather, and more profoundly, in the very form of plot as the forging of a unifying continuity from beginning to end. Aristotle acknowledges that though a far more noticeable mimetic continuity appears always to reside in the visual imitations that bind a representation to a referent, the true import of mimesis lies elsewhere. And we can surmise that even such a well-tethered continuity as the one between thing and referent—or, say, the one between image and object—is underpinned by the far less obvious unities of narration and visual form. It is from this latter species of mimesis—the one that produces not so much likenesses and representations as unities and continuities—that we have much to learn. That is, the mimetic genius of images may lie not in the imitative likening of images to things but in the manner in which every image reproduces and approximates the unity of an object (Fig. 90).

Paul Ricoeur explains the origin of a more expansive, indeed, sweeping understanding of mimesis as first arising out of Aristotle's break with Plato. Plato, convinced of the thoroughly unoriginal and solely reproductive tendency of mimesis, considered it to be the most powerful deflection from truth and reality, a threat to politics and intellect. For Ricoeur, an enlarged, active understanding of mimesis constitutes Aristotle's "rupture" with Plato's static conception, which depicts all human making as proceeding shadowlike from whatever already exists. Whereas Plato's doctrine of mimesis confines it entirely to the realm of reproduction and aftereffect, Aristotle's (mimetic) reconceptualization construes mimesis as a form of dynamic, original human action—more specifically, of making and production not prejudged as inevitably unoriginal. As Ricoeur explains, "far from producing a weakened image of pre-existing things, mimesis brings about an augmentation of meaning in the field of action, which is its privileged field. It does not equate itself with something

Figure 90. Ed Ruscha, *Look-A-Like*, 1990, acrylic on canvas, 48 × 32 in. (121.92 × 81.28 cm) Gagosian Gallery, New York (artwork and photograph © Ed Ruscha).

already given. Rather it produces what it imitates, if we continue to translate mimesis by 'imitation.'"[3] In the enlarged view, mimesis is a form of überproduction: it produces, *and* it produces meanings. The making of meaning, in other words, is another mimetic means of forging continuities.

Mimesis is enabled by the epistemological relation between sense and judgment. David Summers's *Judgment of Sense* shows the great variety of ways in which sense and judgment were construed by a host of medieval and early modern thinkers as necessarily continuous with one another. Judgments about things could thus readily come to be seen as mimetic recapitulations of sensations.[4] We witness this same mimetic coupling of sense and judgment in the essay that would become the most important touchstone for many eighteenth-century writers on taste and aesthetic judgment: Joseph Addison's 1712 essay "Pleasures of the Imagination."[5] Addison describes imagination as an elaborated, controlled, and willed resuscitation of the pleasures of sensation. Imagination's pleasure is grounded in a return to the pleasures of sensation, and imagination takes pleasure in the submission of sensation to the possibility of imaginative mimetic repetition.

The appearance in 1755 of Johann Joachim Winckelmann's *Reflections on the Imitation of Greek Works* marks a watershed in the history of thinking about mimesis, since it cordons

Figure 91. Mary Jo Vath, *Batman Piñata,* 2010, oil on linen, 25 × 20 in. (25 × 50.8 cm) (artwork © Mary Jo Vath).

off mimesis to the realm of art making.[6] Winckelmann's contraction of mimesis severely restricts the range of the term, stipulating that originality can arise only from imitative continuity. With a wave of the hand, Winckelmann elevated mimesis to the center of all genuine artistic production. His exhortation to make truly original art by imitating the art of the ancient Greeks is complemented by his justly renowned phrase in praise of all successful art: "a noble simplicity and quiet grandeur [*eine edle Einfalt und eine stille Größe*]" not only elevates the best of ancient Greek art, it also signals elevation and equipoise—of style, subject, and affect. Winckelmann's famous phrase is no empty recommendation of beautiful art but an acknowledgment, via simplicity and stillness,[7] of the Aristotelian formulation of mimesis as the simultaneous movement toward continuity and unity (Fig. 91).[8]

Gotthold Ephraim Lessing, whom we rightly thank for the modern discovery of artistic medium,[9] conceives his book *Laocoön* as a rebuttal to what he takes to be Winckelmann's mischaracterization of mimesis.[10] Lessing's division of the arts according to their kinship either to painting or poetry signals more than the recognition of the distinction between time-based and non-time-based arts. It is also an implicit claim that all art making proceeds mimetically from one of two constitutive categories of human experience: time and space.

From the Aristotelian position, all of the now long-standing characterizations of mimesis as variations of imitation, resemblance, representation, and so on are mere secondary appearances of a more primal mimetic impulse toward unity. The suspicion that mimesis is more importantly a momentum toward unity perched very deep within us is likewise found

in Sigmund Freud's investigation of what underlies our human inclinations toward pleasure. Freud locates a tendency akin to mimesis in his speculation that repetition—more fundamental even than pleasure—manifests itself most often as imitation.[11] Freud comes to characterize this overarchingly imitative, repetitious momentum as the return motion toward whatever state a thing might previously have been—and he asserts that this fundamental inclination lies at the base of all organic life. Alongside Freud we might nominate Walter Benjamin as having provided another important twentieth-century reconfiguration of mimesis. Benjamin's conception of the human mimetic faculty yields an ideal location in which to witness the convergence of its most primal and most sophisticated facets. For Benjamin, human language is both the active instigator as well as the passive resonator of nature's self-generative, repetitive dynamic.[12] Human language is the appearance, the approximation, and the most recent iteration of nature's own recapitulating mimetic pulse.[13] For Freud and Benjamin, mimesis figures a continuity constitutive of human experience.[14]

Georg Wilhelm Friedrich Hegel, oddly enough, comes to mind here. Granted more time and space, perhaps even his dialectic could be made to reveal its mimetic allegiances. For Hegel, the origin of consciousness emerges when sensuousness takes flight. Consciousness first appears in the content arising from the negation of the features and stuff of sensuousness.[15] In this view, consciousness is the obverse mirror image of sensuousness, for consciousness comprises all that sensuousness leaves behind.[16] Just picture that.

Notes

1 I thank Ellen Levy for helping me collect and recall my ideas about mimesis.

2 Aristotle, *Poetics,* trans. Richard Janko (Indianapolis: Hackett, 1987).

3 Paul Ricoeur, "Mimesis and Representation," in *A Ricoeur Reader: Reflection and Imagination,* ed. Mario J. Valdés (Toronto: University of Toronto Press, 1991), 138.

4 David Summers, *The Judgment of Sense: Renaissance Naturalism and the Rise of Aesthetics* (Cambridge: Cambridge University Press, 1987).

5 Joseph Addison, "Pleasures of the Imagination," *Spectator,* nos. 411–21 (1712).

6 Johann Joachim Winckelmann, *Reflections on the Imitation of Greek Works in Painting and Sculpture* (1755), trans. Elfriede Heyer and Roger C. Norton (La Salle: Open Court, 1987).

7 For an illuminating discussion of alternative translations of *stille* (calm, quiet), see the introduction to Alex Potts's *Flesh and the Ideal: Winckelmann and the Origins of Art History* (New Haven: Yale University Press, 1994).

8 This point is made still more forcefully in Winckelmann's remarks on the unity between surface and depth in successful works of sculpture. It's just this unity of surface with all that appears to be beneath it that signals the triumph of a work of sculpture.

9 This is, of course, Clement Greenberg's view of Lessing. See Greenberg, "Towards a Newer Laocoon" (1940), reprinted in *Clement Greenberg: The Collected Essays and Criticism,* vol. 1, *Perceptions and Judgments, 1939–1940,* ed. John O'Brian (Chicago: University of Chicago Press, 1986), 23–38.

10 Gotthold Ephraim Lessing, *Laocoön: An Essay on the Limits of Painting and Poetry* (1766), trans. Edward Allen McCormick (Baltimore: Johns Hopkins University Press, 1984).

11 Sigmund Freud, *Beyond the Pleasure Principle* (1920), trans. James Strachey (New York: W. W. Norton, 1989).

12 I'm grateful to Jon Edelson for reminding me of Wallace Stevens's "The Idea of Order at Key West," which begins: "She sang beyond the genius of the sea. / The water never formed to mind or voice, / Like a body wholly body, fluttering / Its empty sleeves; and yet its mimic motion / Made constant cry, caused constantly a cry, / That was not ours although we understood, / Inhuman, of the veritable ocean."

13 Walter Benjamin, "On the Mimetic Faculty" (1933), in *Walter Benjamin: Selected Writings,* vol. 2, *1927–1934,* ed. Michael W. Jennings (Cambridge, MA: Harvard University Press, 1999), 720–22.

14 For a particularly illuminating treatment of the mimetic history of the term *figure,* see Erich Auerbach's "Figura" (1938), reprinted in Auerbach, *Scenes from the Drama of European Literature: Six Essays* (New York: Meridian Books, 1959).

15 G. W. F. Hegel, *Phenomenology of Spirit* (1807), trans. A. V. Miller (Oxford: Oxford University Press, 1977).

16 Hegel credited Friedrich Schiller for having inspired in him the insight that the shape of consciousness was first and foremost set by the determinations of sensuousness. See Schiller, *On the Aesthetic Education of Man in a Series of Letters* (1794), eds. E. M. Wilkinson and L. A. Willoughby (Oxford: Oxford University Press, 1967).

Jeanette Kohl

Blood Heads: Index and Presence

Art is imitation of nature. The more the imitation imitates, the greater the art is.
—Kurt Schwitters, "What Art Really Is: A Rule for Great Critics," 1920[1]

Mimesis as a core concept of human creativity defines many of our actions and aesthetic practices in relation to the world. In antiquity, the term *mimesis* (from the Greek word group *mimos*) related not least to practices of acting and reenactment, and in Pindar, Aeschylus, and Herodotus, mimesis refers to imitation with an emphasis on impersonation. As such, it is closely associated with portraying something or someone. For a scholar of Renaissance art and portraiture, concepts of mimesis become second nature. "Memes" related to the culture of *memoria* and self-fashioning are as much at the core of this period's intellectual setup as is the awareness of the role of mimetic processes in nature and religion. The Renaissance is a period of deceptions and illusions, but it is also one of likenesses and similarities.

While *similitudo* is a form of structural resemblance,[2] mimesis is a procedural paradigm. The first is passive and relational, whereas the second is generative. Similarity is a common product of mimesis. Yet, while similarity or resemblance is based on categorical comparisons, mimetic production not only reproduces the visible world but it also potentially improves, idealizes, embellishes, generalizes, or exaggerates. One might say that mimetic acts bear the inspiring potential to subvert and play with similarity and our expectations about it in creative ways. In the Renaissance, artistic mimesis provided a leeway for the artistic mind on the margins of reproduction. Mimesis is an innate talent, and beautification and the freedom of *election*, or artistic choice to improve nature become the ingredients of artistic theory—and associated mythmaking—that strives to overcome a conception of art as the ape of nature and the artist as a slave to the visual facts.

In portraiture, the early modern artist had to submit to the strictures of similarity more than in other fields. This is not to say that the artist had no latitude. Rather, indebtedness to the recognizable exterior forms of the face and body was central to the problematic status of portraiture in aesthetic theories, fueled, still, by a Neoplatonic skepticism of images. Portraiture in this perspective was the shadow of a shadow, but it was also more an outcome of the repetitive *ritrarre* than the more interpretative *imitare*.[3]

At the same time, indexical, merely documentary portraits were extremely popular. In images produced by sheer mechanical procedures of imprinting and casting, the immediate touch of material on material eliminates the artist's "thinking hand" and creative mimesis.

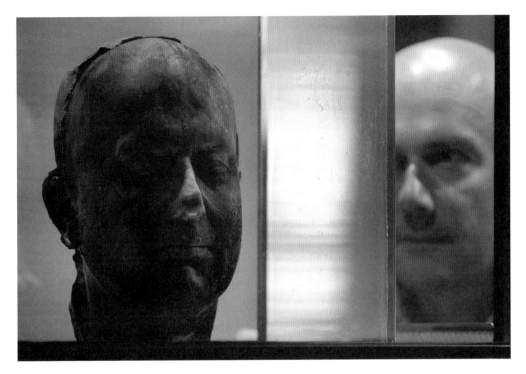

Figure 92. Marc Quinn, *Self (Blood Head)*, 2006, the artist's blood, liquid silicone, stainless steel, glass, perspex and refrigeration equipment, 80¾ in. × 25⅝ in. 25⅝ in. National Portrait Gallery, London (artwork © Marc Quinn, photograph provided by EFE/Andy Rain).

The physicality of the facial imprint, which we find in many sculpted Renaissance portraits, infiltrates the lofty thought processes we associate with the mimetically versed Renaissance artist. The preference for the index is part of an intellectual framework that operates heavily with tropes of imprinting: virtuous behavior from father to son, pious and beautiful ideas into women's and children's minds, and the beloved's image onto the lover's soul. In turn, these portraits "imprint" themselves in a very striking way into our collective memory of faces.

First produced in Roman antiquity, such "ultramimetic" portraiture, which aims at maximal likeness rather than the re-creation of an individual through the artist's eye, leads an interesting afterlife in British artist Marc Quinn's group of four self-portraits, dated 1991 to 2006, entitled *Self (Blood Head)* (Fig. 92).[4] These portraits bring to life an array of questions about the relation of mimesis, materiality, and portrait sculpture in a substantial way.[5] Each of the images—the portraits vary slightly in outcome and appearance—is made from ten pints of Quinn's blood, poured into a cast of his head and subsequently deep-frozen. As documentary indices of the head with all its details, the sculptures are quite disturbing. In their "brutalist" mimesis and materiality, Quinn's skinless faces record his aging, yet the process

is literally frozen in time. In this way, they address the central function of portrait sculpture: to keep the dead alive. Ironically, the material used is not known to be particularly durable in itself. The durability of the portrait bust carved in marble or cast in bronze is counteracted by the precarious nature as well as the aggregate state of the matter used. Blood is usually hidden within the body and only emerges through the skin if it is injured. Needless to say, it is not typically the material of mimetic portraiture.

By turning his body's internal fuel into the raw material of its own image, Quinn addresses the idea of the body turning into an image in death.[6] He also radicalizes traditional artistic casting practices and their relation to concepts of *memoria* and genealogy. *Self (Blood Head)* tackles these ideas in a biologistic manner. It also evokes Christian blood metaphors, such as the New Testament substituting the Old Testament's covenant carved in stone with the liquid covenant of the Eucharist: blood as the everlasting fluid, the medium of circulating the testament through Christ. Quinn's blood heads clearly operate with the idea of physical and spiritual sacrifice, but they cast the material and Christological fluidity and currency of the medium into a state of technically mastered preservation. Engineering makes it possible for Quinn to be literally and substantially *in* his own image—at the expense of the artist's blood and his likeness both being at the utter mercy of a refrigerating system.

Historically, an artist's portrayal of themselves was the outcome of close introspection and observation. The challenge of traditional self-portraiture requires a reflected form of automimesis in which an inner similarity shines through in the likeness of one's visible self. Quinn's *Selfs* are less character portraits than simulacra, addressing (and counteracting) the function of portraits as making memory present. The series documents and testifies to the artist's physical life in the guise of a blood relic. But Quinn's is also a series of antiportraits, in the sense that the London version is designed to be melted, recast, and refrozen when moved: the artwork's mimetic form can be "destroyed" and re-created technically. Such a re-creation would revive nothing, however. On the contrary, the artwork literally freezes and deactivates the oscillating contiguity of presence and absence, closeness and distance characteristic of portraiture. What we get is what we see: frozen blood—and a blatant violation of conventions related to the promise of presence, which the mimetic portrait generates.

Notes

1 Kurt Schwitters, "Was Kunst ist: Eine Regel für große Kritiker," in *Kurt Schwitters: Das literarische Werk*, vol. 5, *Manifeste und kritische Prosa*, ed. Friedhelm Lach (Cologne: DuMont, 1981), 57. The ironic statement reads in German: "Kunst ist die Nachahmung der Natur. Je intensiver die Nachahmung ahmt, desto größer ist die Kunst."

2 Jeanette Kohl, Martin Gaier, and Alberto Saviello, "Ähnlichkeit als Kategorie der Porträtgeschichte," in *Similitudo: Konzepte der Ähnlichkeit in Mittelalter und Früher Neuzeit* (Munich: Fink, 2012), 11–27.

3 For a lucid analysis of the terms and their meaning in Renaissance art theory, see Rudolf Preimesberger, "Vincenzo Danti: Das Allgemeine, nicht das Besondere—'imitare' statt 'ritrarre' (1567)" and "Lodovico

Castelvetro: Das Besondere, nicht das Allgemeine—'ritrarre' statt 'imitare' (1570)," both in *Porträt*, eds. Rudolf Preimesberger, Hannah Baader, and Nicola Suthor (Berlin: Reimer, 1999), 273–87 and 288–96.

4 The last in the series of four Blood Heads (2006) was acquired in 2009 for £300,000 by the National Portrait Gallery in London. It is the only cast in a British public collection; see http://www.npg.org.uk/about/press/marc-quinn-press.php.

5 For a discussion of Quinn's *Self* of 1991, see also Monika Wagner, *Das Material der Kunst: Eine andere Geschichte der Moderne* (Munich: C.H. Beck, 2001), 229.

6 Hans Belting, "Image and Death: Embodiment in Early Cultures," chap. 4 of *An Anthropology of Images: Picture, Medium, Body*, trans. Thomas Dunlap (Princeton: Princeton University Press, 2011), 84–124, originally published as *Bild-Anthropologie. Entwürfe für eine Bildwissenschaft* (Munich: Fink, 2001).

<div style="border: 1px solid black; text-align: center; padding: 10px;">

Niklaus Largier

</div>

The Figural Shape of Perception

In the *Life of Moses,* the fourth-century theologian Gregory of Nyssa makes an attempt to explain what he considers the deep paradox and ultimate challenge of mimetic figuration. Reaching the summit of Mount Sinai, dwelling in "darkness" after gaining access to "the invisible and the incomprehensible […] beyond all knowledge and comprehension," Moses is "led […] to the place where his intelligence lets him slip in where God is." There, Moses "sees that tabernacle not made with hands" that he will have to show "to those below by means of a material likeness [*mimesis*]." Moses has to do so in order to guide them in their way to the contemplation of true reality, and its beauty—"Beauty" and "Being," as Gregory calls the divine in a Greek philosophical vein.

The gap could not be more gnawing between the reality of the things Moses sees in divine darkness and the "material mimesis" he is meant to engage in. As he learns, the very mirroring that material mimesis performs—Latin translations speak of *speculatio*—is *the* only access to the truth of all things and of each particular thing in its worldly and temporal existence.[1] Gregory, to be sure, is not a Gnostic who chooses a spiritual flight into a world of ideas. Instead, he emphasizes that as Moses returns from the heights of Sinai, he brings back not only the Law but also an art of figuration, a "material mimesis," that "reweaves" perceptions and opens a path where conceptual knowledge fails. This path includes allegorical readings of the mimetic figures drawn from the Holy Scriptures that are to be interpreted in the process of contemplation. However, as Gregory and Origen, a theologian very close to him, make abundantly clear, mimetic figuration is more than a practice of representation that opens ways of reading and of a hermeneutic engagement with things, the world, and God.

Beyond and below the level of hermeneutics, material mimesis creates networks of figures and figuration—figures that do not "mean" anything but that impose themselves on our sensual and affective perception, forming a particular sphere of knowledge. The fact that Moses "boldly approached the very darkness itself" thus translates—as Origen stresses in his engagement with the Scriptures—into a form not of conceptual knowledge (*gnosis*) but of aesthetic experience (*aisthesis*).[2] Ideally, material mimesis would bring back the true nature of things, lost in darkness. Yet, it can never be more than the production of a growing and ever more absorbing intimacy with that very nature of things.

What I have been fascinated with in recent years is both the utterly realist side of these theological thoughts and the light they throw on our view of mimetic figuration. Gregory and Origen engage in an elaborate understanding of "material mimesis," of image and object making that does not end with an allegorical reading of images and their symbolic function.

Instead, they foreground the aspect of *aisthesis,* of sensual and affective perception, and thus of aesthetic experience. As Origen points out, the scriptures have to be read in light of intellectual understanding and in forms of an experience where figures and tropes deploy their effects by shaping perception, sensation, and affects and by liberating things from a discursive grasp that turns them into idols and ideology.

Erich Auerbach, trying to understand what he sees as the realism, the "concreteness," the "intensity," the "sensuality," and the absorbing style of Dante's poetry,[3] returns to this theological concept of mimetic figuration in a 1944 essay with the title "Figura." In a detailed analysis of the use of the word in classical rhetoric and poetry, he elaborates on the material quality of the term, which, as he points out, never loses the character of plasticity and concreteness. It is remarkable that exactly this plastic-concrete and haptic aspect of *figura* is most prominent in the Christian use of the term. In Tertullian, Auerbach writes, "*figura* is something real and historical" that points to something else that is also "real and historical."[4]

This, however, does not mean that the reader or viewer of a figure is to interpret it in a spiritual way, moving from a literal-historical meaning to an allegorical one. Rather, we discover in Tertullian's lively and evocative poetic writing what Auerbach calls Tertullian's "energetic realism." This realism produces an absorbing figural reality that not only affects the reader and shapes his affects and perception but also brings figures in communication with each other in the very act of perception. Thus, the plastic sensual and historical concreteness of figures never moves into the background. Instead, it produces figural networks below the horizon of hermeneutics and allegorical interpretation.

What is striking here is another aspect that Auerbach does not mention explicitly. It is the very experimental nature of this practice of material mimesis or, to put it in broader terms, the openness of experimental figuration toward the production of aesthetic experience. Born out of the impossibility to name and represent things "as they are," mimetic practice is to be understood as a never-ending play with figures, their capacities to produce effects and to form networks. The history of the adaptations and reworkings in poetry and the visual arts of elements drawn from the biblical Song of Songs since Gregory of Nyssa and Origen is a wonderful example of exactly this history of experimentation. The history of still lives is another case worthy of study. In their thoughts about a modern notion of aesthetics, Alexander G. Baumgarten and Johann G. Herder argue in the eighteenth century (far away in time but not far from the problems discussed by the early theologians) that this experimental play with figures on a ground of darkness constitutes the very foundation of aesthetic experience—not as a practice of mimetic illustration and allegory, but as a practice of creation of ever new possibilities of sensual, affective, and cognitive perception through "material mimesis."[5]

Notes

1 Gregory of Nyssa, *The Life of Moses,* trans. and ed. Abraham J. Malherbe and Everett Ferguson (New York: Paulist Press, 1978), 41–44, 94–106.

2 See Karl Rahner, "Le début d'une doctrine des cinq sens spirituels chez Origène," *Revue d'Ascétique ET de Mystique* 13 (1932): 116.

3 Erich Auerbach, *Dante als Dichter der irdischen Welt* (Berlin: De Gruyter, 2001), 42–61.

4 Erich Auerbach, "Figura," in *Six Scenes from the Drama of European Literature* (Gloucester: Peter Smith, 1973), 29.

5 See Niklaus Largier, "The Plasticity of the Soul: Mystical Darkness, Touch, and Aesthetic Experience," *Modern Language Notes* 125 (2010): 536–51.

Peter Mack

Mimesis for Artists, Writers, and Audiences

The high value placed on the concept of mimesis offers a point of comparison between the literary and visual arts. Aristotle, writing about tragedy, focused on the imitation of an action, while implying that there should also be an imitation of character, whereas theorists of the visual arts in the Classical period speak of the imitation of reality.[1] The ancient anecdotes about the skill of the painter center on the ability of his representations to trick either animals or other painters into thinking that the painting is a real object: a bunch of grapes or a curtain.[2] In order for a painter to be taken seriously, a certain skill in mimesis seems to be a requirement. In that sense, mimesis for the painter may be not so much a goal as a means to an end. The fact that you can portray apparently unimportant objects (grapes, curtains) realistically provides a guarantee of competence that can recommend you as a candidate for more ambitious projects (portraits of an emperor, depictions of mythological or landscape scenes). In rhetorical terms, to demonstrate skill in mimesis might be thought of as part of the painter's *ethos,* part of his self-presentation as a dependable partner in the transaction of creating a public visual image. Since *ethos* is part of rhetorical theory, to speak of *ethos* inevitably directs attention to the role of the audience in such a transaction.[3] If you engage someone to make a representation of a subject, you want to be sure that you are at least paying for competence; in ideal circumstances and in order for your commission to achieve a great success, you want to engage the person capable of the best possible imitation of the subject. Of course, successful imitation of reality requires an illusion to be created. In keeping with most Western theorists, who consider mimesis a preeminent goal of painting, E. H. Gombrich has described the part that expectations and projections on the part of the viewer play in the process of responding to the visual stimuli provided by art objects.[4]

The effect of successful imitation is often amazement at the painter's skill. When we look at a van Eyck or Vermeer, we are astonished at the precision of the detail even though we must to some extent be collaborating in viewing the panel or canvas as a representation of people in a sitting room, a studio, or a bedroom. But it can also be shock. On looking at a large nude by Lucian Freud, I am both amazed at the detailed rendition of the flesh colors and blemishes and in some way stunned by the apparent pitiless, unflinching gaze of the artist, as if he is determined to show me the kind of animals we humans actually are, without illusions of idealization, compassion, or love. Some of this shock (if that is the right word) comes from a crossing in perceptions. We are so used to projecting a certain kind of idealization on the central nude figure of a painting that to be compelled to confront so much that is

nonidealized can be a jolt. The size of the paintings and the postures imposed on the models may also contribute to their startling effect. Freud's paintings may also implicitly comment on other imitative nudes. What we usually think of as a realistic portrayal of a body may in fact involve a degree of idealization, both in the models chosen and in the manner of their depiction. An unintended idealization may be a component of the "realistic depiction" of brothel or drinking scenes in genre painting. Even unattractive people look better in films and on television than in our lives.

To depict scenic reality in literature, writers focus on specific objects and on visual sensations in the viewer. These depictions are always selective and are often celebratory. We think that we have seen the whole of King Arthur's feast in *Sir Gawain and the Green Knight* (lines 60–84, 114–29) because the poet has described in detail a few of the textiles and sounds, leaving the audience to fill in the rest of the scene. Successful literary mimesis requires a very strong fit between characters, causes, and action so that it will seem that the action results almost inevitably from the people and the situation. At its most successful, the writer's art of illusion goes beyond mimesis and becomes *enargeia,* bringing an action before the eyes of one's audience and thereby achieving a tremendous emotional impact on them.[5] *Enargeia* is produced by the way in which the circumstances are portrayed. The force attributed to *enargeia* is the literary artist's envy of the power of the eye. To the eye, an effect is always immediate and individual. Only when they are used with great skill can words and narrative have the same impact. A literary mimesis works through time; it depends on a fit between what we learn about the people involved and the action portrayed. Painting sometimes implies the elements of time and causation, but it can also make its effect without them. Francis Bacon may have had something like this difference in mind when he spoke about the difficulties involved in narrative painting. "I don't want to avoid telling the story, but I want very, very much to do the thing that Valéry said—to give the sensation without the boredom of its conveyance. And the moment the story enters, the boredom comes upon you."[6]

The requirements of mimesis differ according to the different media. In the theater, mimesis depends on providing adequate causations for actions that evolve at appropriate speeds and in accordance with what can be presented onstage. There is no doubt that actual bodies perform the action; the question, which depends on the complementary skills of writer and actor, is whether they are credibly and significantly motivated. In media where less is already given, the requirements of mimesis may be satisfied with less, or an audience may be more willing to collaborate in the illusion. With the right words and the right actors, an audience may be willing to accept a row of umbrellas as an artful imitation of Noah's ark or the flapping of a single umbrella as the flight of a raven. In painting, there may be more expectation of a certain degree of skill with line, organization, and color, less toleration of improvisation; in sculpture, especially in restricted places, correspondingly more.

Mimesis depends largely on what an audience is willing to regard as a realistic representation. This will vary according to both their expectations about the world (under what circumstances is what sort of person likely to perform what sort of action?) and their

understanding of the medium in which the imitation is conveyed. Understanding a particular culture or period's criteria of accurate representation involves studying its beliefs, its practices of education, and the representations that artists and audiences will have had before them as models. It requires us to investigate the different types of plausible connection that individuals have learned from the stories they have been told, from their practical social lives, and from their visual experience. A period or a cultural mimesis will depend fascinatingly on the interactions between the conventions of different forms of expression; in some periods, on the relations of visual art, theater, and literature; in others, of video games, social media, film, and photography. The conventional aspect of mimesis gives artists the opportunity to present new visions of reality shockingly and convincingly.

Notes

1 Aristotle, *Poetics* 1448a1, 1449b24, trans. M. Hubbard in *Ancient Literary Criticism,* eds. D. A. Russell and M. Winterbottom (Oxford: Clarendon Press, 1972), 92, 97.
2 Pliny, *Natural History,* 35.65.
3 On ethos, see Aristotle, *Rhetoric,* 1356a1; and Quintilian, *Institutio oratoria,* 6.2.8–19.
4 E. H. Gombrich, *Art and Illusion* (London: Phaidon, 1960), 2–4, 9–14, 181–82, 203–34.
5 Quintilian, *Institutio oratoria,* 6.2.29–36, 8.3.61–72, 9.2.40.
6 Francis Bacon, quoted in David Sylvester, *Interviews with Francis Bacon* (London: Thames and Hudson, 1980), 65.

Alex Potts

Mimesis and the Anti-Mimetic

The term *mimesis* is not often deployed in modern discussions of the visual arts. There is no art historical equivalent to Erich Auerbach's magisterial study of literary mimesis.[1] Mimesis is generally conceived of in terms of imitation, the term that stood in for mimesis in traditional art theory. With modern theories of art prioritizing the constructive dimensions of artistic process, imitation has acquired increasingly negative connotations. Terms such as *depiction* or *representation* tend to be used instead, even if these, too, are associated with uncritical reflection of given appearances in the more radically antimimetic twentieth-century theorizing about art. Nevertheless, much modernist or avant-garde art that is characterized by commitment to abstraction and to rejection of the artistic imitation of reality often powerfully evokes aspects of a larger world lying outside the domain of art.[2] To make sense of these complexities, with antimimetic imperatives existing alongside equally powerful impulses to engage with nonartistic realities, much can be gained from considering the broader meanings mimesis has had in earlier thinking about art and literature.

Roughly speaking, Western conceptions of mimesis that originated in ancient Greek theorizing about literary representation and image making fall into two categories.[3] One prevalent view has it that mimesis is the fashioning of an image or appearance that imitates something in the real world or gives the illusion of doing so. Such understanding of mimesis as the artistic reflection of something real has dominated conceptions of representation in the visual arts. In contexts where naturalistic notions of art have held sway, it acquired positive connotations as endowing the work of art with lifelikeness and vitality. Equally, it has often, as it did in Plato, been envisaged negatively—with the image realized in the work of art being seen either as an inadequate copy of something real or as a deceptive illusion. Envisaging mimesis thus as a reflection of reality often entails a disregard for the internal configurational aspects of the artwork, as if the most compelling picturing has a visual immediacy that cancels out awareness of artistic medium and process. Yet medium was integral to ancient understandings of mimesis. Even for Plato, mimesis was "intentionally making an appearance (*phainomenaon, phantasma*) that resembles something of a certain kind but is not something of that kind itself."[4]

An alternative theorizing of mimesis, which had its origins in Aristotle's poetics, focused on the internal configurational coherence of a work. At issue was the compelling nature of the work seen as a whole rather than reflective resemblances between individual images and motifs and realities they purportedly conjured up. A work of art envisaged in these terms

was mimetic because the compelling picture or fiction generated through the artistry deployed in fashioning it evoked something significant about the world without imitating it directly. In traditional post-Renaissance artistic and poetic theory, these two understandings of mimesis usually went hand in hand. The antimimetic turn, which became particularly acute in the late nineteenth century, operated in part by instituting a dichotomy between the world-reflecting and the world-creating capacities of art, with mimesis being associated with passive reflection.

The antimimetic turn was more thoroughgoing in the visual arts than in literature, giving rise to modern artistic formations in which the configurations were entirely abstract and divested of representational or mimetic elements. There are two broad points to be made here. First, this development originated in part in reaction against a very particular understanding of pictorial mimesis that had taken hold in the later nineteenth century—one in which processes of artistic representation were conceived of as drawing or painting directly from life, almost as if the artist were a living camera registering visual sensations of things seen through the filter of his or her temperament. Second, the pioneers of radical abstraction were often motivated by a belief that the self-generating artistic processes to which they gave themselves over were resonant with a reality inaccessible to conventional pictorial representation. They were, in effect, holding onto something of the world-creating aspect of traditional understandings of mimesis.

The imperative driving the modern antimimetic turn had less to do with representational forms as such than with a larger compulsion to fashion radical alternatives to prevailing artistic conventions seen as empty and as confirming the established cultural and political order of things. Such an imperative was already at work among the more radical nineteenth-century realists,[5] so it cannot simply be identified with an abandonment of the mimetic impulse. What occurred was an increasingly fraught split between world-reflecting and world-making processes that had been encompassed, largely without critical anxiety, within traditional understandings of artistic mimesis.

New forms of art emerged in which mimesis existed uneasily, if suggestively, alongside an artistic configuring that operated independently of conscious portrayal. A good instance is Jean Dubuffet's painting *Shot in the Wing* (Fig. 93). A modernist engagement with painting's messy and polychromatic materiality is central to its conception. It is in no way a depiction of an observed street scene. Even so, it contains representational cues evoking the urban environment's chaotic flow of traffic and array of discordant signage and its isolating collectivity. These cues prompt one to envisage the melee of paintwork as possibly having something to do with the fabric of experience in the modern metropolis. Any direct apprehension of this kind, though, is blocked by the image-disintegrating effects of the painterly process. Ideally, the representational motifs should acquire a more lifelike resonance through being embedded in the material fabric of the work, while the latter's generalized evocativeness should take on a vivid concreteness from the mimetic cues. Yet, the impact the work has comes more from interferences and disparities between the largely

Figure 93. Jean Dubuffet, *Shot in the Wing (Le Plomb Dans L'Aile)*, 1961, oil on canvas, 74¾ × 98⅜ in. (190 × 250 cm). Detroit Institute of Arts, Gift of W. Hawkins Ferry (artwork © ADAGP, Paris and DACS, London 2017; photograph © Bridgeman Images).

nonrepresentational power of the painting and the fragmented representational cues, blocking any easy resolution and prompting one to keep looking.

This argument has been advanced from a context very different from the one in which Dubuffet and other self-consciously modern artists were operating in the earlier and mid-twentieth century. Nowadays, the urgency attaching to the modernist or avant-garde commitment to a negation of lifelike pictorial representation understood in narrowly reflective terms has dissipated, leading to clearer awareness of the historically and culturally diverse nature of artistic mimesis. Gone is the idea of a revolutionary artistic project pursued through a radical reconfiguring or negation of traditional cultural forms. This is a loss that has had its effect on the urgency that can be claimed for a committed artistic practice. But it does not mark the end of art that seeks to be modern and politically engaged. Understandings of the viability of artistic formations have shifted, with overtly mimetic effects and the explicit referencing of realities lying outside the domain of art being more

freely exploited. What persists in experimental work is a willingness to face up to ongoing dislocations and tensions between the configurational and the representational dimensions of artistic process—symptomatic of a broader disintegrative logic in capitalist culture—and a refusal that is as much political as it is aesthetic of the affirmative synthesis of the two posited in classical art theory.

Notes

1 Erich Auerbach, *Mimesis: The Representation of Reality in Western Literature* (Princeton: Princeton University Press, [1953] 2003).

2 These issues are discussed in Alex Potts, *Experiments in Modern Realism: World Making, Politics and the Everyday in Postwar European and American Art* (New Haven: Yale University Press, 2013).

3 Stephen Halliwell, *The Aesthetics of Mimesis: Ancient Texts and Modern Problems* (Princeton: Princeton Universty Press, 2002), 1–33, 358–81.

4 John Hyman, *The Objective Eye: Color, Form, and Reality in the Theory of Art* (Chicago: University of Chicago Press, 2006), 61.

5 Frederick Jameson, *A Singular Modernity: Essay on the Ontology of the Present* (London: Verso Books, 2002), 119–28.

TIME

Figure 94. Eric Fischl, *The Sheer Weight of History*, 1982, oil on canvas, 60 × 60 in. (152.4 × 152.4 cm) (artwork © Eric Fischl).

Time Is of the Essence

In art, time is of the essence. That is to say, all art is involved with time, and artists find ways of working with time to achieve its greatest effect. Narrative time, gestural time, the starting and stopping of time, the frozen, arrested, captured, stolen moments of time, all these exist in art. There are also the timeless archetypes, the fleeting glances, exhalations and inhalations, social moments, political periods, epochs, religious eternities, all requiring the language of art to find form and expression.

Unlike the kind of street photography, which, in the click of a finger, captures a moment, as though a revelation, painting is a journey that ultimately arrives at its destination. Painters invite the viewer to come along with them on that journey. Painting stops time but does not interrupt the flow of the narrative. With painting, there is the time it takes to "see" the painting and the time it takes to "understand" why we are looking at it. Every painter has a distinct sensibility regarding the "looking" time. A painter moves the eyes of the viewer around the canvas causing them to stop or pause or return to the beginning by how colors are used, gestures made or edges treated. The way the "looking" is orchestrated is in direct relation to the desired emotional effect.

For me, each painting is a struggle to find the precise moment in which everything meaningful is present and nothing extraneous, frivolous, or self-satisfied remains. The action interrupted by observation, the moment captured in painting, cannot have strayed from the cathartic event, cannot have become flaccid or give the impression of arbitrariness. As a rule, the dynamic moments, the moments most pregnant with meaning, happen just before something takes place or just after it has happened. The moments leading up to a significant event trigger the anxiety or thrill of anticipation. The moments leading away from that event deal with its consequences. The drama occurs when the event unravels. So one of the most critical decisions a painter must make is when to arrest the moment. But regarding the element of time, it is not the only way the artist uses it.

Painting toward an important moment while simultaneously tearing it down has been a particular preoccupation of mine. The time it takes for something to happen and the time it takes to understand it are grossly disproportionate. Understanding can take years, or in the case of metaphysics, a lifetime. Some examples of how I have used time in my work.

In my diptych *Bayonne*, I painted in the left panel a naked woman sitting in a chair in her bedroom. She is pensive and is looking over her shoulder, across the room, at something.

In the right panel, I painted a young girl in a tutu performing/practicing a ballet move. Her arms are outstretched before her and her hands are opened, palms turned outward as if pressing against an invisible wall. The panels overlap, with the right panel cantilevered from the wall. When the work is viewed straight ahead, the two scenes blend into a coherent and cohesive scene as the light and the architectural elements line up. The scene suggests that the "mother" is watching her "child" perform for her. But when you move physically from one side to the other, the cohesion breaks apart and you have two separate moments. Now, the mood of the woman becomes more charged. She is not really looking outward at the girl but is looking inward, contained and introspective. What is she thinking about?

The painting is about memory. The woman is perhaps looking back at herself when she was a child with aspirations to be a dancer: a self not realized. The gesture of the child is curious and evocative because it is anything but a graceful balletic motion. It is stiff and awkward, giving the impression that she is resisting something, keeping it at bay, stopping it from happening. There is a feeling that the girl (the woman's past?) is closing off access, is stopping the woman from being able to connect to that time before, that time when the future held such promise.

I am interested in an instant and a lifetime and I have tried in various ways to make both present in one work. My painting *The Travel of Romance* is a sequence of small events captured on five canvases. They become, in effect, a theater piece staged in five acts. The first scene depicts a white woman naked and squatting in the middle of the floor. Glowing, tucked into an almost fetal position, she looks out toward you but not at you. Behind her is a naked black man, crouching and very animated. He is skin close but she pays no attention to him. It is as if the two do not occupy the same room at the same time or, more precisely, one is the figment of the other's imagination. In the second scene, she crawls across the floor, eyes focused on someone or something outside the picture plane. There is a sense that he is present but not in view. In the third scene she stands looking off the canvas, again at someone or something. In the fourth scene she is bending over an open suitcase, no longer looking for someone but looking for something she has misplaced, lost, or forgotten. In the fifth and final scene, on the floor, she is curled into a fetal-like ball drenched in an obliterating white light (Fig. 95).

All the scenes take place in the space of a small room over the course of a few hours, possibly an entire evening. But if you look at the body language of our protagonist, she goes from fetal position to crawling to standing to bending and finally returning to fetal position. Metaphorically, it is her lifetime.

I did a series of paintings entitled *The Bed, the Chair,…* The conceit for each painting was that there was always the same bed and the same two chairs in each scene but the people portrayed were different each time, much like a hotel room that marks time by the passing through of guests.

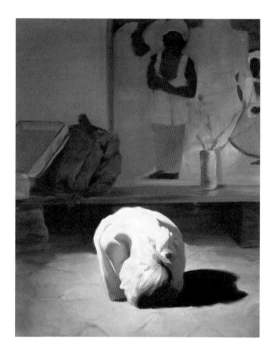

Figure 95. Eric Fischl, *The Travel of Romance; Scene V*, 1994, oil on linen, 70 × 54 in. (177.8 × 137.2 cm) (artwork © Eric Fischl).

The Renaissance sculptor Donatello carved a wooden sculpture that depicts Mary Magdalene moments before her death (Fig. 96). She is ravaged with age, the physical toll of an ascetic life, and the brutality of her poverty. She is standing in prayer, clad in a moth-eaten hair shirt. Her open, near-toothless mouth beseeching her Lord reinforces the crushing hardships she has endured. But the genius of this masterpiece of suffering is in exactly how and where the artist stops time. Showing her with elbows bent, hands lifted in prayer position in front of her bony chest, Donatello chose not to clasp or close her hands but, leaving the smallest space between the fingertips, made it appear that her petitioning is not quite over. The astonishingly precise and intimate space he has captured between her hands measures the small amount of time she has remaining. It is clear she is beyond our ability to help her. She is no longer with us. This space, wide enough so only a soul may pass through, marks both a fleeting moment of life and the enormity of the timeless chasm to follow.

Auguste Rodin, in his sculpture *Eve*, captures the torment of her expulsion. Though the event is not yet over, the emotional consequences are understood to be guilt and shame. But in a surprisingly curious small grouping of four plaster studies, incomplete and uneditioned, that were found in his studio, Rodin was looking for a different moment in the expulsion narrative. He literally strapped another sculpture, completely unrelated to the biblical narrative, to the heads of two copies of Eve. It is a sculpture of a woman squatting. He duplicated

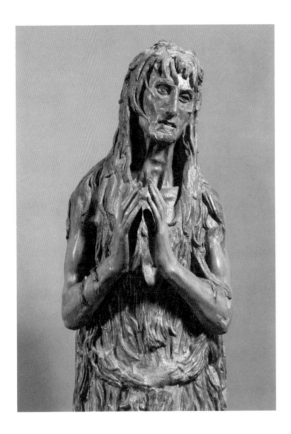

Figure 96. Donatello, *Mary Magdalene*, detail, 1453–55, polychrome wood, height 74 in. (188 cm). Museo dell'Opera del Duomo, Florence (artwork in the public domain; photograph © Scala / Art Resource, NY).

the piece and placed both of them next to each other, not quite back to back. By doing so he created a moment more associated with panic than emotion. Eve, with the startling irrationality of the other woman, this burden strapped to her head, is twisting violently to and fro. Rodin brings us that much closer to the immediate experience of her transgression. In this piece, the consequences of her act are not resolved. Time has been stopped during the greatest moment of confusion and uncertainty.

| Jan Assmann |

Time in Ancient Egypt

The human sense of time is based on our immediate experience, which is twofold: the cyclical return of waking and sleeping, of eating and fasting, of summer and winter, and so forth, and the consciousness of our own finality that distinguishes us from other animals. Every cultural concept of time, then, is determined by cyclicity and linearity, by the circle and the arrow. The ancient Egyptian concept of time is no exception to this general rule; however, the leading temporal dichotomy captures time here in the form of negation: the endlessness of repetition, which in Egyptian is called *neheh,* and of duration, or *djet.* This dual concept of time is rooted in human experience and in the Egyptian language.

The temporal system of the Egyptian language is based not on the triad of tenses—past, present, future—but on the opposition of aspects—perfective and imperfective. The perfective aspect shows a process from without, understood as complete and terminated; the imperfective aspect shows this process from within, as ongoing, continuing. It follows that *djet* refers to the unchangeable and endless duration of something that is accomplished and complete. The deity that represents time in this aspect is Osiris and his epithet is Wenen-nefer, "who exists in perfection." *Neheh,* on the other hand, refers to endless repetition and regeneration, and the corresponding deity is Ra, the sun god in his morning aspect as Khepre, "who transforms himself." Whereas *neheh* is associated with the sky, the stars, and their endless rotation, *djet* is associated with the earth, the stone, and its endless duration. Both concepts—*neheh* and *djet*—denote time in the mode of negation, and together they refer to "eternity," our notion of negative time. For us, "eternity" negates time in its motion, from future via present into past, or vice versa. For the Egyptian, eternity negates time in its cessation of repetitions and its ending of duration.

Time in its *neheh* aspect is endless but measurable and countable in terms of hours, days, months, and years. In its *djet* aspect, however, time is evaluative. Only the perfect is admitted to it. The Egyptians were highly inventive at forming strategies to overcome the curse of perishability inherent in their understanding of everything imperfect. How may a human being be saved from decay and corruption? The Egyptian answer is twofold: by mummification and by Ma'at, and it concerns the bodily and the spiritual self. The ritual of embalming culminates in a statement that mentions both components of the person, and it refers one to *neheh* and the stars, and to *djet* and the stone:

May your Ba (soul) exist, living in *neheh*
like Orion in the body of the heavenly goddess;
may your corpse endure in *djet*
like the stone of the mountains.

In its last stages, the ritual of mummification turns to the spiritual self in order to bring it into the state of perfection. This is the moment when Ma'at becomes important. We circumscribe the concept of Ma'at with notions such as "truth," "justice," "order," "harmony" (social and cosmic), and also of a goddess personifying this complex concept. It is believed that the dead have to undergo a process of justification by appearing before a divine tribunal consisting of forty-two judges (one for each of the forty-two nomes, or provinces, of Egypt) and their president, Osiris, and to declare their innocence with regard to a list of some eighty sins. During this recitation, the heart will be weighed on a balance against a feather, the symbol of Ma'at. With every lie, the scale with the heart would sink, and if it ends up heavier than the scale with the feather, a monster will devour the heart, and this would be the end of the person. In the case of perfect equilibrium, however, the deceased will be "justified" and then admitted among the "lords of eternity," who enjoy an eternal life in the world of the gods.

This idea of a postmortem judgment, which originated in Egypt about 2000 BCE, determined the Egyptian sense of time in the most fundamental way. "Do not trust in the length of years," we read in a text: "they [the judges] view a lifetime in an hour. When a man remains over after death, his deeds are summed up beside him. Being yonder lasts forever—[he is] a fool who does what they reprove. He who reaches them without having done wrong will exist there as a god, free-striding like the lords of eternity." Some centuries later, a certain Baki states that he is "a noble and pleased with Ma'at, who conformed to the laws of the Hall of Truths [the divine judgment]; for I planned to reach the necropolis without a baseness attached to my name." Ma'at is the principle of moral perfection, which individuals may attain during their lifetime by observing its laws and which bestows incorruptible duration on its followers: "Ma'at lasts for eternity, it enters the graveyard with its doer. When he is buried and the earth enfolds him, his name does not pass from the earth. He is remembered because of perfection."

Ma'at and the divine judgment are allegories of memory in which the "justified," who is recognized as perfect on account of his or her moral conduct, has won an everlasting place. In view of the eternity of memory, the time of earthly existence shrinks to a short moment: "Only a little of life is this world, but eternity is in the hereafter" reads an inscription in a tomb. It is from this perspective that the Egyptians, as stated by Hecataeus, who visited Egypt at the end of the fourth century BCE, "regard the time spent in this life as completely worthless; but to be remembered for virtue after one's demise they hold to be of the highest value [...]. For this reason, they trouble themselves little about the furnishings of their houses, but betray an excess of expenditure and ostentation concerning their places of burial." This explains why Egypt is covered with pyramids, tombs, and monuments of all sorts—for stone, memory, moral perfection, and eternity go together in the Egyptian mind.

<div style="text-align:center">

Malcolm Bull

</div>

Stop–Start

Karol Berger's study of the origins of musical modernity, *Bach's Cycle, Mozart's Arrow*, opens with a comparison of Nicolas Poussin's *Dance to the Music of Time* and Giandomenico Tiepolo's *The New World* (1791). Whereas Poussin presents a cyclical image of time, Tiepolo, like Mozart, depicts a time that is "linear, progressive, oriented toward the future." Humans, no longer subject to "an eternal unchanging order," have become autonomous individuals who value movement and change.[1]

Picking up E. R. Curtius's idea that the history of the West is marked by two caesuras—one at the end of antiquity, the other around 1750—Berger suggests that the latter was characterized above all by a transformed apprehension of time. But the shift did not come suddenly in the decades between Bach and Mozart, for both attitudes toward time can be found before and after. If the same is true of painting, then the two types of time must sometimes coexist, not just as works painted contemporaneously but also in works that can be experienced simultaneously—something that would be almost impossible in music. So if Berger's hypothesis about attitudes to time is correct, that overlap is something that we should sometimes be able to see.

Erwin Panofsky once claimed that "Mozart marches with Tiepolo," but he was thinking of Giambattista, not Giandomenico, and nobody would seriously claim that Giambattista's time was linear and progressive. So was Mozart in step with the father or the son? The obvious place to look for an answer is the Villa Valmarana ai Nani outside Vicenza, where in 1757 both Giambattista and Giandomenico were working on the decoration, with Giambattista taking responsibility for almost all the frescoes in the Palazzina and Giandomenico executing most of those in the Foresteria. The former represent scenes from epic poetry—Homer, Virgil, Tasso, and Ariosto—whereas the latter are mostly scenes of everyday life. Do they also embody two distinct attitudes to time?

Berger's account of cyclical time in Bach uses the example of the opening chorus of the *St Matthew Passion*, where in a variation of da capo form the ending "conflates in a single phrase what normally is presented in successive ones." According to Berger, this bends "the linear flow of time from past to future into a circular shape" in order "to abolish the flow of time in favour of the eternal now."[2] The act of uniting the past and the future in a single moment was usually thought to be the role of the history painter, who (as Gotthold Ephraim Lessing emphasized) could depict only a single moment of the action and therefore had to choose the one most evocative of what had gone before and what was still to come. At the

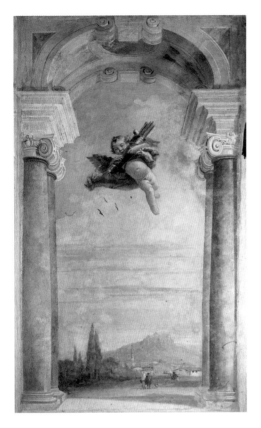

Figure 97. Giandomenico Tiepolo, *Cupid above a Landscape*, 1757, fresco. Villa Valmarana ai Nani, Vicenza, Sala dell'Iliade (artwork in the public domain; photograph © Luca Sassi/Bridgeman Images).

Villa Valmarana, Giambattista can be seen doing precisely this in the Sala dell'Iliade, where on one wall Athena is shown grabbing Achilles by the hair as he stands with his sword half unsheathed. To interpret the action correctly, the viewer needs to infer what happens both before and afterwards: that Achilles is enraged by Agamemnon's plan to seize Briseis and that Athena's intervention prevents him from drawing his sword against the king.

Compare this with the landscape on the facing wall, the only fresco in the Palazzina attributed to Giandomenico. This, too, represents a moment: a moment in which Cupid is caught in the frame of Girolamo Mengozzi Colonna's fictive architecture, and in the landscape beyond, four rustic figures seen from the back stand ahead of the viewer in the middle distance (Fig. 97). They are seemingly motionless, and in only one case—the woman to the left who has one foot a little ahead of the other—is there a hint of forward momentum. Unlike the scene of Athena and Achilles opposite, a freeze-frame moment that presupposes those that precede and follow and makes the instant the summation of the narrative of which it is a part, Giandomenico's landscape shows a moment entirely emptied of meaning: Cupid's flight is arrested, but the figures in the background have not yet begun to move away.

Cupid in Giandomenico's fresco looks very like one of Giambattista's cupids, and in the Stanza dei Puttini in the Foresteria, Giandomenico's cupids are based on drawings by his father, so the same is probably true here as well. Cupid is flying toward the room because he is the cause of all the trouble within it—the rivalry of Achilles and Agamemnon over Briseis—but he is stopped at the threshold. The figures seen from the back are unmistakably Giandomenico's, however—related to those in the Stanza delle Scene Carnevalesche in the Foresteria, where Giandomenico painted his first version of *The New World* (a crowd of onlookers with their backs to the viewer looking at a magic-lantern display). Here, too, is a figure stopped in his tracks—on the adjoining wall, a black servant halfway up a fictive staircase who suddenly turns back toward the carnival scenes behind him.

The repeated conjunction of one figure in arrested motion with others seen from the back suggests that in *Cupid above a Landscape* in the Palazzina, Giandomenico has depicted not a timeless moment, like that painted by his father on the wall opposite, but rather a moment of timelessness, when the past is over and the future has not yet begun, and the moment is not a moment of time but rather a moment out of time, a moment that is not a moment at all.

If so, the caesura in the painting may perhaps be seen not just as a gap in time but as a moment between two temporalities—between the eternal now of the history painter and the linear time of modernity into which those figures in the landscape will eventually start to walk. It is a lot to see in a single landscape, but in the transition to modernity described by Berger, such moments should be, if not audible, at least visible.

Notes

1 Karol Berger, *Bach's Cycle, Mozart's Arrow: An Essay on the Origins of Musical Modernity* (Berkeley: University of California Press, 2007), 1.
2 Ibid., 59, 106.

Notes from a Field

Just above My Head, a black-and-white film by the British artist Steve McQueen, is a 9-minute 35-second document of the artist out for a walk in the English countryside.[1] Agitated camera movement tells of an uneven terrain clearly lacking the fluency of a sidewalk or roadway. McQueen created the film by holding at arm's length a 16-millimeter camera pointed at himself. Always exhibited in a continuous loop, the film opens with a view of the artist from below, against a stippled expanse of clouds. He stands still briefly before commencing his stroll. The unorthodox camera work abbreviates McQueen's figure: he never occupies more than the bottom third of the screen or an even smaller fraction of its width. For nearly ten minutes, his part-figure bobs shakily along, above and below the frame's edge, at points seeming to descend into the floor beneath our feet.[2] Sometimes, McQueen passes under a copse of leafy trees; at all others, seeing only the sky above him, we note the absence of any architectural array (Fig. 98). A cryptic naturalism—contorted perspective, cloud forms rendered in grainy grisaille—locates McQueen's action squarely in the rural landscape. This much is utterly familiar: a British artist films himself undertaking the perambulatory ritual that for two long centuries has been emblematic of his country's visual and literary arts.

The raw material of tradition is in some way reworked and realigned. Yet, this fact is not registered in the literature on the artist, which, moreover, routinely places him on the "street." A rich bevy of contextual support surrounds this assumption: the film's story began in London; the scenography of McQueen's early works is predominantly urban, and his characters are mostly black. His emergence into prominence coincided with the zenith, in the mid-1990s, of the politics of difference that would significantly alter the public profiles of museums, galleries, and schools in major metropolitan centers. This context and reception lend the work a generous share of its historical texture.

Eventually, though, the course of this work's interpretation, so marked by its time, must open itself to a longer view of its historical character and form, and to the ways in which the artist has responded to tradition. McQueen's action clearly attends the development of a plot, and a plot requires a stage, a space wherein to develop, and time to unfold.[3] That plot is provided not only by late dramas of identity politics but also by a long-standing British literary and pictorial convention. However unforeseeably, *Just above My Head* restages the intellectual's occupation of the rural English landscape as a starting ground for subjective expression. Since the beginning of the nineteenth century, the country walk has been a crucial scene for British artists working through the anxieties besetting individual expression in

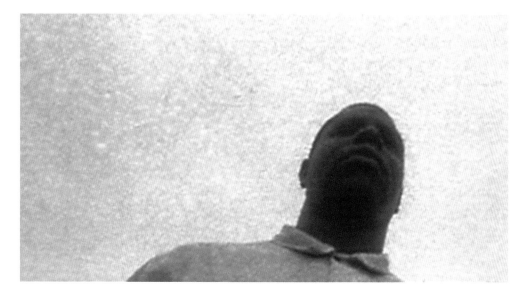

Figure 98. Steve McQueen, still from *Just above My Head*, 1996, 16mm black-and-white film, transferred to video, no sound, 9 minutes 35 seconds, continuous projection (artwork © Steve McQueen; photograph provided by the artist and the Marian Goodman Gallery, New York).

a culture every bit as addled by traditionalism as animated by it. The idiom proves expansive enough to gather the wildly divergent aesthetic sensibilities of, say, Samuel Taylor Coleridge and Stanley Brown, or William Wordsworth and Richard Long, into a fraught proximity. The symbolic process and the imagined displacement from the vicissitudes of metropolis it generally entails are not so easily bracketed. The specificity and power of McQueen's appropriation do *not* illustrate formalized pieties about postcolonial social relations (as dramatized, say, by symbolically reclaiming land rights withheld), but instead frustrate the supposition that McQueen would, or could, illustrate them at all.

Readings of the film urge vigilant attention to the artist's restive confinement to the lower margin of the screen, where, try as he might to close the gap between himself and us, his effort is continually thwarted. But the spatiality immanent within the film's subject matter is too vivid to permit us to confine our attention to the edge. The film gives a great deal else to see, if not exactly to look at. McQueen's prospect, what his outlook encompasses, remains his business. The inverted, mobile camera provides a decisive transposition: the practice of attentive looking, which discussions of such art invariably ascribe to a hyperembodied viewer, here shifts onto McQueen himself. The restless frame suggests a concerted labor to establish an image in which McQueen is an incidental rather than a determining force. The film's generally solitary affect makes it all the more redolent of the peculiar tradition it awkwardly extends. The most appropriate term for the condition it represents is *privacy*. Recall that for Wordsworth, too, in his poem of 1804 "I Wandered

Lonely as a Cloud," the salient encounter was not with the well-known "crowd of daffo-dils" that bursts forth in the poem's opening stanza.[4] By the lyric's end, we find the nar-rator's attention shifted from this sweet scene to its afterimage in a subsequent reverie, which is to say, to the impression it left on his mind. Wordsworth's narrator finally locates "solitude's bliss" in the very separateness between a concretely picturesque view and the "flash upon that inward eye" that returns it to the viewer, only now as a uniquely bracing but utterly private image.

What the *viewer* sees in this film's halting but deeply affecting articulation of McQueen's location is an individual's curious, shifting, and nontransparent relation with one of his cul-ture's most enduring representational system. By withholding rather than sharing the view, the film reframes the artistic gesture of the country walk without domesticating it in a pat statement about belonging. *Just above My Head*, in fact, resists making the kind of deperson-alizing pronouncement about cultural location that was virtually a precondition of profes-sional visibility for minority artists in 1996. In this way, it is a work of art so completely of its time, not only compliantly so: it insisted on the sacredness of the individual, her or his body and experience, at a moment when it was preferable to project them as metaphors for an entire social condition. What called forth McQueen's artistry was not the concreteness of outward events but the private self's outlook on them, and the space needed to elaborate one. These themes he pursued enthusiastically, even at the risk of distorting the tempestu-ous realities of race and racial conflict in contemporary England. This, finally, is the more credible marker of his difference.

Notes

1 McQueen disclosed his location to me as "somewhere in Devon," personal correspondence with the author, November 26, 2012.

2 McQueen's preferred display apparatus places the viewer in a standing position before a screen that terminates in the gallery floor.

3 See John Dewey, "Having an Experience," in *Art as Experience* (New York: Penguin Books, [1934] 2005), 43.

4 See William Wordsworth, "'I Wandered Lonely as a Cloud,'" in *William Wordsworth: The Poems,* ed. John O. Hayden, vol. 1 (New Haven: Yale University Press, 1977), 619–20.

Ludmilla Jordanova

Time, Death, and History

Historians work with time, just as geographers work with space. At first sight, this is a simple and straightforward claim. But considering it for just a moment allows complexities to proliferate. Do we mean that historians possess theories *of* time, that they work on phenomena *in* time, or that they have to conceptualize change *over* time? Or are they perhaps interested in Time, where the capital letter signals an abstract, metaphorically rich idea ripe for personification through a gendered human figure?

I can identify a number of key moments in my professional life when I have engaged with these questions specifically in relation to visual culture. Historians in "business as usual" mode think about continuity and change but rarely reflect on time as such. It is true that periodization is increasingly discussed in debates about the nature of the discipline, yet such debates can be quite general in nature and do not necessarily demand that we consider images or objects in relation to time. How visual images relate to time is or should be one of the issues that arise whenever the character and usefulness of style as an analytic tool is considered. It is noticeable that, whatever the reservations of some art historians, style terms are used with increasing frequency and abandon by historians. The concept of style contains, in a highly condensed form, an array of questions about time and visual culture. Nonetheless, in many discussions about style, its relation to time in its diverse senses remains somewhat oblique.

In 2000, the first edition of my book *History in Practice* was published.[1] It seeks to give an accessible account of the discipline of history, and it deals, among other issues, with periodization. I wanted the cover to speak somehow to "history," that is, to a protean idea, and I chose a painting by Giambattista Tiepolo, *Time Unveiling Truth,* about 1745–50, in the Museum of Fine Arts, Boston. This theme is found in a number of works by Tiepolo, who frequently gave body to abstract ideas. Here, Time, although winged, as was common, is not a wizened old man but a dark, even virile figure, who has laid down his scythe to clutch at the body of a fair young woman. I hoped that the figure of Time conveyed something about History, and that the contested status of historical knowledge was neatly alluded to by the presence of Truth. Today, I would not use such an image: while I find myself repeatedly returning to the ways in which abstract ideas are given human form, this one now seems too statically moralized for my purposes. Since the figures of Death and Time often resemble each other, is it apt to use such an allegorical representation of time, which can function as a *memento mori*, in discussions of the discipline of history?

M^{rs} COWPER

Mother of the Poet

Figure 99. William Blake, after Dietrich Heins, *Mrs. Cowper Mother of the Poet,* engraving, 5¾ × 6½ in. (14.6 × 16.5 cm), from William Hayley, *The Life, and posthumous writings, of William Cowper, Esqr. with an introductory letter to … Earl Cowper,* London, 1803, vol. 2, between pp. 4 and 5 (artwork in the public domain; photograph reproduced by kind permission of the Syndics of Cambridge University Library, Keynes.P.6.4).

A later encounter I had with seeing time suggested quite different, even opposed, connections between time and death. For many years, I have been working with portraits and reflecting upon the genre. I am intrigued by the elaborate relations between portraits and time. One premise of the genre is that some form of likeness, of a nameable person, is given material expression, which will last, perhaps for centuries, available to be seen and appreciated when the sitter is not present. That is, portraits project human specificities into the future. They also embody the social relationships of the situation in which they were created—they are deposits of a present. Inevitably, they draw upon precedents and conventions from the past and may be designed to stand in some kind of sequence, which originated before they came into existence. While these elaborate transactions between future, present, and past may not obtain in every case, they are worth considering when working on portraits and, more particularly, when thinking about the kinds of behavior associated with them.

I offer this as a context for a poem by the eighteenth-century Englishman William Cowper. Cowper composed a number of verses about the visual arts and his experience of sitting for his portrait. The best-known one, written in 1790, records his responses to the gift of a

Figure 100. *Divinity, Humanity, Time, Immortality,* engraving, 6⅛ × 8½ in. (16.2 × 21.6 cm), pl. LIV from George Richardson, after Cesare Ripa, *Iconology; or, A Collection of Emblematical Figures,* vol. 2, facing p. 6, London, 1779 (artwork in the public domain; photograph reproduced by kind permission of the Syndics of Cambridge University Library, 400:8.a.95.77-78).

portrait of his mother, who had died when he was young.[2] For him, portraiture defies and defeats time: "The art that baffles time's tyrannic claim/To quench it. [...]"[3] Her portrait triggers memories and acts as a surrogate, a prompt for intense feelings of love that must in one sense be fresh, since he revisits his mother's image as an adult, armed with experiences he could not have had while she was alive: "Time has but half succeeded in his theft—/Thyself remov'd, thy power to soothe me left."[4] For this troubled person, a work of art possessed the capacity to both re-create and calm the pains of the past. Cowper eloquently expressed his belief that art captures a moment, confers immortality, and thereby defies Time, the thief.

Time was treated by Cowper as a metaphor for grieving and loss, in the face of which the portrait was restorative. But it could just as easily have gone the other way—that his beloved mother's image was such a potent evocation of the happy period before her death that looking at it became unbearable. The portrait of Ann shows her at a moment when William did not know her, just like the photograph of Roland Barthes's mother, which he did not share with readers of *Camera Lucida* (Fig. 99).[5]

When time is opened out to reveal its many and often contradictory meanings, the relation of the visual image to time becomes more than an exercise in periodization. Invoked in the spirit of Cesare Ripa, time in the form of the body of an aging man gives apparent coherence to an idea that spins off in a dizzying array of directions (Fig. 100).[6] The elaborate

history of such figures, their capacity to represent time and Time, provides historians with important devices for thinking about such subjects. In so doing, we embrace the ambiguities, even the playfulness of time and its cognates and ask: How is it possible to visualize and embody it? What does it mean when it is given material form? Pursuing such questions must be an interdisciplinary project, at the very least, the product of intricate blendings between history, literary studies, and art history.

Notes

1 Ludmilla Jordanova, *History in Practice,* 2nd ed. (London: Bloomsbury Academic, [2000] 2006). The third revised edition appeared in 2017.
2 William Cowper, "On the Receipt of My Mother's Picture Out of Norfolk, the Gift of My Cousin Ann Bodham," 1790, in *William Cowper,* ed. Michael Bruce (London: Everyman, 1999), 45–48.
3 Ibid., lines 9–10.
4 Ibid., lines 120–21.
5 Roland Barthes, *Camera Lucida: Reflections on Photography* (London: Cape, 1982), originally published as *La chambre claire: Note sur la photographie* (Paris: Gallimard, 1980).
6 There are too many editions and versions of Ripa to cite here. I have frequently turned to George Richardson, *Iconology; or, A Collection of Emblematical Figures,* 2 vols. (London, 1779).

<div style="border:1px solid; padding:10px; text-align:center; width:30%; margin:0 auto;">Ajay Sinha</div>

Painting Time

The Zeitgeist of 2012 is that we have a lot of Zeit *but not much* Geist.
—Douglas Coupland, "Convergences," 2012[1]

One of the most striking features of contemporaneity is the coexistence of very different senses of time, of what it is to exist now, to be in place, and to act, in relation to imagined histories and possible futures.
—Terry Smith, Okwui Enwezor, and Nancy Condee, *Antinomies of Art and Culture*, 2008[2]

Hidden in these two quotations from contemporary art and literary practice is a desire for multiplicity in the imaginings of time. Here, time is imagined not in time lines or in chronological order but as an explosion created by the speed of modernity, producing in different parts of the planet what Douglas Coupland describes in his review of Hari Kunzru's novel *Gods without Men* (2011) as "extreme present." In those varied places, the extreme present might be "psychically sparse" but it pulsates with the possibilities of "histories and possible futures," located by critics in "small world-making," as opposed to the "big-picture concepts" that were thought previously to have organized our planet around a unifying, Hegelian *Geist*.

Contemporary art and literary "world-making" humanizes time for diverse peoples of this planet, and it participates in a politics of liberal democracy on a global scale. But this humanizing also leads me to a riddle: Is it possible to imagine the coexistence of different senses of time beyond the singularity of the human premise? The riddle takes a visual form in *Crows with Debris*, a small painting on canvas, created in 2000, by Gieve Patel, a contemporary artist in India (Fig. 101). In this painting, two scruffy crows pick at the remains of a roadkill with surgical focus, separating fleshy bits of a rodent from bloody tire marks. As this is also an image of "extreme present," hinted at in the springy legs of these alert birds, the riddle rephrases itself into a question posed by Jacques Derrida: "For we shall have to ask ourselves, inevitably, what happens to the fraternity of brothers when an animal enters the scene."[3] My exploration of Patel's riddle and its possible answer centers on what I call "painting time," meaning both "human time"—the temporality of making and viewing the painting—and the particular temporality of the painting as a thing in itself. The gap between these, two divergent temporalities that Patel's painting opens, leads to an overlooked possibility in the contemporary desire for the copresence of temporal multiplicity heralded by Smith, Enwezor, and Condee.

Figure 101. Gieve Patel, *Crows with Debris*, 2000, acrylic on canvas, 33 × 28 in. (83.8 × 71.1 cm), Chemould Prescott Road-Contemporary Art Gallery, Mumbai (artwork © Gieve Patel; photograph provided by Chemould Prescott Road-Contemporary Art Gallery).

Indeed, we experience *Crows with Debris* spatially and also temporally. Here is an event packed with uncontrollable multiplicity, staged like a snapshot of a banal, everyday recklessness. A discarded condom and a broken plastic flip-flop at the lower right distract our attention from the central subject, underlining the point that the painting is not only a scene (a coherent picture) of an accident, but it also needs to be experienced as such. An accident is an incomplete event in which unrelated things come into contact and are evacuated, suddenly, of their coherence and meaning. In this sense, an accident has the opposite outcome of a painting, since we generally seek coherence and meaning in a painting.

In presenting the scene without visible coherence, Patel delivers us to a moment of excitement just prior to sense making. The artist mimics our excitement by bringing visual acuity to all details, however random they may seem. Blood traces a vivid pattern from the automobile tire at the site of the skid. Mud still sticks to the underside of the blue footwear. Sharp chiaroscuro makes the condom glisten like a jellyfish. And here is the twist. As we begin to take stock of the scattered remains, our sense making is unexpectedly identified with the nervous attention of the corvids in the center. We discover somewhat uncomfortably that the painting stages a double accident, one represented inside the pictorial frame and another produced when we interact with it.

Against Time as We Know It

What is the difference between the temporality of this double accident and time as we know it? If it were a banal photograph, the painting would have led to forensic investigation (as in crime photography) or social commentary on industrial waste (as in documentary photography). The birds in the center could have made the image "artistic," expressing what Derrida calls "zoopoetics," mythic and allegorical evocations of animals.[4] This range of responses shows that the temporality of a photograph is contiguous with human temporality. The eye of the camera serves historically and ontologically as a surrogate or a prosthetic for the human eye, revealing to human consciousness what the eye cannot see. Pursuing this revelatory logic into the history of art and visual media, Walter Benjamin claimed that the touch of photography made even distant artworks step out of their mysterious, auratic universe to participate in our contemporary world in the form of a reproduction.[5]

Time in Patel's painting is not of the photographic order. The preoccupation with photographic time began in the 1960s in reaction precisely to the tradition of painting to which Patel belongs, namely, artistic modernism. In the early twentieth century, the project of modernism would evacuate art of all traces of human temporality. Abstract painting became a quintessentially "chronophobic" form by removing narrative and history from imagery and by taking the medium and surface of painting as pictorial ends in themselves.[6] At the turn of the millennium, when Patel painted his canvas, photography's temporality had spread all over the world into contemporary installation and video and performance art. In many ways, Patel is the opposite of his contemporaries, such as the American video artist Bill Viola, who reacts to pictorial chronophobia by inserting time back into painting. Viola exposes staged tableaux of Renaissance paintings to a high-speed digital camera and then plays back the digital image at such a slow speed that the actors representing the pictorial figures display in them, ever so imperceptibly, a sequential progression of interrelated emotions. It is as if the video form activates a dormant human temporality inside the painting.

Patel's painting could at best be called "photogenic," using Michel Foucault's term for painting that interacts with the conditions of photography.[7] But there is a difference. Foucault places photogenic painting against a history of modernist painting and critiques of photography, starting from Charles Baudelaire and continuing into the "long period during which painting always minimized itself as painting in order to 'purify' itself, to sharpen and intensify itself as art."[8] According to Foucault, photogenic painting "laughs at" Baudelaire and relocates itself in a busy "thoroughfare" of contemporary media. By contrast, Patel insists on the recalcitrant stillness of painting against photography and photography-based image practices, making his intervention in contemporary art seem anachronistic.

Patel works resolutely within the modernist premise. Thus, while the debris at the site of the skid suggests photographic temporality (and the roughly square canvas evokes large-format photographic negatives), the photogenic details do not lend the image to our "world-making." For instance, the painted tire marks do not prompt our investigation of the skid. Rather, we read in it an uncanny double of the photographic impression. What in a

photograph would have been a negative trace of automobile tires becomes in the painting a positive feature, a carefully delineated lace of blood. As the roadway recedes and blurs, the bloody fragment comes into sharp relief, like the barbed wire of the broken fence above, and locates itself within the alternating gray bands of the road, like a precise musical notation on a score. The crows confirm the weight and heft of the fragment by pulling apart its meaty bits. The transformation by which an impression of something becomes a concrete, self-contained detail would not have worked in a photograph. Roland Barthes reminds us that a photograph always refers to something outside itself.[9] By contrast, the painter asks us to see the tire marks as a design having an internal, visual logic and coherence, as if they were parts of a suddenly revealed mandala, to which the painter, like crows, brings visual acuity and a sense of wonderment.

Using, briefly, terms coined by the mathematician and semiotician Charles Sanders Peirce, we could say that Patel's painting switches from an indexical sign to an iconic sign. An index represents its referent through contiguity. An icon represents its referent through cartographic semblance. Peirce's understanding of an icon as belonging to a parallel order, not intersecting with or affected by the body it represents, is partly comparable to the way icons operate in Hindu religious traditions. As Michael Meister explains, a religious icon in a Hindu shrine is beyond the human body, represented often by smoothened stones found along riverbeds or the abstract, cylindrical form of a *linga*. An icon, of course, could assume a human form, which, however, could be something like "the female body, with a lotus instead of a head, as the surface of the earth/altar, her knees drawn up, her pregnant potential rooted to the soil through the soles of her strangely down-turned feet."[10] The humanoid assemblage stands parallel to the human world, as in Peirce's icon, but, importantly, the gap between the two is temporal rather than spatial. The Hindu icon marks the presence in our world of an unknowable reality existing on the other side of human temporality. In Patel, a similar *temporal* distance between the painted image and our human world is marked when crows delicately touch the lacy fragment with their beaks, invoking in it another order of things.

Anachronistic Modernism

I am intrigued by the painting's dialectical relationship to modernism. According to Michael Fried, the chief characteristic of modernist painting is the liquidation of (human) time into an aloof and luminous sort of "presentness."[11] Patel mirrors this "presentness" of painting, but he reverses what it reflects in two different ways. First, a modernist painting's endless and expansive sense of auratic being is reversed into an alienating image, representing what I have described as the "extreme present" of the pictorial double-accident involved in our experience of looking. Second, if modernist painting reflects the human intellect at its Kantian purest, and if by "human" we understand the state of being, or *Dasein,* as Martin Heidegger would say, of a post-Enlightenment creature, Patel's crows embody an utterly different temporality.

Literally, Patel's imagery describes an abject subject, and this is consistent with the art-ist's preoccupation for the last forty years. A series painted in the 1980s depicting dead and decomposing corpses elaborates on "the body turned inside out, of the subject literally abjected, thrown out."[12] But *Crows With Debris* also departs from the humanistic dialectic according to which "the abject is what I must get rid of in order to be an *I* at all."[13] While the condom represents this dialectic, the rodent is not only crushed and discarded by humans but also incorporated by crows that, consequently, redirect the formation of the human "I" in the painting. The switch from human disorder to a nonhuman order is completed by the inclusion of the abject subject within what Fried calls a painting's "continuous and entire *presentness*, amounting, as it were, to a perpetual creation of itself."[14]

In Patel's painting, the abject subject becomes what Georges Bataille defines as "*informe*." In his entry for "dictionary" in *Document*, Bataille explains the word *informe* as "not only an adjective having such and such a meaning, but a term which works to disorder, gener-ally requiring that each thing take its form." Since this "form" does not yield meaning, it is "crushed everywhere like a spider or a worm."[15] In Patel's painting, the bloody rodent becomes an emblem of the *informe*, the creature "taking its form" at the moment it is crushed. In translating blood marks into brush marks, and a photographic trace into a visual lace, the *informe* performs one more reversal: it reanimates the legible, photogenic detail, as if it were the metaphoric rope turning literally back into a snake, or, in Bataille's phrasing, a worm.

Animal Time

The *informe* occurs when modernist enters the contemporary art scene in the form of an animal. The *informe* has no *Geist* to give it human and social meaning. The *informe* embod-ies only a compelling look, comparable to the eyes of the cat that looked at Derrida as he stood naked in front of it.[16] Partly, this look is also similar to the look of the religious icon in Meister's sense, whose stare comes across the gap separating human temporality from that of unknowable gods. Derrida explores two kinds of temporal encounters with animals, one of "seeing and being seen" by an "unsubstitutable singularity," and the other, the expe-rience of "Descartes, Kant, Heidegger, Lacan and Levinas," who have "made of the animal a *theorem*, something seen and not seeing."[17] Against the humanizing "theorem," Derrida confronts the uneasy feeling of being watched by the animal. It is a "bottomless gaze" he says biblically, one that

offers to my insight the abyssal limit of the human: the inhuman or the ahuman, the ends of man, that is to say the border crossing from which vantage man dares to announce himself to himself, thereby calling himself by the name that he believes he gives himself. And in these moments of nakedness, under the gaze of the animal, everything can happen to me, I am like a child ready for the apocalypse. […].[18]

Derrida's discursive tailspin, now expanded into a book-length publication, modifies a humanist philosopher's usual question, "Can animals think?" with another, taken from Jeremy Bentham: "Whether animals *can suffer*?"[19] W. J. T. Mitchell explores a similar switch regarding pictures when he asks, "What do pictures 'really' want?"[20] In raising the possibility of a picture having desire, Mitchell, like Derrida, brings to his question the full weight of Heidegger's *Dasein*. Like Derrida, this sense of a painting as its own temporal being turns it into a disturbing *informe*, causing the humanist critic's meaning making and linguistic practices to come undone. In the end, Mitchell concludes, a picture's desires "may be inhuman or nonhuman," like that of animals, cyborgs, and plants. Patel's little painting gives concrete form to precisely this nonhuman or ahuman temporality of art.

In relation to the contemporary desire for the copresence of temporal multiplicity, this amazing painting performs what Derrida calls "limitrophy." Based on the word *trepho*, meaning "to transform by thickening, as, for example, in curdled milk," limitrophy is not simply about what touches the limit but "what sprouts or grows at the limit, around the limit, by maintaining the limit, but also what *feeds the limit*, generates it, raises it and complicates it."[21] For more than a decade after *Crows with Debris*, Patel has obsessively been painting the large canvases known as his Looking into a Well series. The images are of a type, showing a view down a narrow well filled with water. Abstract shapes represent the inner walls of the well, with vegetation growing here and there, leading our eyes to the center, where luminous forms denote circular reflections of the sky, made brighter and heavier by the mirrorlike surface of the water. The series elaborates on what is barely visible in *Crows with Debris*, namely, the throbbing alterity of the *informe*. These life-size paintings place the viewer at the mouth of the well, as if in a position of being swallowed by the "bottomless gaze" of a nonhuman oculus. If Derrida explores "a multiplicity of organizations of relations between the living and dead"[22] at the limits of human language, Patel gathers and thickens the *informe* into a "painting time" at the limits of the "world-making" that defines human temporality.

Notes

I thank Elizabeth Young, Gieve Patel, Sudhir Patwardhan, Dana Liebsohn, and Mimi Hellman for commenting on various versions of this essay.

1 Douglas Coupland, "Convergences," *New York Times Book Review*, March 11, 2012, 1.
2 Terry Smith, Okwui Enwezor, and Nancy Condee, introduction to *Antinomies of Art and Culture: Modernity, Postmodernity, and Contemporaneity* (Durham: Duke University Press, 2008), xv.
3 Jacques Derrida, "The Animal That Therefore I Am (More to Follow)," trans. David Willis, *Critical Inquiry* 28, no. 2 (Winter 2002): 381.
4 Ibid., 389. For a survey of the zoopoetics of corvids, see Boria Sax, *Crow* (London: Reaktion Books, 2003).
5 Walter Benjamin, "The Work of Art in the Age of Its Technological Reproducibility: Second Version (1935)," in *Walter Benjamin: The Work of Art in the Age of Its Technological Reproducibility and Other*

Writings on Media, eds. Martin W. Jennings, Brigid Doherty, and Thomas Y. Levin (Cambridge, MA: Harvard University Press, 2008), 19–55.

6 Pamela Lee, *Chronophobia: On Time in the Art of the 1960s* (Cambridge, MA: MIT Press, 2004), 37–55.

7 Michel Foucault, "Photogenic Painting," in *Gérard Fromanger: Photogenic Painting*, by Gilles Deleuze and Michel Foucault (London: Black Dog Publishing, 1999), 91.

8 Ibid., 102.

9 Roland Barthes, *Camera Lucida: Reflections on Photography*, trans. Richard Howard (New York: Hill and Wang, 1981), 4–7.

10 Michael W. Meister, "Giving Up and Taking On: The Body in Ritual," *RES: Anthropology and Aesthetics*, no. 41 (Spring 2002): 95.

11 Michael Fried, "Art and Objecthood," *Artforum* 5, no. 10 (June 1967), reprinted in *Art and Objecthood* (Chicago: University of Chicago Press, 1998), 167.

12 Hal Foster, "Obscene, Abject, Traumatic," *October*, no. 78 (Fall 1996): 112.

13 Foster explaining Julia Kristeva's discussion of the "abject" in *Powers of Horror*, trans. Leon S. Roudiez (New York: Columbia University Press, 1982), in ibid., 114.

14 Michael Fried, "Art and Objecthood," 167, emphases in the original.

15 George Bataille, quoted in Pierre Fédida, "The Movement of the Informe," *Qui Parle* 10, no. 1 (Fall–Winter 1996): 49.

16 This is the primal scene in Derrida, "The Animal That Therefore I Am."

17 Ibid., 382–83.

18 Ibid., 381.

19 Ibid., 396.

20 W. J. T. Mitchell, "What Do Pictures 'Really' Want?" *October,* no. 77 (Summer 1996): 71–82.

21 Derrida, "The Animal That Therefore I Am," 398.

22 Ibid., 399.

Gloria Sutton

The Texture of Time: Durational Conditions of Contemporary Art

"If art has had a scientific mission," the American artist Hollis Frampton wrote in 1980, "we find it in the exposure of such mechanisms, in a nonlinear display of the *occasions* of meaning. For meaning is not, for image or word, in things; it is in people."[1] Frampton reminds us that meaning resides in relationships and that works of art are *occasions* of meaning. Over time, he implies, art has served as an occasion for meaning in a nonlinear display, as the meanings residing in people have encountered the meanings occasioned by works of art. In a nuanced response to a questionnaire on "the Contemporary" posed by the editors of the journal *October* and published in 2009, Grant Kester describes the development of the "dialogue around contemporary art" as "synchronic, contradictory, and lateral," and he contrasts this with the "gravity and scholarly detachment" typically ascribed to earlier periods of art historical research.[2] Contemporary art history is often perceived as weak on account of its proximity in time to its objects of investigation and for the seeming nonlinearity of the development of its dialogue. Yet, what if these perceived weaknesses of contemporary art history were recast as its core strengths? What would this imply?

In his 1962 book *The Shape of Time: Remarks on the History of Things*, George Kubler argued that events, and more significantly, the intervals between them, are the "elements of the patterning of historical time."[3] When "the contemporary" has become synonymous with the present, what is the pattern of historical time in contemporary art? Within the discipline of art history, "time" has habitually been addressed as a problem of periodization. The quandary posed by the contemporary, though not unique to post-1945 scholarship, is rendered more acute on account of the breakneck speed by which "the contemporary" has become the object of specialization in the academy (post-1945 art historical doctoral study has outpaced any other category in the United States and the United Kingdom) and the anchor for the establishment of newly configured, period-based collecting categories for museums internationally.

As an art historian who specializes in two emergent fields, contemporary art and new media, I am often asked about the relevance of art history's methodologies to subjects that are inherently tethered to the new and the now. This ongoing pedagogical hand-wringing has become constrictive for those of us who actively chose to work in the relatively un-moored field of contemporary art history precisely because it provides a level of critical acuity not found in the burgeoning arena of new media studies. (On its emergence, the study of new media, like the field of contemporary art history, was preoccupied with its own ontological narratives, territorial boundaries, and institutional legitimacy during the early 1990s, and it continues to focus largely on subjects distinct from the "digital humanities,"

such as digital culture, software, game design, and social media.) Still, the skepticism toward contemporary art within the discipline of art history, and the question of the relevance of art history's methods for the study of contemporary art, may alert us to its potential.

The absence of historical distance and detachment from contemporary art raises the ethical stakes of our practice. Contemporary art historians do not occupy a position of remove or privilege. Instead, we are absolutely complicit with the editors, publishers, critics, archivists, researchers, indexers, dealers, curators, and, especially, the artists themselves, who generate the primary source material and the interpretative network that coalesces into a historical record. What is more, the dialogue around contemporary art, developing in a "synchronic, contradictory, and lateral" way rather than through a "gradual accretion of reasoned judgments over time," as Kester put it saliently, demands a willingness to revisit one's postulations, for the comparative categories of early, middle, and late remain, by definition, in flux.[4] Significantly, contemporary art history's methods are self-reflexive, in that they require a critical recognition of the formal and the social conditions of a work of art's production and circulation (this also refers to works that are ephemeral and antimaterialist in nature).

In equal parts, however, the field of new media's activation of a broader range of reception models and feedback mechanisms over the past decade has arguably tested contemporary art history's proclivity for maintaining a divide between form and content, just as it has arguably pushed the domain of representation beyond purely visual terms, adding the capacity for modeling nondiscrete operations like collaboration and participation. Working within and between the collapsing spheres of "the contemporary" and "new media" has suggested that in much recent art, the patterning of time is shaped less by the anxiety of periodization and more by tensions surrounding the trajectory of media and, more specifically, time-based media.

The chronological relation between analogue and digital media is not strictly linear. Usually positioned as adversarial and acknowledged as inevitable, the digital have not fully supplanted or eradicated the analogue. In contradistinction, digital ubiquity in the broader culture industry has contributed to a resurgence in outmoded and relatively obsolete formats, such as small-gauge film and hand-processing techniques.[5] In the contexts of contemporary art, the preponderance of film projections and time-based media installations may in fact cause this decade to be recast as a renaissance for analogue film. Kester's terms "synchronic, contradictory, and lateral" capture the ways in which artists employ digital and analogue formats indiscriminately. The artist's use of both formats renders much time-based media art impervious to the ideological debates initiated in the late 1960s and early 1970s by the practitioners of experimental film and expanded cinema, who often considered film, analogue video, broadcast television, and digital media to form absolute, discrete categories.

Underlining the conditions by which history takes shape, "synchronic, contradictory, and lateral" also serve to mitigate an understanding of these media as imbricated with technology. Rather than foregrounding the apparatus or the means of image projection, we would do well to remember that time-based work is first and foremost concerned with duration. The shape of time in contemporary time-based media can be characterized by the patterning or texture of its two basic structural elements, the grain and the pixel, as both continue

to be broadly and simultaneously deployed in often contradictory ways within the context of contemporary art. Grain or granularity is the optical texture found in processed film (photographic and cinematic), in which an image develops gradually (though not necessarily evenly) through a sequence of alchemical processes that transform the behavior of minute particles. Subject to diffusion and distortion to the point of noise, granularity suggests a relatively fragile or unstable sense of time. Like its counterpoint, the pixel (or picture element) is also the smallest physical point that can be altered, varied, or controlled for intensity. The relative stability of the pixel allows for a type of modularity that can appear to render digital time unified and seamless. The most compelling time-based work goes against the grain, stretches the seams, and investigates the structuring of time.

For example, American artist Kerry Tribe's film installation *H.M.* (2009) produces a type of mnemonic dissonance in the viewer similar to that experienced by her film's subject, "patient H.M.," an amnesiac who could hold thoughts for only about twenty seconds.[6] A study of H.M.'s short-term memory loss, conducted over five decades, has shaped the understanding of memory and its related disorders in the field of neuroscience. Tribe's installation *H.M.*, based on this scientific study, includes a series of color photographs, letterpress prints, and drawings, all of which relate to a double projection of a single 16-millimeter film arranged so that the film's celluloid passes through two adjacent projectors. This results in side-by-side projections of two different moments throughout the 18-minute 30-second film. A custom-built looping mechanism modulates the 16-millimeter film's speed and weight, allowing the strip to be suspended in the space between the two projectors so that a twenty-second delay is generated between the two images (Fig. 102). Appearing in a continuous loop, the film installation's formal fissure creates a sense of spatial and temporal deferment for the viewer.

Tribe's performance *Critical Mass* (2010–) asks viewers to reconsider the expectations they have for "live" versus "recorded" events. On October 27, 2012, in the newly opened subterranean galleries of the Tate Modern, London, Tribe restaged Hollis Frampton's 1971 black-and-white film *Critical Mass*, shot for shot, as a live performance involving a male and female actor who had memorized the dialogue of the 1971 experimental film as well as its strange vocal intonations and inflections—the result of the complex editing structure Frampton had used to render a couple's heated argument as a string of truncated and repetitive utterances. Tribe's *Critical Mass* reproduces the formal stutters and staccato pacing of analogue film as a live event, and for approximately twenty-five minutes, it collapses real time and running time.

On the one hand, the fact that both *H.M.* and *Critical Mass* were exhibited in contemporary art museums is representative of current interest in analogue forms of filmmaking and in the recovery of the seemingly lost or obsolete. On the other hand, *H.M.* and *Critical Mass* are suggestive of a range of works that take a nontypical approach to presenting the operations of time-based media. Tribe's astute formal decisions about scale and presentation parlay her interest in historical disjunction, while her choice of media formally interrogates

Figure 102. Kerry Tribe, installation view of *H.M.*, 2009, double projection of a single 16mm-film loop, 18 minutes, 30 seconds, 1301PE, Los Angeles (artwork © Kerry Tribe; photograph © Fredrik Nilson).

the mechanisms of experiencing something in real time. Most significantly for the field of contemporary art history, *H.M.* and *Critical Mass* support the claim that in the current moment, time-based media enact a set of relations, not a technology, and that these relations are very often "synchronic, contradictory, and lateral."

Notes

1 American artist Hollis Frampton (1936–84) was a key figure in the fields of experimental film, photography, and digital media. This quote is from the typewritten notes that Frampton wrote in 1980 to accompany an exhibition of the xerographic series *By Any Other Name: Series One* (1979), twelve prints, each 8 1/2 by 14 inches, made using a Xerox 6500 color copying machine to reproduce the packaging from various food items. See Hollis Frampton, "Notes: By Any Other Name," in *On the Camera Arts and Consecutive Matters: The Writings of Hollis Frampton*, ed. Bruce Jenkins (Cambridge, MA: MIT Press, 2009), 298. The images in *By Any Other Name: Series One* (1979) are in the Hollis Frampton Collection, 1963–2001, Harvard College Library, Cambridge, MA, Harvard Film Archive, Fine Arts Library, box 1, folder 3.

2 See Grant Kester, "Response to the Questionnaire on 'the Contemporary,'" *October*, no. 130 (Fall 2009): 7–9.

3 George Kubler, *The Shape of Time: Remarks on the History of Things* (New Haven: Yale University Press, 1962), 13.

4 Kester, "Response to the Questionnaire."

5 A broadening consumer market for film and photographic equipment has given contemporary artists access to an unparalleled array of media, and architecturally scaled projection has become widespread in no small part because it is now technically and financially more feasible. Frequently and somewhat arbitrarily referred to as moving image arts and artists' cinema, these forms place an emphasis on media (in both digital and analogue formats) as technologies of projection. For a survey of artists' cinema, see Maeve Connolly, *The Place of Artists' Cinema: Space, Site and Screen* (Bristol: Intellect, 2009). Berlin-based British artist Tacita Dean's project *FILM* (2011), a 35-millimeter silent film projected over 42 feet (13 meters) high in the Tate Modern's Turbine Hall from October 11, 2011, to March 11, 2012, functioned as a type of *memento mori*, not only in acknowledgment that analogue film is no longer being processed within the United Kingdom but also because Dean believes the skills of editing and shooting film to be vanishing. The artist has proposed that the medium of film be recognized as a world cultural heritage, in an effort to preserve its continued production.

6 *H.M.* was exhibited most recently at Toronto's Powerplant Contemporary Art Gallery (March 24 to June 3, 2012).

Gerrit Walczak

What Father Time Has Left Behind

In the multilingual vernacular of tourist guides, the adjective "timeless" ranks among the strongest stimuli, inevitably causing listeners to point a camera in the direction of any artwork so designated. In the literal sense, of course, no material object is timeless. Time ultimately equals destruction, the practice of which most art historians will have little, if any, experience in. My own initiation into inflicting damage on historical artifacts took place in an antiquarian bookstore when, being new on the job, I was handed a box cutter. At first sight, my instrument seemed to bear no resemblance to Father Time's scythe, nonchalantly applied to a canvas in William Hogarth's well-known etching (Fig. 103).[1] Neither did I rip through or literally "smoke" a picture, though I was indeed allowed an ashtray next to the stock I was cataloging in the back of the shop, however outrageous this particular detail may seem in retrospect. The torso I had been asked to gnaw away at was a derelict 1652 atlas to be pillaged for its engraved maps, which were to be individually framed. Uneasily staring at my victim until I forced myself to assail it established yet another link to the Hogarth print, as the iconographic detail of Father Time's peculiar forelock is an allusion to the concept of "Kairos," the decisive moment one could either seize or let pass. This moment, unfortunate as it was, proved decisive in shaping my interests well after leaving the trade and turning to art history. I would always belong to the ignorants Hogarth ridiculed in his print, though drawn to what is old for reasons not necessarily theirs. Being contemporary myself, I fail to muster much interest in things new and shiny, works of art among them. As an art historian I admit being far less obsessed by art, whose shifting definitions are historical themselves, than by history. Remoteness in time, impossible to bridge but worth grappling with, is a basic prerequisite for history.

Unlike the eighteenth-century connoisseurs who are the targets of Hogarth's satire, art historians are unlikely to mistake time for a beautifier of paintings, or any other artworks. The intentionally corrupted Greek quotation on the picture frame in Hogarth's print thus makes a point that once was provocative but seems self-evident today: "Time is not a great artist (or expert craftsman), but weakens all he touches." Accordingly, we object to the infamous "Rembrandt brown" once held in high esteem, its murky glow being the result of having indeed been "smoked" by time into discolored varnish, dirt, and the deterioration of paint layers. In fact, time translates into the cumulative decay of historical artifacts as well as into the number of opportunities likely to result in their immediate destruction by a would-be antiquarian, or any other assailant. Time does not operate on abstract "images" like the digital photograph illustrating this page, which reproduces a handmade sheet of paper pulled through a printing

Figure 103. William Hogarth, *Time Smoking a Picture*, 1761, etching and mezzotint, 10¼ × 7½ in. (26.2 × 18.4 cm). The British Museum, London (artwork in the public domain; photograph © The Trustees of the British Museum).

press in 1761. It seems a safe bet to assume that neither Hogarth nor the workmen operating the press wasted a thought on whether part of their print run would still be around today. They would have been surprised that it is, and we should be, too.

Paper, canvas, and wood are materials of limited durability, even though their respective chances of outlasting a couple of centuries vastly improve when stored away in libraries, cabinets, and galleries. We are easily prone to take for granted that the work of art we are looking at must naturally be there to be looked at, coinciding with our temporal existence. Yet, only a fraction of all the artworks once produced have actually come down to us, and a long list of works of art lost could make a good start with a compilation from Giorgio Vasari's *Vite*. As a rule, art historians focus on those works of art that survived; next to aesthetic preferences past and present, the proverbial tooth of time has its share in establishing our canon. Dealing with artworks lost but recorded in writing or in visual documents of some sort or another is far less gratifying, and we are barred from doing research on those lost without having been documented. Any church not ravaged by iconoclasts, any castle

saved from fire, and any city spared from bombing thus might well have resulted in a history of art inadvertently written along different lines.

Tourist guides speaking of "timeless" artworks are usually to be encountered in museums of art, where time indeed is largely negated in favor of a direct encounter of beholder and material object. When passing through the flights of gallery rooms, our impression of the simultaneity of all the riches on display is truly "anachronistic," the sole common denominator being, of course, that all exhibits survived a time span of varying length from their production to us staring at them. We do not have to dash through a museum *Bande à part*-style in order to move within minutes through hundreds of years of artistic production and appreciation, every single exhibit taken out of context, as if fallen out of time and space. Our misconception about these artworks naturally sharing their presence with us (curators do not leave empty spaces in order to remind us of what is missing) easily leads to the unacknowledged assumption that a work of art dating back to a time not ours was painted, sculpted, drawn, or printed with *us* in view and for *our* sake, which obviously amounts to fallacy. Secretly, I suspect, none of us will ever lose this belief, and maybe this is why I cannot get too excited about contemporary art: it actually is painted, sculpted, drawn, and printed for us, which is why no tiger's leap from the *Jetztzeit*, or the time of the now, into the past need even be attempted.[2]

Notes

1 On this print, see Ronald Paulson, *Hogarth's Graphic Works*, 2 vols. (New Haven: Yale University Press, 1965), vol. 1, 241–43, no. 207; and Günther Klotz, "Hogarth and Addison: 'Time Smoking a Picture' und 'The Spectator,'" *Zeitschrift für Kunstgeschichte* 22, no. 2 (1959): 102–11. On the iconography of "Kronos," "Chronos," and "Kairos," see Erwin Panofsky, "Father Time," chap. 3 in *Studies in Iconology: Humanistic Themes in the Art of the Renaissance*, 3rd ed. (New York: Harper and Row, 1972), 69–93.

2 Walter Benjamin, "Über den Begriff der Geschichte," in *Gesammelte Schriften*, ed. Rolf Thielemann, vol. 1, pt. 2 (Frankfurt: Suhrkamp, 1991), 701.

<div style="text-align:center; border:1px solid black; display:inline-block;">David E. Wellbery</div>

The Origin of Time

Philosophical reflection often draws its energy from a perceived incongruity or conundrum it labors to resolve. Certainly, this is true of philosophical thought about time, which from the beginning of the Western tradition has been animated by perplexity. Perhaps the most poignant expression of such intellectual puzzlement was Augustine's keen observation: "What, then, is time? If no one asks of me, I know; if I wish to explain to him who asks, I know not." Certainly, we are intimate with time, our very being is "in" or "of" or perhaps even "by" it (prepositions lose their grip here), but as soon as we attempt to render this prethematic knowledge explicit our epistemic mooring snaps, setting us adrift on the waves of paradox. No one captured this seasickness of thought better than Augustine: "If, then, time present—if it be time—only comes into existence because it passes into time past, how do we say that even this is, whose cause of being is that it shall not be—namely, so that we cannot truly say that time is, unless because it tends not to be?"[1] Several of the most significant achievements of modern philosophy can be understood as endeavors to solve the Augustinian problem by finding a language that cleaves to our intimacy with time: to the way time is felt, suffered, lived. One recalls in this connection Friedrich Nietzsche's doctrine of the "moment" as the eternal return of the same, Henri Bergson's notion of *durée* as the plasticity of becoming, and George Herbert Mead's philosophy of the present as regenerative newness. In the work of these writers, thought struggles to reach behind the schema of linearity that distorts the dynamic of time even as it makes time manageable. The task of modern thought is to *discover* time: to disclose its origination, its irruption, and therewith the emergence of the world. This is also the task of the finest modern criticism of art.

In the opening book of *Ulysses,* James Joyce shows us Stephen Dedalus at the sea's edge, in peripatetic meditation. Closing and opening his eyes, the aspiring artificer parses the foundational metrics of the emergent world, the "ineluctable modalities" of the visible and the audible.[2] In his meandering rumination, each modality receives a German name: *Nebeneinander* (adjacency) and *Nacheinander* (succession), terms purloined from the sixteenth chapter of Gotthold Ephraim Lessing's brilliant aesthetic treatise of 1766, *Laocoon; or, On the Limits of Painting and Poetry.* The different types of arrangement expressed by those terms, Lessing claimed, distinguish the plastic arts from poetry, thereby limiting each to the representation of contents cognate with its own inner form: the plastic arts to bodies in space and poetry to actions in time. Can we say that Joyce's protagonist is conducting an experiment in formalist

criticism? That he is endeavoring to bring the constraints and possibilities inherent in his own medium into view? Indeed, soon enough Stephen's meditation lets rhythm shape itself out within the monotony of sheer succession, and critics before and after him have conducted similar *Laocoon*-inspired investigations. As chapter and essay titles by Rudolf Arnheim and Clement Greenberg acknowledge, some of the most acute formalist criticism of the twentieth century unfolds as a reprise of Lessing's fecund hypothesis. The essential matrices of artistic form are time and space, those "forms of intuition" that Immanuel Kant, just a few years after Lessing, identified as the ineluctable modalities of perception, the very conditions of every world encounter. This is a discovery, to be sure, but does it go far enough?

An infrequently noticed weakness of formalism is that it conceives of the time relevant to art in abstraction from content as well as from the concrete placement of aesthetic experience. Lessing's claim was that "painting" (his use of the term also covered sculpture) is limited to a single moment, a slice of sequence; it deploys a compelling array of extended things—bodies in space—that happen to cohabit a single moment. Considered in this way, no moment qua moment is distinct from any other except by virtue of its position before or after. Therein lies the abstraction. Time is etherealized (de-realized) to an ordered series of experientially neutral, hence empty, slots, and the task of the painter or sculptor is to select one of these and fill it with content thinkable as simultaneous. With respect to any particular painting or sculpture, then, time has only a framing function, setting the perimeters of simultaneous coexistence, but never penetrating to the interior of the artwork's meaning. Our premise, however, was that both the deepest philosophical thought about time as well as the profoundest art criticism modernity has on offer strive to get behind such abstractions, to bring to light the irruption of time, and to achieve this in and through the engagement with works of art. The wager of such thought and criticism, one might say, is that the artwork assumes form out of the origin of time in experience. This is no doubt one implication of the title Martin Heidegger gave to his essay *The Origin of the Work of Art*: the thought that human temporality as such becomes accessible in the artwork. But where is one to find such criticism?

I offer, in all brevity, a single example: Goethe's essay "On Laocoon" from 1798, a telling case because its object is the very marble group of late antiquity that served as the point of departure for Lessing's argument in the treatise mentioned above. Goethe, too, is concerned with the sculpture's relation to a single moment of time, but the crucial matter is that he grasps that moment not as a slice or frame but, rather, as the *present* moment: a moment that tears itself loose from the flow of activity that preceded it and from everything that will follow. In Goethe's analysis, this present (*Gegenwart*) emerges because the sculpture is centered on the exact instant in which the snake's fangs penetrate the soft flesh above and to one side of the buttocks (a ticklish spot). Everything radiates outward from this acute strike: the contraction of the abdomen, the expansion of the breast, the twist of the head and drop of the left shoulder, the mouth's gasp. Taken together, these elements are the becoming-body of "sudden terror or fright," and this terror (*Schrecken*) is not a content inserted into a neutral temporal frame. Rather, it is inseparable from the suddenness that rips time apart and casts Laocoon

into *his* present, the present of his agony. In such an absolute present ("absolute" because free from the relativism of sequential positioning), time and body are co-emergent. They are, one might say, of one form, and this is the form of the sculpture itself (at least of its central figure). With Goethe, criticism undertakes to disclose the origination of time and world in the felt present that achieves itself in the work and thus becomes accessible to thought.

Notes

1 Saint Augustine, *Confessions,* bk. 11, chap. 14, translated by David Wellbery from the Latin edition at http://www.stoa.org/hippo/frames11.html.
2 James Joyce, *Ulysses,* eds. Hans Walter Gabler et al. (New York: Random House, 1986), 31.

TRADITION

Figure 104. Obiora Udechukwu, *Rhythms of the Threshold*, 2005, graphite on paper, 14 × 11 in. (35.6 × 27.9 cm). Newark Museum, Newark, N.J., Simon Ottenberg Collection (artwork © Obiora Udechukwu; photograph provided by the Newark Museum).

Obiora Udechukwu

Art, Tradition, and the Dancing Masquerade(r)

Sometime in the late 1970s, I designed a cover for a proposed journal to be published by the Faculty of Arts at the University of Nigeria, Nsukka. My design relied on some of the hallmarks of traditional Igbo *uli* body drawing and wall painting, namely, the simplification of forms (mostly abstract and curvilinear) and the balancing of marks with large open spaces. On seeing the work, a visiting British professor of music had the immediate response,[1] "Reminds me of Joan Miro." Of course, he did not know about *uli*, nor about the project spearheaded by Uche Okeke at Nsukka to study indigenous art traditions as a necessary step for Nigerian contemporary artists in their inevitable interactions with other traditions. Now, contrast that incident with another that took place about a decade later at the University of Ibadan. The mother of Nigerian poet Niyi Osundare walked into his office and stopped abruptly. She stood there and gazed steadily at a reproduction of my ink drawing *The Road to Abuja* hanging on the wall. Then, simultaneously tracing lines in the air with her finger and looking at the picture, she asked her son in Yoruba, "Isn't that the type of marking we did in the village?"

My journey has been one of seeking the right idiom to convey more satisfactorily my creative impulses. In the catalog of my 1988 exhibition at the National Gallery of Zimbabwe, Harare, I noted, "The aesthetic strategies of Igbo *uli* and the linear symbolism of *nsibidi* writing have been deployed for a largely satirical exposition of the African condition."[2] I have studied and analyzed Igbo drawing and painting for many years, compared them with the Chinese tradition; spent time in the field recording and studying Igbo epics and minstrels; group-written four plays as a member of the Ọdụnke Community of Artists,[3] founded during the Biafran War. I have traveled widely in different parts of the world, looking at the arts and cultures of many peoples. In the same spirit that European modernists borrowed from African sculpture and Japanese woodblock prints to revitalize their work and, by extension, their tradition, I am open to using ideas or media from anywhere to advance my own work. For me, tradition is complex, flexible, and multilayered—both horizontally and vertically. One can perhaps see this reflected at another level, in my own marriage in 1982. First, there was a traditional ceremony (as portrayed in Chinua Achebe's novel *Things Fall Apart*) in my wife's village, followed by a "white" Christian wedding on my university campus and then a civil one at the marriage registry—an illustration of Ali Mazrui's "triple heritage."[4]

The Nsukka group of artists that I am associated with[5] views the recourse to indigenous tradition as aligning with the Igbo aphorism "A na-esi n'unọ a di mma, welụ a pụ ezi" (Charity begins at home) and complementing the ideology of "If you want to get a good view of a

279

Figure 105. Obiora Udechukwu, *"Where Something Stands ...,"* detail, 2007, acrylic and ink on canvas, 5 ft. 1 in. × 21 ft. (154.9 × 640.1 cm). Collection of the artist (artwork © Obiora Udechukwu).

masquerader dancing, you do not stand in one place." This means that tradition is neither static nor rigidly localized. A traveler absorbs novel elements from other locations and melds them to the familiar; with time the foreign is seamlessly domesticated, giving rise to the new traditional. The Nsukka project was influenced by the concept of "Natural Synthesis"—the unforced blending of the best in indigenous and foreign art traditions—as espoused by Uche Okeke, Bruce Onobrakpeya, Demas Nwoko, Yusuf Grillo, Okechukwu Odita, Simon Okeke, and other members of the Art Society, a group of young college students at the then Nigerian College of Arts, Science and Technology, Zaria, just before Nigeria's independence in 1960. Despite the multiple and diverse sources from which I have borrowed, Igbo aesthetics remain central to my work.

It is the view of many Igbo cultural producers that talent emanates from God, the Earth Goddess, and "the Owner of Art," as is encapsulated in a statement by Okafọ Okefi of Agulu that the sculptor bodies forth what "the grasses on the earth reveal to him."[6] The Igbo refer to visual art as "ife nkili" (spectacle, something to be looked at [for pleasure]), and artists often use the expression "ịchọ mma" (literally, to search for beauty, to decorate, to beautify) to describe aspects of their work. *Mma* also means "good" or "goodness." In addition, art has a functional or instrumental component, be it sculpture, pottery, textiles, masking, or minstrelsy. In general, both entertainment and message are central to the creative endeavor.[7] How these twin elements are handled differs from artist to artist, for, as the traditional *uli* artists would say, "Uli dị n'aka n'aka" (*Uli* varies from hand to hand).[8] This is a variant of the broader saying "Ike dị n'awaja n'awaja" (Power runs in many channels),[9] an acknowledgment of the multiplicity of individual endowment and specialization.

I see my art as the subconscious side of me working in concert with the deliberative or intellectual. *Rhythms of the Threshold*, executed directly in the manner of a traditional *uli* artist drawing on the human body without erasing, shows the lyrical manipulation of pure line, suggestive gestures, open spaces, and elaborate detailing. Some of these qualities are evident in the last segment of the large painting *Where Something Stands…* (2007) (Fig. 105). In addition to the abstract patterns (*akịka*) and the spiral motifs (*agwọlagwọ*) derived from the *uli* repertoire, as well as the large *nsibidi* sign for mirror at the top right, I have introduced lines from Christopher Okigbo, Wole Soyinka, and Nnamdi Azikiwe in my ongoing exploration of image and calligraphic text. Apart from Igbo arts, my art and poetry benefited also from the examples of my predecessors, especially Uche Okeke, Ibrahim el Salahi, and Christopher Okigbo, who themselves learned from and enriched their own traditions. Looking ahead, I envisage that my practice will continue to be driven by a respect for the past and an awareness of myself, of my specific location temporally and geographically.

Notes

1 Three good sources on *uli* are Sarah Adams, "One Person Does Not Have the Hand of Another: *Uli* Artists, the Nsukka Group, and the Contested Terrain in Between," in *The Nsukka Artists and Nigerian Contemporary Art,* ed. Simon Ottenberg (Washington, DC: Smithsonian National Museum of African Art, in association with University of Washington Press, Seattle, 2002), 52–62; Elizabeth W. Willis, "Uli Painting and the Igbo World View," *African Arts* 23, no. 1 (1989): 62–67, 104; and Elizabeth W. Willis, "A Lexicon of *Uli* Motifs," *Nsukka Journal of the Humanities* 1 (1987): 91–120.

2 Obiora Udechukwu, introduction to *Drawings and Paintings by Obiora Udechukwu* (Harare: National Gallery of Zimbabwe, 1988), n.p. For *nsibidi* writing, see Simon P. X. Battestini, "*Nsibidi,*" in Ottenberg, *The Nsukka Artists and Nigerian Contemporary Art,* 63–83.

3 The first Ọdụnke play, *Veneration to Udo,* group-written and performed in Biafra, was very critical of corruption in high places, and many people thought that members of Ọdụnke would be arrested and detained. In the "Author's Note" to his novel *Toads of War* (London: Heinemann, 1979), vii, Eddie Iroh

remarked: "In writing this second volume of a trilogy I have drawn great inspiration from the Ọdụnke Community of Artists, whose lyrical insight into the civil war period remains a very significant creative appraisal of this tragic interlude. I express my utmost gratitude to them for the permission to adapt their dance-drama, *Veneration to Udo*, for this novel as well as the use of their various poems." In a note, Iroh added, "With a courage uncommon at the time, the play boldly attacked the decadence and perversion of the new nation, indicting the messiahs, the prodigals, the toads of war, the greedy disaster millionaires who festered in the misery of war" (95 n. 3).

4 Chinua Achebe, *Things Fall Apart* (New York: Doubleday, [1958] 1994), 110–19. Ali A. Mazrui, *The Africans: A Triple Heritage* (Boston: Little, Brown, 1986).

5 For a detailed study of the Nsukka group, see Simon Ottenberg, *New Traditions From Nigeria: Seven Artists of the Nsukka Group* (Washington, DC: Smithsonian Institution Press in association with the National Museum of African Art, 1997).

6 Okafọ Okefi, personal communication with the author, 1972. In much the same way that the Chinese traditionally classified painters, reserving the highest or "divine" class (*shen*) for those whose works exuded an inexorable, mysterious aspect (*qi* or *ch'i*, "life energy," "vital force") over and above the mastery of form and technique, the Igbo see certain artists as channels for the expression of the supernatural. Among the Mande, blacksmiths, sculptors, and other artists are held in awe because they can manipulate *nyama*, the life force. As the novelist Chinua Achebe (1930–2013) always claimed, storytelling chose him, not the other way around.

7 The elaborate Mbari houses of the Owerri Igbo provide a good example from the plastic arts; see Herbert M. Cole, *Art and Life among the Owerri Igbo* (Bloomington: Indiana University Press, 1982). Onyekulum and Ọsụlụgwọgwọ, masquerades that satirize members of the community, are discussed in Obieze Ogbo, "ỊFỤ EGWU: The Use of Lampoons in Igbo Oral Literature," *Ụwa ndị Igbo* 2 (1989): 32–35.

8 See Adams, "*Uli* Artists, the Nsukka Group, and the Contested Terrain in Between," 56.

9 Chinua Achebe notes in "Foreword: The Igbo World and Its Art," in *Igbo Arts: Community and Cosmos*, eds. Herbert M. Cole and Chike C. Aniakor (Los Angeles: Museum of Cultural History, University of California, 1984), ix, "*Ike*, energy, is the essence of all things human, spiritual, animate, and inanimate. Everything has its own unique energy which must be acknowledged and given its due. *Ike di na awaja na awaja* [*sic*] is a common formulation of this idea: 'Power runs in many channels.'"

```
┌─────────────────────────────┐
│                             │
│        John Brewer          │
│                             │
└─────────────────────────────┘
```

Tradition: History and Reification

At Cambridge University in the 1960s, my fellow students and I were implacably hostile to "tradition." We reveled in Quentin Skinner's denunciations from the podium of the British conservative philosopher and doyen of the *National Review,* Michael Oakeshott, whose critique of rationality and plaudits for change tempered by practice and tradition struck us as at once hopelessly limited and, in an easily heard echo of Edmund Burke, deeply opposed to any sort of rationally justified radical innovation. Oakeshott and Burke were deemed to offer a descriptive and prescriptive account of change as a process of reverential accretion that we wanted (in somewhat contradictory fashion) both to deny and ignore. It is obvious, then, that we saw "tradition" as an unwelcome constraint, *mortmain,* the suffocating dead hand of our ancestors. This was pretty blind, as well as a sign of the times, because it threatened to inhibit us from addressing properly questions about the processes of artistic, political, and social change. Our case against the invocation of tradition—that it served as a means of avoiding those very same questions—still appears to me a telling one, though our own position, in retrospect, looks little better. All of which is to say that the tenor of these remarks is that claims based on "tradition," "traditions," and "the traditional" are worthy objects of scholarly criticism, but that "tradition" has very limited value as a term of critical analysis. This may seem provocative; it is intended to be so.

But just think about the ways in which the term is used. As often as not the concept is platitudinous, flabby, and capacious—for example, in the use of such phrases as "the Western tradition" in art, the Christian, Islamic, Chinese, European, and so on, tradition.[1] It provides a useful, often heuristic holdall that when put under any serious analytic pressure splits at the seams. When the term is used more specifically, as by those seeking to create a genealogy or canon—for example, in F. R. Leavis's *The Great Tradition* (1948)—it is frequently tendentious. When used as a precise descriptor, it often turns out to be little more than an elegant variation for "conventional or customary practices/values," as in Thomas Kuhn's discussion of "tradition-bound" scientific research,[2] or as something more aptly described as a genre or style. It also serves as a shorthand reminder of the self-evident point that much artistic and intellectual facture refers—in a multitude of ways—back to its precursors. Of course, "tradition" carries more freight than the term "convention," and it's the perlocutionary force (to use J. L. Austin's term) of the term's employment that raises red flags for me.

To say of a belief or a practice that it is a tradition is to give it not just a certain character—to claim that its origins lie in an (ill-defined) past—but to invest it with a certain symbolic importance and to assert that its strengths lie in its *continuity* with the past, and that that

continuity constitutes a part of its validation. Eric Hobsbawm makes this point in functionalist terms in his introduction to *The Invention of Tradition* (1983), the collected volume he and Terence Ranger edited. Tradition-making, he argued, was a means of legitimating certain practices and beliefs, of creating continuities, in order to cope with processes of rapid social change; its objects were the making of *Gemeinschaft*, the fabrication of certain sorts of community, the legitimation of (sometimes novel) institutions, and the inculcation of values, all of which laid claim to be traditional, and therefore legitimate and worthy of conservation and transmission. Such claims, he emphasized, were more frequently made in "modern," as opposed to "customary" societies, but were not peculiar to them. Tradition may not have been an invention of "modernity," but it has had a huge investment in the concept to which it is symbiotically tied. Think of "heritage," the commodity version of tradition, and "nostalgia," a modern disease that takes the form of hankering for a world we have apparently lost but, in fact, we never had. The great strength of *The Invention of Tradition* was that it demystified the transhistorical claim for tradition(s) to have existed "time out of mind" or since "time immemorial," and that it also dispelled the spatial miasma that surrounds the location of tradition, by administering a strong dose of history, reminding us that both the category "tradition" as well as many so-called traditions were rooted in specific and identifiable circumstances and chronologies, and that the continuities they claimed were, in Hobsbawm's word, frequently "factitious."[3]

Hobsbawm and Ranger were interested in the creation of tradition(s), but much of the scholarship about artistic and literary practice, even when (perhaps especially when) enamored of the concept of tradition, has been concerned with what the literary critic Walter Jackson Bate called "the burden of the past." Here, the play is not so much between traditional and modern as between traditional and original. In T. S. Eliot's 1919 essay "Tradition and the Individual Talent" and Harold Bloom's enormously influential, psychoanalytically informed study *The Anxiety of Influence: A Theory of Poetry* (1974), and in many an art historical monograph devoted to a single artist, we are presented with different accounts of how innovation and creativity, even genius, work. This has the virtue of grappling with the knotty question of the processes by which change and invention occur, though it is usually rather crudely formulated as a task of distinguishing plodding sheep from swift-footed goats, those who are overawed by their predecessors and follow meekly in their footsteps and those who succeed in surpassing or overtaking their predecessors, creating something new: thus, Eliot talks of "immature" and "mature" poets, and Bloom of "poets" and "strong poets." These heroic accounts of creativity—whether, as in Eliot's case, as an act of creative self-effacement or "depersonalization" or, as with Bloom, through a series of confrontational misreadings of poetic forefathers—depend heavily on an idea of tradition, as seen from the artist's point of view. This sort of analysis is, of course, not new and can be found in the extremely rich classical and Renaissance discussions of *imitatio* and *aemulatio* (imitation and emulation) as mechanisms for cultural inheritance and transmission, though these tend to be more rigorous because less concerned with "a tradition" than with the relations between particular individuals or between particular works.

Transmission is a process whose recuperation enables us to answer the questions of how, why, and through whom it has occurred and to examine what has changed in the process. The range of possible answers to these questions is extraordinarily broad. Temporally linear models of cultural transmission embodied in the term "tradition" seem a rather parsimonious account of cultural and intellectual exchange and lock us into binaries shaped by concepts of innovation and originality. In short, "tradition" is mere reification, albeit, as Hobsbawm and his colleagues demonstrated, one of a most powerful kind.

Notes

1 "Tradition […] appears far more often in the title of art historical works about non-European arts—Native American, African, Asian, Australian aboriginal, and so on—than about Western art."

2 But see Eric Hobsbawm's distinction between "routines," "conventions," and "tradition," in his introduction to *The Invention of Tradition,* eds. Eric Hobsbawm and Terence Ranger (Cambridge: Cambridge University Press, 1983), 3.

3 Ibid., 2.

Etching, Tradition, and the German Imagination

Tradition can be defined as the practice of transmitting or handing down information, beliefs, and customs from one generation to another. In art history, it is enacted layer upon layer, text upon text, image upon image: a process of aggregation. Printing, as visual art or as text on the page, played a seminal role in the transmission of tradition in Germany from Gutenberg on, and was especially significant following unification in 1871. Two artists making prints and writing books in the 1890s and early 1900s, Max Klinger and Max Liebermann, reveal how artists with different formal and methodological agendas revived and channeled the past in surprisingly interconnected ways.

The etching revival that swept through Europe during the last half of the nineteenth century was, as its name indicates, looking back, as it "revived" a medium inextricably linked to the past. The etching revival in Germany, which gained momentum in the 1880s and continued through the turn of the century, was supported economically by the state in a post-unification effort to teach and promote this purportedly *urdeutsch* (thoroughly German) medium. The raw woodcut style of German Expressionism has long been understood as the pinnacle of graphic modernity after the turn of the century. However, their predecessors Klinger and Liebermann enacted similarly radical graphic programs, in both print and printed word, although their imagery and style may appear less progressive.

During the 1890s, print production became a lively topic of debate in German art journals and the popular press. "Original" prints, created by the painter-printmaker, were promoted in contrast to "reproductive" prints, which were condescendingly characterized by progressives as slavish copies and threatened by the encroachment of photography despite their popularity with a mass audience. Etchings were described by forward-thinking art writers as containing a poetic and subjective content that allowed viewers to project their own imaginative, intellectual readings onto the work of art. Imagination, intellect, and emotion were tied to the poet, the musician, and the graphic artist, who were considered the most spontaneously creative. Moreover, these forms of cultural production were understood as part of Germany's heritage, which was less true for painting.

Klinger, a painter, sculptor, and printmaker, won critical acclaim through his print series. Each of the fourteen portfolios, published between 1879 and 1915, was subtitled with opus numbers, thereby directly associating his prints with music. The fourth was titled *Intermezzi*, a musical term connoting "in between." The montagelike excerpts that form the series of twelve prints included *Battling Centaurs* (Fig. 106), a work that exemplifies

Figure 106. Max Klinger, *Battling Centaurs*, plate 5 from *Intermezzi*, 1881, etching and aquatint on paper, 16½ × 10⅜ in. (41.9 × 26.4 cm). Sterling and Francine Clark Art Institute, Williamstown, Massachusetts (artwork in the public domain; photograph by Michael Agee).

Klinger's richly textured imagery. *Battling Centaurs* depicts two beasts fighting over a dead rabbit as the magisterial German Alps rise up behind them. The artist frequently incorporated motifs from antiquity, such as the centaur, impregnating them with issues relevant to contemporary trends in literature, science, music, and philosophy. Klinger transformed motifs inherited through tradition into sociocritical weapons. *Intermezzi* contained many of Klinger's hallmark visual and textual preoccupations, including Darwinian evolution and Schopenhauerian pessimism. He suggestively complicated tradition, constructing subversive messages of irony and desire within a high degree of formal realism, perhaps making his prints more palatable to the bourgeois market whose mores he critiqued.[1]

Max Liebermann, the powerful artist, collector, and co-founder of the Berlin Secession, turned to printmaking with a different formal vocabulary but no less complex relation to tradition. Displaying an Impressionist-inspired facture, Liebermann's prints have largely been considered as extensions of his paintings, repetitions of painted motifs in etched

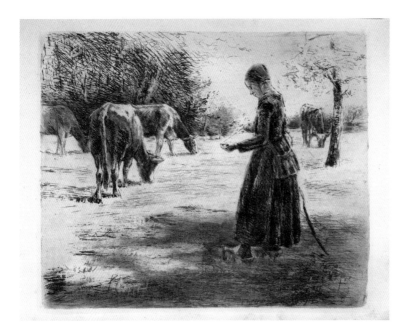

Figure 107. Max Liebermann, *In the Pasture (Near Delden in Holland)*, 1891, etching, soft-ground, and drypoint on paper, 7⅜ × 9¼ in. (19.4 × 23.5 cm), as published in *Zeitschrift für bildende Kunst* (1893), Sterling and Francine Clark Art Institute Library, Williamstown, Massachusetts (artwork in the public domain).

form. But during his lifetime, Liebermann's prints were connected (by himself and others) to the German past and to creative ideation, whereas his paintings were described (often in anti-Semitic terms) as French-inflected and derivative. Prints such as *In the Pasture (Near Delden in Holland)* (Fig. 107), made in a combination of etching, soft-ground, and drypoint, self-consciously linked the artist to his second home in Holland and to the production of its most famous printmaker, Rembrandt. In the 1890s, Rembrandt was being co-opted as German by authors such as Julius Langbehn in his polemic *Rembrandt as Educator* (1890). While art critics allied Liebermann's oil paintings to nature via Impressionism and the humble peasants he depicted, his prints were understood as manifestations of his personality and individuality, the same terms used to describe Klinger's diametrically opposed imagery.

Klinger and Liebermann each published important texts to promote and explain their art, especially their graphic production. Klinger's 1891 treatise *Painting and Drawing* championed the intellectual and creative drive behind drawn art (what he called *Griffelkunst*), discussing prints and drawings as vehicles for invention and social criticism.[2] His text was a descendant of Gotthold Ephraim Lessing's seminal *Laocoon*, which differentiated painting from poetry, whereas Klinger distinguished graphic art from painting. Klinger argued that drawn art was most suitable for representing artistic personality via the world of fantasy and the imagination, enabling the artist to evoke a spiritual world akin to poetry and music. Above all, Klinger celebrated the subjectivity of drawn art, which offered the freedom to express one's interior world view.

Liebermann, writing a decade later, likewise considered drawing (and, by extension, printmaking) as the ultimate site of artistic creativity. As he argued in the 1901 catalog foreword to the Berlin Secession's first "black-and-white" exhibition: "a sketch provides the most immediate insight into [the artist's] creativity. Drawings undoubtedly make greater demands on the collaborative imagination of the viewer […]. But only the viewer who has penetrated the hieroglyphics of the drawing will fully understand the completed work of art."[3] Liebermann similarly built his artistic theories on German tradition and Romantic aesthetics, describing his own project as inextricably linked to imagination and poetry. He further elaborated on these ideas in a series of articles written between 1904 and 1916 and published as *Fantasy in Painting* (1916), frequently invoking Goethe and Lessing. Whereas Klinger subscribed to Lessing's notion of the poetic and imaginative as manifested in the "thought of the idea," Liebermann disagreed with Lessing and saw imagination manifested in the "thought of reality." One stressed content over form and the other form over content.

Regardless of the differences in their imagery and formal styles, Klinger and Liebermann each described the drawn, printed, written, and etched line as revelatory of the inner thoughts of the artist/author. The transmission of ideas through line—for artists, art historians, and philosophers—was a way to transform tradition into a living, modern idiom. This was a particularly national trait, a way to negotiate history while transforming the present, allowing culture to evolve continuously out of a shared, if illusory, sense of the past.

Notes

1 Marsha Morton, *Max Klinger and Wilhelmine Culture: On the Threshold of German Modernism* (Burlington: Ashgate, 2014).

2 Max Klinger, *Malerei und Zeichnung* (Leipzig: Insel, 1891).

3 Max Liebermann, *Phantasie in der Malerei: Schriften und Reden* (Frankfurt: S. Fischer, 1978), 172.

Tapati Guha-Thakurta

Field Notes on the Contemporaneity of Tradition

The idea of "tradition" once rose like a colossus over the field of Indian art history. As an idea embodying the antiquity and pedigree of the "nation," its authority remained firmly in place through the years in which the modern discipline emerged from its foundations in colonial scholarship and institutions to assert its status as an independent, nationalized domain of knowledge. At the same time, given the indeterminacy and elasticity of the term, "tradition" would become one of the most intensely debated themes in Indian art historiography. Its meaning could be seamlessly expanded to cover the entire art of the past or to signify a religious dispensation and a spiritual aesthetic as the unique attributes of India's artistic classicism. It could be used to introduce specific stylistic conventions or treatises on architecture, sculpture, or painting, to scrutinize the vast complex of divine and secular iconographies of Indian art, to break up the broad geographic unit of the "national" into an evolving grid of regional, vernacular styles, or to look beneath the canons of the "classical" or the "imperial" for the country's "living" heritage of crafts, ritual, and folk arts. In its most generalized usage and abstracted form, "tradition" is what best defined the "Indianness" of Indian art—that troubling yet never fully discarded concept that served its prime polemical ends at the turn of the twentieth century in countering the hegemony of Western art and giving the nation's art its own rightful place in the global sphere.

As an oppositional category, the "traditional" also acquired its main heuristic value in sharp contradistinction to the time and place of the "modern." Here, the field can be seen to have been continually split between the "traditional" and the "modern" along an overlapping set of temporal, normative, and social registers. So, for instance, it was clearly from the vantage perspective of modernity that the chronology of traditional periods, styles, and schools of Indian art could be constructed and given their elaborate art historical classifications, distinguishing between major and minor genres, between imperial and subimperial/regional trends, and between India's deep archaeological antiquity and its continuing vernacular traditions of building, sculpting, or painting. By the same logic, it was only through a pointed sense of historical distance from all that constituted its "pre-modern" past that different phases and movements of the nation's modern art history could unfold, create its reserve pool of visual traditions to revive and reclaim, and define its own autochthonous twentieth-century narratives of modernism. Equally important was the social division that came into being in the sphere of practice between

Figure 108. Bhabatosh Sutar, Durga Puja installation, October 2012, Naktala Udayan Sangha Puja, Calcutta, enclosure with giant winged butterflies, made with wood, steel rods, wire mesh, and embossed cloth (photograph by the author, provided by the visual archives of the Centre for Studies in Social Sciences, Calcutta).

those who would take on the vocation of "artist" in modern India and the vast anonymous collective of those who were the temple builders, masons, sculptors, or painters of the past, or those who carried on their work as the hereditary artisans, craftspeople, and folk practitioners of the day. From the late nineteenth and early twentieth century, the modern lineage of the "artist" in India would be etched in pointed distinction from the heredity and milieu of these "traditional" art practices of the past and the present—whether they be of the temple sculptor and idol maker, the miniaturist and court painter, the fabricators of India's world-famous handicrafts, or the maker of tribal objects and wall paintings.

These ideological formations of the "traditional" and the "modern" are now part of the distant past of Indian art history. In laying out this brief schematic framework, I became aware of how far back this also pushes into my own past of art historical research, done largely over the 1980s and 1990s, when I had worked, first, on the early colonial and nationalist contexts of the making of a new "Indian art" in modern Bengal, and later on the disciplinary and institutional apparatus of archaeology, art history, and museums in colonial and postcolonial India. The new scholarship of the past two decades has moved far from these deeply embedded polarities and divisions (which were once the constitutive core of the discipline) to radically dismantle the overarching category of the "traditional" and relocate it within a series of historically contextual usages in art production and patronage in different periods and regions.

One of its most powerful thrusts, for instance, has been to pitch the weight of the "traditional" outside the time frame of the "premodern" into the popular image complexes

Figure 109. Bhabatosh Sutar, Durga Puja installation, October 2012, Naktala Udayan Sangha Puja, Calcutta, synchronized iconography of a winged goddess Durga, clay sculpture (photograph by the author, provided by the visual archives of the Centre for Studies in Social Sciences, Calcutta).

of modern and contemporary India—to show how a changing iconography of India's religious and mythological pantheon has grown out of the thick mesh of modern technologies of mass-production and circulation, linking the representational idioms of the cheap picture print with the imaging devices of photography, cinema, or the latest digital media. In recent times, as Indian art history underwent its anthropologizing turn and reinvented its profile as "visual studies," its object worlds expanded provocatively to embrace a widening range of productions and practices of the present—from popular calendar art to public religious and political statuary, from mega Hindu temple complexes that deploy the latest exhibitory technologies to folk art forms that confidently negotiate global themes and the international art market. In each case, we have been brought face to face with new creeds of images and image makers that fall between the traditional/modern, religious/secular, or artist/artisan binaries. In each case, "tradition" (in the sense of inherited formal conventions, iconographies, or community practice) is made freshly serviceable for the current sectarian politics of caste, language, and region, even as it gears up to meet the new demands of mass spectatorship and corporate publicities.

It is within this rapidly mutating field that I would also locate my current ethnographic engagement with a contemporary genre of "festival art" that has grown around Bengal's annual autumnal celebrations centered on the worship of the goddess Durga. My "notes from the field" here remain steeped in the thick layers of a vernacular tradition of, first, the emergent iconography of the goddess, where Durga's martial image as slayer of the buffalo demon blends with her maternal image of a married daughter returning to her parental home every year with her four divine children, and, second, a hereditary practice of anthropomorphic image making in alluvial day that dates back to the eighteenth century, if not earlier. My main concern has been with the way this iconographic and sculpting tradition is being creatively reworked in the cause of a new urban "public" art, as the ritual occasion of the Durga Pujas in the city of Calcutta has transformed itself into a weeklong exhibitory event, designed for popular touring and viewing. The field today is filled with aspirant artists (many from backgrounds barely distinguishable from those of artisans and craftsmen) who have today taken to Durga Puja designing as a lucrative profession and are creating their own signature-style Durga images and pavilion enclosures to attract competition awards and corporate sponsors (Figs. 108 and 109). Why do they choose to invest such intensity of artistic aspirations and so many months of thought and labor into these ephemeral displays? What sustains the name and claims of "art" within the body of the religious event and this space of mass festivity? How does the goddess assume her concurrent identities as a devotional object, an advertising brand image, and a collectible work of art in the life of the festival? What enables such open-ended transactions between avowedly "sacred" and "secular" worlds of image-making and reception? Tradition, I would argue, remains an ever-fertile ground of the present where each such question sown can yield a bounty of answers, and where many of the given provenances of "artist," "art object," or "art viewer" can be dug up and tossed around to redefine the scope of Indian art history.

Hans Hayden

Tradition and Critical Historiography

In his famous essay "The History of Art as a Humanistic Discipline," Erwin Panofsky characterizes the relationship between the humanist, authority, and tradition: "The humanist, then, rejects authority. But he respects tradition. Not only does he respect it, he looks upon it as upon something real and objective which has to be studied and, if necessary, reinstated."[1] If we situate this text historically in the year in which it was first published—1940—it is quite clear that it not only refers to academic issues, but it also defines an ideological position. Panofsky pleads for the values of the Western tradition of enlightenment and democracy, which at this time were under immediate threat from the dictatorships of Nazi Germany and the Soviet Union. However, considered as a general characteristic of the task of art history, it becomes more problematic. Panofsky's characterization reads as a traditionalist appeal to the humanist to devote his or her energy to preserve and defend the enduring values that tradition carries, even if there is also a demand to look critically at authority per se. One can ask, though, if the art historian as humanist does not have a broader and more critical task.

The word "tradition" is insidious. It belongs to our familiar, everyday vocabulary, and it simultaneously holds a great variety of connotations that make it quite difficult to define. In its basic, etymological form, the meaning of tradition appears to be unproblematic: it can be derived directly from the Latin *traditio*, which, according to Edward Shils, was "a mode of transferring the ownership of private property in Roman Law," whereas nowadays it means "whatever is persistent or recurrent through transmission, regardless of the substance or institutional setting."[2] To define one's practice as part of a tradition is, then, to pass on values of a long-established and continuing pattern of cultural beliefs or practices (statements, beliefs, legends, customs, information, and so forth). Accordingly, the word "tradition" embraces the trivia of everyday life as well as the fundamental issues that define one's worldview. But it seems clear that the problem with the word "tradition" is not so much its definition as its function: how it is used, in what context it occurs, with what purposes—or, in short, what the word *does* (as J. L. Austin could have put it).

It is possible to distinguish at least two basic functions brought to bear by the word "tradition," whatever the context: first, that it identifies *a temporal continuity*, and second, that it *marks a distinction*. Whether we are talking about a tradition or manifesting a tradition, the concept includes two elements that serve as cornerstones in any production of meaning, identity, and context. Here, we also touch on the core of the ideological aspects of the word: as it

performs a distinction that discriminates what is included in a designated context from what is excluded, it creates rituals and attributes that tie us together and separate "us" from "them." At the core of the meaning of the word "tradition" there is a figure of thought that seems to be common to any kind of production of personal, cultural, or academic identity, as well as a derogatory denial of anything or anyone outside the borders of the distinction. If such an attitude operates in an unreflected way, it could, obviously, constitute a profound ethic and/or epistemological problem.

The use and reuse of tradition in the modern era can be seen as both a passive and an active attitude: as an unreflective approach to relate to things as they have always been comprehended or as an active reaction to a perceived threat and a means of defense. Hans-Georg Gadamer understands the enhancement and defense of tradition in the Romantic movement as a conscious opposition to the Enlightenment's emphasis on progress, science, observability, and objectivity.[3] These two movements could be perceived as two fundamental and dissonant modes of what we define as modernity. It is pointless to try to delegitimize any one of them as reactionary, as they are intertwined in every cultural, philosophical, or ideological direction that is not considered to be revolutionary. From this perspective it is possible to understand Panofsky's plea for a traditionalistic approach as a way to define a situation in which the open society makes use of tradition as a bulwark against oppression and tyranny as well as a necessary transmission of the scientific progressivity of the Enlightenment. Such an approach has proved to be crucial, not least in the last decades, in the political, social, and academic fields, where economic cuts have gone hand in hand with the rise of populist and nationalist forces. The open society is not to be taken for granted, neither in 1940 nor today. Still, it seems to me that the stipulation of a context—whether of the Western tradition of the open society or of the idea of an antiauthoritarian academic ideal—as something to be taken for granted is doubtful. Instead, context should be conceived as something always in need of redefinition and argument.

In my opinion, we ought to bring the views of both Panofsky and Gadamer closer to the idea of the emancipatory function of science and scholarly traditions that Jürgen Habermas enunciates in his definition of "Knowledge-constitutive interests" in his Frankfurt inaugural address of 1965.[4] He stipulates a distinction between natural science, humanities, and social sciences in order to highlight the progressive nature of the latter (the field in which he himself was about to attain a chair) at the expense of the others—in particular, the humanities, which he defines stereotypically, according to the hermeneutic views of the day, as a tradition-laden branch of conservation and mediation. Here, we enter the realm of critical theory of the 1970s and the alternative directions and canons of the New Art History and visual studies in the following decades. As opposed to Panofsky's iconological stance for the development of art history in the postwar era, one could address Roland Barthes's "Rhétorique de l'image" as a similarly canonical perspective for the formation of visual studies in the 1990s: where the former asks what the image means, the latter asks how it means; where the former talks about intrinsic meaning, the latter examines meaning as a cultural and

ideological construction; where the former defines the goal of interpretation as reaching the artwork's core of meaning, the latter outlines its task as understanding the context in which meaning is established and normalized; where the former comprehends the goal for the humanities as transmitting the content of tradition, the latter perceives that goal as the exposure and analysis of the ideological context of the image and tradition.[5]

In this intellectual showdown, it is perhaps easy enough to sympathize with Barthes's perspective. At the same time, I cannot but feel ambivalence toward this comparison. What is at stake here is not some kind of a judgment about whether one intellectual position is more radical than another, whether you like or dislike tradition as such, but to what extent one obtains an awareness and capacity for critical reflection on one's own intellectual and ideological position. A consciousness of this type could be called *critical historiography*. Critical historiography regards tradition—and, actually, all kinds of traditions—as something real, as something one is obliged to investigate. In addition, the task of critical historiography is to examine critically the premises taken for granted in each tradition—and, ultimately, to reflect deeply on those premises for one's own intellectual position. Such a critically reflexive approach is, to my mind, a tradition a humanist has to respect and, if necessary, to reinstate.

Notes

1 Erwin Panofsky, "Introduction: The History of Art as a Humanistic Discipline" (1940), in *Meaning in the Visual Arts* (Harmondsworth: Penguin Books, [1955] 1993), 26.

2 Edward Shils, *Tradition* (Chicago: University of Chicago Press, 1981), 16.

3 Hans-Georg Gadamer, *Truth and Method*, trans. Joel Weinsheimer and Donald G. Marshall, 2nd rev. ed. (New York: Continuum, [1960] 1995), 277–85.

4 Jürgen Habermas, "Appendix: Knowledge and Human Interests; A General Perspective," in *Knowledge and Human Interests*, trans. Jeremy J. Shapiro (Cambridge: Polity Press, [1968] 2007), 301–17.

5 Erwin Panofsky, introduction to *Studies in Iconology: Humanistic Themes in the Art of the Renaissance* (New York: Oxford University Press, 1939), 3–31, reprinted in *Meaning in the Visual Arts*, 51–81; and Roland Barthes, "Rhetoric of the Image" (1964), in *Image, Music, Text*, trans. Stephen Heath (London: Fontana Press, 1977), 32–51.

Gregg M. Horowitz

Tradition as Treason

The concept of "tradition," when not used in the narrowly anthropological sense as a synonym for folkways, has nowadays an ineluctable fustiness about it. Anyone who uses it in its normative sense, as a source of justification for judgment and action, is in danger of being dragged backward into a way of thinking that is traditional in the narrowly anthropological sense. No doubt there are many reasons for the deliquescence of tradition, but here are two. First, "tradition" serves a synthetic function insofar as it enables us to build structures of meaning out of a welter of historical materials. We are, however, currently living through a time of grand and festive dispersal, in which the worry over chaos and confusion that motivated caretakers of tradition has, to all appearances, lost its bite. David Joselit, for example, argues in his lectures *After Art* that to understand art in our global and digital world we must turn away from Walter Benjamin's thesis that ours is the age of the decay of art's aura, which melancholically maintains an orientation toward and from the past, and instead treat art as circulating anarchically in decentered distribution networks.[1] In Joselit's view, analyzing art in the space of tradition is, if not exactly wrong, at least untimely. Second, tradition building, like its sister practice of canon formation, seeks to shore up meaning against the passing of time, the drift of memory, and the heaping up of catastrophe. Insofar as no tradition can do its work without a principle of conservation that saves only some (objects, events, ideas) from the flood of historical change, tradition building has fallen under the equally principled suspicion of capricious selectivity and exclusivity. We find a compelling instance of the refusal to choose at the Museum of Modern Art's *Inventing Abstraction, 1910–1925* (2013).[2] The first work of art we see at the exhibition is Pablo Picasso's *Woman with Mandolin*, a nearly abstract painting of 1910 that, almost in the last ditch, shores up diagrammatically its disappearing referentiality. The *image* that greets us, however, is the curators' wall chart of the dense network of relationships out of which the world of abstract art emerged. The contrast is striking: Picasso's painting struggles to embody the idea of a world the artist is not sure he can capture, while the curators' network-image replaces the narration of the historical world with intensities and lines of force that, although perhaps searchable, are not navigable. The arrogance of locating works within a tradition—which is really nothing more than the arrogance of judgment—is forbidden in our posttraditional atmosphere of indifferent, which is to say largely academic, egalitarianism.

Yet, two considerations, one analytic and the other ethico-political, ought to make us hesitate before acquiescing to relegate the concept of tradition to the dustbin of history. The analytic point first. Even if everything solid has melted into air, the neglect of the relation of art to tradition threatens to leave our understanding of our present moment unanchored not merely from the traditions that have, let us grant, ceased to nourish us, but also from the history that has ex hypothesi proven to be the universal solvent of techniques of transmission. Let us recall that tradition in its normative sense is not simply a fancy name for the past but for the past constituted as a cognitive, ethical, and political authority in the here and now. Whether one leans toward the Eliotic view of tradition as what an artist subserves in order to unlock artistic power in the present or the contrary and stormier Bloomian view of tradition as what an artist must, on threat of losing artistic power, reshape by revolting against, tradition is the medium that delivers the past's authoritative self-understandings to the present and in which the present tests and discovers its own formative powers. This is the thought Karl Marx had in mind when, in order to discredit the idea that we can be free in our thinking while unfree in our lives, he asserted that "men make their own history, but they do not make it just as they please; they do not make it under circumstances chosen by themselves, but under circumstances directly encountered, given and transmitted from the past."[3] Marx's dialectical point is that the terms in which we come to grips with our present condition are themselves transmitted by the same history with which we struggle. To think historically about the present requires analyzing not just our current historical moment but also the conditions and resources of thinking itself as artifacts (products, relics, ruins) of previous human struggles. Even if the present of and in which we try to make sense is oddly detached from its own history, we still need to apprehend our sense-making apparatus as inherited. Tossing the concept of tradition overboard in the face of the very real transformations of contemporary modes of meaning making yields, in this light, not freedom from history but cognitive powerlessness to reflect on it. On pain of generating a phonier universal than the concept of tradition ever was, we must continue to find ways to understand the history that has washed us up on these shores with this set of analytic tools.

Looked at from this materialist point of view, "tradition" names not some particular inheritance from the past, not the Classical Tradition or the Marxist Tradition or what have you, but more broadly the way we take up our inescapably historical nature. It designates not the past as such but the past as inherited and reshaped by creatures with culture and memory. And this brings us to the ethico-political reason to slow ourselves down before acceding to the mad rush of the future. Tradition refers to how the past is taken up in the light and shadow of the present day. Such a thought invites us to consider that tradition does not really designate the past at all but the persistence of the past in the present and future. Tradition is the unwilled power of the past that, not having finished its business in its own time, offers us here and now the occasion to turn it to new purposes. ("Tradition" and "treason," it is worth recalling, share a common root; to carry away what has been

left behind is also to betray it.) Tradition, then, is not simply the inert past but the past sublimated into artifacts, images, and ideas that are on the march. No one has grasped this better than that fustiest of thinkers, Matthew Arnold, who attributed the passing of the political authority of the European aristocracy to that class's "fail[ure] to appreciate justly, or even to take into their mind, the instinct pushing the masses towards expansion and fuller life." Arnold concludes the thought by saying, "It is the old story of the incapacity of the aristocracies for ideas, the secret of their want of success in modern times."[4] Tradition as mutability grounds both traditional and nontraditional understandings of the past—grounds nontraditional understandings, I would even say, only insofar as it also grounds traditional understandings. Only when authority circulates as tradition is it ripe for the taking.

Notes

1 David Joselit, *After Art* (Princeton: Princeton University Press, 2013), 14–15.

2 Leah Dickerman, *Inventing Abstraction, 1910–1925* (New York: Museum of Modern Art, 2013).

3 Karl Marx, "The Eighteenth Brumaire of Louis Bonaparte," in *Marx: Later Political Writings*, ed. Terrell Carver (Cambridge: Cambridge University Press, 1996), 32.

4 Matthew Arnold, "Democracy," in *Matthew Arnold: Culture and Anarchy and Other Writings*, ed. Stefan Collini (Cambridge: Cambridge University Press, 1993), 8.

Susanne Küchler

Material Translation and Its Challenges

Traditions arguably are sustained by the affinity of sets of materials selected for the manufacture of artworks with what Georg Simmel has coined the "art of social forms."[1] The difference made by such a relational clustering of materials to ways of being and thinking unfolding in their vicinity has emerged as a popular idea that is uniting disciplines in the "underground" of material culture studies. Archaeologists, for example, have pointed to the importance of mud to the development of pottery, to the domestication of plants and animals, and to the formation of settled societies,[2] while anthropologists, art historians, and architectural historians have begun to examine the selective take-up of materials in the making of social worlds and the creation of civilizations.[3] From an overt concern with the social forms of art, a powerful, but by no means new, question has emerged, enthralling social and historical sciences alike, directed at the nature of empathy with a shared manifold of ideas, attitudes, and vocabulary that is carried within bundles of materials.[4] Cultures of materials, we no longer dare to deny, are good to think with when it comes to understanding how societies recognize one another and remember themselves.[5]

Following David Pye, materials are widely assumed to act as a constraint on technical processes and social imagination.[6] Preoccupied with overcoming such constraints, we rarely entertain the prospect that the seizing of a material is never random but follows a logic that never targets one material in isolation, instead proceeding relationally via the perception of *bundles* of materials,[7] whether they are at hand or not. This logic shapes not just the selection and take-up of materials but also the relative mobility of materials and their substitution by other materials over time—raising interesting questions about the boundaries of cultures of materials and their civilizational importance. Material translation, the process by which materials are substituted for one another, brings to the fore the power of relational thought at work in materials selection.

Materials are a foothold for thought, tangible threads along which thought can extend itself, and can be held as memory in much the same way as gestures and numbers. We know that materials have their own measure, their characteristic weight, malleability, durability, transformational capacity, and elective affinity with other materials. When materials are substituted in manufacture, the action- and thought-oriented relational measure of the material becomes overt, as quantities are transformed into qualities and are made available to conscious elaboration.

Figure 110. *Tivaivai* in the Cook Islands 'on show' in competitive exhibition in Rarotonga (photograph by the author).

Material translation is most straightforwardly perceived when a new material is chosen to do the same job as an existing one. The technical term for this is *skeuomorphism*. In short, a skeuomorph is an artifact that is made from some new material that is taking on (inheriting) characteristics of the original material that the artifact was made in, even though these may no longer serve any function. The Wellington boot is the best example of material relations made visible through acts of translation, in that the seam at the back of the rubber boot makes visible the joining of the original leather. It is via the quite unnecessary seam at the back of the boot, rather than its own material, shape, or function, that the Wellington boot "works" as an affect-laden actor among our footwear—one that we tend to keep, even if old and battered.

It is, however, not the material and the bundle of relations it may conjure up that alone entices a kind of imaginative and intuitive recognition by recalling what has been rendered absent, but the actions on the material that the material itself calls forth. In the take up of colored and woven cloth across the islands of Oceania in the late nineteenth century, the ripping and conjoining of fibrous materials came to translate gestures of the body, while gestures of the mind were made visible in indexical patterns that translate the logic of an algebraic system, such as a noncommutative or quaternion group. The material translation of fibrous bark into woven cloth, however, also brought with it ways of inhabiting this

301

material technology. New modes of deportment, new relational actions—washing, drying, and flattening—began to inform new intersubjective relations, new networks of exchange, and new cosmologies of divestment that are recognized and shared across island societies. At the same time, distinctions in local practice began to separate peoples more profoundly than spatial distance could ever achieve.[8]

Pre-colored, woven cloth began to be harnessed for purposes of material translation when the figurative representation of the connection between two concepts, the visible and the invisible, first came under threat in Polynesia with the arrival of Christianity. Patch and piece-works known as *tifaifai/tivaivai* are today the iconic markers of identity across the islands of Hawaii, Tahiti, and the Cook Islands (Fig. 110). The pattern created from the cutting and resewing of cloth gift, or *taunga*—a must-have at every wedding, birthday, and funeral and the main gauge of community relations—extends the mind of the maker tangibly to all those through whose hands it passes, creating huge networks in its wake. However, if we look at *tivaivai* as a tradition that connects persons to one another via the act of exchange, we have just half the story. The power to connect in fact lies in the associative force of this rather nonfunctional piecework—made from material you cannot wash and using a mode of assemblage of time-consuming effort, always done by hand and involving careful calculation.

The patch and piecework calls up beneath its folds actions and calculations associated with a complex genealogical system whose relational logic is made manifest in the numerical sequence and arrangement of colored patches on the surface of the coverlet. The ethnography of making and exchanging coverlets would not by itself yield an understanding of the articulations involved in assembling cut cloth. To decode the logic of the biographical relations distinguishing Hawaii from Tahiti, and both from the Cook Islands, and the mapping of these relations into the cloth, we have to combine ethnography with an analysis of inter-artifactual relations that tracks both the visible relations between artifacts made of a single bundle of materials and the inferred indexes, indexes that are absent visually yet nonetheless recalled. In the case of the Cook Island *tivaivai,* the clue to understanding that the patterns of piecework are not merely metaphoric but actual maps of biographical relations can be found in the "outer" elements. In figurative pre-Christian assemblages, for example, the numbered sequence of knotted feather holders forms an algebraic sequence informed by "inner" assemblages. In the replications and iterations of motivic pattern on the surface of a coverlet, these "inner" assemblages are made visible through material translation. The study of material relations and translations visible in the piecework coverlet demands an extension of research to complex areas in mathematics. Research is thereby rewarded with hypothetical concepts and big questions that can drive the emergence of new research in turn. Cultures of materials, the *tivaivai* teaches us, are composed not just of what is used and consumed but also of what may be merely remembered. The material traces of the *tivaivai* reveal the actions of the body and the relational actions of the mind.

Notes

1 Georg Simmel, *Rembrandt: An Essay in the Philosophy of Art* (Leipzig: Wolff, 1916).

2 M. Stevanovic, "The Age of Clay: The Social Dynamics of House Destruction," *Journal of Anthropological Anthropology* 16 (1997): 334–95; David Wengrow, *What Makes Civilisations: The Ancient Near East and the Future of the West* (Oxford: Oxford University Press, 2010); and Nicole Boivin, *Material Cultures, Material Minds: The Impact of Things on Human Society and Evolution* (Cambridge: Cambridge University Press, 2010).

3 Tim Ingold, *The Perception of the Environment: Essays on Livelihood, Dwelling and Skill* (London: Routledge, 2000); Monika Wagner, *Das Material der Kunst: Eine andere Geschichte der Moderne* (Munich: C. H. Beck, 2001); and Adrian Forty, *Concrete and Culture: A Material History* (London: Reaktion Books, 2012).

4 B. Latour, "On Technical Mediation," *Common Knowledge* 3, no. 2 (1994): 29–64; and K. Barad, "Posthumanist Performativity: Towards an Understanding of How Matter Comes to Matter," *Signs: Journal of Women in Culture and Society* 28, no. 3 (2003): 801–31.

5 Londa Schiebinger and Claudia Swan, eds., *Colonial Botany: Science, Commerce, and Politics in the Early Modern World* (Philadelphia: University of Pennsylvania Press, 2005); Pamela H. Smith and Paula Findlen, eds., *Merchants and Marvels: Commerce, Science, and Art in Early Modern Europe* (New York: Routledge, 2002); and Ursula Klein and E. C. Spary, *Materials and Expertise in Early Modern Europe: Between Market and Laboratory* (Chicago: University of Chicago Press, 2009).

6 David Pye, *The Nature and Art of Workmanship* (Cambridge: Cambridge University Press, 1968).

7 Webb Keane, "Signs Are Not the Garb of Meaning: On the Social Analysis of Material Things," in *Materiality*, ed. Daniel Miller (Durham: Duke University Press, 2005), 182–206.

8 Susanne Küchler and Andrea Eimke, *Tivaivai: The Social Fabric of the Cook Islands* (London: British Museum; Wellington: Re Papa Press, 2009).

Maria Loh

Tradition Is an Exquisite Corpse

How does one begin to write about "tradition" if not with a quote?

> In an old house in Paris that was covered with vines…

Here is where the majority of those who were children, who have children, or who have ever watched over small children in the United States will know that the next lines can only unfold as such:

> …lived twelve little girls in two straight lines.
> In two straight lines they broke their bread
> And brushed their teeth and went to bed.
> They smiled at the good and frowned at the bad,
> Sometimes they were very sad.
> They left the house at half past nine
> In two straight lines in rain or shine—
> The smallest one was Madeline.[1]

This is the opening of Ludwig Bemelmans's story of *Madeline*; this is the very stuff of tradition—the things that impress themselves on our tender young memories. Long after we have all grown up and become serious art historians, the words "In an old house in Paris" will still evoke a distant time when those words (and words from other storybooks, like Margaret Wise Brown's *Goodnight Moon* or Dr. Seuss's *Green Eggs and Ham*) represented the small sum of our cultural knowledge about the large world beyond ourselves.

Connoisseurs might direct the reader's attention to Bemelmans's beloved *Central Park* paintings, which still grace the walls of the bar that bears the artist's name in the Carlyle Hotel in New York City. Biographers might note that Bemelmans was the child of Belgian and German parents and made his way in the United States after World War I. Wikipedia can even detail the site of his burial plot in Arlington National Cemetery: section 43, grave 2618. But all of this is, in a sense, beside the point. Tradition is not founded on data, but on the spectral presence of the past that suddenly erupts, often when we least expect it to, in our everyday lives. Tradition (like children) thrives when we lavish attention on it. Sometimes tradition can be unruly, obstinate, and resistant, but (again as with children) it is our duty

304

Figure 111. Alone with a drawing by Bartolomeo Passerotti in the Département des Arts Graphiques, Musée du Louvre, Paris, Thursday, December 22, 2011 (photograph by the author).

to embrace it all the same and try to help it find its way in a world that is of our making. Occasionally, too, it teaches us something extraordinary about that world.

A few days shy of Christmas some years ago, I found myself at 54, Rue du Château, standing before what I expected to be an old house in Paris (just like in the books of my childhood). Let me retrace my steps: earlier that morning, in the deserted study room of the Musée du Louvre, I had visited a bizarre drawing by Bartolomeo Passerroti of a dissection scene supervised by a group of identifiable Renaissance art stars (Fig. 111). In the center, Michelangelo converses with Sebastiano del Piombo while Raphael lectures a group of attentive artists, and Titian lurks in the background, like a grumpy adolescent, with another gang.[2]

Here and now, I am thinking of the beginning of Roland Barthes's *Camera Lucida*, where he is looking at a photograph of Napoléon's brother and is struck in that instance: "I am looking at eyes that looked at the emperor."[3] For Barthes, the "that-has-been" ("ça-a-été") was specific to photography, but for the historian, "ça-a-été" haunts all objects. Then and there—Thursday, December 22, 2011—I was holding a sheet of paper once held by Passerotti, an all-but-forgotten specter who was the founder of one of the first informal art schools in Bologna and the teacher of the Carracci. As in the atemporal space of a *sacra conversazione*, artists of different generations gather together in his sketch for what might be described figuratively as an early modern "exquisite corpse."[4]

By the time Passerotti made the drawing, in the late sixteenth century, most of the men portrayed in the gathering were themselves already gone. The melancholic encounter with such an illustrious pantheon of ghosts left me feeling bereft; like a Proustian cliché, I began to wander the streets of the fourteenth arrondissement in search of Marcel Duhamel's house at 54, rue du Château, where the Surrealists were said to have gathered to compose

Figure 112. 54, Rue du Château, Paris, Thursday, December 22, 2011 (photograph by the author).

the mythical *cadavre exquis*, or exquisite corpse. By all accounts, Duhamel's residence was a haven for young artists in his circle. In the interwar years, he worked as a hotel manager and generously paid the rent that kept his creative (but largely unemployed) friends off the streets. But on that chilly late December afternoon, standing at the top of this historic site just off the roundabout at the Place de Catalogne beyond Montparnasse Cemetery, I was confronted instead by a banal building dressed up in cookie-cutter ornaments (as if a modern block had arrived at an architectural costume party in Renaissance gear). No house, no vines; it hardly even looked like Paris. In this amnesic *lieu de mémoire*, I—the belated time traveler—was mysteriously greeted instead by a sign that bore my name and yet was not my name: Pizzeria via Maria (Fig. 112).

They smiled at the good and frowned at the bad, sometimes they were very sad…

Loss. Disappointment. Frustration. Surprise. Enchantment. This is the historian's affective journey. Some part of me—the ghost in me—couldn't help but laugh. The Surrealists would undoubtedly have relished the fateful desecration of their residence by these large yellow and green letters that pronounced a foreign name floating above a kidney-colored canopy, and this play of chance somewhat fortuitously brought me—the foiled historian—in a second unscripted move, back to the Louvre just on the other side of the River Seine where in a locked cabinet Passerotti's drawing was preserved.

Reflecting back on the *Anatomy Lesson*: the intimacy and creative collectivity that must have animated those exhilarating nocturnal meetings in Duhamel's drawing room in the mid-1920s suddenly endowed on Passerotti's image a new sense of sympathetic attachment

Figure 113. *"But the biggest surprise by far—on her stomach was a scar!"* from Ludwig Bemelmans, *Madeline*, New York: Simon and Schuster, 1939 (photograph by Gabriel Loh).

that allowed both traditions to vibrate more intensely in each other's presence. By the time the Surrealists were mounting their revolution, the hopeful dream of the early modern art academies (forged by men like Passerotti) had become obscured by centuries of institutional interference, and the utopian *corpus academicus* as portrayed in the Louvre drawing had faded into a history of which the young men at 54, Rue du Château had long since lost sight.

And yet, despite the cultural, economic, political, and philosophical specificities that would sequester them in their respective historical moments, both traditions were bound by the same dream of artistic fraternity and collective creativity:

> In two straight lines they broke their bread
> And brushed their teeth and went to bed.

Two straight lines might not necessarily converge, but occasionally there is one, often the smallest one, who unexpectedly rises up and scrambles the order, producing new configurations and sympathies hitherto unseen (Fig. 113). Moreover, a continuous line does not have to be unidirectional like the linearity of a master narrative. Sometimes a line, even a straight one, crosses back and over upon itself, accumulating in dense ink blots, skipping across the surface, or retracing its own steps; risk and time are always a factor.[5]

Like Duhamel's house, which is lost to us today, this *punctum caecum* gets to the heart of the historian's task: we must strive to see the ghosts of the past in the forms of the present, and vice versa, to comprehend the aspiration of the Surrealist revolution as shadows of a reform or as lines in a continuous drawing—an exquisite corpse—begun centuries ago by someone like Passerotti.[6]

Tradition is an exquisite haunting. The time of ghosts is always out of joint, just as the past and the future are always already the haunted present tense of tradition.[7] "In an old house in Paris that was covered with vines" a man who is now a phantom once divined: "The future belongs to ghosts! […] long live ghosts!"[8] To be sure, tradition is born from the sympathetic attachments that we keep for the specters of our own distant childhoods, ghosts that we nourish and that nurture us in return. Tradition is an exquisite corpse.

Notes

1 Ludwig Bemelans, *Madeline* (New York: Simon and Schuster, 1939).

2 For an identification of the figures, see Kristina Herrman Fiore, "Un dipinto inventato da Federico Zuccari: *La lezione di anatomia degli artisti*," *Federico Zuccari. La Pietà degli Angeli, il prototipo riscoperto del fratello Taddeo e un'Anatomia degli artisti*, ed. Claudio Strinati (Rome: Miligraf, 2001), 63–84.

3 Roland Barthes, *Camera Lucida: Reflections on Photography*, trans. Richard Howard (New York: Hill and Wang, 1982), 3.

4 André Breton and Paul Éluard give the following definition of the "Jeu du cadavre exquis" (trans. Keith Aspley, *Historical Dictionary of Surrealism* [Lanham: Scarecrow Press, 2010], 267): "Game with folded paper that involves the composition of a sentence or a drawing by several people in which none of them can take account of the previous collaboration or collaborations."

5 Tim Ingold, *Lines: A Brief Story* (London: Routledge, 2007), 162.

6 On the role of the historian as ghost hunter, see Alexander Nemerov, "Seeing Ghosts: *The Turn of the Screw* and Art History," in *What Is Research in the Visual Arts?: Obsession, Archive, Encounter*, eds. Michael Ann Holly and Marquard Smith (Williamstown, MA: Sterling and Francine Clark Art Institute, 2008), 13–32.

7 On the anachronism of ghosts, see especially Peter Buse and Andrew Stott, "Introduction: A Future for Haunting," in *Ghosts: Deconstruction, Psychoanalysis, History* (London: Palgrave Macmillian, 1999), 1–20.

8 Jacques Derrida, *Ghost Dance*, directed by Ken McMullen, 1983.

Ruth B. Phillips

Recovering (from) Tradition: Jeffrey Thomas, Kent Monkman, and the Modern "Indian" Imaginary

Until the 1980s, the authenticity of Native North American art was defined according to a construct of the traditional as premodern and immutable. Modernist primitivism was tradition's other face, enforcing adherence to certain media, styles, and modes of production.[1] Johannes Fabian termed the imaginary time associated with representations of Indigenous peoples the "ethnographic present," and his 1983 identification of the "allochronism" and "denial of coevalness" produced by modernist anthropological discourse provided analytical clarity for a postcolonial project of deconstruction.[2] Since the mid-1980s, this project has proceeded in two registers, one a scholarly and reflexive critique of anthropological and art historical discourses, and the other a critical reimaging pursued by Native North American artists.

In a 1986 essay, J. C. H. King succinctly summarized the circularity of modern attempts to distinguish the traditional and the nontraditional in Native American art:

> The concept of the "nontraditional" [...] reflects stereotyped ideas about Indians and expectations of art appropriate to noble savages untainted by Western society, which in turn altered (if it did not devastate) their ideal products. This judgment is, in the end, of no use since it is based on unworkable ideal types of what Indians should be in order to be traditional [which] depend on the imposition of Western standards on Indian art.[3]

He showed how patterns of collecting had resulted in a lack of basic documentation needed to attribute works of art to times, places, and individual artists. Scholarly work is beginning to restore some of this information, and we now understand more about the ways that Native American artists have negotiated received traditions and the larger processes of change, hybridization, and reinvention that Indigenous arts, like all art traditions, have undergone.

In tandem, contemporary Native American artists have been grappling with the pervasive stereotypes inscribed by representations of American Indians in Western art and popular culture. These images have worked together with past collecting practices to fix the Indian in a frozen past, cut off from modern, urban worlds and their institutions—including art schools and museums. Onondaga photographer Jeffrey Thomas's series A Conversation with Edward Curtis and Cree artist Kent Monkman's repaintings of the nineteenth-century corpus of artists such as George Catlin, Charles Russell, Frederic Remington, and others exemplify the critical engagement of Native American artists with this tradition.

Bear Portrait, 1984, Toronto, Ontario

Figure 114. Jeffrey Thomas, *Culture Revolution*, 1984, pigment print on archival paper, 17 × 22 in. (43.2 × 55.9 cm). Collection of the artist (artwork © Jeffrey Thomas).

Curtis intended the photographs that fill the twenty volumes of *The North American Indian* (1907–30) to "form a comprehensive and permanent record of all the important tribes of the United States and Alaska that still retain to a considerable degree their primitive customs and traditions."[4] He produced his intensely romantic images by staging reenactments of traditional life and carefully excising any indication that his subjects inhabited a modern world. Thomas recalls the beginning of his engagement with Curtis in 1984 during a walk through downtown Toronto with his young son Bear:

> I noticed a brick wall spray painted with the words "Culture Revolution." I stopped at the wall to photograph, but decided instead to have Bear pose next to the graffito so that he could have a memento of our day. Once I developed the print in my darkroom […] the unexpected convergence of visual elements changed my view of the urban landscape […]. Bear was wearing a baseball cap with an image of an Indian man by the name of Two Moons made by Edward S. Curtis in 1910. Two Moons was a respected Cheyenne

310

Plate 724 Sense of Self

. . .those who cannot withstand these trying days of the metamorphosis must succumb, and on the other side of the depressing period will emerge the few sturdy survivors. Edward S. Curtis

Figure 115. Jeffrey Thomas, *Sense of Self*, 2009, from *Rebinding the North American Indian, Volume 21*, pigment print on archival paper, 45 × 36 in. (114.3 × 91.4 cm). Collection of the artist (artwork © Jeffrey Thomas).

leader and a participant in the infamous battle of The Little Big Horn in 1876. Together the image of Two Moons with the words culture revolution, made me realize that if I was going to make the invisible urban-Indian visible, I had to take on the role of an interventionist.[5]

The photograph (Fig. 114) launched Thomas's series A Conversation with Edward Curtis, realized through juxtapositions of Curtis's images and his own. In 2005, this conversation entered a new register with a second series, Rebinding the North American Indian, in which Thomas continues the series where Curtis had left it off, by adding his own paired images as new, consecutively numbered plates. Plate 724, for example, shows us Two Moons next to a teenage Bear in an urban-industrial setting (Fig. 115).

Rather than a deconstructive dismantling, Thomas's diptychs reveal the complex cross-cultural resonances of a now shared body of mass-circulated images. Such pairings imply a measure of acceptance, a recognition that Curtis's images have penetrated too deeply to be merely dismissed. The psychic toll exacted by the stereotype is redeemed in part by Thomas's recognition of the indexicality of Curtis's images, which he sees as traces—often unique and therefore precious—of ancestral lives. His juxtapositions initiate a mutual interrogation, each acknowledging the entangled elements of truth and fiction present in each of the images.

Monkman came to art world attention during the 1990s with a series of meticulously executed repaintings of the romantic nineteenth-century depictions of Indian life that are the beaux arts equivalents of Curtis's photographs. His key strategy of subversion is a homoerotic inversion of the messages of white male dominance these paintings convey. White men appear in the positions usually occupied by Indians; eroticized, seduced and objectified, they become disempowered, passive, and mesmerized. More recently, Monkman has extended his strategy of inversion to the full span of canonical Western art. His 2012 series Modern Love is perhaps his most comprehensive engagement yet.[6] In each of the giclée prints, an artist, represented as Umberto Boccioni's sculpture *Unique Forms of Continuity in Space*, sits at an easel, painting a modernist work while the male Indian model from whom he works reclines in the pose of the Barberini Faun. In each of the twenty-five images in the series, Monkman varies the model's state of dress and nudity (Roman armor, fringed hide leggings), the painting style of the image on the canvas (Joan Miró, Pablo Picasso, Mark Rothko), the objects displayed in the room (Northwest Coast masks, classical weapons, animal skulls). As in his other repaintings, Monkman takes control of the art historical narrative through tricksterish transformations that manifest the magic powers of Indigenous "tradition"—and the equally magic powers of artists.

Thomas's and Monkman's work exorcize the paralyzing force exerted by tradition when defined from the outside at the same time that they affirm the shared frames of reference of our increasingly global art world. For Dipesh Chakrabarty, this decolonizing and globalizing shift requires that we "provincialize 'Europe.'" We must "see the modern as inevitably contested" and "write over the given and privileged narratives of citizenship other narratives of human connections that draw sustenance from dreamt-up pasts and futures where collectivities are defined neither by the rituals of citizenship nor by the nightmare of 'tradition' that 'modernity' creates."[7] Yet, at the same time, the recovery of traditions suppressed by assimilationist colonial policies is a priority for Indigenous Americans. Mark Salber Phillips's argument about the malleability of tradition helps to resolve this contradiction. He makes an important distinction between a reactionary *traditionalism* and a more liberal view of traditions as continuities of engagement that "can be constituted or reconstituted on the basis of acts of rupture as well as of renewal."[8] Such a view releases us from the circularity identified by King and acknowledges—as do Thomas and Monkman—that all traditions are hybrid (Fig. 116).

Figure 116. Kent Monkman, *Modern Love #6*, detail, 2012, archival giclée print on canvas with hand-painted acrylic, 19 × 22 in. (48.3 × 55.9 cm) Private collection (artwork © Kent Monkman).

Notes

1 Robert Goldwater wrote in 1938: "since tradition matters primarily for its contrastive value, it is always modernity, not traditionality, that requires specific analysis" (*Primitivism in Modern Art* [New York: Vintage Books, 1967], 17). Susan Stanford Friedman has reiterated the same point: "Modernity and tradition are relational concepts that modernity produces to cut itself off from the past, to distinguish the 'now' from the 'then.' Modernity invents tradition, suppresses its own continuities with the past, and often produces nostalgia for what has been seemingly lost" ("Periodizing Modernism: Postcolonial Modernities and the Space/Time Borders of Modernist Studies," *Modernism/Modernity* 13, no. 3 [September 2006], 434). See also important discussions of primitivism in Frances Connolly, *The Sleep of Reason: Primitivism in Modern European Art and Aesthetics* (University Park: Pennsylvania State University Press, 1999); Mariana Torgovnik, *Gone Primitive: Savage Intellects, Modern Lives* (Chicago:

University of Chicago Press, 1989); Sally Price, *Primitive Art in Civilized Places* (Chicago: University of Chicago Press, 1990); Hal Foster, "The 'Primitive' Unconscious of Modern Art, or White Skin Black Masks," in *Recodings: Art, Spectacle, Cultural Politics* (Seattle: Bay Press, 1985); Susan Hiller, ed., *The Myth of Primitivism: Perspectives on Art* (New York: Routledge, 1991); and Elazar Barkan and Ronald Bush, eds., *Prehistories of the Future: The Primitivist Project and the Culture of Modernism* (Stanford: Stanford University Press, 1995).

2 Johannes Fabian, *Time and the Other: How Anthropology Makes Its Object* (New York: Columbia University Press, 1983).

3 J. C. H. King, "Tradition in Native American Art," in *The Arts of the North American Indian: Native Traditions in Evolution*, ed. Edward L. Wade (New York: Hudson Hills Press, 1986), 78.

4 Edward S. Curtis, "General Introduction," in *The North American Indian*, vol. 1 (Cambridge, MA: University Press, 1907), xiii.

5 Jeff Thomas, "Seize the Space: Buffalo Boy," *BlackFlash Magazine*, November 2012, http://www.blackflash.ca/jeffthomas-2 (accessed March 10, 2013).

6 The series consists of twenty-five giclée prints with hand-painted details.

7 Dipesh Chakrabarty, "Provincializing Europe: Postcoloniality and the Critique of History," *Cultural Studies* 6, no. 3 (1992): 353–54.

8 Mark Salber Phillips, "What Is Tradition When It Is Not 'Invented'?: A Historiographical Introduction," in *Questions of Tradition*, eds. Phillips and Gordon Schochet (Toronto: University of Toronto Press, 2004), 7.

Regine Prange

The Tradition of the New: Alois Riegl's Late Antiquity

Even if an artwork breaks with tradition, it acquires its value by successfully following and modifying an accepted tradition of art production. In the Renaissance, the reference to classical antiquity legitimated the modern idea of the artist as an autonomous, creative subject, while the perceived ideal of classical sculpture demonstrated the necessity of breaking with the formula of Byzantine art. Classicism recommended the imitation of antique sculpture and architecture over the empirical study of nature. In this way, it maintained a metaphysical synthesis of individuality and divine authority, underpinned by a concept of universal truth. Mediated by the fine arts, this concept of universal truth was not abandoned but transformed in the nineteenth and twentieth centuries. Promoted by the feudal lords and representing their sovereignty, classicism was gradually appropriated and revised by a newly established academic practice located in universities and museums, themselves institutions of the liberal civic state. German authors, such as the philosopher Friedrich Wilhelm Joseph von Schelling, the art historian Karl Friedrich von Rumohr, and the architect Gottfried Semper, contributed considerably to this transformative process. In effect, an anthropological and psychological "translation" of normative classicist ideals was effected to fit industrial societies and their democratic structures. Absolute harmony could no longer be derived from handcrafted imitation, since machines increasingly created the handcrafted. Instead, and more than ever before, absolute harmony had to be explained by inner, unconscious forces of genius. The classical idea of form was consequently replaced by an ideal perception. What Ernst Gombrich termed "the preference for the primitive"[1] accompanied the epistemological shift from *natura naturata,* the static nucleus of classicist art theory, to *natura naturans,* which conceived of the artist's activity as a process of perception *and* production.

The scholarly focus of the Viennese art historian Alois Riegl on late antiquity grew out of this context. It followed the Romantic reevaluation of the Middle Ages and it widely agreed with Semper's and Adolf von Hildebrand's anthropological definition of art production, which viewed the making of art in relation to natural laws of perception and to social and aesthetic needs. Riegl's rehabilitation of late antiquity (which had been languishing as a period of "degeneration") was motivated by his idea of the evolutionary process of the *Kunstwollen,* the form- and style-producing artistic will, which moved from a primitive tactile mode of perception to an advanced, premodern, "optical" mode in which spatial values were experienced only by the mind. In his book of 1901, *Late Roman Art Industry* (*Spätrömische Kunstindustrie*), Riegl analyzed the main features of the art and art industry of

Figure 117. *Justinian's Court*, ca. 547 CE, mosaic, Church of San Vitale, Ravenna, north wall of the apse (artwork in the public domain; photograph © Photo SCALA, Florence 2017).

late antiquity. Between the lines, he also described the characteristics of the art contemporary to his time, namely, Impressionism and Symbolism. To align past and present as Riegl implies, the tradition of the antique had to be suited to modern aesthetics. In other words, the tradition of the antique had to emerge from the dissolution of anthropocentric rules of perspective and narration.

In *Late Roman Art Industry,* Riegl examined nothing less than the modernist tension between illusionary space and material flatness. In order to solve this tension, he did not look at Roman reliefs, architecture, or ornament as such. Rather, he concentrated his attention on the way an artwork expresses a tactile or optical mode of seeing, and he considered the movement from one mode to the other as a historical schema. Riegl observed that antique art, corresponding to the tactile mode of seeing, was generally restricted to the plane and that it "strove for the representation of individual unifying shapes via a rhythmic composition on the plane."[2] Without questioning this restriction to the plane, he argued that the late

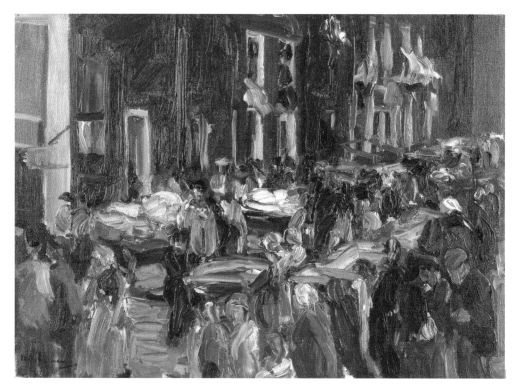

Figure 118. Max Liebermann, *Judengasse in Amsterdam,* 1905, oil on canvas, 15¾ × 21⅝in. (40 × 55 cm). Kunstmuseen Krefeld (artwork in the public domain; photograph © Kunstmuseen Krefeld).

Roman *Kunstwollen* generated an abstract quality of space. Form was related to and unified in space rather than the reverse. The intensified isolation of form in space led "the hitherto neutral shapeless ground" to be elevated "to an artistic one, that is, to an individual unity of a finished powerful shape."[3] Not surprisingly, the climax of the late antique *Kunstwollen* is the "emancipation of the interval, ground, and space."[4] According to Riegl, figures represented directly facing the spectator, as in the famous mosaics at Ravenna (Fig. 117), have separated from the plane in order to become spatialized.

Riegl's anachronism held true until Abstract Expressionism and Post-painterly Abstraction. Both these styles are considered the outcome of a continuous modern tradition, beginning with Impressionism (Fig. 118). Riegl had discovered the antique origins of Impressionism *and* Symbolism in the linear and coloristic rhythm of Roman art. Jackson Pollock's linear and coloristic painting *Autumn Rhythm* (Fig. 119) appears to conform still to Riegl's description. Pollock's promoter Clement Greenberg employed Riegl's term "opticality" to characterize an evolutionary model of art history, with the goal of the autonomy of art. Instead of representing reality, Greenberg argued, painting should

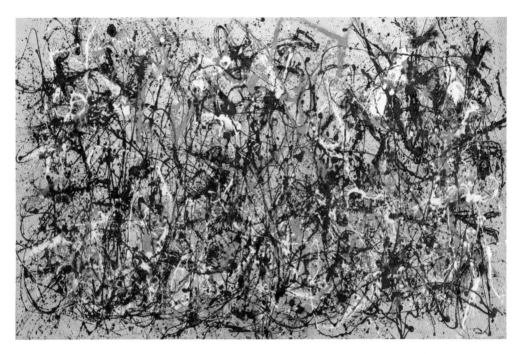

Figure 119. Jackson Pollock, *Autumn Rhythm, Number 30,* 1950, enamel on canvas, 105 × 207 in. (266.7 × 525.8 cm). Metropolitan Museum of Art, New York, George A. Hearn Fund, 1957, 57.92 (artwork © Pollock-Krasner Foundation/ VG Bild-Kunst, Bonn 2017).

represent its own essential quality—flatness. In terms still appropriate to Riegl's definition of the protomodernist features of the art of late antiquity, Greenberg claimed that spatial expression is nevertheless obligatory: "The flatness towards which Modernist painting orients itself can never be an absolute flatness. The heightened sensitivity of the picture plane may no longer permit sculptural illusion, or *trompe-l'oeil,* but it does and must permit optical illusion. The first mark made on a canvas destroys its literal and utter flatness."[5]

It is well known that Minimalism aimed at the complete negation of spatial illusion and that painting was finally abandoned in favor of the object. The arrival of pop art seemed to make clear, moreover, that Greenberg's Rieglian construction was a false one. Greenberg's formalistic approach, culminating in an antisculptural, nonperspectival space, could not explain the new, literalist attitudes of pop art. Yet, Riegl's message (one might call this the ideological function of his historiography) is still valid and legible: Riegl's interpretation of the late Roman art industry as a tradition of the modern *autonomy* of line and color— an autonomy beyond figuration—was the first step in the generalized appropriation of all styles and the leveling of high and low that characterize postmodern strategies of art production. Claiming the "leveling of ground and the individual shapes," Riegl's optical impulse foregrounds the depthlessness that Frederic Jameson pronounces the cultural logic of late capitalism, namely, its ability to abolish the hermeneutic model of depth and the idea

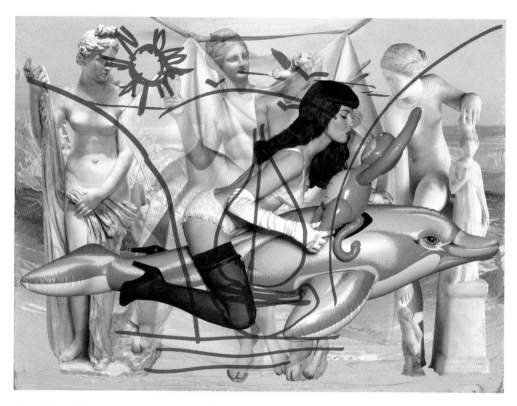

Figure 120. Jeff Koons, *Antiquity 3,* 2009–11, oil on canvas, 102 × 138 in. (259.1 × 350.5 cm). Private collection (artwork © Jeff Koons; photograph provided by Gagosian Gallery).

of the "subject as a monadlike container."[6] Today, the gesture of anachronism has become a rhetorical means of citation in art itself. Its master, Jeff Koons, employs the models of classicism again in his work *Antiquity 3* (Fig. 120)—this time, as part of a collage painting whose hypermediated surfaces imitate the technologies of digitization.[7] By combining three sculptures of Venus on a flat "expressionist" painting with erotic and childhood figures and toys—a woman (Gretchen Mol) posing with an inflatable pool dolphin and an inflatable monkey—Koons presents the ambition of the art historian's magisterial gaze. Its truth is evident. The absence of history's depth generates the pleasures of opticality. But there exists no pleasure, for there is no ground on which to create, or to believe in, an aesthetic totality.

Notes

1 E. H. Gombrich, *The Preference for the Primitive: Episodes in the History of Western Taste and Art* (New York: Phaidon, 2002).

2 Alois Riegl, *Late Roman Art Industry,* trans. Rolf Winkes (Rome: Bretschneider, 1985), 223.

3 Ibid., 224.

4 Ibid., 229.

5 Clement Greenberg, "Modernist Painting" (1960), in Clement *Greenberg: The Collected Essays and Criticism,* ed. John O'Brian, vol. 4, *Modernism with a Vengeance: 1957–1969* (Chicago: University of Chicago Press, 1993), 85–93, at 90.

6 Riegl, *Late Roman Art Industry,* 224; and Frederic Jameson, *Postmodernism or the Cultural Logic of Late Capitalism* (Durham: Duke University Press, 1992), 15.

7 See *Jeff Koons: The Painter and the Sculptor,* exh. cat. (Ostfildern: Hatje Cantz, 2012), *The Painter,* 180; and Joachim Pissarro, "Jeff Koons's Antiquity Series," in ibid., 39–43.

Contributors

Kirk Ambrose is Professor and Chair of the Department of Art and Art History at the University of Colorado Boulder. He is the author of many books and articles on medieval art.

Jan Assmann (born 1938) was Professor of Egyptology at the University of Heidelberg from 1976 until 2003. In addition to ancient Egypt, his main interests are the origins of monotheism, the theory of cultural memory, and music.

Georg Baselitz, born in 1938 in Deutschbaselitz (Saxony, Germany), is an internationally renowned artist who is especially known for his upside down figure paintings. He lives and works at the Lake Ammersee (Bavaria), in Basel (Switzerland), in Imperia (the Italian Riviera), and in Salzburg (Austria).

J. M. Bernstein is University Distinguished Professor of Philosophy at the New School for Social Research. His publications include *The Fate of Art: Aesthetic Alienation from Kant to Derrida and Adorno* (Cambridge, 1992) and *Against Voluptuous Bodies: Late Modernism and the Idea of Painting* (Stanford, 2005).

Daniela Bohde is Professor and Chair of the Department of Art History at the University of Stuttgart. Her publications on art historiography and late medieval and early modern art include *Kunstgeschichte als physiognomische Wissenschaft: Kritik einer Denkfigur der 1920er bis 1940er Jahre* (Akademie Verlag, 2012) and *Haut, Fleisch und Farbe: Körperlichkeit und Materialität in den Gemälden Tizians* (Edition Imorde, 2002).

Giovanna Borradori is Professor of Philosophy at Vassar College. Her bestselling book *Philosophy in a Time of Terror: Dialogues with Jürgen Habermas and Jacques Derrida* (University of Chicago Press, 2004) has appeared in eighteen languages.

Marcia Brennan is Carolyn and Fred McManis Professor of Humanities, and Professor of Art History and Religious Studies at Rice University, and she is Artist in Residence in Palliative Care and Rehabilitation Medicine at the M. D. Anderson Cancer Center. In addition to many books in art history, she is the author of *Life at the End of Life: Finding Words Beyond Words* (Intellect, 2017).

John Brewer is Faculty Associate Harvard University History Department and Eli and Eyde Broad Emeritus Professor of Humanities and Social Sciences at California Institute of Technology. His most recent book is *The American Leonardo: A Tale of Obsession, Art and Money* (Oxford University Press, 2009).

Spike Bucklow is currently Director of Research at the Hamilton Kerr Institute, University of Cambridge. His research interests are artists' materials and methods and his publications include *The Alchemy of Paint* (Marion Boyars, 2009) and *The Riddle of the Image* (Reaktion, 2014).

Malcolm Bull is Professor of Art and History of Ideas at Oxford University. His books include *Inventing Falsehood, Making Truth: Vico and Neapolitan Painting* (Princeton University Press, 2013), and *The Mirror of the Gods: Classical Mythology in Renaissance Art* (Oxford University Press, 2005).

Caroline Walker Bynum is Professor Emerita at the Institute for Advanced Study and University Professor Emerita at Columbia University. Recent articles include "Avoiding the Tyranny of Morphology, Or, Why Compare?" *History of Religions* 53 (2014); "'Crowned with Many Crowns': Nuns and Their Statues in Late-Medieval Wienhausen," *The Catholic Historical Review* 101 (2015); and "Are Things Indifferent? How Objects Change Our Understanding of Religious History," *German History* 34 (2016).

Jay A. Clarke is Rothman Family Curator of Prints and Drawings at The Art Institute of Chicago.

Linda Connor, Professor at the San Francisco Art Institute since 1969 and founder of PhotoAlliance, received the Society of Photographic Education's Honoured Educator Award in 2005. Her photographs have been exhibited nationally and internationally and her book *Odyssey: The Photographs of Linda Connor* was published in 2008 (Chronicle Books).

Dexter Dalwood is Professor of Fine Art at Bath Spa University and the artist liaison trustee for the National Gallery, London and the Tate Gallery. He was short-listed as one of the four nominees for the Turner Prize, 2010, and is represented by Simon Lee Gallery, London.

Carolyn Dean is Professor of History of Art and Visual Culture at the University of California, Santa Cruz. Her research focuses on Inka (Inca) visual culture both before and after the Spanish colonization of the Andean region of South America with particular attention to the materiality of stone and aniconic visual expression across a variety of media.

Mary Ann Doane is Class of 1937 Professor of Film and Media at The University of California, Berkeley. She is the author of *The Emergence of Cinematic Time: Modernity,*

Contingency, the Archive (Harvard University Press, 2002), *Femmes Fatales: Feminism, Film Theory, Psychoanalysis* (Routledge, 1991), and *The Desire to Desire: The Woman's Film of the 1940s* (Palgrave Macmillan, 1987).

Natasha Eaton is Reader in History of Art at UCL and an editor of *Third Text*. Her publications on the cultural entanglements between Britain and South Asia include *Mimesis across Empires: Artworks and Networks in India* (Duke, 2013) and *Colour Art and Empire: The Nomadism of Representation* (I.B. Tauris, 2013).

Caroline van Eck, Professor in the History of Art at Cambridge University, delivered the Slade Lectures at Oxford University in 2017. Recent publications include *Art, Agency and Living Presence: From the Animated Image to the Excessive Object* (De Gruyter, 2015).

Elizabeth Edwards is a visual and historical anthropologist. She is Andrew W. Mellon Visiting Professor, Victoria and Albert Museum Research Institute (VARI), professor emerita of Photographic History, De Montfort University, Leicester, and honorary professor, Department of Anthropology, University College London.

Johannes Endres is Associate Professor of Comparative Literature and Art History at the University of California, Riverside. He works on German and European art and literature in an interdisciplinary perspective.

Darby English teaches art history and cultural studies at the University of Chicago.

Helen C. Evans is the Metropolitan Museum's Mary and Michael Jaharis Curator for Byzantine Art. There she installed the first Byzantine galleries in a major encyclopedic museum and curated *The Glory of Byzantium*, recognized by *Apollo* as a major exhibition of the year; *Byzantium: Faith and Power*, winner of the CAA's Barr Award; and *Byzantium and Islam*, awarded the World Book Award for the best new book in Islamic Studies by the Islamic Republic of Iran.

Eric Fischl is an internationally acclaimed American painter and sculptor, considered one of the most important figurative artists of the late twentieth and early twenty-first centuries. Fischl's paintings, sculptures, drawings, and prints have been the subject of numerous solo and major group exhibitions and his work is represented in many museums as well as prestigious private and corporate collections, including The Metropolitan Museum of Art, The Whitney Museum of American Art, The Museum of Modern Art in New York City, The Museum of Contemporary Art in Los Angeles, St. Louis Art Museum, Louisiana Museum of Art in Denmark, Musée Beaubourg in Paris, and The Paine Weber Collection.

Angus Fletcher (1930–2016) was one of the crucial scholars and literary theorists of his generation, a thinker of Coleridgean scope. His books include the ground-breaking *Allegory:*

The Theory of a Symbolic Mode (Princeton University Press, 1964), as well as *Colors of the Mind: Conjectures on Thinking in Literature* (Harvard University Press, 1991); *A New Theory for American Poetry: Democracy, the Environment, and the Future of the Imagination* (Harvard University Press, 2004); *Time, Space, and Motion in the Age of Shakespeare* (Harvard University Press, 2007); and *The Topological Imagination: Spheres, Edges, and Islands* (Harvard University Press, 2016).

Finbarr Barry Flood is Director of Silsila: Center for Material History and William R. Kenan, Jr., Professor of the Humanities at the Institute of Fine Arts and Department of Art History, New York University. He has published on the history and historiography of Islamic architecture, cross-cultural dimensions of Islamic art, image theory, technologies of representation, and Orientalism.

Sarah E. Fraser is Professor of Chinese Art History, Institute of East Asian Art History, University of Heidelberg. She is the author of *Performing the Visual: The Practice of Buddhist Wall Painting in China and Central Asia, 618–960* (Stanford University Press, 2004) and editor-in-chief of the Mellon International Dunhuang Archive (MIDA), ARTstor.

Ursula A. Frohne, Professor of 20th and 21st century Art History at the University of Münster, has been a visiting scholar at Brown University and Professor at the University of Bremen and the University of Cologne. Prior to joining academia, she curated several landmark exhibitions at the ZKM | Center for Art and Media in Karlsruhe.

Dario Gamboni is Professor of Art History at the University of Geneva. His numerous books and articles include *Potential Images: Ambiguity and Indeterminacy in Modern Art* (Reaktion, 2002) and *Paul Gauguin: The Mysterious Centre of Thought* (Reaktion, 2014).

Jane Garnett is Fellow and Tutor in History at Wadham College, Oxford. She has published and taught widely on the history of Christianity, visual culture, gender, and philosophy.

Peter Geimer is Professor of Art History at the Freie Universität, Berlin, and co-director of the Center of Advanced Study BildEvidenz, Geschichte und Ästhetik. His book *Inadvertent Images: A History of Photographic Apparitions* appeared in 2018 with University of Chicago Press.

Carlo Ginzburg taught at Bologna, at UCLA, at the Scuola Normale Superiore, Pisa; he has now retired. His books include *The Night Battles* (Johns Hopkins University Press, 2013); *The Cheese and the Worms* (Johns Hopkins University Press, 2013); *The Enigma of Piero* (Verso, 2002); *Clues, Myths, and the Historical Method* (Johns Hopkins University Press, 2013); *Wooden Eyes* (Verso, 2002); *History, Rhetoric, and Proof* (Brandeis University Press, 1999); and *Threads and Traces* (University of California Press, 2012).

Cordula Grewe, Associate Professor of Art History at Indiana University Bloomington, specializes in German art of the long nineteenth century, with particular emphasis on questions of visual piety, word–image relationships, and aesthetics.

Tapati Guha-Thakurta is Professor of Art History at the Centre for Studies in Social Sciences, Calcutta, India. She has published widely in the fields of art and nationalism, institutional practices, and the political locations of art history and archaeology, on the careers of monuments and museum objects, and popular urban visual culture in modern and contemporary India, including *In the Name of the Goddess: The Durga Pujas of Contemporary Kolkata* (Primus Books, 2015).

Thomas Habinek is Professor of Classics at the University of Southern California and editor of the forthcoming *Cultural History of Ideas in Antiquity* (Bloomsbury Academic Press). With art historian Hector Reyes, he is also at work on a synoptic account of the divergent physical theories employed in aesthetic discourse.

Hans Hayden is J.A. Berg Professor of Art History at Stockholm University. The main areas of his research are the historiography of art history, art and theory of the twentieth century, and theory of interpretation.

Daniel Heller-Roazen is the Arthur W. Marks '19 Professor of Comparative Literature and the Council of the Humanities at Princeton University. His most recent books are *No One's Ways: An Essay on Infinite Naming* (Zone Books, 2017) and *Dark Tongues: The Art of Rogues and Riddlers* (Zone Books, 2013).

Susan Hiller, an internationally acclaimed artist and writer, works in broad range of media. Her commitment to exploring "the unconscious" of our culture is often cited as a major influence on younger artists.

Michael Ann Holly is the Starr Director Emeritus of the Research and Academic Program at the Clark Art Institute, and she teaches in the graduate program at Williams College. She is the author of books and essays on the intellectual history of the history of art, with the most recent book being *The Melancholy Art* (Princeton, 2013).

Gregg M. Horowitz has been Professor of Philosophy at Pratt Institute. His publications include *Sustaining Loss: Art and Mournful Life* (Stanford University Press, 2001), "Absolute Bodies: The Video Puppets of Tony Oursler" (2010), and "A Made-to-Order Witness: Women's Knowledge in Vertigo," in *Vertigo: Philosophers on Film* (Routledge, 2013).

Tom Huhn, Chair of the Departments of Art History and Visual & Critical Studies at the School of Visual Arts, has published *Imitation and Society: The Persistence of Mimesis in the*

Aesthetics of Burke, Hogarth, and Kant (Pennsylvania State University Press, 2006); *The Semblance of Subjectivity: Essays in Adorno's Aesthetics* (MIT Press, 1999); and *The Cambridge Companion to Adorno* (Cambridge University Press, 2010).

Ludmilla Jordanova is Professor of History and Visual Culture at Durham University. Recent books are *The Look of the Past* (Cambridge University Press, 2012) and *Physicians and their Images* (Little, Brown, 2018).

Joan Kee is Associate Professor in the History of Art at the University of Michigan. She co-edited *To Scale*, an anthology of writing on scale and size in the visual arts for Wiley-Blackwell in 2016.

Michael Kelly is Professor of Philosophy, University of North Carolina at Charlotte; editor of the *Encyclopedia of Aesthetics* (Oxford UP, 2014, 2nd edition); author of *A Hunger for Aesthetics: Enacting the Demands of Art* (Columbia UP, 2012; paperback 2017); and founder and president of the Transdisciplinary Aesthetics Foundation, which sponsors an international "Questioning Aesthetics Symposium" series (https://transaestheticsfoundation.org/).

Robin Kelsey is Dean of Arts and Humanities and Shirley Carter Burden Professor of Photography at Harvard University. He is the author of the books *Photography and the Art of Chance* (Harvard University Press, 2015) and *Archive Style: Photographs and Illustrations for U.S. Surveys, 1850–1890* (University of California Press, 2007).

Elizabeth King is an artist who combines figurative sculpture with stop-frame animation. Her work reflects her interest in early clockwork automata, the history of the puppet, and literature's host of legends in which the artificial figure comes to life. She is professor emerita, Department of Sculpture and Extended Media, Virginia Commonwealth University, Richmond, Virginia, and is represented in New York by Danese/Corey Gallery.

Jeanette Kohl, Associate Professor of Art History at the University of California, Riverside, earned her PhD from the University of Trier/Germany in 2001. She has chaired the academic network *The Power of Faces* (Deutsche Forschungsgemeinschaft, 2006–09), was a fellow at *Morphomata* Center for Advanced Studies at the University of Cologne (2015), a Getty scholar (2014), a Postdoctoral Fellow at the Kunsthistorisches Institut in Florence (2001–04), and has published extensively on Renaissance sculpture, the history of portraiture and the human face, and questions of mimesis and representation in Italian Art.

Susanne Küchler, Professor of Anthropology and Material Culture at University College London, has conducted ethnographic fieldwork in Papua New Guinea and eastern Polynesia for twenty-five years. Her work focuses on social memory and material translation and on the epistemic nature of materials and their role in long-term social change.

Alisa LaGamma, Curator of African Art at the Metropolitan Museum of Art, has overseen since 1998 an ambitious program of exhibitions and publications, recognized for its outstanding scholarship in 2012 by the Bard Graduate Center. Her dissertation on the Punu Mukudj masquerade was based on fieldwork in southern Gabon.

Karen Lang will be the Slade Professor of Fine Art at the University of Oxford (2019-20), and previously Professor in the Department of History of Art at the University of Warwick. She has published on modern German art, contemporary art, aesthetic theory, and the intellectual history of the history of art; a monograph on the American artist Philip Guston is forthcoming (Reaktion, London).

Niklaus Largier teaches German and comparative literature at the University of California, Berkeley, where he holds the Sidney and Margaret Ancker Chair in the Humanities. He has published widely on Christian mysticism, ascetic practices, and the history of the emotions and the imagination.

Mark Ledbury is Power Professor of Art History and Director of the Power Institute at the University of Sydney. The author of studies including *Sedaine, Greuze, and the Boundaries of Genre* (Oxford, 2000) and *James Northcote History Painting and the Fables* (YCBA/Yale, 2014), his research explores histories of genre and theatre–art relationships in eighteenth-century Europe.

Maria H. Loh is Professor of Art History at CUNY Hunter College, and previously taught in the Department of History of Art at University College London. Her publications include *Titian Remade: Repetition and the Transformation of Early Modern Italian Art* (Getty, 2007), *Still Lives: Death, Desire, and the Portrait of the Old Master* (Princeton, 2015), and *Titian's Touch* (Reaktion, forthcoming).

Peter Mack FBA is Professor emeritus of English and Comparative Literature at the University of Warwick, from which he was seconded as Director of the Warburg Institute (2010–14). His books include *Reading and Rhetoric in Montaigne and Shakespeare* (Bloomsbury Academic, 2010), *A History of Renaissance Rhetoric 1380–1620* (Oxford University Press, 2011), and (edited with Robert Williams) *Michael Baxandall, Vision and the Work of Words* (Routledge, 2015).

Saloni Mathur is Professor of Art History at the University of California, Los Angeles. Her most recent book, *A Fragile Inheritance: Radical Stakes in Contemporary Indian Art,* is forthcoming with Duke University Press.

Ian McLean, Hugh Ramsay Chair of Australian Art History and Acting Head of Australian Indigenous Studies at the University of Melbourne, is the author of *Rattling Spears a History*

of Indigenous Australian Art (Reaktion, 2016); *Double Desire: Transculturation and Indige-nous Art* (Cambridge Scholars, 2014); *How Aborigines Invented the Idea of Contemporary Art* (Power, 2011); *White Aborigines Identity Politics in Australian Art* (Cambridge University Press, 2009); and *The Art of Gordon Bennett* (Craftsman House, 1996).

James Meyer is Curator of Art, 1945–74, at the National Gallery of Art in Washington, DC. He was previously Winship Distinguished Research Associate Professor of Art History at Emory University and Chief Curator and Deputy Director at Dia Art Foundation.

Miya Elise Mizuta Lippit, an independent scholar of Japanese art and literature teaching at the University of Southern California, is executive editor and managing director of the *Review of Japanese Culture and Society* (Josai University). Her book *Aesthetic Life: Beauty and Art in Modern Japan* (Forthcoming Harvard University Asia Center, 2019) studies the figure of the beautiful woman in the Meiji period.

Spyros Papapetros is Associate Professor of History and Theory at the School of Architec-ture and an associated faculty member of the Department of Art and Archaeology at Princ-eton University. He is the author of *On the Animation of the Inorganic: Art, Architecture, and the Extension of Life* (University of Chicago Press, 2012) and the co-editor of *Retracing the Expanded Field: Encounters between Art and Architecture* (MIT Press, 2014).

Ruth B. Phillips is Professor of Art History at the Institute for Comparative Studies in Art and Culture at Carleton University, Ottawa. A specialist in Native American art history, her most recent books are *Museum Pieces: Toward the Indigenization of Canadian Museums* (McGill-Queen's University Press, 2011) and the revised edition of the survey text *Native North American Art*, with Janet Catherine Berlo (Oxford University Press, 2014).

Alex Potts is Max Loehr Collegiate Professor at the University of Michigan. His books in-clude *Flesh and the Ideal: Winckelmann and the Origins of Art History* (Yale University Press, 1994), *The Sculptural Imagination* (Yale University Press, 2000), and *Experiments in Modern Realism: World Making, Politics and the Everyday in Postwar European and American Art* (Yale University Press, 2013).

Regine Prange is Professor of Art History at the Goethe University, Frankfurt am Main. Her areas of specialization include modern and contemporary art and art theories, history, and methodology of art history, painting and film aesthetics.

Joanna Roche is Professor of Art History at California State University Fullerton. She earned her PhD from UCLA in twentieth-century art history and contemporary theory. Areas of research include performance art, assemblage art, and the interrelation of memory

and artistic process. She is the author of numerous essays and reviews on contemporary art, as well as a book of poetry, *Tyrannical Angels* (Createspace Independent, 2011).

Martha Rosler is an internationally acclaimed artist who lives and works in Brooklyn, New York. Her work in photography, video, and installation has long focused on matters of the public sphere and landscapes of everyday life, especially as they affect women.

Gervase Rosser is Professor in the History of Art at Oxford University and fellow of St Catherine's College. His research and publications have focused on the social, visual, and religious culture of medieval and Renaissance cities.

Nina Rowe is Associate Professor of Art History at Fordham University, and she is working on a new book, *From Adam to Achilles to Alexander: Illuminated Weltchroniken and the Anecdotal Past in the Late Medieval City*. Previous publications include *The Jew, the Cathedral, and the Medieval City: Synagoga and Ecclesia in the Thirteenth Century* (Cambridge University Press, 2011); *Manuscript Illumination in the Modern Age: Recovery and Reconstruction* (co-authored with Sandra Hindman, Michael Camille, and Rowan Watson) (Oak Knoll, 2001); and an edited volume, *Medieval Art History Today: Critical Terms*, special issue of *Studies in Iconography* (2012).

Alain Schnapp is an archaeologist and historian. He is mainly interested in cultural history and history of archaeology.

Ajay Sinha teaches in the Art History and the Film Studies Programs at Mount Holyoke College. His publications on India include studies of modern and contemporary art, photography, ancient religious architecture, the book *Imagining Architects: Creativity in Indian Temple Architecture* (University of Delaware Press, 2000), and the co-edited book *Bollyworld: Popular Indian Cinema through a Transnational Lens* (SAGE, 2005).

Chris Spring is an exhibiting artist (www.chrisspring.co.uk). He has curated many exhibitions at the British Museum, including *La Bouche du Roi* (2007), *A South African Landscape* (2010), *Social Fabric: Textiles of Eastern and Southern Africa* (2013), and was co-curator of *South Africa, Art of a Nation* (2016), while his books include *African Arms and Armour* (1993)*, North African Textiles* (1995) with Julie Hudson, *Angaza Afrika: African Art Now* (2008) (Winner the ART BOOK AWARD for 2009), *African Art in Detail* (2009)*, African Textiles Today* (2012) (Winner: Choice [USA] award for outstanding academic title), *African Art Close Up* (2013) and *South Africa, Art of a Nation* (2016) with John Giblin.

Blake Stimson teaches at the University of Illinois, Chicago. He is the author, most recently, of *Citizen Warhol* (Reaction Books, 2014).

Gloria Sutton is Associate Professor of Contemporary Art History and New Media at Northeastern University. Her research focuses on the engagement of visual art with durational media and audience reception, as examined in her book *The Experience Machine: Stan VanDerBeek's "Movie-Drome" and Expanded Cinema Practices* (MIT Press, 2015), which is being translated into French.

Obiora Udechukwu is a Nigerian born artist and poet. He taught at the University of Nigeria, Nsukka for many years before moving to St. Lawrence University, Canton, NY, where he is Charles A. Dana Professor in the Department of Art and Art History.

Monika Wagner is Professor emerita of Art History at the University of Hamburg. Her publications on eighteenth- to twentieth-century art include a focus on the semantics of materials (*Das Material der Kunst. Eine andere Geschichte der Moderne*, Beck C. H., 2013).

Gerrit Walczak, PD Dr., Associate Professor of Art History at the Technische Universität Berlin, is author of a study on artists in Ancien Régime and Revolutionary Paris, *Bürgerkünstler: Künstler, Staat und Öffentlichkeit im Paris der Aufklärung und Revolution* (De Gruyter, 2015), and other writings on eighteenth-century art, public exhibitions, and artistic migration.

Oliver Watson worked at the Victoria and Albert Museum (1979–2003), in Doha, Qatar (2003–05), the Ashmolean Museum (2005–08), and as the director of the Museum of Islamic Art, Doha (2008–11). He was appointed the first I. M. Pei Professor of Islamic Art and Architecture at the University of Oxford in 2011, and retired in 2016.

Tristan Weddigen is Director of Bibliotheca Hertziana – Max Planck Institute for Art History, Rome, and Professor of Early Modern Art History at the University of Zurich. He has published on Italian art and art theory, the history of art history, and on the iconology of the textile medium.

David E. Wellbery is the LeRoy T. and Margaret Deffenbaugh Carlson University Professor at the University of Chicago. He is the author of numerous studies on German literature and thought.

Iain Boyd Whyte has been Professor of Architectural History at the University of Edinburgh, a fellow of the Alexander von Humboldt-Stiftung, a Getty scholar, and Samuel H. Kress Professor at the Center for Advanced Study in the Visual Arts at the National Gallery of Art, Washington, DC. The founding editor of *Art in Translation*, he has published extensively on architectural modernism in Germany, Austria, and the Netherlands, on twentieth-century German art, and on Anglo-German literary relations.

Short Bibliography

Anthropomorphism

Appadurai, Arjun, ed. *The Social Life of Things: Commodities in Cultural Perspective.* Cambridge: Cambridge University Press, 1986.

Barolsky, Paul. "The Spirit of Pygmalion." *Artibus et Historiae* 24, no. 48 (2003): 183–84.

Belting, Hans. *An Anthropology of Images: Picture, Medium, Body.* Translated by Thomas Dunlap. Princeton and Oxford: Oxford University Press, [2001] 2011.

Benjamin, Walter. "Unpacking My Library: A Talk about Collecting." Translated by Harry Zohn in *Walter Benjamin: Selected Writings,* vol. 2, edited by Michael Jennings, Howard Eiland, and Gary Smith, 486–93. Cambridge, MA and London: Harvard University Press, [1931] 1999.

Bernstein, J. M. *Against Voluptuous Bodies: Late Modernism and the Meaning of Painting.* Stanford: Stanford University Press, 2006.

Boyer, Pascal. "What Makes Anthropomorphism Natural: Intuitive Ontology and Cultural Representations." *Journal of the Royal Anthropological Institute* 2, no. 1 (1996): 83–97.

Bredekamp, Horst. *Theorie des Bildakts.* Frankfurt: Suhrkamp, 2010.

Carr, J. L. "Pygmalion and the Philosophes: The Animated Statue in Eighteenth-Century France." *Journal of the Warburg and Courtauld Institutes* 23, no 3–4 (July–December 1960): 239–55.

Costello, Diarmuid, and Dominic Wilsdon, eds. *The Life and Death of Images: Ethics and Aesthetics.* London: Tate Publishing, 2008.

Fried, Michael. "Art and Objecthood." Reprinted in *Art and Objecthood: Essays and Reviews*, 148–72. Chicago and London: Chicago University Press, [1967] 1998.

Garnett, Jane, and Gervase Rosser. *Spectacular Miracles: Transforming Images in Italy from the Renaissance to the Present.* London: Reaktion Books, 2013.

Gell, Alfred. *Art and Agency: An Anthropological Theory of Art.* Oxford: Clarendon Press, 1998.

Guthrie, Stewart Elliott. "Anthropology and Anthropomorphism in Religion." In *Religion, Anthropology, and Cognitive Science*, edited by Harvey Whitehouse and James Laidlow, 37–62. Durham: Carolina Academic Press, 2007.

Hallowell, Irving A. "Ojibwa Ontology, Behavior, and World View." In *Contributions to Anthropology: Selected Papers of A. Irving Hallowell*, edited by Raymond D. Fogelson, 357–90. Chicago: Chicago University Press, [1960] 1976.

Horkheimer, Max, and Theodor Adorno. *Dialectic of Enlightenment: Philosophical Fragments*, edited by Gunzelin Schmid Noerr; translated by Edmund Jephcott. Stanford: Stanford University Press, [1947] 2002.

Kanz, Roland, and Hans Körner, eds. *Pygmalions Aufklärung: Europäische Skulptur im 18. Jahrhundert.* Munich: Deutscher Verlag, 2006.

Kemp, Wolfgang, ed. *Der Betrachter ist im Bild: Kunstwissenschaft und Rezeptionsästhetik.* Cologne: DuMont, 1985.

Krauss, Rosalind E. *Passages in Modern Sculpture.* Cambridge, MA: MIT Press, 1977.

Mallgrave, Harry Francis, and Eleftherios Ikonomou, eds. *Empathy, Form and Space: Problems in German Aesthetics 1873–1893.* Santa Monica: Getty Center for the History of Art and the Humanities; Chicago: University of Chicago Press, 1994.

Mazzoleni, Donatella. "The City and the Imaginary." Translated by John Koumantarakis. *New Formations* 11 (Summer 1990): 91–104.

Melion, Walter S., Bret Rothstein, and Michel Weemans, eds. *The Anthropomorphic Lens: Anthropomorphism, Microcosmism and Analogy in Early Modern Thought and Visual Arts.* Leiden: Brill, 2015.

Payne, Alina. *From Ornament to Object: Genealogies of Architectural Modernism.* New Haven: Yale University Press, 2012.

Steinberg, Leo. "Monet's Water Lilies." In *Other Criteria: Confrontations with Twentieth-Century Art*, edited by Leo Steinberg, 235–39. Chicago: University of Chicago Press, [1956] 1972/2007.

Stoichita, Victor. *The Pygmalion Effect: From Ovid to Hitchcock.* Chicago: University of Chicago Press, 2008.

van Eck, Caroline. *Art, Agency and Living Presence.* Berlin: Akademie Verlag; Leiden: Leiden University Press, 2015.

Viveiros de Castro, Eduardo. "Exchanging Perspectives: The Transformation of Objects into Subjects in Amerindian Ontologies." *Common Knowledge* 10, no. 3 (2004): 463–84.

Wagner, Kirsten, and Jasper Cepl, eds. *Images of the Body in Architecture: Anthropology and Built Space.* Tübingen and Berlin: Wasmuth, 2014.

Warburg, Aby. *The Renewal of Pagan Antiquity.* Translated by David Britt. Los Angeles: Getty Research Institute for the History of Art and the Humanities, 1999.

Weemans, Michel, Dario Gamboni, and Jean-Hubert Martin, eds. *Voir double: Pièges et révélations du visible.* Paris: Hazan, 2016.

Weigel, Sigrid. *Grammatologie der Bilder.* Frankfurt: Suhrkamp, 2015.

Wittkower, Rudolph. *Architectural Principles in the Age of Humanism.* London: Architectural Press, [1949] 1988.

Appropriation

Bal, Mieke. *Quoting Caravaggio: Contemporary Art, Preposterous History.* Chicago: University Press, 2011.

Barthes, Roland. *Mythologies.* New York: Farrar Straus & Giroux, 1972.

Baxandall, Michael. *Patterns of Intention: On the Historical Explanation of Pictures.* New Haven: Yale University Press, 1987.

Beitien, Andreas F., et al. *Hirschfaktor: Die Kunst des Zitierens* (*Hirschfactor: The Art of Citation*), exh. cat., Museum für Neue Kunst, ZKM, Karlsruhe. Karlsruhe: ZKM, 2012.

Boon, Marcus. *In Praise of Copying.* Cambridge, MA: Harvard University Press, 2010.

Bourriaud, Nicolas. *Postproduction: Culture as Screenplay; How Art Re-programs the World.* New York: Lukas and Sternberg, 2002.

Brilliant, Robert, and Dale Kinney, eds. *Reuse Value: Spolia and Appropriation in Art and Architecture from Constantine to Sherrie Levine.* Farnham: Ashgate, 2011.

Buchloh, Benjamin. "Allegorical Procedures: Apppropriation and Montage in Contemporary Art." *Artforum* 21 (September 1982): 43–56.

Crimp, Douglas. "Pictures." *October* 8 (Spring 1979): 75–88.

Elsner, Jas. "Art History as Ekphrasis." *Art History* 33, no. 1 (2010): 10–27.

Grewe, Cordula. "Re-enchantment as Artistic Practice: Strategies of Emulation in German Romantic Art and Theory." *New German Critique* 94 (2005): 36–72.

Jameson, Frederic. "Reification and Utopia in Mass Culture." *Social Text* 1 (1979): 130–48.

Kahng, Eik. *The Repeating Image: Multiples in French Painting from David to Matisse.* New Haven: Yale University Press, 2008.

Kubler, George. *The Shape of Time: Remarks on the History of Things.* New Haven: Yale University Press, 1962.

McLean, Ian. "Post-Western Poetics: Postmodern Appropriation Art in Australia." *Art History* 37 (2014): 628–47.

Nelson, Robert S. "Appropriation." In *Critical Terms for Art History*, edited by Nelson and Richard Shiff, 160–73. 2nd ed. Chicago and London: The University of Chicago Press, [1996] 2003.

Owens, Craig. "The Allegorical Impulse: Toward a Theory of Postmodernism," parts 1 and 2. In *Beyond Recognition: Representation, Power, and Culture*, edited by Scott Bryson and Craig Owsen, 52–87. Berkeley: University of California Press, [1980] 1992.

Pang, Laikwan. *The Art of Cloning: Creative Production during China's Cultural Revolution.* London: Verso, 2017.

Strang, Veronica, and Mark Busse, eds. *Ownership and Appropriation.* Oxford: Berg, 2011.

Venuti, Lawrence. "Ekphrasis, Translation, Critique." *Art in Translation* 2, no. 2 (2010): 131–52.

Vischer, Friedrich Theodor. "Overbeck's Triumph of Religion (1841)." In *Art in Theory, 1815–1900: An Anthology of Changing Ideas*, edited by Charles Harrison, Paul Wood, and Jason Gaiger, 196–99. Malde: Blackwell, 1998.

Welchman, John C. *Art after Appropriation: Essays on Art in the 1990s.* Amsterdam and London: G+B Arts International/Routledge, 2001.

Ziff, Bruce, and Pratima V. Rao. *Borrowed Power: Essays on Cultural Appropriation.* New Brunswick: Rutgers University Press, 1997.

Contingency

Agamben, Giorgio. *Remnants of Auschwitz: The Witness and the Archive.* Translated by Daniel Heller-Roazen. New York: Zone Books, 1999.

Baudelaire, Charles. "The Painter of Modern Life." In *The Painter of Modern Life and Other Essays*, translated and edited by Jonathan Mayne, 1–41. London: Phaidon, [1863] 1995.

Beyer, Andreas, Angela Mengoni, and Antonia von Schöning, eds. *Interpositions: Montage d'images et production de sens.* Paris: Fondation Maison des sciences de l'homme, 2014.

Buskirk, Martha. *The Contingent Object of Contemporary Art.* Cambridge, MA: MIT Press, 2003.

Butler, Judith, Ernest Laclau, and Slavoj Žižek, eds. *Contingency, Hegemony, Universality.* London: Verso, 2000.

Doanne, Mary Ann. *The Emergence of Cinematic Time: Modernity, Contingency, the Archive.* Cambridge, MA: Harvard University Press, 2002.

Gamboni, Dario. *Potential Images: Ambiguity and Indeterminacy in Modern Art.* Translated by Mark Treharne. London: Reaktion Books, 2002.

Haskell, Francis. *Rediscoveries in Art: Some Aspects of Taste, Fashion and Collecting in England and France.* London: Phaidon, 1976.

Laxton, Susan. "As Photography: Mechanicity, Contingency, and Other-Determination in Gerhard Richter's Overpainted Snapshots." *Critical Inquiry* 38, no. 4 (2012): 776–95.

Mason, Zachary. *The Lost Books of the Odyssey.* New York: Farrar, Straus and Giroux, 2007.

Rorty, Richard. *Contingency, Irony, and Solidarity.* Cambridge: Cambridge University Press, 1989.

Shiff, Richard. "Realism of Low Resolution: Digitisation and Modern Painting." In *Impossible Presence: Surface and Screen in the Photogenic Era*, edited by Terry Smith, 125–56. Chicago: University of Chicago Press, 2001.

Detail

Arasse, Daniel. *Le détail: Pour une histoire rapprochée de la peinture.* Paris: Flammarion, 1992.

Bucklow, Spike. *The Alchemy of Paint: Art, Science and Secrets from the Middle Ages.* London: Marion Boyars, 2009.

Cheeke, Stephen. *Writing for Art: The Aesthetics of Ekphrasis.* Manchester: Manchester University Press, 2008.

"Detail." In *Goethe-Wörterbuch*, edited by Berlin-Brandenburgische Akademie der Wissenschaften, Akademie der Wissenschaften in Göttingen, and Heidelberger Akademie der Wissenschaften, vol. 2, 1157–58. Stuttgart: W. Kohlhammer, 1989.

Didi-Huberman, Georges. "L'art de ne pas décrire: Une aporie du détail chez Vermeer." *La Part de l'Oeil* 2 (1986): 102–19.

Elkins, James. "On the Impossibility of Close Reading: The Case of Alexander Marshack." *Current Anthropology* 37, no. 2 (1996): 185–226.

Gamboni, Dario. *Potential Images: Ambiguity and Indeterminacy in Modern Art.* London: Reaktion Books, 2002.

Ginzburg, Carlo. "Morelli, Freud, and Sherlock Holmes: Clues and Scientific Method." In *The Sign of Three: Dupin, Holmes, Peirce*, edited by Umberto Eco and Thomas Sebeok, 81–118. Bloomington: Indiana University Press, 1983.

Goulish, Matthew. *39 Microlectures: In Proximity of Performance.* London: Routledge, 2000.

Hollander, John. *The Gazer's Spirit: Poems Looking at Silent Works of Art.* Chicago: University of Chicago Press, 1995.

Mitchell, W. J. T. *Picture Theory: Essays on Verbal and Visual Representation.* Chicago: University of Chicago Press, 1995.

Schäffner, Wolfgang, Sigrid Weigel, and Thomas Macho, eds. *"Der liebe Gott steckt im Detail": Mikrostrukturen des Wissens.* Munich: Fink, 2001.

Schor, Naomi. *Reading in Detail: Aesthetics and Feminine.* New York: Methuen, 1987.

Sekula, Allan. "The Body and the Archive." *October* 39 (Winter 1986): 3–64.

Thomas, Chantal. *Farewell, My Queen.* Translated by Moishe Black. New York: Simon and Schuster, 2004.

Materiality

Barry, Fabio. "The Mouth of Truth and the Forum Boarium: Oceanus, Hercules, and Hadrian." *The Art Bulletin* XCIII, no. 1 (March 2011): 7–37.

Baxandall, Michael. *Painting and Experience in Fifteenth-Century Italy.* Oxford: Oxford University Press, 1972.

Bois, Yve-Alain. "Base Materialism." In *Formless: A User's Guide*, edited by Yve-Alain Bois and Rosalind E. Krauss, 51–62. New York: Zone Books, 1997.

Brown, Bill. "Materiality." In *Critical Terms for Media Studies*, edited by W. J. T. Mitchell and Mark Hansen, 49–63. Chicago: University of Chicago Press, 2010.

Bruno, Giuliana. *Surface: Matters of Aesthetics, Materiality, and Media.* Chicago: University of Chicago Press, 2014.

Bynum, Caroline Walker. *Christian Materiality: An Essay on Religion in Late Medieval Europe.* New York: Zone Books; Cambridge, MA: MIT Press, 2011.

Clunas, Craig. *Superfluous Things: Material Culture and Social Status in Early Modern China.* Honolulu: University of Hawai'i Press, 2004.

Cole, Michael. "The Cult of Materials: Sculpture through Its Material Histories." In *Revival and Invention*, edited by Martina Droth and Sébastien Clerbois, 1–15. Oxford: Lang, 2011.

Daston, Lorraine, ed. *Things That Talk: Object Lessons from Art and Science.* New York: Zone Books, 2004.

Gell, Alfred. *Art and Agency: An Anthropological Theory of Art.* Oxford: Clarendon Press, 1998.

Gumbrecht, Hans Ulrich, and Karl Ludwig Pfeiffer, eds. *Materialität der Kommunikation.* Frankfurt: Suhrkamp, 1988.

Hamburger, Jeffrey. *Script as Image.* Paris: Peeters, 2014.

Haus, Andreas, Franck Hofmann, and Änne Söll, eds. *Material im Prozess.* Berlin: Reimer, 2000.

Ingold, Tim. "Materials against Materiality." *Archaeological Dialogues* 14, no. 1 (2007): 1–16.

Lange-Berndt, Petra, ed. *Materiality.* London: Whitechapel Gallery; Cambridge, MA: The MIT Press, 2015.

Löschke, Sandra Karina, ed. *Materiality and Architecture.* London: Routledge, 2016.

Lyotard, Jean-François, and Thierry Chaput, eds. *Les immatériaux*, 3 vols. Paris: Centre Georges Pompidou, 1985.

Morgan, David, ed. *Religion and Material Culture: The Matter of Belief.* London: Routledge, 2010.

Raff, Thomas. *Die Sprache der Materialien.* Munich: Deutscher Kunstverlag, 1994.

Roberts, Jennifer L. *Transporting Visions: The Movement of Images in Early America.* Berkeley: University of California Press, 2014.

Rübel, Dietmar, Monika Wagner, and Vera Wolff, eds. *Materialästhetik.* Berlin: Reimer, 2005.

Wagner, Monika. *Das Material der Kunst: Eine andere Geschichte der Moderne.* Munich: Beck, [2001] 2013.

Wagner, Monika, and Dietmar Rübel, eds. *Material in Kunst und Alltag.* Berlin: Akademie, 2002.

Mimesis

Aristotle. *Poetics.* Translated by Richard Janko. Indianapolis: Hackett, 1987.

Auerbach, Erich. "Figura." In *Scenes from the Drama of European Literature: Six Essays*, by Eric Auerbach, 11–76. Gloucester: Peter Smith, 1973.

Auerbach, Erich. *Mimesis: The Representation of Reality in Western Literature.* Translated by Willard Trask with a new introduction by Edward Said. Princeton: Princeton University Press, [1953] 2003.

Balke, Friedrich, and Hanna Engelmeier. *Mimesis und Figura: Mit einer Neuausgabe des »Figura«-Aufsatzes von Erich Auerbach*, Medien und Mimesis, vol. 1. Paderborn: Wilhelm Fink, 2016.

Bann, Stephen. *The True Vine: On Visual Representation and the Western Tradition.* Cambridge: Cambridge University Press, 1989.

Beistegui, Miguel de. *Aesthetics after Metaphysics: From Mimesis to Metaphor.* New York: Routledge, 2012.

Benjamin, Walter. "On the Mimetic Faculty." In *Walter Benjamin: Selected Writings,* vol. 2, *1927–1934,* edited by Michael W. Jennings, 720–22. Cambridge, MA: Harvard University Press, [1933] 1999.

Bohde, Daniela. *Kunstgeschichte als physiognomische Wissenschaft: Kritik einer Denkfigur der 1920er bis 1940er Jahre.* Berlin: Akademie, 2012.

Freud, Sigmund. *Beyond the Pleasure Principle.* Translated by James Strachey. New York: Norton, [1920] 1989.

Gombrich, E. H. *Art and Illusion.* London: Phaidon, 1960.

Halliwell, Stephen. *The Aesthetics of Mimesis: Ancient Texts and Modern Problems.* Princeton: Princeton University Press, 2002.

Huhn, Thomas. *Imitation and Society: The Persistence of Mimesis in the Aesthetics of Burke, Hogarth, and Kant.* University Park: Penn State University Press, 2004.

Hurley, Susan, and Nick Chater, eds. *Perspectives on Imitation: From Neuroscience to Social Science*, 2 vols. Cambridge, MA: MIT Press, 2005.

Hyman, John. *The Objective Eye: Color, Form, and Reality in the Theory of Art.* Chicago: University of Chicago Press, 2006.

Jameson, Frederic. *The Antinomies of Realism.* London: Verso, 2013.

Johach, Eva, Hasmin Mersmann, and Evke Rulffes, eds. "Mimesen." *ilinx. Berliner Beiträge zur Kulturwissenschaft,* no. 2. Hamburg: Philo Fine Arts, 2011.

Kulvicki, John. "Pictorial Representation." *Philosophy Compass* 1, no. 6 (2006): 535–46.

Kofman, Sarah. *Camera Obscura of Ideology.* Translated by Will Straw. Ithaca: Cornell University Press, [1973] 1999.

Largier, Niklaus. "The Plasticity of the Soul: Mystical Darkness, Touch, and Aesthetic Experience." *Modern Language Notes* 125 (2010): 536–51.

Lessing, Gotthold Ephraim. *Laocoön: An Essay on the Limits of Painting and Poetry.* Translated by Edward Allen McCormick. Baltimore: Johns Hopkins University Press, [1766] 1984.

Okere, A. C. "Art, Mimesis, Mythography and Social Relevance: The Aesthetics of Wole Soyinka's *Season of Anomy.*" *Literary Criterion* 29, no. 4 (1994): 44–54.

Podro, Michael. *Depiction.* New Haven and London: Yale University Press, 1998.

Potts, Alex. "The Image Valued 'As Found' and the Reconfiguring of Mimesis in Post-War Art." *Art History* 37, no. 4 (2014): 784–805.

Rabinbach, Anson. "The Cunning of Unreason: Mimesis and the Construction of Anti-Semitism in Horkheimer and Adorno's Dialectic of Enlightenment." In *In the Shadow of Catastrophe: German Intellectuals between Apocalypse and Enlightenment.* Berkeley and Los Angeles: University of California Press, 1997.

Ricoeur, Paul. "Mimesis and Representation." In *A Ricoeur Reader: Reflection and Imagination*, edited by Mario J. Valdés, 137–55. Toronto: University of Toronto Press, 1991.

Rorty, Richard. *Philosophy and the Mirror of Nature.* Princeton: Princeton University Press, 1979.

Taussig, Michael. *Mimesis and Alterity: A Particular History of the Senses.* London: Routledge, 1993.

Villinger, Rahel. "Form und Mimesis: Elemente frühromantischer Kunsttheorie bei Husserl, Benjamin und Adorno." *Zeitschrift für Ästhetik und Allgemeine Kunstwissenschaft* 60, no. 2 (2015): 277–98.

Winckelmann, Johann Joachim. *Reflections on the Imitation of Greek Works in Painting and Sculpture.* Translated by Elfriede Heyer and Roger C. Norton. La Salle: Open Court, [1755] 1987.

Time

Bann, Stephen. *The Clothing of Clio: A Study of the Representation of History in Nineteenth-Century Britain and France*. Cambridge: Cambridge University Press, 1984.

Bergson, Henri. *Matter and Memory*. Translated by N. M. Paul and W. S. Palmer. New York: Zone Books, [1896] 1991.

Certeau de, Michel. "Writing vs. Time: History and Anthropology in the Works of Lafitau." *Yale French Studies* 59 (1980): 37–64.

Fabian, Johannes. *Time and the Other: How Anthropology Makes Its Object*. New York: Columbia University Press, 1983.

Fritzshe, Peter. *Stranded in the Present: Modern Time and the Melancholy of History*. Cambridge, MA and London: Harvard University Press, 2004.

Groom, Amelia, ed. *Time*. London: Whitechapel Gallery; Cambridge, MA: The MIT Press, 2013.

Habermas, Jürgen. "Modernity's Consciousness of Time and Its Need for Reassurance." In *The Philosophical Discourse of Modernity: Twelve Lectures*. Translated by Frederick G. Lawrence, 1–22, 386–89. Cambridge, MA: MIT Press, [1985] 1991.

Hunt, Lynn. *Measuring Time, Making History*. Budapest and New York: Central European University, 2008.

Jordanova, Ludmilla. *History in Practice*. 3rd revised ed. 2017. London: Bloomsbury Academic, [2000] 2006.

King, Homay. *Virtual Memory: Time-Based Art and the Dream of Digitality*. Durham: Duke University Press, 2015.

Kracauer, Siegfried. "Time and History." *History and Theory* 6 (1966): 65–78.

Kubler, George. *The Shape of Time: Remarks on the History of Things*. New Haven: Yale University Press, 1962.

Lee, Pamela. *Chronophobia: On Time in the Art of the 1960s*. Cambridge, MA: MIT Press, 2004.

Lipsitz, George. *Time Passages: Collective Memory and American Popular Culture*. Minneapolis and London: University of Minnesota Press, 1990.

Lyotard, Jean-François. *The Inhuman: Reflections on Time*. Translated by Geoffrey Bennington and Rachel Bowlby. Stanford: Stanford University Press, [1988] 1991.

Moxey, Keith. *Visual Time: The Image in History*. Durham: Duke University Press, 2013.

Rosa, Hartmut, and William Scheuerman, eds. *High-Speed Society: Social Acceleration, Power and Modernity*. University Park: The Pennsylvania State University Press, 2009.

Ruda, Frank, and Jan Völker. *Art and Contemporaneity*. Zurich and Berlin: Diaphanes, 2015.

Smith, Terry, Okwui Enwezor, and Nancy Condee, eds. *Antinomies of Art and Culture: Modernity, Postmodernity, and Contemporaneity*. Durham and London: Duke University Press, 2008.

Zimmermann, Michael F., ed. *Vision in Motion: Streams of Sensation and Configurations of Time*. Zurich and Berlin: Diaphanes, 2016.

Tradition

Adorno, Theodor W. "On Tradition." *Telos* 94 (1993–94): 75–82. Translated from the version of an article that first appeared in 1966, Adorno, *Gesammelte Schriften* X:1 (Frankfurt, 1977), 310–20.

Arendt, Hannah. "Tradition and the Modern Age." *Partisan Review* 21, no. 1 (January–February 1954): 53–75.

Assmann, Aleida. *Cultural Memory and Western Civilization: Functions, Media, Archives*. Cambridge: Cambridge University Press, 2011.

Assmann, Jan. *Cultural Memory and Early Civilization: Writing, Remembrance, and Political Imagination.* Cambridge: Cambridge University Press, 2011.

Bloom, Harold. *The Anxiety of Influence: A Theory of Poetry.* New York: Oxford University Press, 1973.

Bredekamp, Horst. "A Neglected Tradition? Art History as *Bildwissenschaft.*" *Critical Inquiry* 29, no. 3 (2003): 418–28.

Bruns, Gerald. "What is Tradition?" *New Literary History* 22 (1991): 1–21.

Eliot, T. S. "Tradition and the Individual Talent." In *Selected Essays*, 13–22. London: Faber and Faber, [1917] 1932.

Gadamer, Hans-Georg. *Truth and Method.* Translated by Joel Weinsheimer and Donald G. Marshall. New York: Continuum, [1960] 1995.

Gazda, Elaine K. "Beyond Copying: Artistic Originality and Tradition." In *The Ancient Art of Emulation: Studies in Artistic Originality and Tradition from the Present to Classical Antiquity*, edited by Elaine K. Gazda, 1–24. Ann Arbor: University of Michigan Press, 2002.

Giddens, Anthony. "Living in a Post-Traditional Society." In *Reflexive Modernization: Politics, Tradition and Aesthetics in the Modern Social Order*, edited by Ulrich Beck, Anthony Giddens, and Scott Lash, 56–109. Cambridge: Polity Press, 1994.

Greenberg, Clement. "Modernist Painting." In *Clement Greenberg: The Collected Essays and Criticism*, edited by John O'Brien, vol. 4, 85–93. Chicago: University of Chicago Press, [1960] 1993.

Hobsbawn, Eric, and Terence Ranger, eds. *The Invention of Tradition.* Cambridge: Cambridge University Press, 1983.

Hung, Wu. *The Double Screen: Medium and Representation in Chinese Painting.* London: Reaktion Books, 1996.

Jauss, Hans Robert. "Tradition, Innovation, and Aesthetic Experience." *The Journal of Aesthetics and Art Criticism* 46, no. 3 (Spring 1988): 375–88.

Kaufmann, Thomas DaCosta. *Toward a Geography of Art.* Chicago: University of Chicago Press, 2004.

Klein, Peter, and Regine Prange, eds. *Zeitspiegelung: Zur Bedeutung von Traditionen in Kunst und Kunstwissenschaft; Festschrift für Konrad Hoffmann zum 60. Geburtstag.* Berlin: Reimer, 1998.

Kleinberg, Ethan, ed. "Tradition and History." Special issue, *History and Theory* 51, no. 4 (2012).

Levin, Harry. "The Tradition of Tradition." *Hopkins Review* 4, no. 3 (1951). Reprinted in *Contexts of Criticism*, 55–66. Cambridge, MA: Harvard University Press, 1957.

MacIntyre, Alasdair. *Whose Justice? Which Rationality?* London: Duckworth, 1988.

Paiva, Josè de. *The Living Tradition of Architecture.* London and New York: Routledge, 2017.

Panofsky, Erwin. "Introduction: The History of Art as a Humanistic Discipline" (1940). In *Meaning in the Visual Arts.* Harmondsworth, UK: Penguin Books, [1955] 1993.

Phillips, Mark, and Gordon Schochet, eds. *Questions of Tradition.* Toronto: University of Toronto Press, 2004.

Shiff, Richard. "Cézanne and Poussin: How the Modern Claims the Classic." In *Cézanne and Poussin: A Symposium*, edited by Richard Kendall, 51–68. Sheffield: Sheffield Academic Press, 1993.

Shils, Edward. *Tradition.* Chicago: University of Chicago Press, 1981.

Index

Okeke, Uche, 280. *See also* Nigeria: postcolonial art
Onobrakpeya, Bruce, 280. *See also* Nigeria: postcolonial art
Onunke artists (Nigeria), 279, 281n3. *See also* Nigeria: postcolonial art
Origen of Alexandria, 230–31
Orwell, George, 12
O'Sullivan, Timothy H., 171–73
Overbeck, Johann Friedrich, **21**, 63

P
Panel of the Horses (Chauvet Cave, France) **5**, 8, 11. *See also* Herzog
Panofsky, Erwin, 146, 249; on details as disguised symbols, 140; on tradition during the Nazi regime, 294, 295 (*see also* Gadamer; Habermas); iconology as opposed to Barthes's semiology of images, 295–96. *See also* space
Pan Tianshou, 127–28
Parmiggiani, Claudio, 184
Passerotti, Bartolomeo, **111**, 305, 306
Patel, Gieve: *Crows with Debris*, **101**, 259–65
Paz, Octavio, 160.
Peyron, Jean-François Pierre, 100
photography
 and contingency, 83–84, 85–88, 90–92, 94, 96–98, 106
 as a means of appropriation of identity, 53–55
 as a teaching subject, 84
 as re-enactment of tradition, 310
 as reproduction of artworks, 57–61 (*see also* Höfer)
 digital, 93–95
 ethnographic, 53–55
 in a postcolonial context, 54
 redemptive power of, 85–86
 social media, 85
 triggering moral indignation, 86
 violence and suffering documented by, 85–86, 91

visual power of, 84
 widening artworks' creative qualities, 59, 62n12
Physiognomics. *See* Mimesis
Picabia, Francis, 43, 47
Picasso, Pablo, 10–11, 146, 148, 201, 312; *Woman with Mandolin*, 297
pigments. *See* colors; materials: pigments
Piles, Roger de, 207
Plato, 153. *See also* Mimesis: Plato
Pliny, the Elder, 120
Polke, Sigmar, 96
Pollaiuolo, Andrea, **80**, 201
Pollock, Jackson, 46, 96; *Autumn Rhytm*, **119**, 317
Poussin, Nicolas, 249
Proust, Marcel, 148

Q
Quatremère de Quincy, Antoine-Chrysostome, 17–18
quechua, language, 12–13
Qin Shi Huangdi, emperor of China, 143
Quincey, Thomas de, 158
Quinn, Marc, **92**, 227–28. *See also* sculpture: made with blood

R
Ranger, Terence, *The Invention of Tradition*, 284, 285. *See also* Hobsbawm
Raphael, **22**, 63, 100, 305
Ray, Charles, **12**, 34–35
Ray, Man: *Dust breeding*, photograph of Duchamp's *Large Glass*, **72**, 182–83. *See also* materials: dust
Reynolds, Joshua, 112; on the ornamental style and the sublime, 139
Ricoeur, Paul, on mimesis as a form of production of meaning, 221–22; phenomenological hermeneutics, 74
Riegl, Alois, from tactile to optical perception of art, 315–20; *Kunstwollen* (artistic will), 315, 316;

Warhol, Andy, 146
Wilde, Oscar, 93
Winckelmann, Johann Joachim, 17–18,
117; on mimesis at the center of
artistic production, 222–23; on
physiognomics, 205; on surface and
depth in sculpture, 223, 224n8
Wittgenstein, Ludwig: *On colour*, 94
Wölfflin, Heinrich, on the Gothic spirit, 207.
See also space
Wols (Alfred Otto Wolfgang Schulze), 46
Wool, Christopher, **82**, 203
Wurm, Erwin, and dust, **74**, 184–185. *See
also* materials: dust

X
Xu Bing: *Dust project*, 184. *See also* materials:
dust

Y
Yoruba culture (Nigeria). *See* sculpture: Ife

Z
Zaria art society, 280. *See also* Nigeria:
postcolonial art
Zeri, Federico, 120
Zhang Daqian, **89**, 213–15
Žižek, Slavoj, 173